DAVID

Hertfordshire

1 6 OCT 2009

5 NOV

2 5 NOV

25 MAR 2010

24/02/15

Please renew/return this item by the last date shown.

So that your telephone call is charged at local rate, please call the numbers as set out below:

	From Area codes 01923 or 020:	From the rest of Herts:
Renewals:	01923 471373	01438 737373
Enquiries:	01923 471333	01438 737333
Textphone:	01923 471599	01438 737599

L32 www.hertsdirect.org/librarycatalogue

ANTOINE SCHNAPPER

DAVID

PUBLISHERS OF FINE ART BOOKS, NEW YORK

© 1980 by Office du Livre, Fribourg, Switzerland
Published in 1982 by Alpine Fine Arts Collection, Ltd.
164 Madison Avenue, New York, New York 10016

English translation by Helga Harrison

ISBN: 0-933516-59-2

This book was produced in Switzerland

Table of Contents

Introduction . 7

I. On the Threshold . 9

II. Rome . 31

III. From Belisarius to Brutus 57

IV. The Revolution . 95

V. Return to Antiquity . 165

VI. David and Napoleon . 201

VII. Exile . 275

Bibliography . 303

Index . 304

INTRODUCTION

The date when he chanced to be born made David the witness to the fullest and most fast-moving period in the history of France—one that never fails to fascinate historians: he lived through the Ancien Régime, the Revolution, the Consulate, the Empire and the Restoration. This is also true of some other far from negligible French painters, such as Peyron, Vincent and Regnault, but—apart from the differences in their talents—none was so closely involved in the events of his time. A member of the Convention, a Regicide, an intimate of Robespierre, David was soon totally captivated by Bonaparte, thus antagonizing both the Left and the Right; until quite recently, works about the artist were colored by the political bias of the author.

David was a political figure as well as an artist; he played a direct part in the arts during the Revolution, but also an indirect one from the time he returned from Rome until his death, through his paintings and through the influence he exerted as a teacher on hundreds of French and foreign students. The important position he occupied during the Revolution and the Empire led him to commemorate some of the main events of his time, from the oath of the Tennis Court to the ceremonies inaugurating the Empire, and to pay tribute in passing to the "martyrs of the Revolution". Now that school history textbooks tend to become picture books, we increasingly see the events and actors of that period through David's eyes. Through his eyes, too, we see the grandiose, mythical figure of Bonaparte crossing the Grand Saint Bernard Pass, Pius VII exhausted during Napoleon's coronation, Mme Récamier forever immobilized on her sofa. David has also left us a sort of miniature human comedy in his portraits of friends, of officials grown rich, of successful soldiers, diplomats and exiled politicians. Quite a number of these portraits and historical works are unfinished; but they give us a glimpse into the secrets of David's working methods, and their—apparent—casualness seems to freeze the passing moment even more effectively than the completed works do.

David was more closely involved in the political life of his time than any other contemporary painter, and his work—the failures and unfinished efforts as well as the successes—is deeply marked by this fact; but as an artist he witnessed, and then led, another kind of revolution, a revolution of style. Towards 1780, when he had—somewhat belatedly—realized that there was a revival of the *grand style*, which had begun around 1760, he himself gave an authoritative lead to the movement. First he created some masterpieces of neo-classicism, then he renewed the style by imbuing it with the realism demanded by contemporary subjects: here art and politics became inextricably entwined. David, a chronicler of his age,

interpreted them in his works and gave them a style. The somewhat artificial severity of the neo-classical *grand style* was tempered and regenerated (to adapt one of the terms of the Revolution) thanks to the need for a certain realism. David's genius found expression in this perpetual oscillation between style and nature.

It would be pointless to try and distinguish between the frankly realist works, such as the *Couronnement (Coronation)*, and the subjects from antiquity, whether light or heroic, or to oppose historical paintings and portraits, as was done at the David exhibitions in 1913 and 1948. His preparatory studies for antique subjects are so similar to those for contemporary ones that it is sometimes difficult to tell them apart: all the figures are portrayed in heroic nudity. As much as in his power of observation, the greatness of a portrait painter lies in his ability to compose and construct what is most difficult to compose and construct, the simple bust of a unique human being against a plain background. The greatness of the historical painter—however much his style may be steeped in classical sublimity—lies in the way he shows the surface of men and objects, the dumb presence of a workbasket on a table or a ribbon in Hersilia's hair. Surely the fact that in *The Sabines* one of the standards dominating the Roman soldiers is a simple bundle of hay is a telling symbol.

I. ON THE THRESHOLD

Art in France during David's youth: the Royal Academy and teaching methods. The grand style *and minor style. Painters of the 1760s: Boucher, Greuze, Vien. David's first steps at the Academy. The Grand Prix de Rome of 1774:* Antiochus and Stratonica. *First portraits.*

Art in France was organized along much the same lines from the age of Louis XIV until the Revolution. Apart from the whole area of the work of second-rate artists which has been almost entirely excluded from the history of art, it was centralized in Paris, governed by a royal department, the *Direction des Bâtiments du roi* (Department of Royal Buildings), and a corps of artists grouped in various academies.

From 1751 to 1773 the director of the department was the Marquis de Marigny, Madame de Pompadour's brother; he started his career very young, but was well equipped for it, since he was a sincere art-lover, steeped in the new ideas of a return to a simple, genuine style. He ran the rather difficult family of artists by building up support among some of them. In the 1760s, when David's talent was taking shape, these supporters were Carle Van Loo, Painter-in-Chief to the King since 1762, who died suddenly in 1765, F. Boucher, who was just reaching the end of his career (he died in 1770), and finally J. B. M. Pierre, a very talented painter who was devoting himself increasingly to the administration of art, a process in which he offended a fair number of his colleagues by his arrogance and self-importance. There were others who collaborated—often harmoniously enough despite the chronic lack of funds from which the *Direction des Bâtiments* suffered—literary men like Abbé Leblanc and artists like Charles-Nicolas Cochin, the engraver, appointed secretary to the Royal Academy of Painting and Sculpture in 1755, and *Chargé du Détail des Arts* under the director.

It was Cochin who initiated the first great program of "moral" painting, in 1764, in the decoration of the royal château at Choisy. Instead of the usual mythological decor, Cochin suggested to Marigny that they should show "the generous and humane actions with which good kings made their people happy". The princes chosen were Augustus, Trajan, Titus, and Marcus Aurelius; thus we were to be shown that "*Marcus Aurelius took great pains to relieve his people at a time of famine and plague*, a touching scene which offers great scope to an ingenious, expressive artist". The four paintings were indeed executed by Carle Van Loo, Lagrenée the Elder, N. Hallé, and J.-M. Vien. Cochin envisaged further subjects

from antiquity to decorate the space above the doors. There were to be other examples of virtue, like Furius Camillus coming to the aid of Rome although he had been banished from the city, the Piety of Lucius Albinus, and Solon presenting the Athenians with the tablets of his laws.

Cochin had rushed the change of taste a little, and the king yawned when he contemplated the new paintings: in 1766 their execution was suspended, those that had been completed were taken down, and, resignedly, the inevitable Boucher was called in. However, he died before he could paint the pictures, and in 1771, Pierre, Cochin's successor at the *Détail des Arts*, revived the program in the original style, using antique examples to illustrate Courage, Vigilance, Filial Piety and Humanity. It fell to d'Angiviller to carry through the projected reforms, which had the support of the coterie of intellectuals. The latter took an increasingly active interest in the arts, which occupied a far from negligible place in the *Grande Encyclopédie*, and they were about to take over a new discipline, art criticism—to the great annoyance of the artists, who would have liked to exclude anyone but themselves from that field.

The growth of criticism was linked to the development of an institution that was both old and new, the Salons: old, because they had been known in France under Louis XIV, and new since they did not really emerge definitively until 1737, and especially from 1747, when they were first organized on a regular biennial basis. It is difficult for us today to understand their place in the life of the arts. Thousands of people, with a printed booklet at their disposal, visited this solemn exhibition which opened at the Louvre for a fortnight. The fame of the Salon was broadcast throughout France, and even Europe, by the gazettes, all of which carried more or less witty letters about the event. This special form of literature for the occasion, in which Diderot came to distinguish himself, had a tremendous influence on the fate of the artists concerned.

For painters, sculptors and engravers everything centered on the Royal Academy, which grew even more influential through the development of the Salons. David always regarded it—and its preliminary school, the French Academy in Rome—with a keen, persistent hatred. He went up the traditional ladder, with many disappointments, as we shall see. The apprentice—often no more than a child—took lessons from an artist, a famous one if he was ambitious and gifted, who subsequently gave him a letter of recommendation to the Academy in the Louvre. In fact, since its creation and its reorganization in 1663, the Academy had primarily been a school of drawing. The pupil followed a carefully

prescribed syllabus, first of all copying nude drawings and engravings. He then progressed to copying three-dimensional objects, generally casts of antique works. Then at last came the ultimate exercise, almost the hallmark of the Academy—drawing from life; this was a rather expensive exercise, which the Academy provided almost free of charge for its pupils by virtue of its monopoly, which was contested timidly by the Académie de Saint-Luc, the medieval guild of painters. These sessions were ceremoniously regulated: the order in which the pupils entered and their place in the room where the model posed were rigidly prescribed; the sons of Academy members had the best places, then came the *Grand Prix* winners, then those who had won *Prix de Quartier* or *petits prix*, and finally the common herd of pupils. This petty hierarchy, which anticipated that found in the Academy proper, was challenged from the earliest days of the Revolution. The fact that the Academy was first and foremost a school accounts for its organization around a group of twelve elected professors (to whom eight assistant professors were added), each of whom served for one month; according to the statutes of 1663, they "shall be there at the prescribed time every day to open the Academy, arrange the pose of the Model, draw or sculpt it, as an Example to the Students, correct their work and keep them studying assiduously during these Exercises".

In the speeches he delivered at the Convention in 1793, through which he finally obtained the suppression of the Academy, David stigmatized the system:

> I promised I would show the damage the Academicians do to the art they profess, and I shall keep my word. I won't bore you, citizens, with pedantic details, with the poor teaching methods used by the Academy of Painting and Sculpture; it will be easy enough to convince you when I tell you that twelve professors a year, that is one for each month (note, too, that they were irremovable), vied with each other to demolish the first principles a young artist has learnt, and is learning daily, from his teacher; and as each of these professors approves of no principles but his own, the poor young man has to change his way of working and seeing things twelve times a year to please each one of them in turn, and when he has learnt his art twelve times over he ends up knowing nothing at all, for he doesn't know what to believe.

Traditionally, there is no education without competition, without some selection and assessment of talents. The students were offered drawing contests, the *Prix de Quartier* or *petits prix*, while waiting for the *Grand Prix de Rome*, the

culmination of their studies. Drawing from the round, drawing from life—it was not until after all this that the student, although he continued to practise drawing without a break, was judged ready to tackle painting: in fact, he practised painting in his master's private studio. The theoretical aspects were not wholly neglected, and we can judge the interest the authorities took in the Academy by the measures they enforced to sponsor theoretical study. Left to themselves, the artists were inclined to neglect it. Like Colbert before him and d'Angiviller after him, Marigny did not fail to provide for it. The means were always more or less the same—lectures given by artists or Honorary Associates of the Academy, the purchase of books on history and literature, lessons in history, perspective and anatomy to complete the young artist's stock-in-trade. This aim was shared by the *Ecole Royale des Elèves Protégés*, created in 1749 for *Grand Prix* winners so that they could improve their general culture before undertaking the journey to Rome. David, however, was excused this period of study, which was soon to be discontinued in any case.

The *Grand Prix*, which continued with very little change in its administration until 1960, was a source of bitter disappointment to David. The procedure of selection is well known: sketch, painting from the nude, and the final competition *en loge*, in a separate room. The winners had the right—except in cases of extreme financial difficulties—to a three-year stay in Rome. From the time of its foundation the French Academy in Rome served the purpose of allowing painters, engravers, sculptors and architects to complete their training through a sojourn in Italy, the land of the classics *par excellence*: there they had access to a wealth of works of antiquity, which were regaining public favor, and also to modern masterpieces, whose definition might vary slightly according to the period but which always included Raphael, Titian, Carracci and their chief pupils. According to the methods of education current at the time, it was thought that the student absorbed the beauties of the model through copying, and that copying would enable him to emulate the masters of the past. The system had the additional advantage of providing copies of all the great masters, which could then embellish royal residences, for at that period a fine copy was not considered out of place in the choicest collection. These exercises were not allowed to interrupt the study of the nude in drawing or painting, for through these the painter or sculptor would learn to master his craft. It is perhaps a simplification, but not a misrepresentation, of the facts to say that until the middle of the nineteenth century the plastic arts aimed above all at imitation of the human body.

Again, we can judge the interest taken by the royal authorities in the arts from the strictness with which they applied and renewed the old regulations. David went to Rome at the time when d'Angiviller, the new *Directeur des Bâtiments*, wanted to apply them to the letter, after a period of benevolent neglect under Marigny.

Once back in Paris, the former *pensionnaire* (student) from Rome aimed at being admitted to the Academy. This was a crucial matter since his chance of fame would depend on it. To belong to the Academy entailed a great many privileges, both by right and in fact. To begin with, it meant access to the Salon, which was exclusive to those who were at least *agréés* (approved) by the Academy; it also ensured—at least for those who were admitted as historical painters—some royal commissions, although around 1760 these were relatively rare. Those artists who felt that the rather subordinate—if fruitful—career of portrait or still-life painter was not enough had to exhibit at the Salon and work for the king if they wanted to make a name for themselves. But the Academy in the eighteenth century was not the Institute of the nineteenth. The salient differences were that there was no rule limiting the number of members and therefore there was no need to wait for a vacancy before applying. This does not mean that any Sunday painter could get himself admitted: one had to be known and recognized. The system seems to have worked well enough, at least until the eve of the Revolution. Apart from the usual reluctance to recognize such minor genres as landscape, still lifes etc., in which the Academy only followed the opinions held generally by the theorists of the time, it seems to have refused few real talents and not to have discriminated systematically against any particular trend.

On the other hand, the rigid hierarchical organization, which made decision-making the prerogative solely of the "officer" class, was a source of irritation to ordinary academicians and *agréés*, and David fulminated against it during the Revolution.

The admission procedure consisted of two stages: first the candidate showed some of his work to the assembly, which voted either to approve it or not. The title of *agréé* (approved), as we have seen, opened the doors of the Salon. Next the candidate had to submit a work on a set subject, the *morceau de réception*, and if it was accepted he became a full academician. This élite was itself divided along hierarchical lines, with a core of "officers" (professors, counsellors, rectors etc.) who held additional privileges, were exclusively responsible for the administration of the Academy, and in particular of the juries. This hierarchical organization,

which David attacked so bitterly, contributed to the suppression of the Academy in 1793, although in 1795 it was reborn in the different, but more rigid, guise of the Institute.

Once the keys of fortune were in the painter's hands—what then? The art world was about to slide into a paradoxical situation which led to a full-scale crisis during the Revolution. All the critics, the "philosophers", and with them the public authorities preached a return to historical painting and the *grand style:* it was the artist's task to show the heroes of religion, history or legend, and to depict their actions in the noblest manner possible. The old hierarchy of genres, stated by Félibien with unchallenged authority under Louis XIV, was accepted without question in France and even took on a new currency with the reform of style that was taking place. Greuze was a spectacular victim of this system, which did not prevent a painter of the lowest genre, the still life, from living comfortably, but which reserved its serious appreciation and its rewards for the historical painter. It was this attitude that made Chardin turn to figure painting on several occasions in his career.

What about the collectors, who do not write about art but on whom its day-to-day life really depends? We are dealing with a period which saw the triumph of seventeenth-century Flemish and Dutch painting, mostly genre painting or peaceful landscapes full of cows. The small exquisite pictures by the younger Teniers, Gérard Dow, and Metsu fetched fabulous prices at auctions, of which there were more and more during the 1760s. The great collections, except for that of La Live de Jully, the discoverer of Greuze, gave very little space to contemporary French paintings and consisted mainly of genre paintings, landscapes, portraits and still lifes. The great collectors were no more ready than the occasional art patrons for a severe neo-classical art. It was all they could do to accept the erotic neo-classicism launched by Vien precisely at the start of the 1760s. Nothing demonstrates this better than the turn taken in 1773 by the career of N. B. Lépicié. Born in 1735, an *agréé* of the Academy in 1764, he was one of those historical painters who revived the *grand style*, but the success of his *Lever de Fanchon (Girl Rising)* in 1773 encouraged him to change direction; from then on, until his premature death in 1784, he produced a wealth of genre scenes whose subject and delicate, mannered execution resemble those of seventeenth-century northern masters.

The Church, however, supported historical painting and continued to order large numbers of such pictures. Important groups of them were executed in Paris,

at the church of Saint-Sulpice, Notre-Dame des Victoires and the chapel of the Ecole Militaire; until his death in 1763 Jean Restout devoted almost his entire career to religious paintings; N. G. Brenet worked for a host of churches in the provinces until the Revolution. David, however, painted only two major religious pictures.

Royal commissions were thus of vital importance, not only for the fame they brought but in themselves, especially after the accession of Louis XVI when d'Angiviller, the new director of the Academy, took energetic measures to restore the dignity and pre-eminence of historical painting. David, like all painters of repute in his generation, was commissioned to treat edifying subjects taken from antiquity or French history. *The Oath of the Horatii* was one of many large pictures (more than three metres each side) intended to be used also as cartoons for Gobelin tapestries.

Great subjects, large formats—but there were not many customers, and it is not surprising that David, like so many others, turned to portrait painting. He certainly did not dislike the genre (he did portraits of almost all his relatives and of himself, and did not give up portrait painting even at the peak of his fame), but this was not the sole motive; David never lost sight of material advantages. There is at least one similar example among his students: Gérard, who was launched on a brilliant but not very lucrative career as a historical painter, and devoted himself to portrait painting from the time of the Directorate onward. This offered an infinitely larger clientele: one needed no classical culture nor vast salons to have one's own head or that of a dear one reproduced by a skilful brush. The salons of the revolutionary period, which were open without any formality, witnessed a proliferation not of the stories of Brutus and of Mucius Scaevola, but of landscapes and portraits of Mr. X. and Mrs. Y.

What was the state of French painting in 1766, when the young David registered as a student at the Academy? One style was on the wane, another waxing. Boucher was at the close of his career. His work, which dominated and represented a whole generation, became synonymous with the *petit goût*, which the critics slated while, like Diderot, admiring the artist's outstanding virtuosity:

What coloring! What variety! What a wealth of objects and ideas! This man has everything—except truth. There is no part of his composition that pleases when taken apart from the rest: yet the composite whole enchants you.

You wonder where you have ever seen shepherds dressed with such elegance and luxury. When have there ever been so many men and women, children, cows, oxen, sheep, dogs, haystacks and water, fire, a lantern, a stove, jugs, cauldrons, all gathered together in one spot in the heart of the country, under the arches of a bridge, far from any human dwelling? What is this delightful woman doing in such a place—so well dressed, so clean, so voluptuous? Are these sleeping and playing children hers? And that man carrying burning coals which he is about to spill on his head—is that her husband? What is he going to do with them? Where has he got them from? What a jumble of disconnected objects! We are aware of the absurdity of it all. Yet we cannot take our eyes off the picture. It fascinates us. We come back to it. It is such a pleasant vice, such an inimitable and rare piece of nonsense. There is so much imagination, so much to impress, such magic, such facility!

... Nobody understands the art of light and shade like Boucher. He bewitches two kinds of people, the worldly and the artistic. His elegance, his delicacy, his romantic chivalry, his flirtatiousness, his style, his facility, his variety, his vividness, his artificial flesh tints, his debauchery—all these appeal both to the dandy and to the common woman, to the young, the worldly, all those who have no real taste, no truth, no right-mindedness and who do not understand the severe demands of art.

In 1763 he was again looking despairingly at one of Boucher's *Bergeries*: "That man is the ruin of all young students of painting! They have hardly learnt to hold a brush and palette when they try desperately to garland children, to paint chubby rosy bottoms, and indulge in all kinds of silliness which they don't offset with warmth or originality, or the sweetness and witchery of the man they are imitating: they copy only his faults."

Artificiality in the subjects, artificiality in execution, artificiality in coloring, which makes all women pink and trees blue—Boucher's heady opera was losing its appeal: not perhaps for the general public, who loved even the frivolous trifles of a Baudoin and a Schall, but for the critics, who wanted to see a return to naturalness and dignity. For a while Diderot thought he had found his man in Greuze, who managed to dress up historical painting as genre painting. His "Village Bride" is neither Esther nor Roxane, but the "passions", the virtues, the dramas he shows are our own, raised to the highest dignity. If he had been less bad-tempered, if the Academy had been capable of taking a broader view, Greuze might have been the first neo-classical historical painter, ten years before the next

1 *The Cage.* By François Boucher (1703-70). Signed and dated 1763. Oil on canvas. 93×73 cm. Musée du Louvre, Paris; on loan to the Musée de Peinture, Bayeux.
A typical example of Boucher's work at the height of his fame, i.e. just when the young David was beginning his studies. The execution is of the highest quality, whereas the colors and the subject are utterly fanciful.

comer: in his *Septimus Severus Reproaching Caracalla for Wishing to Assassinate him* (Musée du Louvre, Paris), for which, in 1769, Greuze had to submit to the humiliation of being admitted as a genre painter and not as a historical painter, the strict order and the underlying reference to Poussin's work already foreshadow David's masterpieces. Indeed, there are many unobtrusive but significant assonances between the two artists.

The critics placed their hopes for the restoration of the *grand style* in two painters born at the end of the 1720s: first Doyen, whose large paintings of Roman history, executed in the 1760s and now in Russia, had cadences of impressive majesty; especially the *Miracle des Ardents*, painted in 1767 for Saint-Roch, had a dynamism and fervor that might have swept French painting along new paths. The second, Deshayes, was one of Boucher's sons-in-law, whose mythological work was not very different, but his large pictures of the martyrdom of St. Andrew (Rouen Museum) were imbued with a sense of dramatic action and a realism of detail that created a stir at the Salon of 1761. Unfortunately, Doyen could not live up to his promise and made no further progress, and Deshayes died in 1765, at the age of thirty-five.

When Fragonard abandoned historical painting after producing his brilliant admission piece for the Academy (*Coresus and Callirhoe*, dated from 1765), there was no one left, until the advent of a new generation, except Lagrenée—charming, but minor—and, of course, Vien. Lagrenée had the outstanding merit of trying to reconcile historical subjects with a careful execution, suited to small formats, on his favorite wood or copper. His love of compromise, and his reassuring sameness enabled him to pursue a fruitful career rather than to impose his style, although his paradoxical experiment was taken up in a different form by David's worthy rival, Peyron.

Vien, if we are to believe his memoirs, which were written later, had from the start aimed at reviving the *grand style* in France. No sooner had he arrived at the Academy in Rome than, he claims, he reproached his fellow students for admiring Pietro da Cortona and Maratta instead of going back to the source "by studying the antique, Raphael, Carracci, Domenichino and Michelangelo, all the masters who bear the imprint of truth and greatness in their immortal paintings". Soon after his return to Paris, as a teacher with a large following (David, as we shall see, worked in his studio), "I realized that the young had to learn to see and know nature, so I was the first in France to bring a live model into my studio, three times a week from morning till evening... I succeeded, not without difficulty, in destroying—I

say so boldly—the bad taste prevailing in all the arts. How much perseverance and firmness it took, what a battle it was against recurring obstacles, how I had to chase away the clouds that threatened to obscure the truth I wanted to bring to light!... I finally succeeded in bringing them to... the faithful imitation of nature."

His contemporaries acknowledged him as the restorer of French painting, or rather of the true style; David certainly paid him that tribute and remained faithful to him through all the revolutionary storms, although, for a long time, as a pupil he rebelled against his lessons of realism. On November 11, 1800 he gave a banquet in Vien's honor which was described as follows by the *Moniteur*: "David and his pupils gave a party for citizen Vien, their teacher, whom they honored as the restorer of the French school. The company consisted of 120 people. The portrait of citizen Vien was placed in the *salon* where he was welcomed; his place at table was marked by garlands in the shape of a dais, and a laurel wreath was placed on his head with the following words on it, *To Vien, from the grateful arts.*" David proposed the toast: "To citizen Vien, our master. May he, a new Diagoras, see the works of his fifth generation distinguish themselves at the Salon exhibitions" (Hats off to this knowledge of the classics—here we may recall that Diagoras, the Rhodian athlete sung by Pindarus, had the satisfaction of seeing his sons crowned at the Games at the same time as himself).

From 1748-50, during his first stay in Rome, the young Vien had in fact pointed the way to a revival of historical painting by way of observing nature. His *Ermite Endormi (Sleeping Hermit)*, now in the Louvre, posed a large figure, carefully observed, a worthy heir of Carracci's or Guercino's solid compositions. So, too, the fine series relating the story of St. Martha painted for the church at Tarascon, where it is still, had the generous forms, the noble attitudes, the minutely planned sequence of movements, the restrained coloring, following the great examples of the seventeenth century, that initiated a revolution similar to that wrought in architecture by Gabriel's *grand style*.

To tell the truth, the movement did not make any great progress through Vien's work, and his success in the 1760s had other reasons. A close friend of the Comte de Caylus, the most enthusiastic scholar of antiquity in Paris at the time, he worked with him to rediscover the technique used in encaustic paintings by the Ancients. He also created a delightful view of antiquity, subtly erotic, peopled with virtuous but half-naked young women, who were busy arranging flowers in bronze urns carefully copied from engravings after the new archaeological discoveries at Herculaneum and Pompeii. *La Marchande d'Amours (The Cupid*

Seller), which was shown at the Salon of 1763 and is now in the Musée national du château, Fontainebleau, seems a rather mediocre painting to us today but, like his charming women bathing and virtuous Athenian ladies, it had a tremendous success. This pleasant image of antiquity, reflecting the ambiguity of a period which enjoyed both licentiousness and virtue, was an indispensable link in the evolution of style from the licentiousness of Boucher to the virtue of David.

Around 1770, when David was starting to compete for the *Grand Prix de Rome*, a new generation came to the fore which carried the reform initiated by Vien, their inspiration and for some their teacher, one step further. The most representative was doubtless N. G. Brenet, who was born in 1728 and admitted to the Academy in 1769. He was one of the favorite painters of d'Angiviller, the new *Directeur des Bâtiments*, who took up his post shortly after the accession of Louis XVI in 1774. Brenet's static compositions, his sculpture-like figures, his fondness for noble subjects and historical appropriateness made him one of the first "modern" French painters, even if he soon proved incapable of making any headway. Diderot rightly ascribed to him "a style very close to that of a great master".

Next comes Durameau, five years younger, who was *agréé* at the Academy in 1769 and who, like Brenet, participated with distinction in the great commission of paintings on the story of St. Louis for the chapel of the Ecole Militaire (1773). Durameau also became one of d'Angiviller's trusted collaborators, although he was not such a sound or individual artist as Brenet. The "hopes" of the generation also included J. A. Beaufort (1721-84), who fell into oblivion until the recent discovery of his *morceau de réception* for admission to the Academy in 1771, *Brutus Swearing to Revenge Lucretia* (Nevers Museum), which inspired David, much later, when he was preparing *The Oath of the Tennis Court*. Together with his seniors Louis Lagrenée, Vien, N. Hallé, and Pierre, Beaufort also took a brilliant part in the great commission for the Ecole Militaire.

David did not join the great reform movement until much later. He was born on August 30, 1748 and came from a well-to-do family of Parisian tradesmen. His father was killed in a duel at the end of 1757, and Jacques-Louis, the only son, was brought up with the aid of his mother's family. Theirs was a circle of master masons and architects, the Burons and the Desmaisons, who sat for his first portraits and of whom he remained very fond. Another member of that circle was Michel Sedaine, also a master mason (in 1770 he became secretary to the Academy

2　*The Cupid Seller.* By Joseph-Marie Vien (1716-1809). Oil on canvas. 96×120 cm. Musée national du château, Fontainebleau.
This piece of eroticism in the classical manner, directly inspired by a plate in the *Antichità d'Ercolano (Antiquities of Herculaneum)*, was a great success at the Salon of 1763. "What elegance in the attitudes, the bodies, the expressions, the clothes! What tranquillity and finesse in the composition!... A charming piece," wrote Diderot.

of Architecture) as well as a successful playwright; David probably owed some of his general culture to him. According to the fragmentary memoirs he has left, David's vocation for drawing, to which he devoted more time than to his school work, was precocious and persistent. After taking some drawing lessons at the Académie de Saint-Luc, the old guild of painters, he had himself introduced to Boucher, a distant relative of his mother's, in the hope of becoming his pupil. Boucher, pleading advancing age, is said to have sent him to Vien, who accepted him in his studio. This was attended by artists like Taillasson and Vincent, both born in 1746, and both to become—after David—the best painters of their generation. As was customary, Vien inscribed him in the Academy, in whose register he appeared in September 1766: "Jacques-Louis David, painter, of Paris, aged seventeen [he was eighteen], sponsored by M. Vien, living with his uncle, an architect, rue Saint-Croix-de-la-Bretonnerie, opposite rue du Puits."

Not until three years later do we find his name mentioned again: he obtained a modest third medal in the *prix de quartier* which at least enabled him, in the spring of 1770, to compete for the first time for the *Prix de Rome*; he did not reach the final test, to which he was admitted the following year. The subject set was *The Combat of Minerva and Mars*. David was awarded the second prize for the painting, which is now in the Louvre. According to his memoirs, it was his teacher, Vien, who had the prize awarded to Suvée rather than to him. If we compare David's work with Suvée's (Musée des Beaux-Arts, Lille), the grading seems fair: the "V" composition of David's rival, though perhaps a trifle contrived, is none the less harmonious. The clear light, the distinctive forms set in a well-balanced, striking framework, all these show up David's uncertainty. In fact David's composition seems to collapse on one side, the background is not organized, the figure of Venus in the air is drawn faultily, the draperies are weak and moving in all directions, and the coloring is both banal and flashy. The whole is closer to a failed Boucher than to a Vien.

It is clear that David lagged behind several of his contemporaries, both those against whom he competed—Suvée (born in 1743) and Taillasson—and those who immediately preceded him. Thus Berthélemy, born in 1743, *Grand Prix* in 1767 (*Alexander Cutting the Gordian Knot*), and Ménageot, born in 1746, *Grand Prix* in 1766 (*Thomyris and the Head of Cyrus*) showed a far greater ability to handle figures with clarity. Vincent, too, *Grand Prix* in 1768 with a *Germanicus*, although remaining within the eighteenth-century tradition, evinced a power of composition that David could not achieve.

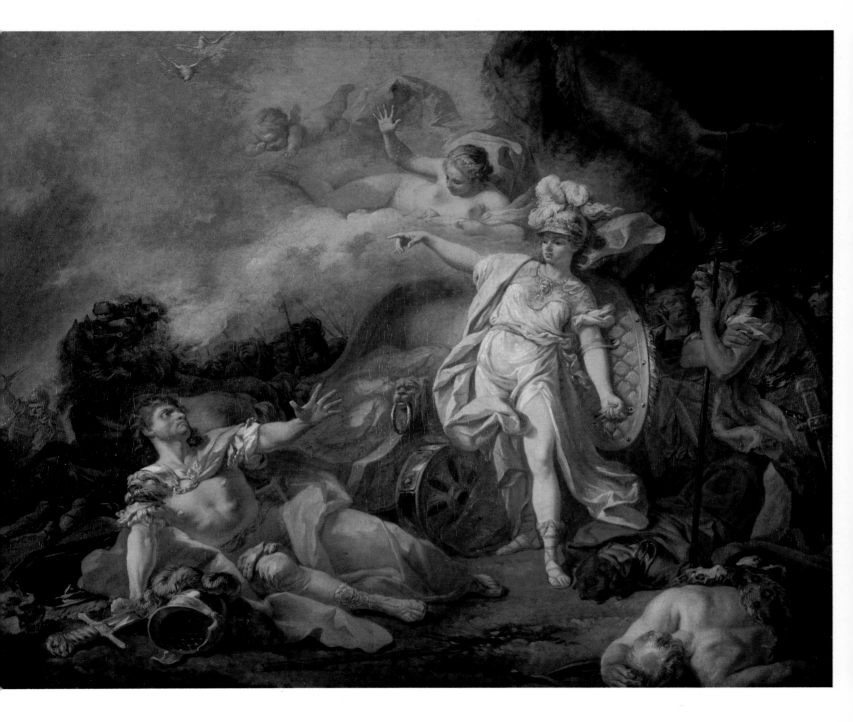

The competition in the following year was fraught with drama for him, as he explains at length at the beginning of his autobiography. On the subject of "Diana and Apollo piercing the children of Niobe with their arrows", David competed in the final selection with five young painters, none of whom became famous. It was decided to award two first prizes. David was sure he would win, but the jury awarded the prizes to Jombert and Le Monnier. David tells how, when he came home, "I was going to carry out my plan: that plan, alas, was to let myself starve to death". Two and a half days passed before "people living in the same house heard my groans and told M. Sedaine, in whose house we were staying. He knocked, no

3 *The Combat of Minerva and Mars.* Oil on canvas. 114×140 cm. Musée du Louvre, Paris.
Second in the Academy's *Grand Prix* competition in 1771. This work shows how much David was influenced by Boucher at the outset of his career; the composition is still awkward and the colors somewhat acid.

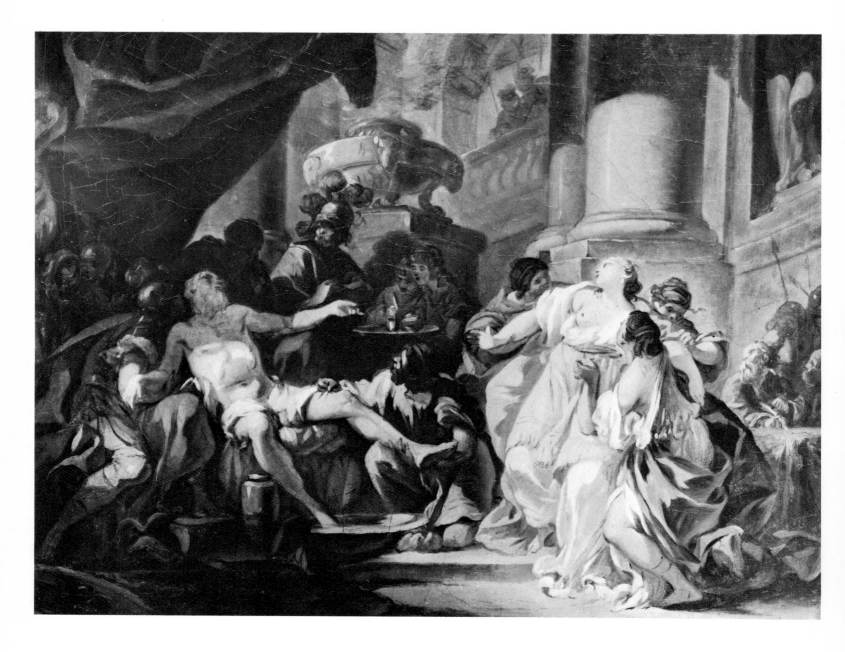

4 *The Death of Seneca.* Oil on canvas. 43×53 cm.
Musée du Petit Palais, Paris.
A sketch acquired in 1969 by the Petit Palais to join
the final version (Pl. 5), an unsuccessful entry for
the *Grand Prix* of 1773. Typical of the taste of the
period, it is intended to extol the stoicism of the
philosopher; however, such features as the billow-
ing draperies and the fantastic setting are some-
what incompatible with the theme.

reply, knocked again, still no reply, although he was told that I was certainly at
home". Whereupon Sedaine ran to Doyen, an Academician and one of his judges,
who had shown a kindly interest in the young man. Doyen hastened to him, and,
calling through the door, persuaded him to go on living with these words:
"Anyone who has painted a picture like that ought to think himself luckier than
those who beat you. They should be only too happy to change places with
you."

Le Monnier's picture, in the Ecole des Beaux-Arts, Paris, is mediocre and we
can understand David's sense of injustice. Jombert's on the other hand, if—as it
seems—it is indeed the canvas sold at the Palais d'Orsay in 1978, is very fine. The
elegant figure of Niobe (not unlike David's) stands out against a serried
composition, the whole painted in a sweeping style that would lead us to predict a
brilliant future for its author; in fact, after his return from Rome, he disappeared

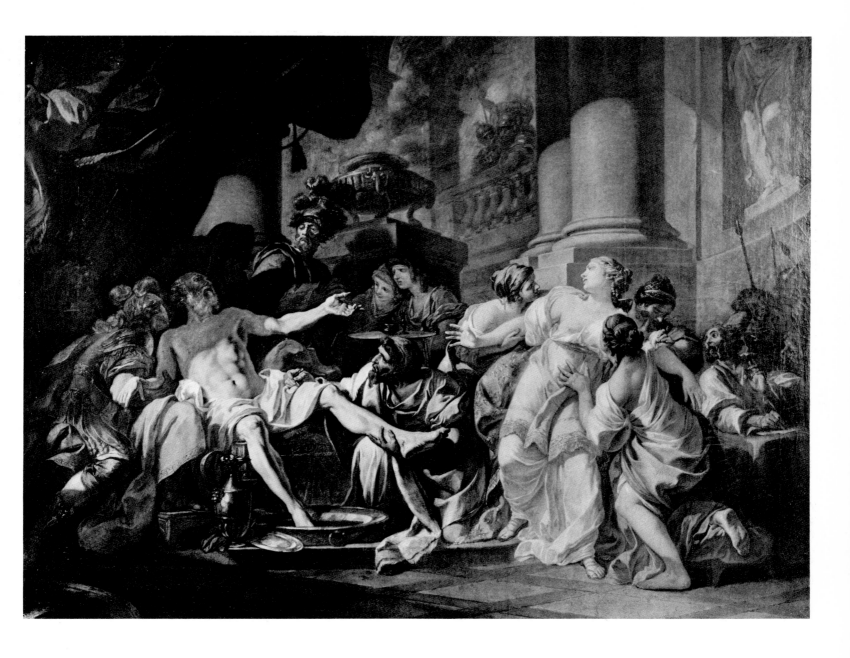

completely from the artistic scene. David's picture (Private collection) is a more richly orchestrated *reprise* of his previous composition: Minerva has become a worried, touching Niobe, Mars has been turned into one of the dead girls, and Venus into Diana. The additional figures are rather badly grouped and the draperies are discordant, though the detail is executed more decisively than in the previous year.

In 1773 came a fresh attempt, another failure, this time on the subject of the death of Seneca. If we looked at this period with hindsight, knowing the artist's subsequent career, we might imagine that this kind of scene, typical of the new ideas compared with the traditional mythological scenes he had had to paint for his earlier attempts, would give him the chance to produce a masterpiece. But David was not yet David, and his age, at that point, was moving faster than he was. The picture (preserved, together with its sketch, at the Petit Palais, Paris) is not

5 *The Death of Seneca.* Oil on canvas. 120×155 cm. Musée du Petit Palais, Paris.

altogether lacking in a rough brilliance and already has a rather Davidian juxtaposition of masculine stoicism and feminine sensibility. The sequence of gestures and postures is more effective, but the impact of the subject is marred by a muddle of unconnected bits of building, by poor, over-light coloring, and a blustering execution.

If the jury's choice of Jombert and Le Monnier had been less than felicitous, in 1773 it was right in selecting Peyron. His picture is lost, but given his working methods and unimaginativeness, we may accept the general view that his composition can be recognized in the engraving he executed himself. Born in 1744, he was almost exactly David's contemporary, only four years older, but David's style seems oddly backward by comparison. Whereas David produced thinly colored, ill composed, teeming pictures, Peyron's were dark, economical and measured. David cluttered up the space with bits of columns, pedestals, draperies and graceful serving maids, while Peyron extolled the poetry of bare, dark walls, in harmony with the strong mind of the philosopher. It was Peyron, not David, who was the heir of Poussin, whose work he collected fervently, Peyron who understood the lesson taught by Vien, and Peyron who led historical painting one step further.

What ultimately prevented Peyron from becoming the leader of a school was his hypochondriac disposition, frail health and modest output. His few paintings often repeat an idea he had already expressed in a previous work. A further limitation was his predilection for delicate, exquisite, polished execution, often on wood, a preference in which he no doubt followed Lagrenée, into whose studio he had moved. He would never have the natural eloquence, the breadth and freedom soon to be found in David.

In 1774 David finally was awarded the *Grand Prix de Rome*, ahead of Bonvoisin, with whom he had been tied, on the subject of *The Physician Erasistrates Discovering the Cause of Antiochus' Illness* (Ecole des Beaux-Arts, Paris). The picture is hardly much better than the earlier ones, especially in view of its false, greenish coloring, the unnecessary play of light, and the ill-controlled accumulation of architectural features in successive and contradictory planes. There are still flaws in the drawing (Stratonice's right arm is not joined properly to the body) and in parts the execution is rather woolly. But there is a firmer organization of the material, thanks to the crossing of the horizontal bed with some vertical architectural structures and the dialogue, at a distance, between Antiochus and Stratonice, linked by the gestures of secondary characters.

6 *The Physician Erasistrates Discovering the Cause of Antiochus' Illness.* Oil on canvas. 120×155 cm. Ecole des Beaux-Arts, Paris.
Grand Prix in the 1774 competition, as a result of which David was at last able to leave for Rome. The greater assurance of the composition shows a certain progress towards the "grand manner" in spite of the rather artificial greenish coloring.

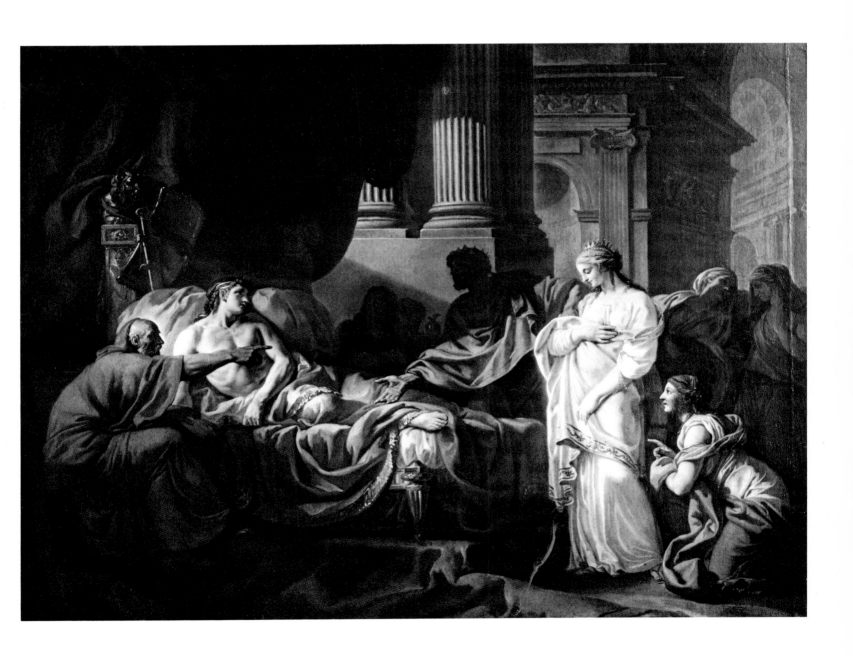

27

28

The best of David's early work are his few family portraits. The *Portrait of Mme Buron* (Art Institute, Chicago) helps us understand both the strengths and weaknesses of the young painter. The former include the concentration on the subject, eliminating superfluous accessories, the simplicity of the background, the intense liveliness of the face; the latter, some awkwardness in the right arm and the sleeve, his difficulty in distinguishing the planes on the side of the left arm and the book, and in suggesting volume, the random impastos, painted for their own sake, while the details of the clothes give no adequate outlines of forms. This portrait is greatly influenced by Duplessis's painting of Mme Lenoir (Musée du Louvre, Paris), which was very successful at the exhibition of the Académie de Saint-Luc in 1764 and again at the Salon of 1769.

A year after he had won the *Grand Prix*, David set off for Rome together with two other new *pensionnaires* and with Vien, who had just been appointed director of the French Academy in Rome.

7 *Portrait of Mme Buron.* Signed and dated 1769.
Oil on canvas. 50×54 cm. Art Institute, Chicago; gift of Mrs. Albert J. Beveridge, in memory of her mother, Abby Louise Spencer Eddy.
The Burons, with whom David spent much of his childhood, were his uncle and aunt on his mother's side. In this simple and natural picture, stylistically reminiscent of Duplessis, David is particularly concerned with the rendering of the materials and the book.

II. ROME

Art and archaeology in Rome in 1775. Gavin Hamilton. A. R. Mengs. The French Academy in Rome. David's earliest studies and the works of the pensionnaires. *The turning point in David's style in 1779: influence of the ancients and Raphael; the school of nature.* St. Roch Interceding with the Virgin for the Plague Victims. Portrait of Count Potocki.

Rome has always been a great artistic center, if only because of the presence of the Papal court. The Church, the Roman nobility, foreign ambassadors and tourists all offered a ready market. From the first half of the century the works of artists like the Frenchman Subleyras and the Italians Pompeo Batoni and Benefial showed signs of a reform in painting—a return to more natural and more restrained compositions. The growing passion for archaeology, which was reaching the whole of Italy (starting from Tuscany and Emilia), and then the whole of Europe, brought a new blossoming to Rome. The Eternal City once more became the obligatory place of pilgrimage for all self-respecting artists; as in the glorious days of the Caravaggesques they settled once more near the Piazza di Spagna. The French Academy, housed since 1725 in the Palazzo Mancini on the Corso, became one of the shrines of artistic Rome. The young French *pensionnaires* were acquainted with Panini, the great painter of weird and fanciful architectural structures, and even more perhaps with Piranesi, a Venetian who settled in Rome in 1744, where he was during David's stay and where he died in 1778.

Piranesi's art was founded on an enthusiastic and imaginative view of antique architecture and decor. He was only one brilliant member of a general movement. To the famous buildings, which were regarded with a renewed veneration, were added the findings of the excavators, who were at work everywhere, especially in the Papal State. The discoveries at Ostia and in Hadrian's Villa fanned the ardor of collectors and filled the purses of gleeful middlemen. Foremost among the collectors were the Popes themselves, Clement XIII, Pius VI and Clement XIV. The latter opened the Museo Pio-Clementino in the Vatican in 1772—to which new buildings were added after 1775—to display the treasures that came flooding in (besides the finds from the excavations, Clement XIV acquired the Mattei Collection in 1770). Another great collector, Cardinal Alessandro Albani, benefited—even before the Pope—from Winckelmann's advice in the furnishing and decoration of his fine villa in the Via Salaria, where A. R. Mengs painted a famous ceiling, the *Parnassus*, in 1761. Thanks to the Bourbons, who brought the

famous collection they had inherited from the Farnese, Naples, too, became a great archaeological center. The Farnese Collection was greatly enlarged by Charles IV from the excavations he had undertaken at Herculaneum and Pompeii: a special museum was installed in the Villa dei Portici and transferred after 1779 to the present Museo Nazionale. Details of the new discoveries were diffused widely through a richly illustrated compilation, the *Antichità di Ercolano*, whose publication began in 1792; it was a source of inspiration to all artists, starting with Vien in 1763, whose *Cupid Seller* was an almost literal copy of one of the plates in the collection. Naples already was an excursion center for tourists interested in scientific curiosities, who naturally felt they must climb the slopes of Vesuvius (the painter P.-J. Volaire made a great name for himself by churning out pictures of the volcano in eruption); it now became an obligatory stop for lovers of antiquity, and the young David duly went there in 1779. With its natural and antique curiosities, Naples symbolized the two poles around which artistic life, or rather the studies of young artists, would henceforth revolve.

It is easy to see, just by leafing through David's Roman notebooks, that illustrated publications played as important a part in his evolution as did direct contact with antique sculptures.

Since 1719-24, the volumes of Dom Bernard Montfaucon's *L'Antiquité expliquée (Antiquity Explained)* had been available; from then on, such publications appeared in ever greater numbers: after Gori's *Museo etrusco (Etruscan Museum)*, which appeared from 1737 on, came the *Antichità d'Ercolano (Antiquity of Herculaneum)*, Piranesi's *Antichità romane (Roman Antiquities*; 1756), Passeri's three folio volumes (1767-73) that gave a wide currency to the chief Italian collections, the William Hamilton Collection published by d'Hancarville (1766-7), Winckelmann's *Monumenti antichi inediti spiegati ed illustrati (Unknown Antique Buildings Examined and Illustrated*; 1767), and Piranesi's *Vasi, candelabri, cippi, sarcofagi...*, compiled in 1778. We can gain an interesting insight into archaeological and artistic life in Rome in 1775 from two of these candelabra: now at the Ashmolean Museum, they were given to the University of Oxford by Roger Newdigate, who had obtained them from Piranesi, through Thomas Jenkins, for 1,000 scudi in 1775. Piranesi had been in charge of their restoration after they had been discovered (with several others) at Hadrian's Villa by Gavin Hamilton in 1769. The engravings of one of them was the source for the candelabrum David placed beside Hector's bed in his *morceau de réception*—his painting for admission to the Academy—in 1783.

The passion of British collectors for antiques helps to explain the activities of that fascinating Scotsman, Gavin Hamilton (1723-98). A friend of Canova and Robert Adam, an active archaeologist who took part in excavations at Hadrian's Villa in 1769-71, then at Tor Colombaro, Gabii etc., he exported a great many antiques for Lord Shelburne, Charles Townley, William Weddell and Henry Blundell. He also catered for patrons of painting: a first-rate painter himself, whom we shall discuss later, he procured sixteenth- and seventeenth-century paintings (it is due to him that Raphael's *Ansidei Madonna* and one of Leonardo's two paintings of the *Virgin of the Rocks* are in London). He particularly admired the Bolognese, the Caracci, G. Reni, Domenichino, and most of all Guercino, whose chief works he sold to Lord Spencer. His admiration for the sixteenth- and seventeenth-century classics, which was shared by Vien and later by David, is illustrated by the forty works he chose to have reproduced in engravings in 1773 (*Schola Italica Picturae*).

Until his tragic death in 1768 Winckelmann was at the center of this international set in Rome. His *Gedanken über die Nachahmung der griechischen Werke* (*Reflections on the Imitation of Greek works in Painting and Sculpture*; 1755) and his *Geschichte der Kunst des Altertums* (*History of Art in Antiquity*; 1763) had, in Hegel's words, given the human race a new form of perception and exerted a tremendous influence on artists. His preference for calm expressions, smooth outlines, the equivocal charm of a Hellenistic Ephebe, found its echo not only in Canova's statues but in such pictures as David's *Death of Barra* and in many of the figures in the *Leonidas*. His idea were conveyed in the simplest terms, addressed straight to the artists, by his friend Mengs (1728-9), whose *Reflections on Beauty* appeared in 1762.

Mengs was also one of the most famous painters in Europe, who worked with Giaquinto and Tiepolo on the decor of the royal palace in Madrid. In 1777 he returned to Rome, where he stayed until his death. We know that David met him

during that period, and there can be no doubt that he admired at least some of his work: not perhaps the famous *Parnassus* on the ceiling of the Villa Albani, but at the Uffizi David would have been able to see examples of the many self-portraits Mengs painted, especially those done around 1774. As in David's own work, there are plain but telling backgrounds, a very simple half-length layout, and a clear relief.

Equally important for David's later works was the example of Gavin Hamilton. From 1760 on, he had executed a series of large pictures on Homeric subjects, thus implementing the ideas of Lafont de Saint-Yenne and especially of the Comte de Caylus (*Pictures Taken from the Iliad and the Odyssey ...*, 1757). In the first, *Andromache Mourning Hector*, the "Greek" forms aroused Winckelmann's admiration. Hamilton was particularly susceptible to Poussin's influence, as most French artists would be before long. The engravings made by Cunego of the whole series gave Hamilton's recreation of antiquity wide currency throughout Europe.

The young artists who converged on Rome in the 1760s—sculptors like Houdon, Clodion and Pierre Julien from France, the Swede Sergel (who stayed in Rome until 1778), the Englishmen Nollekens and Thomas Banks (who had been fascinated by antique subjects since his youth and stayed in Rome from 1770 to 1778), American painters like Benjamin West and Copley, the Dane Abildgaard, the Hackert brothers, James Barry, Angelika Kauffmann and Füseli, all a little older than David, were naturally deeply stirred by contact with the old masters. The enthusiasm and activities of these young people have been described graphically in the memoirs of one of them, J. C. von Mannlich, who arrived in Rome with Sergel in 1767. He came from France, trying to forget all he had learnt in the school of Boucher. Winckelmann promised both him and his friend Weinlig, the architect, that he would take them to see the antiquities of Rome, but he was assassinated; soon afterwards the young people attached themselves to another professional *cicerone*, J. F. von Reiffenstein, who was to be Goethe's guide a few years later. In the mornings Mannlich, together with Houdon, studied anatomy under the surgeon Séguier, or went to draw at the Farnese Gallery. In the afternoon he would do the round of the churches and the collections, either alone or with some of the English group, and in the evening it was drawing from life at the French Academy. His greatest heroes were A. Caracci, Domenichino and, of course, Raphael and Michelangelo. He mentions in passing that the French do not really appreciate Michelangelo, who is too grandiose for them (in fact, David

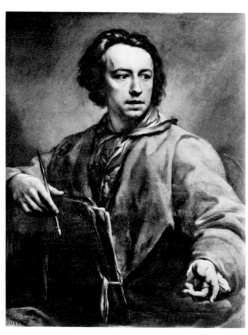

9 *Self-portrait*. By Anton-Raffael Mengs (1728-79). Oil on canvas. 98×73 cm. Galleria degli Uffizi, Florence.
This self-portrait by one of the most celebrated European painters of his time was executed in 1774, the year preceding David's arrival in Italy. It anticipates the latter's mature portraits in its fervent simplicity and the ingenious relationship of the head to the bare yet vibrant background.

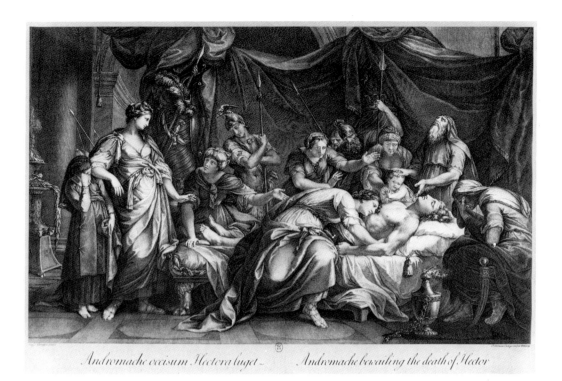

Andromache occisum Hectora luget – *Andromache bewailing the death of Hector*

10 *Andromache Mourning Hector.* Engraved by D. Cunego after Gavin Hamilton (1723-98). 1764. Cabinet des Estampes, Bibliothèque nationale, Paris.
At the beginning of the 1760s Gavin Hamilton—a Scottish painter, archaeologist, and merchant living in Rome—painted a series of Homeric scenes, the engravings of which (by Cunego) enjoyed a great international success. The affinities between this picture, with its classical background and composition reminiscent of Poussin, and David's rendering of the same subject in 1783 (Pl. 31) have often been noted.

admired him greatly, as we shall see). In October 1768 he made the inevitable excursion to Naples with César Van Loo, Sergel, Rehschuh and Weinlig. He describes the natural beauties of Vesuvius, as well as the antiquities, at some length. Towards the end of his stay, in 1770, he had the good fortune to meet Mengs in Florence.

The French *pensionnaires* of the Academy had the choicest place in this busy, enthusiastic circle. It was the architects, stimulated by the example of their friend and neighbor Piranesi, who were the most enchanted with archaeology and who, from the years 1740-50 onward, were in the vanguard of the changes wrought in European style. In 1765, after Clérisseau and de Wailly, Peyre did a survey of the buildings of ancient Rome and published his *Œuvres d'Architecture (Works of Architecture)*, the sum total of his archaeological work and the manual of the new architecture. The recommendations of the Academy of Architecture and those of the *Directeur des Bâtiments* did no more than accelerate the movement from 1775 on. One of the arrivals in Rome during David's stay was L. J. Desprez, winner of the *Grand Prix* in 1776; he was immediately commissioned by the Abbé de Saint-Non to prepare the illustrations for his *Voyage pittoresque, ou Description des Royaumes de Naples et de Sicile (Picturesque Journey or A Description of the Kingdoms of Naples and Sicily)*—which appeared between 1779 and 1786 in five volumes, and for which he did countless documentary drawings from the antique sites.

When David arrived in Italy he does not seem to have given any very close attention to the antique; before leaving France, he is supposed to have said, "the antique isn't going to seduce me, it lacks life, it leaves you cold." This rejection of anything cold is fully in keeping with the style of the young painter's competition

11 *Pietà dei Mendicanti*, after Guido Reni. Drawing in black crayon with Indian ink wash. 14.5 × 10.5 cm. Cabinet des Dessins (Inv. 26130 bis), Musée du Louvre, Paris.
This copy of a picture kept at the time in the Church of the Mendicanti in Bologna, but now in the Pinacoteca there, is part of a series of drawings in similar style, most of them copies of pictures in Bologna. Remarkable for their indifference to outline and the rapid positioning of the forms, they are found in the Roman sketchbooks kept *inter alia* at the Louvre and the Fogg Art Museum.

pieces. On the other hand, on his way to Rome he was full of admiration for Correggio, whose charms had been rediscovered at the beginning of the eighteenth century and had been delighting the French ever since. The first foretaste of his future development can be found in his interest in Bolognese religious painting of the seventeenth century, but unfortunately it is almost impossible to establish the exact chronology of the numerous drawings surviving from his first stay in Rome: it is mainly on a geographical basis—since Bologna was on the route to Rome—that the various sketches after Reni, Cavedone, and Tiarini identified in the collections in the Louvre and the Fogg Museum have been ascribed to the outward journey.

If we look at the small study from the nude, signed and dated 1776, in the Saint-Etienne Museum, we are struck by its conventional character: far from endeavouring to give a simple, faithful rendering of the human anatomy, the young artist is only concerned with the pretty impasto, the brush strokes, the charming fair coloring.

And yet, Vien in Rome and d'Angiviller in Paris were vying with each other to restore the old customs in the obvious hope that these would bring a return to the grand manner. In a letter dated April 29, 1776, d'Angiviller asked that work should again be sent home from Rome, a custom Natoire had allowed to fall into disuse. Each painter at the Academy was to send two works a year back to Paris so that the Academy could judge his progress—one study from a model or after a great master and one of his own compositions. In a letter of August 19, 1778 d'Angiviller, still referring to the old rules, decided that in addition each *pensionnaire* had to execute a large copy "of one of the great masters, to be placed in the royal residences": this had precisely been one of the aims of the French Academy in Rome when it was founded in 1666. All these decisions, which were gradually enforced, were codified in the Rules published in 1780. Vien also wanted the *pensionnaires* to send studies of nudes to Paris, and this was prescribed in a new ruling in 1787. In Rome, as in Paris, the administration of the arts was becoming increasingly reactionary, which aroused the hostility of the *pensionnaires* as well as of the younger members of the Academy. Vien, though most paternal towards his students, fully shared this authoritarian spirit. He even went so far as to suggest that the *pensionnaires* should wear a uniform, but d'Angiviller rejected the idea on the grounds that he did not want to irritate the people of Rome, "who were already not very kindly disposed to the French nation".

To encourage the competitive spirit among the young artists and to make them

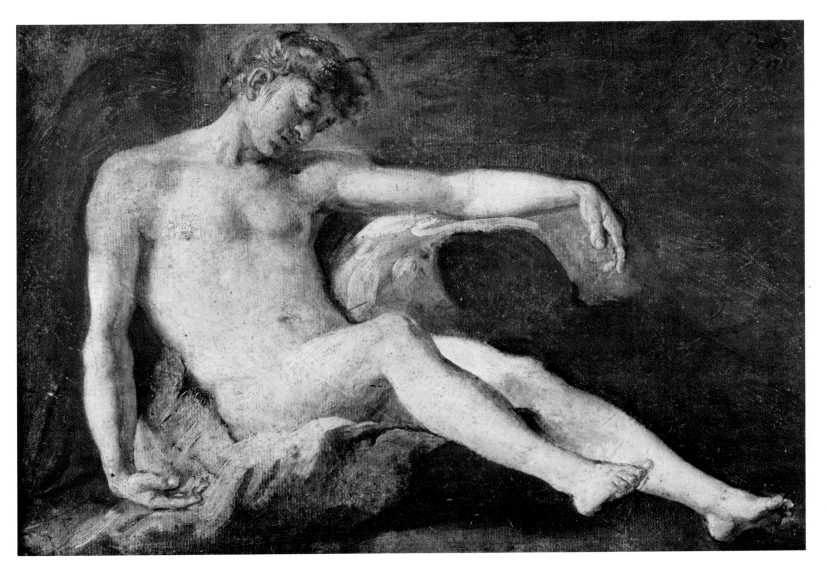

12 *Nude Study*. Signed and dated 1776. Oil on paper with canvas backing. 27×38 cm. Musée d'Art et d'Industrie, Saint-Etienne.
The light tones and arbitrary use of lavish impasto link this little painting to the eighteenth-century tradition.

39

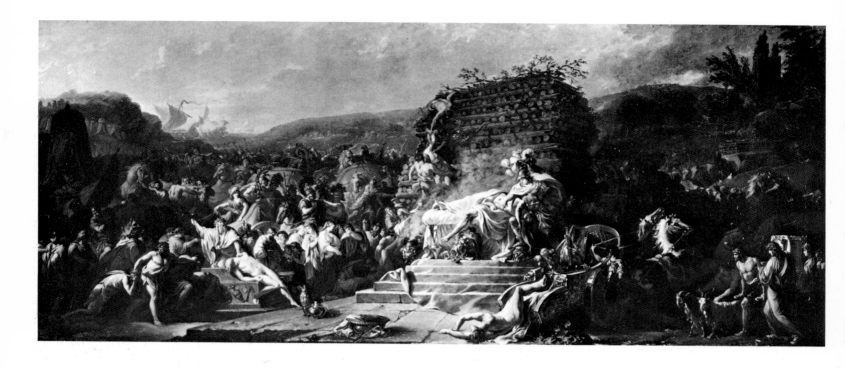

13 *The Obsequies of Patroclus*. Signed and dated 1779 (but probably painted in 1778). Oil on canvas. 94×218 cm. National Gallery of Ireland, Dublin.
One of the large sketches that the residents of the French Academy in Rome had to send to Paris. Here David continues the tradition of Le Brun's great panoramic battle scenes.

14 *The Obsequies of Patroclus*. Central detail. The verve of this detail owes something to the "sketch" concept that David was to relinquish when he painted *St. Roch* (Pl. 22) about a year later.

known in Rome, Vien decided in his first year as director, that is in 1776, to exhibit their studies and compositions at the Mancini Palace, where the French Academy had been housed since 1725, before dispatching them to Paris. The crates containing the first batches of work left Rome at the beginning of March 1777, but as a result of a series of delays the works were not examined by the Academy until January 1778. David's nude and his personal composition have been lost. The nude was probably, like the small canvas at Saint-Etienne, still in "the spirit of the eighteenth century"; the individual composition was "a large battle sketch", which may have resumed the immense drawing (almost 2 metres long) of the *Combats of Diomedes*, signed and dated 1776, which is now in the Albertina in Vienna: a large panoramic composition, full of incident, reminiscent of the battles by Le Brun. Here, too, a return to the models of the seventeenth century hints at an unobtrusive change in taste, leading to a change in manner. Le Brun's influence was especially noticeable in *Moïse et le serpent d'airain (Moses and the Brazen Serpent)*, a rather mediocre picture now in the church of Ruffey (Jura).

The delays in transport and in the examination of the works of 1776, sent in 1777, easily explain why there was no hurry in Rome to start on the new lot. In the summer of 1778 d'Angiviller was growing impatient; after the exhibition in September the works were dispatched to Paris, where they were examined in the following spring. David's contributions on this occasion have survived. One is a nude of a man who has fallen backwards *(Hector)*, now in the Musée Fabre, Montpellier, the other a large sketch of *The Obsequies of Patroclus*, which has recently been rediscovered and is now in the National Gallery in Dublin. It resembles the drawing of 1776, a large operatic production with crowds of people painted in vivid colors, while the treatment retains the freedom of a sketch. It is difficult to assess how much of this spectacular treatment is representative, since it is precisely "a large sketch". But there are signs that David's style was beginning to change: the painted nude shows a much more accurate execution and a more objective

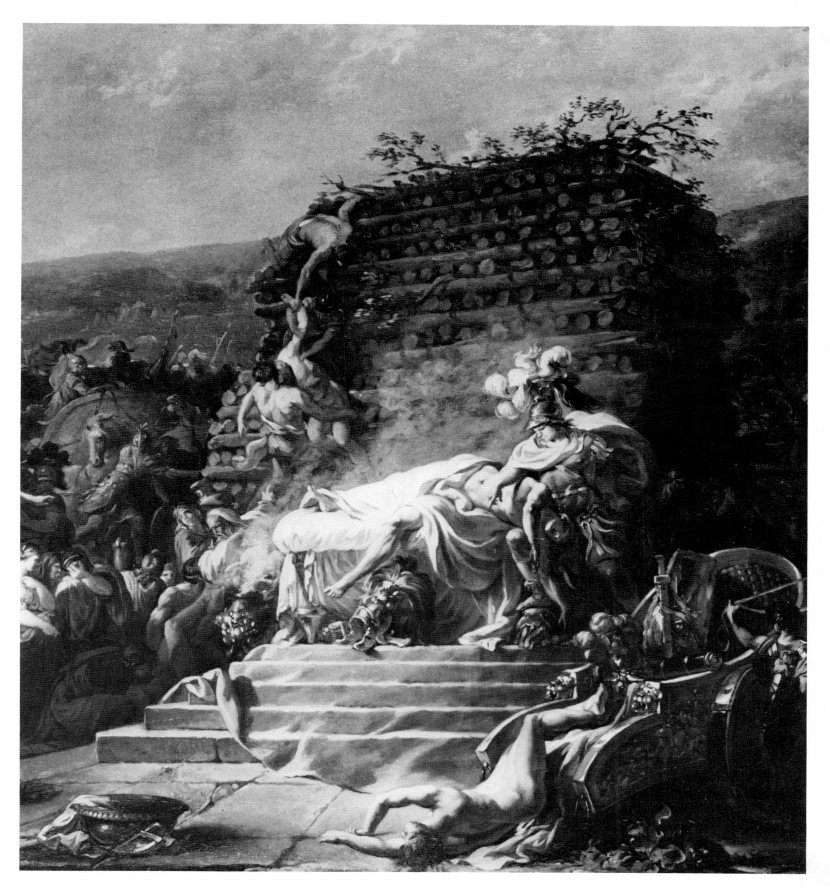

treatment, and the background is darker (a fact the Academy would deplore). Despite the randomness of the pose and the yellow draperies we are aware of a new attitude to reality.

It was not until the following year, 1779, that the painter's style really became recognizable as that of the David we know. One of the decisive turning points in this development must have been the experience of making a copy, intended for Paris, of Valentin's *Last Supper*, which was then at the Palazzo Barberini; on June 16 Vien wrote to say that the copy was finished. To appreciate the importance of this, we need only visualize Valentin's picture side by side with any Boucher. Valentin's apostles immediately will seem real people, almost aggressively alive, painted in dark, dramatic colors. David himself described the therapeutic effect this Caravaggesque picture had on him; he is quoted on this point as follows by his pupil, E. J. Delécluze (who, however, is mistaken in his chronology, for he dates this copy from the beginning of David's stay in Rome, whereas he could not have started it before autumn 1778 at the earliest):

When we think of French painting, from the ceilings by Lemoine to those painted even today (1805) by Berthélemy, including such works as Natoire's, Vanloo's, etc., we are shocked, not so much by the weakness of their style or the lack of taste as by the insipidness and terrible drabness of their coloring. Color is what matters most in art, for it is color that makes the first impact on our senses. When I arrived in Italy with M. Vien, the first thing that struck me in the Italian paintings I saw was the power of the tones and shades. In this they differed most radically from French painting, and this new relationship of light and shade, the impressive vividness of the relief which I had never known before struck me so forcibly that in the early days of my Italian stay I thought that the whole secret of art consisted of reproducing—as some late sixteenth-century Italian colorists have done—the clear, positive relief almost always found in nature. I must admit that at the time my vision was so callow that I was quite unable to benefit from looking at anything so delicate as a painting by Andrea del Sarto, Titian, or any of the most skilful colorists; I could only appreciate and truly understand such brutal works—though they were also excellent—as a Caravaggio, a Ribera, and Valentin, their pupil ... Raphael was far too delicate a dish for my coarse mind; I had to develop my taste gradually, through a diet, and my first ration was copying the *Last Supper* by Valentin.

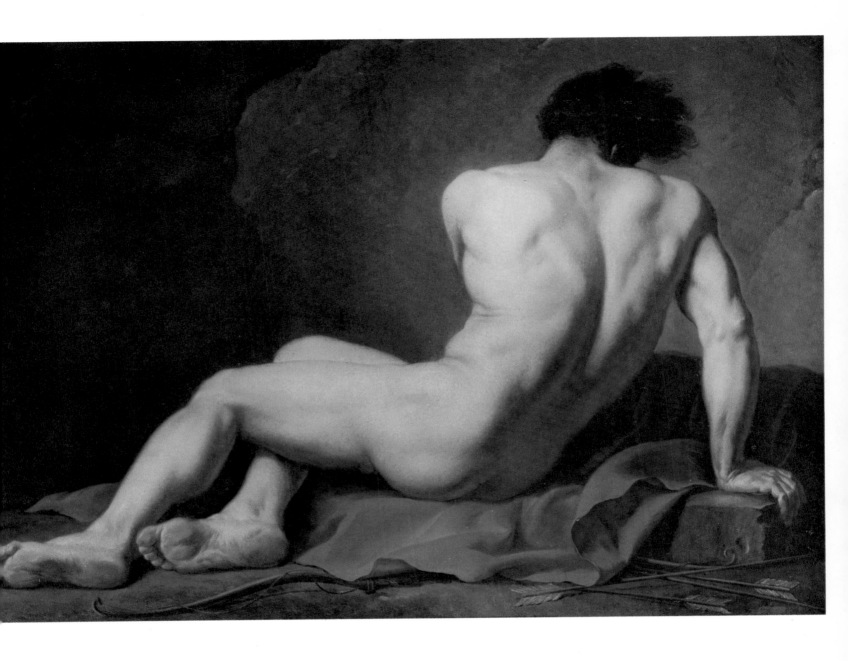

Unfortunately, we do not know what became of that copy by David, which he subsequently recuperated and kept faithfully in his studio. He thought so highly of it that he had it exhibited in Paris in 1824. Delécluze, who knew it well, praises the execution, "firm brush strokes such as he had not yet shown in his previous studies", although he thought Valentin's original "a fourth-rate painting".

Between July and September 1779 David was going through a profound crisis, which Vien anxiously reported to d'Angiviller. Some unknown incident in his private life may have contributed to it, but Vien put it down to problems with his work: on July 21 he wrote that David "has started his nude several times but is still not satisfied with it". The young artist was in such a state of nerves and so depressed that his director suggested he should make the trip to Naples and have a change of scene. This journey, which he made in August together with a fellow student, the sculptor F.-M. Suzanne, and the young archaeologist A.-C. Quatre-

15 *Nude Study*. Oil on canvas. 125×170 cm. Musée Thomas Henry, Cherbourg.
This nude study, which has been given the name *Patroclus*, was probably painted in 1780, shortly before David's return to France. Intended to show the academicians his progress as a *pensionnaire* of the French Academy in Rome, it marks the beginning of his concern with reality, scrupulously observed and painted.

16 *An Ancient Philosopher.* Signed and dated 1779. Oil on canvas. 74.5×64.5 cm. Musée Baron Gérard, Bayeux.
This study of a head is inspired not so much by antiquity as by Valentin, whose *Last Supper* David was copying at the time. It shows how important the influence of Caravaggio was on French artists at the end of the eighteenth century, serving here as a kind of "purgative" for the pastel colors of the rococo painters.

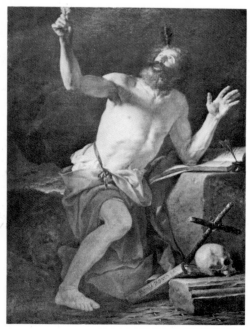

17 *St. Jerome.* Signed and dated 1780 (but probably painted in 1779). Oil on canvas. 174×124 cm. Notre-Dame Cathedral, Quebec.
In its realism—derived both from the Bolognese school and the work of Valentin—this painting bears witness to the change in David's style towards the end of his stay in Rome.

mère de Quincy (who was to become one of the most outstanding figures in the French art world), brought him into direct contact with the antiquities of Herculaneum and Pompeii, and this seems to have precipitated his development. Yet when he came back to Rome at the end of August he seems to have been still so discouraged and so determined to go back to France that Vien did not even dare broach the subject of the additional year in Rome—a favor he had persuaded d'Angiviller to grant the young man. Then, suddenly, everything changed. On September 22 Vien wrote to Paris: "The rest he has taken since then, the fact that I have given him permission to go back to Paris, and finally my high praise of his work have stimulated him so much that he has finished with more fervor than I could have thought possible."

This was still the same nude of which David later spoke to his pupil Delafontaine, with a vagueness characteristic of his memories, describing the important part played by his journey to Naples: "When I got back I felt as if I had had a cataract operated, and moved by a completely new sort of inspiration I did a big figure seen from the back, which was greatly admired by my fellow students." It would seem that this description could refer only to the *Patroclus* (Musée Thomas Henry, Cherbourg), but the report of the Paris Academy in February 1780 proves that this is actually not so: the nude must have been the *St. Jerome* now in Quebec Cathedral, although it is signed and dated 1780. This dating may be due to the fact that the picture was not sent to Paris until December 1779, and that the judges, the "officers" of the Academy, did not see it until 1780. The *St. Jerome*, painted in muted colors, with a strong contrast of light and shade, shows a new realist feeling which, admittedly, owed a great deal to the study of Valentin and to the Caravaggesque influence, but at the same time went back to Vien's tireless teaching which David had rejected for so long. The saint's bearded face is reminiscent of the *Sleeping Hermit* which Vien had painted in 1750 as a young man when he, too, was a student in Rome. As the painting was incorporated in the collection of Louis XVI while David was in Rome he probably did not know it, but he may have seen a sketch of it.

Unfortunately we do not know the personal study David sent to Paris at the end of 1779. Two works from that year are known: a study of a *Philosophe antique* (*An Ancient Philosopher*) (now in the Musée Baron Gérard, Bayeux), a small, somewhat worn picture painted in a brownish orange and greenish grey coloring not unlike that of the *St. Jerome*, whose head actually resembles both that of the philosopher and of one of the apostles in Valentin's *Last Supper*, which David had

copied in the same year. More important, more innovative, is the drawing of *Belisarius*, seized during the Revolution from the Comte de Clermont d'Amboise and now in the Ecole Polytechnique. This was David's first neo-classical composition, and he made use of it almost unchanged for his great painting of 1781 (Musée des Beaux-Arts, Lille). Poussin's influence was definitely replacing Boucher's: a lucid definition of space, well-ordered, grandiose architectural features, the expressive power and moral message of the scene, the emotional tension and poignancy—this is the birth of the great David.

David did not owe this maturity, which was both gradual and sudden, to his Paris teachers, and he never forgave them for the wasted years. This may well account for the bitter resentment with which he always regarded academic teaching. It was a strange quirk of modesty in such a proud man that, instead of claiming credit for his own genius, he should have believed that an artist depends

18 *Study after a Tomb in the Vatican.* Pen drawing with Indian ink wash. 15×21 cm. Cabinet des Dessins (Inv. 26084), Musée du Louvre, Paris. Only the two figures on the left are found on the sarcophagus that inspired this drawing.

19 *Study of a Classical Pedestal.* Drawing in black crayon with Indian ink wash. 12.5×10 cm. Fogg Art Museum, Cambridge (Mass.); Grenville L. Winthrop Bequest (sketchbook 1943-1815-19). Like the following, this is one of the very many drawings of classical monuments from the monuments themselves or from engravings; these took up twelve sketchbooks, which were sold after the artist's death. David reused this drawing, with variations, for the candelabrum on the right of the painted sketch, for *Andromache* (Pushkin Museum, Moscow).

wholly on his teachers to make him what he is; but this belief certainly was in keeping with his devotion to and pride in his own calling as a teacher. Today, after the examples of Cézanne and Mondrian, we are not surprised if a great painter finds himself slowly and rather late in life, but in David's time, when the development of art was a continuous process and it was universally thought that beauty could be taught, such slowness would seem a senseless waste.

According to David himself his true teachers in Rome were the ancients and Raphael. In the autobiography he started around 1808 he recalled Trajan's column, or rather casts of it: "I had several of those bas-reliefs taken up to my studio. I spent six months copying them." The surviving—often annotated—drawings show that he also did the round of the great Roman repositories—the Borghese gallery, the Vatican—copying sarcophagi, statues, all manner of fragments, just as Poussin had done in the past. He also used Winckelmann's and Piranesi's books of engravings. Delécluze gives us an account of what David remembered—rather later—of his own progress. First he copied antique objects because he was told to, without any enjoyment, then he enlivened his copies by adding some expression: "When I had copied this head most carefully and laboriously, I would then do the one you see next to it. *Je l'assaisonnais à la sauce moderne*—I seasoned it with a modern dressing—as I put it. I would give the brows just a tiny frown, heighten the cheekbones, open the mouth just a trifle, in short give it what the modern school calls *expression* and what I now [in 1807] call a *grimace.*"

In the text quoted earlier David pays a stirring tribute to Raphael: Divine Raphael! It was you who led me, step by step, to antiquity. It was you, sublime painter, who managed to come closest to these inimitable models. You yourself made me realize that the antique was greater even than you. It was you, kindly, helpful painter, that set my chair in front of the sublime remains of antiquity. Their beauties were revealed to me by your erudite and graceful paintings. In return for my admiration, will you do me the favor to consider me—even with three hundred years between us—as one of your pupils? You have already showered me with favors, for it was you who placed me in the school of antiquity: how much I owe you, what a marvellous teacher you have given me—I shall never leave him as long as I live!

Although no studies after Raphael have so far been identified among his Roman drawings (but many of these are still missing), his admiration for the great painter is shown in later drawings. Thus, when preparing *The Oath of the Tennis Court,* he let stray memories, sometimes quotations from one of the Stanze in the

Vatican, creep into his work here and there. Still more frequent were his references to Michelangelo, of whom he spoke most feelingly to Wicar in 1789. We know that he greatly admired Andrea del Sarto, Fra Bartolommeo ("What a man there! What splendid heads of old men!") and, inevitably, Daniele da Volterra's *Descent from the Cross* at the Trinità dei Monti, the shrine that was a must for all artists, and in which David copied some expressive heads.

Although there is no reference in David's short memoirs to the influence of the circle in which he was living, it could not have left him untouched. For a long time he continued to resist innovations in style, although they were rapidly becoming the reality in French and European painting. By then Boucher had been dead for ten years and, with growing impatience, the critics kept berating those who still followed him. In Rome itself, at the French Academy, Peyron was drawing his *Belisarius* in 1778; in the following year he painted it as a major work (now in the Musée des Augustins, Toulouse), commissioned by Cardinal de Bernis, the French ambassador in Rome. This was a real manifesto of the new school, at least in its subject matter, its layout as a frieze, and its plain setting of bare stone.

Another influence whose importance Delécluze emphasized was that of the young sculptors who were David's fellow students. None was more systematic in imbibing the antique as an antidote against "the academic rut" than J. B. Giraud. Delécluze tells us how Giraud shut himself in the Vatican Museum for almost three years; he had casts made, at his own expense, of numerous antique statues, starting with the haunting Belvedere Apollo, whose picture we find in countless academies of the period and which certainly influenced Canova. In 1789, when Giraud returned to Italy to complete his collection, just after he had been admitted to the Academy with an *Achilles Removing the Arrow With Which Paris Had Shot Him*, David recommended him to Wicar in these words: "He is ... our foremost sculptor; he is the only one who really keeps to the antique, and the only one who has talent; add to that, if you like, a private income of seventy thousand francs a year ... his town house in Place Vendôme will make you feel you are in Rome—that was how we felt when we saw the more than twenty superb antiques he has in Paris." Ten years later, at the time when he was writing his brochure on *The Sabines*, David again mentioned the collection in the Place Vendôme house.

During his stay in Rome Giraud also did a "nature cure" by studying anatomy in a hospital and working untiringly from life. At the end of 1778 J. Lamarie and Suzanne, two young sculptors with whom David had made friends, arrived at the Academy. Lamarie seems to have had a mania for outline drawing: in this he was

following one of the most fascinating trends of neo-classicism. The aim was to eliminate all concessions to the "sensual" pleasures of color and even values by keeping only the outline, the intellectual essential which contains the permanent substance of things and not their transient appearance. It is quite possible that, after his return to Paris, David tried a similar cleansing process on his own drawings by making tracings, several hundred of which were dispersed in 1953. It is not absolutely certain whether these tracings were actually David's own work, but they were all made in his studio and form an ironic counterpoint to those "prettied up" antiques of which he spoke to Delécluze in 1807.

What part did Suzanne play? All we know is that he accompanied David on the journey to Naples in 1779 which seems to have led to his genuine, sincere discovery of antiquity. David also was quite friendly with a rather unruly young sculptor he knew in Rome and whom he invited during the Revolution, at the beginning of 1794, to work in the new Conservatory of the Museum. This was Antoine Pasquier or du Pasquier, *Prix de Rome* in 1776 with a bas-relief of *Hector's Body Being Carried Back to Troy*, and author of a *Death of the Dauphin and the Dauphine*, in a very modern style, to which Jacques de Caso has recently drawn attention (Musée municipal, Sens). In 1779, at the Academy in Rome, his continual insolence finally exasperated even the easy-going Vien, who had to report him to the *Directeur des Bâtiments*:

> I have to report to you, Sir, that the sieur Paquet, who is the cause of all the quarrels in this house and of whom I have had to complain on previous occasions, last Saturday came into the large drawing room of the first apartment, which was all prepared to receive distinguished guests who were doing me the honor of coming that day to see the horse race, when, as I said, he came in improperly dressed, with just an overcoat pulled round him, so I told him very politely it would be fitting for him to put on decent clothes as we were expecting visitors ... he replied, in a most insolent tone, "I am at home here, and I come and go as I please, but you are not at home, because if there were no students there would be no director", and my remonstrating only made him more insolent.

Du Pasquier was expelled from the Academy. He had had time to begin a huge drawing, a frieze (more than 9 metres long by 0.45 metres wide) of *The Triumph of Marcus Aurelius*, which he sold to the Louvre at the close of his life. This love of friezes, which the sculptors shared with the architects of the day, emerged the following year in David's own work.

How far did the Roman milieu stimulate him? At that time the Italian equivalent of painters like Lagrenée or Vien was Pompeo Batoni, who was not only a fashionable portrait painter to whom all the English went when they were passing through on their Grand Tour, but a historical painter who created a delicate, colorful image of antiquity. There is a great deal of evidence, down to the legacy of his palette and brushes, of the old master's affection for his young French colleague: he is said to have expressed admiration for the *St. Roch* and again for *The Oath of the Horatii*, and of course David in his turn must have recognized Batoni's marvellous skill in ordering his material; it has been suggested that David's *Andromache* has a certain kinship with *The Death of Meleager* painted by Batoni much earlier. The other great painter in eighteenth-century Rome was Mengs, a German whom David certainly met and who died in 1779, during David's stay there. Mengs, as a good follower of Winckelmann, tried to revive antiquity, but it is mainly his numerous self-portraits that are echoed in David's later work.

20 *View of S. Agnese Fuori le Mura in Rome.* Drawing in black crayon with sepia wash. 15.5 × 20.5 cm. Kupferstichkabinett (album 79 D 30 a, p. 47 recto), Staatliche Museen Preussischer Kulturbesitz, Berlin.
Despite the very solid and geometric nature of this architectural ensemble, the light is rendered with great sensitivity.

21 *Study of a Bull.* Drawing in black crayon. 15×21 cm. Cabinet des Dessins (Inv. 26114 ter), Musée du Louvre, Paris.
One of the means whereby David was able to make a break with the artificiality of Boucher's type of painting was a painstaking observation of reality, as is shown both by his studies of the nude and by simple, charming sketches such as this, which also comes from one of his Roman sketchbooks.

The portraits bring us back to nature, which was—as much as antiquity and Raphael—the school in which David learnt his trade. This might seem to be ordinary, but we have seen the significance of a simple study from life provided it was no longer a pretext for fine effects but a means of grasping the structure and working of the human body. Without complete mastery of that "artistic anatomy", without first knowing the truths of the human body, the neo-classical style could become a dangerous pitfall: the noble gesturings of so many Catos, Brutuses, or Senecas can end up just as artificial and pointless as Boucher's pastoral scenes, and indeed this was exactly the reproach the Romantics levelled at David's pupils. But though the poses of David's figures may recall an antique example or a Michelangelo statue, they are above all real people, as is shown by his numerous sketches of nude figures, which he subsequently clothed according to the demands of the picture.

We find a similar concern for realism in many sketches of landscapes among the Roman drawings now at the Louvre, in Berlin and in Stockholm. It is usually nature dominated and partitioned by human constructions, like the "fabrics" that punctuate Poussin's heroic landscapes, but David observed the play of light, whose changing values are conveyed by grey washes. Here and there a more spontaneous sketch, a treelined avenue or a donkey, show a keenness of observation and a faith in the worthiness of any object to be observed. This interest in the setting of life, in objects, breathed life into the archaeological view and gave rise to some of the wonderful glimpses of still lifes we catch dispersed through a number of the major paintings, like the portrait of Lavoisier and the *Brutus*.

In autumn 1779 David started on his first really important painting. The *St. Roch Interceding with the Virgin for the Plague Victims* was assigned to him by Vien, to whom officials of the Marseilles Department of Health had turned when they wanted to decorate their chapel without spending too much money. The small sketch now in the Musée Magnin, Dijon (sketches actually known to have been painted by David are extremely rare) shows the broad plan for the composition: three enormous figures dominate the whole surface of the canvas. The brutal lighting—a somewhat superficial but definite memento of the Caravaggesque tradition—emphasizes the boldness of the central figure, the large body of the sick man thrust across the foreground and entirely detached from the miraculous scene behind him. The stark contrast between this tragic figure lost in almost philosophical meditation and the conventional, graceful image of the Virgin was softened in the final version, which was completed in 1780: instead of the sinuous

22 *St. Roch Interceding with the Virgin for the Plague Victims*. Signed and dated 1780. Oil on canvas. 260×195 cm. Musée des Beaux-Arts, Marseilles. This canvas, one of David's few religious works, was commissioned in 1779, through the intermediary of Vien, by the Office of the Marseilles Health Service to decorate the Lazaretto Chapel and commemorate the plague epidemic of 1720. There is a small sketch of the composition in the Musée Magnin, Dijon. Here David is inspired by the Bolognese painters of the seventeenth century, renouncing facile color effects and treating the foreground with a realism that is new in his work.

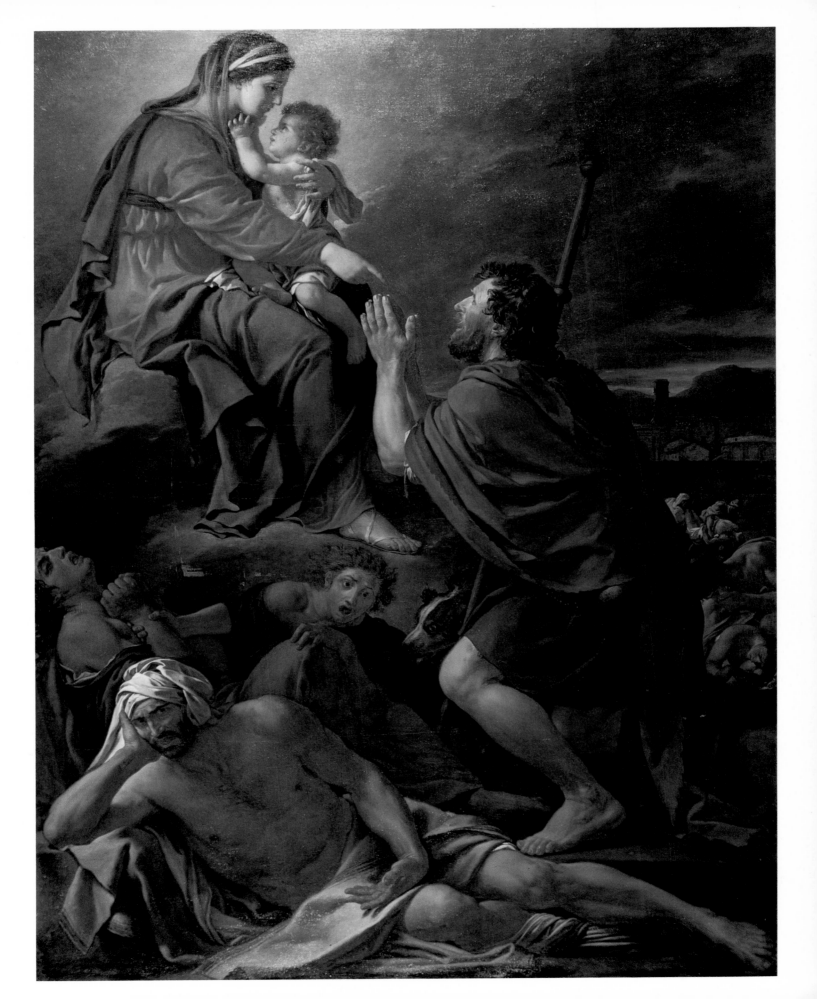

23 *Classical Frieze (The Obsequies of Patroclus).*
Detail. Signed and dated 1780. Pen drawing with
Indian ink wash, touched up with gouache, on blue
paper. Overall dimensions: 26.3×74.6 cm. Musée
de Peinture et de Sculpture, Grenoble.
Left side of a huge drawing (the whole is more than
2 metres long), the greater part of which is in
Sacramento. Here David seems to be summing up
his patient studies of classical monuments during
his first stay in Rome. Some fragments are found in
isolated drawings of statues or bas-reliefs, while
others were to recur in certain background details
of *Andromache* of 1783 (Pl. 31).

movement it had in the earlier sketch, the body of the Virgin now was shown in
profile, with a sculptured authority echoing that of St. Roch. Starting with a rather
banal version of the conventional seventeenth-century Bologna Virgin, David
finally gave her a perfectly "modern" cold, statuesque elegance. The three chief
figures are seen against a host of corpses and sick people, but they fully retain their
special prominence. At the Salon of 1781 the Paris critics recognized the novelty
and power of David's plague victims, but deplored the cautious coloring: in fact
the picture is painted in a range of grey, which shows how far David had come
from the sort of "prettiness" he had delighted in a few years earlier. Yet once his
cure of severity was completed, and he had the greater freedom allowed by the
portrait—when he started his *Potocki*—he also showed what a brilliant colorist he
could be.

In 1780 David was still practising his scales, but he had acquired a new mastery
both in the study of nature and of antiquity. A painted nude which came to light
recently and was bought by the Museum of Fine Arts, Dallas, which I know only
from a photograph, could easily be mistaken for a work of twenty years later if it
were not signed and dated 1780. He had given up picturesque draperies and
spectacular stage-settings. With the aid of rapid scumbling, which he would later
leave visible not only in his unfinished works—which, as we shall see, were
numerous—but in the secondary areas of some of his finest pictures, David
created an abstract world in which the space was divided into two cubes, of wood
or stone, and occupied uncompromisingly by a man's body; its arrangement on
three planes (the elbow, the thigh, the feet) is calculated as painstakingly as the
layout of a large composition and at the same time is perfectly genuine and
simple.

In the same year David executed an extraordinary drawing, a vast frieze: the
left part, signed and dated 1780, is now in the Musée de Peinture et de Sculpture,

Grenoble, whereas the longer right section is in Sacramento. It measures 2.25 metres by 26 centimetres. Nothing could be more striking than the contrast with *The Combats of Diomedes* of 1776, not only because of its size (the frieze is only a third the height of the Vienna drawing) but because of the difference in the whole conception. The incidents of the frieze are played out against a plain background recalling Roman bas-reliefs: the technique of the drawing, with its deep shades and white highlights, accentuates the impression of a bas-relief. The work, whose subject cannot now be defined with any certainty (the traditional title *The Obsequies of Patroclus* is written on the back) is a synthesis of the long studies from antiquity David undertook from the time he arrived in Rome, either direct from the sarcophagi and statues in the Vatican and at the Villa Medicis, or after Montfaucon, Winckelmann and d'Hancarville. Professor Howard has made a careful study that revealed a number of quotations, some literal, some based on an earlier drawing in the albums in the Louvre and the Fogg Art Museum. But although many figures are borrowed and not original, the layout conceived by David makes this an original work, the artist's supreme effort to emulate, perhaps even to equal, antiquity, as Michelangelo, too, had striven to do. David, unlike Canova, did not continue along those lines, but he had now acquired a classical culture that would be unobtrusively present in all his later works: the death of the warrior would reappear in one of the details in the furniture of *Andromache* (1783), while the *Brutus* of 1789 is teeming with antique references.

In 1780, too, in circumstances that are still obscure, David explored yet another avenue. That year he met—apparently in Rome—a young nobleman, a member of one of the richest and most illustrious families in Poland, Stanislas Potocki (1757-1821), who later distinguished himself both in politics and art: minister and then president of the Polish Senate, he also translated Winckelmann's great *History of Art in Antiquity (Geschichte der Kunst des Altertums)*. The portrait was

24 *Classical Frieze (The Obsequies of Patroclus)*. Central part. Pen drawing with Indian ink wash, touched up with gouache, on blue paper. Overall dimensions: 26.3×153 cm. E. B. Crocker Art Gallery, Sacramento (United States).
The theme of a dead warrior being borne away is also found in a classical study by David in the Louvre.

25 *Portrait of Count Stanislas Potocki.* Signed and dated 1781. Oil on canvas. 304×218 cm. Muzeum Narodowe w Warszawie, Warsaw.

One of the pictures (along with *Belisarius, The Obsequies of Patroclus*, and several nudes) that ensured David's success at the Salon of 1781. The painter had met Stanislas Potocki (1757-1821)—future Polish statesman and translator of Winckelmann—in Italy, but he executed the portrait in Paris. Showing the influence of major works by Van Dyck and Rubens, it is an admirable painting with its vibrant blues and yellows; though the treatment is much freer than it is in David's historical paintings of the same period, the composition is highly organized.

prepared in Rome and, according to Polish sources, painted in Paris. It has become deservedly famous at exhibitions all over the world and is one of the most breath-taking examples of David's new-found mastery. First of all, its scale and ambition are astonishing: a full-length portrait on horseback, three metres high, it can compete with the masterpieces of Titian, Rubens and van Dyck. In fact it is reminiscent of van Dyck's portraits of Anton Giulio Brignole-Sale (Galleria di Palazzo Rosso, Genoa) and his Prince Thomas of Savoy (Galleria Sabauda, Turin), of which David made a sketch that is now in the Louvre. His interest in old Flemish painting, which preceded his journey to Flanders in the autumn of 1781, is reflected in the naturalist drawing of the dog—recalling Snyders's life-like creations—and of the horse: actually, David copied the forepart of the horse (here, too, a sketch has survived) from the tapestry of Decius Mus after Rubens.

These realist tendencies are contrasted or complemented by a solemn, grandiose layout whose equilibrium echoes that of the rider on his mount and is fully reinforced by the coloring: the warm sparkle of yellow and blue occupies the center of the picture, with a discreet reminder at the sides in the blue ribbons that decorate the horse's head and tail. The bits of hay in the foreground at once identify the setting as a simple riding school (this is confirmed by the rider's gesture apparently saluting real spectators as well as us) but it is turned into an antique framework by the Piranesi-like wall, surmounted by two bases of columns, that arrests the eye. This whole ordered grandeur is enlivened by the freedom, the verve, with which it is executed—the wonderful lightness of the horse's mane and the dog's open mouth. This first great masterpiece, in which so many contradictory qualities were blended, was already unrivalled in the whole of Europe.

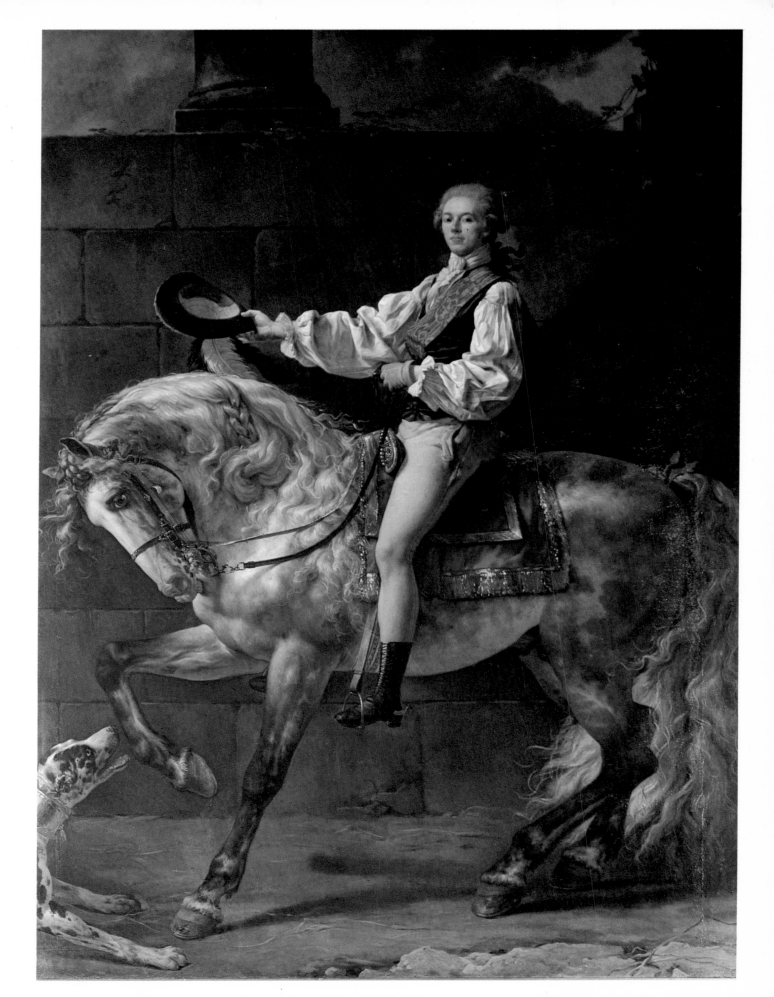

III. FROM BELISARIUS TO BRUTUS

Return to Paris. D'Angiviller and the Academy. Belisarius; *David's admission to the Academy. The Salon of 1781 and the new generation of painters. First successes and pupils.* Andromache Mourning Hector. *First sketches for* The Oath of the Horatii, *a triumph at the Salon of 1785. Rivalry with Peyron.* The Death of Socrates. *Portrait of Lavoisier and his wife. The mania for the antique.* Paris and Helen. Brutus *and its political significance.*

In the summer of 1780, when David returned to France, the situation in the arts had undergone some changes. As in politics, the position of the intellectual party had grown consistently stronger, and its pressure for historical and moral painting at the expense of genres like landscape and portrait became more insistent; this policy had the blessing of d'Angiviller, *Directeur des Bâtiments* since 1774 and one of the most interesting and characteristic figures of his time. A former military man, he had gone into the service of the Dauphin (who died in 1765), and from 1759 was in charge of his children, including the future Louis XVI, which ensured him a high position at court. He was received in the salon of his pupil, the Comte d'Artois; the salon of his mistress, Mme de Marchais, whom he married in 1781, was frequented by men of letters and encyclopaedists such as Marmontel, d'Holbach and Diderot. D'Angiviller himself was a scientist, a collector of minerals, who had been admitted to the Academy of Sciences in 1772; he was promised the office of administrator of the Jardin des Plantes in succession to the incumbent, Buffon, and did in fact succeed him in 1774. A perfect example of the eighteenth-century man, he commissioned Peyron at one and the same time to do a *Death of Socrates* in "an awesome tone setting off the chiaroscuro" and, as a companion piece, "a subject showing some nude women".

His policy on art was all Diderot could have wished for. Historical painting was to have an even more predominant place at the Academy, itself in the service of the monarchy. The social purpose of art was to edify and to contribute to moral regeneration. However, his role as "chief curator" of the royal collections created a certain inevitable ambiguity. He bought some historical paintings, like Le Sueur's large ensembles from the Lambert House and the Paris Carthusian Monastery, yet he also—fortunately—made up the gaps in Flemish and Dutch works, often with genre paintings. From 1776 on he strove unsuccessfully to open a large museum in the Louvre, a plan that did not materialize until the time of the Convention, since its aim was not solely to please art lovers but primarily to train artists. An

enlightened man, but attached to the old monarchy, he emigrated in 1791 and died in exile in 1809. He was generous and most indulgent to David's difficult temperament, but the high opinion he had of the place and function of the Academy was held against him once the Revolution broke out. The favors he showered on David were always balanced by severity, which was accentuated by his right-hand man, J. B. M. Pierre. The latter, who had been painter-in-chief to the king since 1770 and director of the Academy, exasperated the artists, and David with them, by his high-handedness and self-importance.

The reinforcement of the privileges of the Academy led, as a corollary, to the prohibition of all public exhibitions except the Salon, which, as we have seen, was reserved for members of the Academy. Turgot's edict of 1776, which abolished art guilds, masterships and associations, conveniently involved the liquidation of the Académie de Saint-Luc. When some of its members organized exhibitions at the Colisée, a hall recently established on the Champs Elysées, d'Angiviller prohibited them in 1777. He then campaigned against the small periodic exhibitions of the Salon de la Correspondance, a sort of literary salon held by Pahin de la Blancherie, where Fragonard among others exhibited. D'Angiviller succeeded in doing away with it, after having also prohibited a Club des Arts in 1785.

D'Angiviller's harsh policy did not have the unanimous support of the Academy, although his measures were taken for its benefit. To forbid all exhibitions to young artists meant that admission to the Academy necessarily remained their first aim; it meant also avoiding "such unpleasantness as great projects being entrusted ... to young artists who had not yet been to Rome", d'Angiviller wrote in 1777 to Le Noir, the police lieutenant, and added: "The order I am trying to restore in this Academy, the severity I preach and demand for admission to it, have hit several very worthy artists who had become too independent and now are a little less so. They wanted to draw the young people to themselves." This phrase seems, ten years ahead of its time, to sum up the position of David, who led the young artists at the time of the Revolution.

It was vital, therefore, for a young artist just back from Rome to obtain the approval of the Academy and become *agréé*, otherwise it was almost impossible for him to become known. David, aware of the success of his *St. Roch*, which had been acclaimed in Rome, brought it back with him instead of dispatching it to Marseilles, and counted on it for receiving his *agrément* from the Academy.

On December 1 Pierre sternly opposed this: "The picture by the sieur David can be accepted for his *agrément*, as can his nudes; but he cannot present his

candidature until he has done a painting in Paris. This is a custom that has assumed the force of law." D'Angiviller himself would probably not have opposed it, if we are to judge from a letter of 1782, in which he admits that he would have liked to be able to keep the painting for the royal collection. In fact it was he who in June had asked that the picture should be shown in Paris before being sent to Marseilles. It is easy to imagine David's irritation with Pierre. It was probably this episode to which David referred in August 1793 in his speech to the Convention that led to the suppression of the Academy:

> A young man who, on his return from Italy was preceded by a disquieting renown, wanted to apply to the Academy; an old academician who had gone through the whole gamut of honors offered by the Academy and whose lethargic perseverance had occupied all its seats, from the stool to the best armchair, said gravely, "Gentlemen, if, as we are told, this young man has so much talent, I myself see no need to admit him to our midst. Gentlemen, remember the equilibrium of talents, the equilibrium ..." The academicians all cry out, "the Equilibrium of talents, the equilibrium!" and all this simply to postpone a young man's rise to fame for two years, for at that time the Salon was held only once every two years; and they even claimed that he should not be admitted until after the public exhibition, that all the places were filled, that too many candidates applied at the same time...

Nevertheless, he set to work determinedly and within a few months he had completed two major masterpieces: one, the *Portrait of Count Potocki*, which we have already discussed, the other *Belisarius*, the first truly neo-classical painting in France. David used—unchanged—a drawing dating from 1779 (now the property of the Ecole Polytechnique), which miraculously reconciled the "sensibility" of the eighteenth century with the dream of antique grandeur. The full title was *Belisarius is Recognized by One of the Soldiers Who Served Under Him Just as He is Receiving Alms From a Woman.* The subject had been particularly fashionable since the publication in 1767 of Marmontel's *Belisarius*, which in its turn was inspired by an engraving after van Dyck. Belisarius, one of Justinian's generals, won victories for his emperor on every battlefield, in Africa whence he drove out the Vandals, in Italy, in Persia and against the Bulgars, but was subsequently accused of taking part in a plot and was dismissed. According to one version, which is probably apocryphal but was taken up by Marmontel and illustrated by David, he even had his eyes put out and was reduced to begging. In Marmontel's time, as in David's, this story was of great topical interest: Lally-Tollendal, the hero of Fontenoy in

26 *Belisarius*. Pen and wash drawing touched up with gouache, on blue paper. 45.5 × 36.5 cm. Musée des Beaux-Arts, Dijon.
Replica, without any major change, of a drawing signed and dated 1779, now in the Ecole polytechnique, Palaiseau. Based on a theme that had been fashionable in France for some fifteen years and had just been treated by Peyron, this is David's first "neo-classical" composition. The moral content is matched by the severity of the lay-out, which owes a great deal to Poussin.

1745, but beaten by the British in India and accused of treason, had been beheaded in 1766 after a trial whose flagrant injustice was denounced by Voltaire. Rehabilitation procedures were begun in 1778 and were finally successful in 1781.

The tragic fate of Belisarius, the ingratitude of the mighty and the fickleness of fortune had inspired several painters before David: Jollain in 1767, Durameau in 1775 in a painting intended for d'Angiviller, Vincent in 1776 (Musée Fabre, Montpellier), and finally Peyron, who in 1778 began the preliminaries for one we have already mentioned, which he executed in 1779, under the very eyes of David, with whom he shared rooms in Rome. Vincent treated the subject in a different spirit: his waist-length figures are engaged in a silent dialogue, against a background of sky. The gravity of the scene and its heroic emphasis are juxtaposed to the rich pictorial composition used by the artist, who enjoyed fine impastos, with a frank contrast of colors and values. Peyron used a much more modern idiom for a slightly different subject, "Belisarius being offered hospitality by a peasant who used to serve under him". In a heroic interior of bare stone, subtly softened by a set of arcades, openings and shafts of light, the three generations of a family are aligned as if in a frieze, their gestures and looks directed at Belisarius and his guide, who is standing behind him. The figures emerge from the shade in a Caravaggesque manner, but this harshness is belied by the subtlety of the unusual, satiated colors and the precise, mannered execution.

It is easy to understand why Peyron's work raised such high hopes: "he is one of those on whom I rely to raise our standards of painting", d'Angiviller wrote to Vien about that particular picture. David could not fail to be interested in his fellow student's work in 1778, and especially in 1779, when he was himself doing his drawing of Belisarius. From that point on, however, the difference is glaringly obvious: David's scene is concentrated, with only four characters in a painstakingly elaborated architectural setting—an oblique perspective punctuated by fluted columns on a very high base, a tall house, in the background mountains from which we are separated by a high wall. In this carefully ordered space, the figures stand out decisively, three of them closely resembling those in the frieze of Sacramento/Grenoble (Belisarius himself is based more or less directly on antique statues, such as the Chryssipes in the Louvre, which was then in the Palazzo Giustiniani in Rome), but now they are creatures of flesh and blood. The soldier's gesture, the raised arms, alone conveys all his astonishment and grief; in Le Brun's studies on expressing emotion a hundred years earlier we find a similar effect.

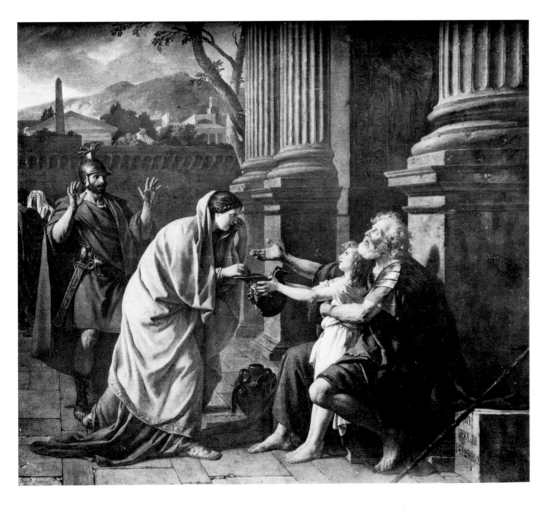

27 *Belisarius.* Signed and dated 1781. Oil on canvas. 288 × 312 cm. Musée des Beaux-Arts, Lille.
It was through this picture that David gained admission to the Academy on August 24; it was subsequently shown at the Salon, where Diderot greatly admired it. David got the young Fabre to make a smaller version, to which he put the finishing touches himself; dated 1784, the second version—in which the composition has lost some of its density—is now in the Louvre.

Going back to his 1779 drawing for which he now used a lengthways format, David lightened the composition somewhat at the sides (he would go much further in the replica of 1784 now in the Musée du Louvre, Paris), took out the "realist" house that prolonged the perspective of the columns, filled in the background with a landscape of "fabrics" on the antique model (perhaps helped by Poussin's examples) and lightened these features by adding two twisted tree-trunks. On the right, Belisarius' stick is placed diagonally, in the direction opposite to the buildings, on a block of stone.

The artist's rendering of this image enhanced its power, which was already considerable. For the first time since the beginning of the return to the grand manner in 1745-50, a French painter harmonized the subject and the means used to depict it. Not perhaps without excesses—contemporary critics deplored the sombre color range. It is, in fact, based on a small number of dull colors, blue contrasting with the pale red and brown, against which the greyish white of the young woman's coat and, even more, the luminous white of the child's clothes stand out sharply.

On August 24, 1781, on submitting his *Belisarius*, David was unanimously admitted as *agréé* to the Academy. Three days later he told his mother the good news: "The Comte d'Angiviller was present at the session of the Academy and gave me the greatest encouragements and said he was waiting for great opportunities to prove his regard." The *agrément* opened the doors of the Salon, which was being held at the same time in the usual Salon Carré of the Louvre. David had a dozen pictures taken there, including a large sketch of *The Obsequies of Patroclus*, the *St. Roch*, the monumental portrait of *Potocki*, the *Belisarius*, his three painted nudes (only the *St. Jerome* is listed in the second edition of the *livret*, which has a supplement with David's submissions). There was also a *Woman Suckling her Child*, which is lost but probably illustrated the realist trends we have noticed in some of the Roman drawings, a *Head of an Old Man*, and, finally, "several other studies under the same number".

David's success was tremendous. He wrote to his mother: "If you come to Paris to see my pictures you will see how the crowds flock to see them. The important people, the *Cordons Bleus* [members of the Order of the Holy Spirit] want to see the author, and at last I am rewarded for my hard work."

The critics were enthusiastic, and Diderot devoted a famous passage to the *Belisarius*, which starts with a pastiche of Racine's *Bérénice*: "I see him every day, and every day I think I am seeing him for the first time. This young man works in the grand manner, he has heart, his faces are expressive without being contrived, the attitudes are noble and natural, he can draw, he can toss down a drapery and make fine folds, his coloring is beautiful without being garish." The *St. Roch* appealed to him, too, despite "that huge and horrifying plague victim": "fine composition, figures full of expression, beautiful draperies setting off the nude parts, well drawn." On the whole, the critics were in agreement, and the highest praise went to the nobility of composition and the intensity of expression, notably in the *St. Roch*: "The unfortunate victims of the cruel scourge who occupy the

lower part of the picture have an expression of exalted suffering that is heartbreaking. This part of the picture is worthy of Poussin," *L'Année littéraire* wrote. Except in *Potocki*, David's coloring was faulted for being "too sombre", but the critics agreed that this newcomer had only one rival in his generation, Ménageot.

The Salon of 1781 witnessed the success of this new generation. With David were Callet, Berthélemy and notably Ménageot, all born in the 1740s and all just admitted or *agréé* by the Academy. Ménageot's *Death of Leonardo da Vinci*, now exiled to the town hall at Amboise, was an absolute triumph. The subject was touching, flattering both to the prince, whose patronage ensured the progress of art and whose magnanimity brought him to the deathbed of a simple artist, and to the artist himself, whose genius raised him from the common herd to be almost the equal of a prince. The picturesque costumes and decor and the use of a historical event contributed to its success as much as the genuine merit of a well-composed and well-painted picture (we know that Ménageot, unfortunately, did not live up to his promise and had no more than a respectable career).

This success was also that of d'Angiviller's policy. To push the restoration of the grand manner, he had set a whole team of painters—whom David would join—to work on big canvases (they were also used as cartoons for Gobelin tapestries) illustrating the most ennobling qualities of man in general and of the prince in particular.

As early as 1774-5, with the help of the faithful Pierre, he elaborated a large-scale program with which sculptors were to be associated too; on March 14, 1776 he wrote to Pierre: "Some time ago, Sir, wishing to encourage grand painting in France, I mentioned to you, as well as to the Academy, a project to share out among a certain number of its artists a series of pictures to be executed for the King, most of which would deal with historical events apt to rekindle patriotic feelings and virtues. I also intended to commission four sculptors of the Academy each to do a marble figure for His Majesty of a great man who had won national fame for his virtues, his talents or his genius."

Every two years, in fact, four life-size statues would be commissioned for the Salon, with smaller versions for the manufacture of Sèvres, a windfall of eleven thousand francs in all for the author of each of these statues. A start was made on the statues of Descartes, Sully, the chancellor of the Hospitallers, and Fénelon, to finish with Poussin, Du Guesclin and Cassini (the fourth was to be Lamoignon) for the Salon of 1789.

The program for the painters was even more conspicuously edifying; the pay was about half as much, so there were to be eight large paintings for exhibition at the biennial Salon, six taken from ancient history and two from that of France. The first program the artists were set for the Salon of 1777 consisted of subjects illustrating great qualities. Lagrenée the Elder was to illustrate "an event in Rome showing disinterestedness": *Fabricius Refuses the Presents the Ambassadors From Pyrrhus Had Been Ordered to Offer Him* (Musée René Princeteau, Libourne), whereas Hallé was commissioned to show the same quality among the Greeks: *Kimon, Son of Miltiades, has the Walls of His Properties Torn Down and Invites the Populace to Share His Crops* (Musée du Louvre, Paris). The national subjects featured "an event showing respect for virtue", which was illustrated by Brenet in *The Town of Randon Honors High Constable Du Guesclin* (Musée national du château, Versailles), and "an event showing respect for morality", illustrated by Durameau with *Chevalier Bayard Restores His Woman Prisoner to Her Mother and Gives Her a Dowry* (Musée de Peinture et de Sculpture, Grenoble).

The Salon of 1781 thus had large paintings, three to four metres long, painted for the king by Vien, Lagrenée the Elder, Doyen, Lépicié, Brenet, Beaufort, Suvée, Ménageot and Vincent, as well as statues of Pascal, Montausier (governor of the children of France under Louis XIV), Tourville, and Catinat.

After his success at the Salon of 1781 David's career progressed smoothly and pupils began to flock to his studio: the young Hennequin, who has left useful *Memoirs*, Drouais and Wicar, soon to be followed by Girodet and Fabre. Nor was there any lack of clients: David sold his large *Obsequies of Patroclus* to the most distinguished of the dealer-collectors, Abraham Fontanel of Montpellier, where he found another client, M. de Joubert, treasurer of the Estates of Languedoc; the *Belisarius* was bought by Duke Albert of Saxe-Teschen; and Marshal de Noailles commissioned a *Christ on the Cross*—David's last religious painting—executed in 1782 and recently rediscovered in Mâcon cathedral. It is a rather unoriginal work, in a dull violet which resembles the color range the artist had used in his last studies of nudes. The Noailles family, reputedly ardent Catholics, most of whom lost their heads on the scaffold, also owned a replica of the *Belisarius*. This was the first known instance in David's career of a practice fairly current at the time, although it may surprise us today. David reverted to the theories of the Renaissance: in painting, the idea counted more than the actual realization, composition and inventiveness more than skill in execution. Thus he had no qualms about signing the replicas although we have evidence that these were mostly done by his pupils.

28 *Portrait of J.-F. Desmaisons.* Signed and dated 1782. Oil on canvas. 90×72 cm. Albright-Knox Art Gallery, Buffalo; General Purchase Funds, 1944.
Jacques-François Desmaisons was married to a sister of David's mother. He was a well-known architect and is shown here with the instruments of his profession. In the treatment of the sumptuous clothes David once again reverts to the tradition of Duplessis.

However, this did bring down the price a bit. When he delivered several copies of his *Bonaparte au Grand Saint-Bernard (Bonaparte Crossing the Great St. Bernard)*, the bill showed a difference between the amount charged for the original and the price of the copies. David himself usually finished off these copies, ensuring a beautiful final surface, to which the *savoir-faire* of such gifted pupils as Fabre and Girodet naturally contributed. This first copy, signed and dated 1784, differs from the copies of later pictures, like *Paris and Helen* and *Brutus*, in having some notable variations due to the change in format, and a less taut composition: for instance, David rethought the soldier's gesture.

Meanwhile he had received the favor of an apartment in the Louvre, and in the spring of 1782 he married the daughter of a well-to-do contractor called Pécoul, whose son David had known in Rome. Thus he renewed his ties with building circles and asserted his place as a member of an active ambitious bourgeoisie. His uncle, Desmaisons, whose portrait he painted in the same year, 1782 (Albright-Knox Art Gallery, Buffalo), is a fine specimen of that class. A successful architect and a member of the Academy who had just designed the grand staircase for the palace of the archbishop of Paris, he is dressed in fashionable clothes—bewigged, a coat with frogging, an embroidered waistcoat—yet is shown at work, pencil in hand, with the tools of his trade on the table: ruler, compasses, plans, a treatise on architecture... This is the very image of a man who owes his success to his work and his talent, and whom his nephew has not flattered, working as earnestly at his painting as the uncle did at his drawings.

Whatever his feelings about the Academy may have been by then, David could not afford to remain aloof: he had to gain admission. This seemed even more urgent to him than the royal commission; the latter was to be *The Oath of the Horatii*, and in February 1783 he decided to work on it during a projected stay in Rome. The main phases of the creation of *Andromache Mourning Hector*, his *morceau de réception*, are known from three drawings (Bibliothèque municipale, Mulhouse, Petit Palais, Paris and Private collection) and a painted sketch (Pushkin Museum, Moscow). He seems to have settled very quickly on the main lines of the composition: the dominant horizontal of Hector's corpse occupying the whole width of the composition, crossed by the draped seated figure of Andromache, at the level of Hector's knees. The pen sketch at Mulhouse, without any decor, puts the emphasis on the grief of Andromache and Astyanax, the latter shown howling like any other child. The accent on the antique—still unobtrusive—is in the body of Hector, inspired by a Florentine tomb of which David had made a sketch we

know from a tracing, and in Andromache, who is like one of the antique statues the painter had seen and copied in Rome (there are several analogous sheets in the albums in Berlin and the Musée du Louvre, Paris).

David then elaborated a rich antique setting, which he kept rigorously ordered within an orthogonal framework. The wall at the back, with a large drapery flung over it (it recalls *The Death of Germanicus* by Poussin or Greuze's *Septimus Severus and Caracalla*), is decorated with a horizontal lance and a shield, an idea taken from Poussin's *Testament of Eudamidas* which David would use subsequently in *The Oath of the Horatii,* and is then surmounted by bases of columns similar to those in the

29 *Portrait of Alphonse Leroy.* Oil on canvas. 72×91 cm. Musée Fabre, Montpellier.
This portrait and the preceding one were probably those shown by David at the Salon of 1783. Leroy (1741-1816) was a very well-known obstetrician in Paris and perhaps attended Mme David when her first son was born in 1783. It was suggested by Chaussard in 1806 that David's pupil Garneray helped him with the painting of the clothes.

30 *Andromache Mourning Hector.* Drawing in black
crayon and ink. 22×24 cm. Bibliothèque munici-
pale, Mulhouse.
In this sketch for the painting, the basic composi-
tion is already there, but not the stoicism and
dignity characterizing Andromache and also little
Astyanax.

portrait of *Potocki.* Astyanax, quietened, is set down between the knees of his
mother, whom he tries apparently to console; she seems to be based on a figure in
The Death of Germanicus. The bed, the chair, Hector's sword and helmet are
observed with accuracy. In the sketch now at the Pushkin Museum in Moscow,
which may be the one David submitted to the Academy on March 29, 1783, the
painter added a candelabrum, which he subsequently changed in the definitive
version. The candelabrum is based on a famous piece engraved by Piranesi which
we have mentioned above. David also embellished the bed with bas-reliefs in
keeping with the subject: on the left Hector's farewell to Andromache, and on the
right Hector's death, which, as we have said, is taken from the frieze in
Sacramento.

The final picture was deservedly acclaimed by the Academy, where it was
shown on August 22, and David was admitted unanimously. At the Salon the
critics were favorable. To the objection raised by some that Andromache's sorrow
was too well contained, Bachaumont replied that, on the contrary, "the enormous
sensibility of such tender women can turn into a complete daze which might be
mistaken for lack of feeling if one did not know its origin". Others complained that
her face had too much grace and not enough antique nobility. The main
disagreement, however, was over the coloring, as some thought that "the dark

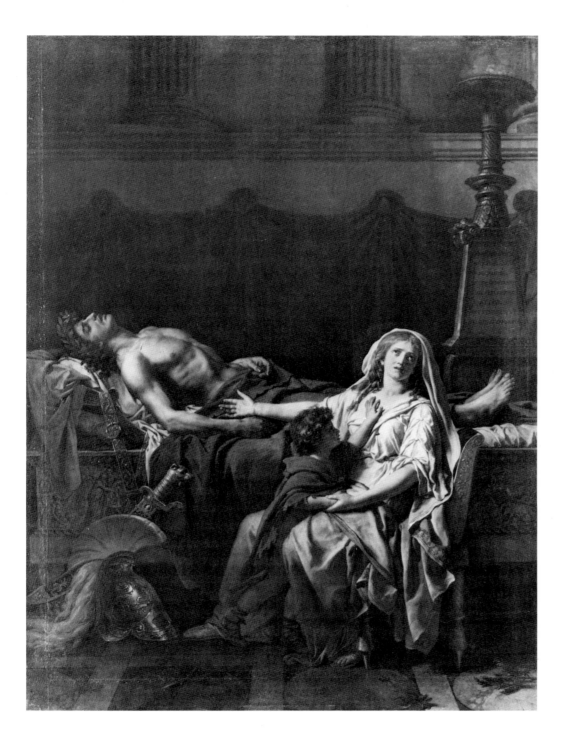

31 *Andromache Mourning Hector.* Signed and dated 1783. Oil on canvas. 275 × 203 cm. Ecole des Beaux-Arts, Paris; on loan to the Musée du Louvre.
Admission piece for the Academy, presented on August 22 and immediately exhibited at the Salon, where its rigorous geometrical composition and the eloquence of its moral lesson from the ancient world made a deep impression.

lugubrious effect heightened the pathos of the scene" *(L'Année littéraire)*, while others felt that "there is something amiss in the coloring and M. David has not made any progress in this field since two years ago" *(Observations générales sur le salon* [sic] *de 1783)*.

While he was preparing and working on his *Andromache*, David was also thinking about the picture he had to paint for the king. That picture, which would be *The Oath of the Horatii*, was part of the program of historical paintings likely "to

rekindle patriotic feelings and virtues", launched, as we have seen, in 1776 by the Comte d'Angiviller to provide eight to ten large pictures, three metres a side, for exhibition at the biennial Salons. In 1780 David seems to have received a commission, or at least the assurance that he would get one, for one of these paintings, and the drawing (Albertina, Vienna) of *Horatius Returning Victoriously to Rome after the Murder of his Sister Camilla*, signed and dated 1781, is thought to be a first sketch for that painting. The subject set in the following year was "Horatius, the conqueror of the three Curatii, condemned for the murder of his sister Camilla, is defended by his father just as the lictors are preparing to lead him off to carry out the sentence, and absolved by the populace who are touched by the scene and by his great services to his country". The fee and dimensions conformed to the usual practices of the *Direction des Bâtiments*: four thousand francs for a canvas of ten feet a side. David's interest in the story of Horatius, which he had already shown in the previous year, may have been revived by a performance of Corneille's play, which ended with that scene although, as E. Wind has pointed out, David's drawing in the Musée du Louvre, Paris, hardly resembles a performance of a classical tragedy.

According to Alexandre Péron's account, published in 1839, David abandoned that second subject on the advice of literary and artist friends (he quotes Sedaine, Lebrun-Pindare, Moitte and de Wailly) at Trudaine's salon, who found the subject lacking in action and too uncouth. The substance of this story is probably true although not perhaps the circumstances: Péron sets the episode in "the salon of M. de Trudaine, Farmer-General", for whom, in fact, David later painted the *Death of Socrates*; but, as we shall see, Trudaine the father (who never was farmer-general, any more than his sons) died in 1777, and his sons were still only adolescents in 1782. David then chose the subject of the Oath, which is not in Corneille's tragedy, but which he might have found in Rollin's *Histoire Romaine*, which was very well known at the time. As we shall see, the Oath would assume a special importance in David's work in general and in the Revolution in particular. The *Horatii*, like the *Brutus*, would be included by contemporaries among David's revolutionary works. Dubois-Crancé said in 1790 that these paintings anticipated the Revolution. There is some truth in this: patriotism was a fundamental element in David's political ideas and those of many other revolutionaries, which explains why they rallied so enthusiastically to Napoleon. On the other hand, from the iconographic and plastic point of view, *The Oath of the Horatii* belonged to a group of paintings which—as everything here is connected—already includes a series of

P

32 *Old Horatius Defending his Son.* Drawing in black crayon and ink with Indian ink wash. 22×29 cm. Cabinet des Dessins (RF 1917), Musée du Louvre, Paris.
This project was abandoned and replaced by *The Oath of the Horatii*. Its classical inspiration, reinforcing the influence of Poussin, can be seen in the subject and lay-out, as well as in the group of women in the foreground, so like David's drawings based on sculptures (see, for example, Pl. 19).

works on the story of Brutus. One *Oath of Brutus* was painted by Gavin Hamilton in 1763-4, and another by Beaufort for his admission to the Academy in 1771 (Nevers Museum); David was familiar with both works, as we know from his later sketches.

Before the end of 1782 the definitive composition, apart from the group of women, was finished, if we are to believe the—admittedly unreliable—date on the important drawing in the Musée des Beaux-Arts, Lille. But David put off the execution on canvas to finish his *Andromache* for admission to the Academy. He had already decided to paint *The Oath of the Horatii* in Rome. His departure was delayed by his wife's second pregnancy; she had had her first child, a son, in February 1783, and the second was born in April 1784. A further delay was caused by the award of the *Prix de Rome*: David hoped that his favorite pupil, Jean-Germain Drouais, would win it and that he would be able to take him to

Rome with him. The young artist's *Christ and the Canaanite Woman* (Musée du Louvre, Paris) did indeed win the first prize and at the beginning of September David was able to set off with him and two other pupils, Wicar and Debret.

After further study, David finalized—in a notebook now in the Louvre (RF 4506)—the group of women on the right, and sketched the large figures touched up with chalk (now in the Musée Bonnat, Bayonne); he then set to work on the great canvas (with the help of Drouais, he even made it one metre wider than the agreed format). According to A. Péron, whose account is based on Debret's direct testimony, David first studied the draperies on the mannequins and arranged the overall composition on the canvas, then he "did the figure of the eldest Horatius, whom he painted completely, just as definitive, just as polished as we see it today". This method of working is confirmed by the finished heads on the large almost blank canvas of the *Oath of the Tennis Court*, and by Delécluze's account of the preparation of *The Sabines* and *Leonidas*. Péron adds further details:

> The whole picture was finished in eleven months. Drouais painted the arm of the third Horatius, in the background, and Sabina's yellow coat. David had also instructed him to paint the figure of Camilla on his rough sketch, but when he came back he said: "What are you doing there? That's a plaster figure." He wiped it out and reworked it completely. He did every bit of the picture with that kind of conscientious, diligent facility, which is the best sort; it only comes to those who have had to overcome great obstacles in the practical execution. But—would you believe it?—the only part of the painting that really gave him any trouble was the forward left foot of the father. He rubbed it out and redid it at least twenty times.

The work was finished in August and was an immense success in Rome. Drouais wrote to his mother: "David finished his work a fortnight ago. No words can describe its beauty ... He is sought after and pointed out everywhere in Rome. The Italians, English, Germans, Russians, Swedes, God knows who else, all the nations envy France for being able to claim a man like that. His picture is on show and people constantly flock to see it. He receives verses in Latin, Italian and French every day."

In February David had asked the Marquis de Bièvre, a friend of d'Angiviller, to see to it that his picture was hung in a good place at the Paris Salon. It arrived a few days late, which actually added to its success. The critics were well aware of the special quality of the painting ("Superb picture, absolutely new composition", wrote one; "Sublime execution, superb and skilful drawing", echoed another),

33 *Study for "The Oath of the Horatii".* Signed and dated 1785. Drawing in black stone, washed and treated with chalk. 58×45 cm. Musée Bonnat, Bayonne.

Study for the group on the left of the picture, in which the principal figure is borrowed almost directly from Poussin's *Rape of the Sabine Women* Musée du Louvre, Paris. There are a number of similar studies of drapery for *The Horatii* and for *The Death of Socrates.*

75

34 *The Oath of the Horatii*. Detail of Pl. 35.
Technical precision without excessive realism
characterizes the handling of this group of women,
whose subtle arabesque contrasts with the rigidity
of the rest of the picture.

although some were so irritated by the ostentation with which David's friends and
pupils voiced their enthusiasm that they tried to set up Peyron as a rival to him.
Peyron, who was still only *agréé* of the Academy, submitted a fine group of
drawings and paintings, first and foremost *Death of Alcestis* (the heroism of conjugal
love) (Musée du Louvre, Paris), undoubtedly still his masterpiece. The subject,
taken from Euripides, is described as follows in the *livret* of the Salon: "Alcestis
having chosen to die in order to save the life of her husband (Admetus, king of
Thessaly, was sick and an oracle had revealed that this was the only way he could
be saved), takes leave of her husband, who is overcome with despair; and, after
making him promise to remain faithful to her memory, she entrusts her children to

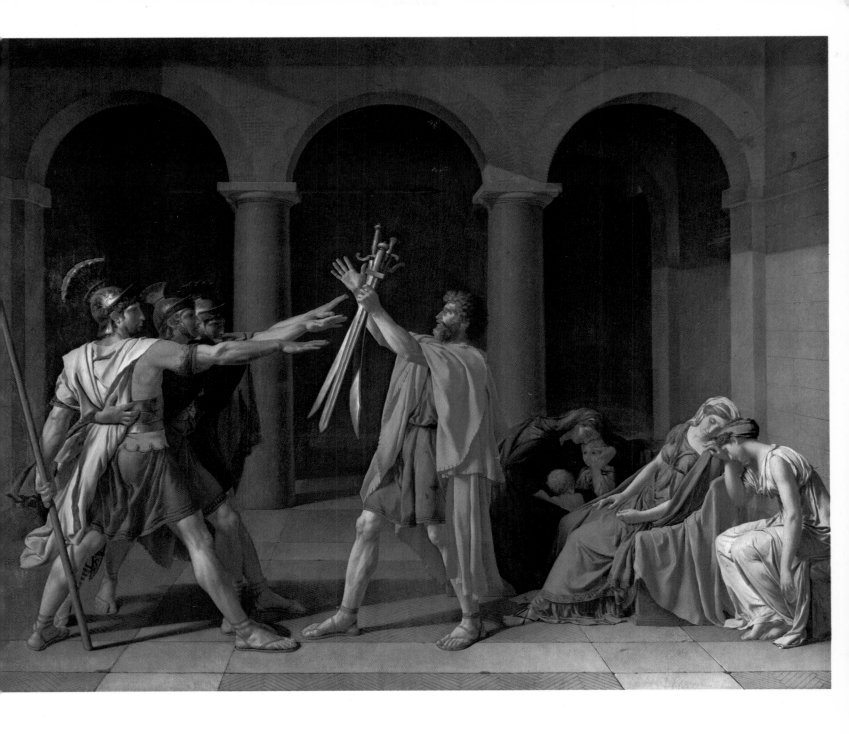

him, who are with her and, in floods of tears, share the pain of this cruel separation as much as their age permits. The women, plunged in grief, fill the palace with their mourning, and the statue of Hymen is veiled for ever as it must never again witness fresh embraces."

A touching subject if ever there was one, it was also one of the paintings commissioned for the king and had some points in common with David's work: the grand antique setting, the deathbed scene and the juxtaposition of grief and heroism, even down to that character seated at the foot of the bed, his back turned, borrowed undoubtedly from Poussin's *Testament of Eudamidas* and used by David a year later in his *Death of Socrates*. But in the light of the absolute simplicity and

35 *The Oath of the Horatii.* Signed and dated 1784. Oil on canvas. 330×425 cm. Musée du Louvre, Paris.
Probably David's most famous picture, painted for Louis XVI during a second sojourn in Rome. For the first time in a historical picture since his "crisis" in 1779, the painter makes up for the rigor of the composition by a warm color scheme based on reds, blues and whites.

36 *Portrait of M. Pécoul.* Signed and dated 1784. Oil on canvas. 92×72 cm. Musée du Louvre, Paris.

On May 16, 1782 David had married the daughter of Charles-Pierre Pécoul, a contractor in the royal building service. David always had a great liking for him, as is apparent from this portrait.

37 *Portrait of Mme Pécoul.* Signed and dated 1784. Oil on canvas. 92×72 cm. Musée du Louvre, Paris.

The cast of features, the flattering pose and the fine clothes, so painstakingly rendered, offer an interesting contrast to the portrait of the husband.

grandeur of *The Horatii*, Peyron suddenly seems complicated and petty. The large diagonal on which his work is built does not agree with the secondary orthogonals, the excessively contrasted chiaroscuro creates an "effect" that appears artificial in comparison with David's work. The execution, moreover, is too smooth, too precious, and does not harmonize with the subject, in contrast to the great example set by David.

In *The Oath of the Horatii* the perfect integration of the figures in the setting is achieved by a most simple device: each group or figure is matched by an arcade. The artist confines himself to a few tall people, seen from close at hand, on the same plane, and painted in a limited (but at last lightened) range of color; this apparent frugality distils the essence of the drama, the terrible conflict between feeling and duty, and we are caught up in it irresistibly now that the dust of centuries seems to have been cleared from it. Anything inhuman that might distract from our interest has been brilliantly compensated by the justly renowned group of Sabina, the mother, and Camilla, the sister, swooning with grief. The

38 *Study for "The Death of Socrates"*. Drawing in black crayon and chalk. 53×37 cm. Musée des Beaux-Arts, Tours.
Another example of those large-scale studies of draperies with which David immediately preceded the execution of a painting. The seated figure is Plato, who was not actually present when Socrates died and whom David depicts as an old man.

striking contrast between the world of men, strong and fierce, and that of the women bent in exquisite arabesques, overwhelmed by the grief caused by the folly of men, makes this one of the great themes David invented. He reverted to it in a masterly manner in *Brutus* and *The Sabines*. It was also the one theme least understood by the painter's innumerable pupils and imitators, who finally wearied the viewer with their relentless succession of bas-reliefs.

The archaeological idiom of the Horatii, which has been stripped of all bric-a-brac and strictly limited to Doric columns without bases, and the quotations from Poussin, from whom the character of the young Horatius has been borrowed more or less in its entirety, are fully integrated in the picture, absorbed by the powerful unity of the composition.

At the same Salon David had also exhibited the replica of his *Belisarius* and the portrait of his father-in-law, M. Pécoul, together with the portrait of his mother-in-law, also dating from 1784, now in the Louvre. Mme Pécoul's portrait is better known because of its vividness and freshness. The good lady's blotchy complexion is treated with the same frankness as her mauve satin dress and orange ribbons. But despite some superb features, such as the lace and the open drawer with its key, the work is ultimately more superficial than the much simpler, much more appealing portrait of the artist's father-in-law, to whom he seems to have been deeply attuned.

Towards the beginning of 1786, perhaps in March, David received a commission for a *Death of Socrates* from Charles-Michel Trudaine de la Sablière, a councillor at the Parliament of Paris and younger brother of Charles-Louis Trudaine de Montigny. Both were sons and grandsons of high-ranking state officials, financial administrators and members of the Academy of Sciences. Their father, who died prematurely in 1777, was a friend of Turgot's and an intimate of the Physiocrats. The two brothers, who were about twenty, had just rounded off their education with a Grand Tour that took them as far as Constantinople. They remained very close to the poet André Chénier, their fellow pupil at the College of Navarre, which gives some credibility to the story, told by P. A. Coupin in 1827, that it was Chénier who suggested to David that he should show Socrates not already holding the cup but at the moment when he is about to grasp it. The subject had been fashionable for a good twenty-five years at least, ever since Diderot recommended it to artists in his *Traité de la poésie dramatique (Treatise on Dramatic Poetry)* (1758). Imagining "a sort of drama that would point a direct moral", he sees the death of Socrates in five scenes. In his prison, where he would be shown

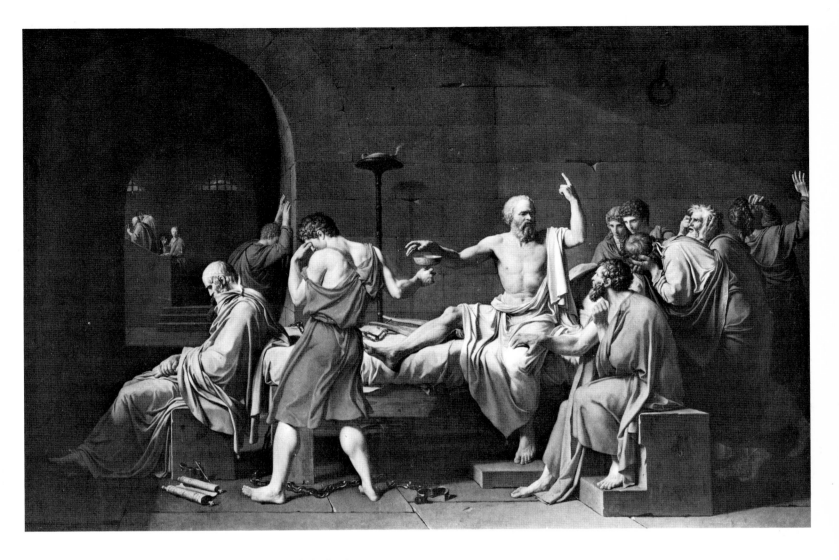

first in chains, peacefully asleep, "All Athens is in uproar, but the just man sleeps". Then he refuses to escape; in a third picture he is facing his judges; in the fourth, he is discussing the immortality of the soul. Finally, he drinks the hemlock. "Holding the cup in one hand and looking up to heaven, he says: 'Oh you gods who are calling me, grant me a happy journey!'" Then he remained silent and drank.

"Until then his friends had been able to contain their anguish, but as he raised the cup to his lips they could control themselves no longer. Some buried their faces in their cloaks; Crito had got up and was pacing about the prison, crying out. Others stood transfixed, looking at Socrates in desolate silence while the tears ran down their cheeks. Apollodorus had sat down on the bed, his back to Socrates, his hand over his mouth, stifling his sobs." Here Diderot goes back to the account given by Plato in the last pages of *Phaedo*, but the interesting point is that he sees the scene as a painting: "If the spectator in the theater is like someone in front of a canvas ... why should the philosopher who sits at the foot of Socrates' bed, afraid of seeing him die, be any less touching on the stage than the wife and daughter of Eudamidas in Poussin's painting?"

Like Diderot, David was a great admirer of Poussin, who was not yet understood by the painters who—like Challe, Alizard, and Sané—had treated the

39 *The Death of Socrates.* Signed and dated 1787. Oil on canvas. 130×196 cm. Metropolitan Museum of Art, New York.
In the matching of subject with technique, this is one of the finest fruits of the efforts of a whole generation of critics and artists to achieve nobility of style in the service of the *exemplum virtutis.*

same subject around 1760. Sané's painting, which is lost, is nevertheless interesting because of its somewhat heavy primitivism, which has been transmitted by the engraving published by Danzel in the very year 1786. The painter adopted the deathbed formula—used so unforgettably by David in his *Andromache*—but it lost its impact in his almost exclusive concern for the draperies. This may have been the picture Diderot was alluding to in the *Essay on Painting* (1765): "The most austere, the poorest philosopher in all Greece is made to die on a bed of state. The painter has not realized how touching and ennobling it would have been to show the virtue and innocence that is willing to die in the corner of a prison cell, on a pallet of straw."

Touching and ennobling—these words sum up the effect of David's composition. He consulted Father Adry, a Hellenist and Oratorian, on the circumstances of Socrates' death. The reply, dated April 6, has survived. Father Adry suggested that Plato should be immobile (in fact, Plato was ill and not present), that Crito should show more emotion, and Apollodorus especially should be very visibly moved. We know very little about the planning stages of the painting, but David seems to have used his Roman notebooks a great deal, for example a drawing after an anonymous Caravaggesque painting on the same subject as the studies from the antique, especially for the heads. For instance, Socrates' gesture can be found in a drawing in the Berlin album; it also closely resembles that used by Peyron in his own *Death of Socrates*, whose "finished sketch" was shown at the same Salon.

This was the last, decisive episode in a rivalry that had gone on for twelve years. Peyron, who had become Inspector of the Manufacture of Gobelins and who had, like David, hoped to become Lagrenée's successor as Director of the French Academy in Rome (in fact, it was Ménageot who was appointed on July 1), first sent his Academy *morceau de réception, Curius Dentatus Refusing the Presents of the Samnites* (Musée Calvet, Avignon) to the Salon, then, at the last moment (as David often did), his *Death of Socrates*. The incident he selected for his painting and its message were the same as David's: "Socrates ready to drink the hemlock, and after making a sublime speech on the immortality of the soul, scolds his friends for weeping: 'what are you doing?', he asks them. 'What, such splendid men give way to grief! Where is virtue? Didn't I send the women away precisely because I was afraid they would show such weakness? I have always heard that we must die quietly, blessing the Supreme Being; be still and show greater strength and firmness.'"

Peyron's painting, now in a private collection, belonged to d'Angiviller; the first idea for it no doubt goes back to the letter of 1780 we have mentioned. The painter was told to transcribe the picture on a larger scale for the king, which he did with his usual slowness (the large canvas is at the Palais-Bourbon); he also did an engraving of it himself in 1790, and faithfully dedicated the block to d'Angiviller. At the scent of a confrontation the critics were on the alert. As Count Potocki justly said of Peyron's work, "it has shown up the quality of David's picture by proving to the public how far beneath him one could be, even if talented." Despite the similarity of the compositions David's picture easily carries the day on account of the restrained archaeological features, the antique dignity of the figures, and its unity, due as much to the harmony of the red coloring as to the coherent grouping of the figures. Potocki's enthusiasm is understandable:

Socrates, in the midst of his friends, is ready to swallow the deadly cup that will separate him from them for ever. Their faces plainly show the sorrow, anguish and desolation they feel. Even the executioner is moved to tears and averts his eyes as he hands him the cup. Socrates takes it with a look of indifference; he alone is calm and at peace, preoccupied with a higher thought, his eyes and hands raised to heaven; he seems to console his friends with a sublime speech on the immortality of the soul and to scold them gently for their weakness. His soul already seems to have left his mortal coil; and yet we can see it shine through all his features, his figure, his bearing ...

Look at this group of despairing friends and disciples at his bedside; the greatest beauty that can be gleaned from nature and the antique is mirrored in their faces: their expressions are real, varied and moving. Through what mighty opposition, through what magic does Socrates, the misshapen Socrates, crush so much beauty, so much grace and solidarity? This is the triumph of virtue which is raised higher than all other things by a heroic courage and an inspired soul.

In examining the execution of the painting, Potocki sensed its marvellous balance—so peculiar to David—between freedom and accuracy: "His coloring is virile and strong, his touch firm and bold, his manner generous, his brush easy although its execution leaves nothing to be desired ... The choice of draperies is perfect: they in no way diminish the beauty of the outlines and show up the nude parts with that artful simplicity that conveys truth and freedom ..." Nobody could have been more enthusiastic than Reynolds, the painter, who described *The Death*

of Socrates as "the greatest work of art since the Sistine Chapel and Raphael's Stanze in the Vatican".

As a companion to *The Death of Socrates*, the Metropolitan Museum of Art has just acquired the large portrait of Lavoisier and his wife, painted in the following year. The scale, the layout, the innovative interpretation of the traditional Muse who inspires the artist and the scientist, turn the portrait into a historical event, just as *Potocki* had done. In 1788, too, David painted for the Comte d'Artois an antique and poetical version of the same subject, *Paris and Helen*. It was natural that he should have received 7,000 francs for the Lavoisiers, which was rather more than for the large historical paintings he did for the king. Lavoisier, like the other farmers-general, was very rich, especially as his wife (whom he had married in 1771, when she was barely an adolescent) was also the daughter of a farmer-general. But it was not Lavoisier the financier whom David portrayed for posterity but Lavoisier the chemist, who had been elected to the Academy of Sciences in 1768 at the age of twenty-five. A specialist on oxygen, he had studied respiration and combustion, and in 1784 described the composition of water, before he published his *Treatise on Elementary Chemistry* (1789) which diffused the results of his research throughout Europe. His wife, who was thirty when the portrait was painted, is said to have been one of David's pupils. Her skill as a draughtsman, suggested by the portfolio on the armchair in the background, enabled her to prepare the illustrations for the *Treatise*. One of these drawings shows her seated at a table, noting down the results of one of her husband's experiments. As Ducis, the poet, said drily: "Pour Lavoisier, soumis à vos lois/Vous remplissez les deux emplois/Et de muse et de secrétaire" (For Lavoisier, subject to your law, you fill two posts, that of muse and of secretary).

So far very few painters, except Wright of Derby and A. Van Loo, had depicted a scientific experiment; very few, too, had dared transpose into everyday life the old idea of the Muse who brings the artist and scientist a portion of divine inspiration. In this painting the supernatural role is played simply by love (as in *Paris and Helen*), by the noble but everyday conjugal love between two very real people. Rarely have the tension of allegory and the grand manner been blended so harmoniously with such scrupulous observation of reality. The heroic scale of the layout, of the setting with its fluted pilasters, beautifully tempered by the slant of the portfolio, of Lavoisier's leg and the fold of the red cover on the table, corresponds to the care with which the painter shows the glints of light on the ball on the floor and the refracted image of the box seen through water in a bottle.

40 *Portrait of M. and Mme Lavoisier.* Signed and dated 1788. Oil on canvas. 286×224 cm. Metropolitan Museum of Art, New York.
In this portrait, which is on as ambitious a scale as David's historical paintings, the eminent chemist and farmer-general is depicted in a sort of allegory of inspiration and conjugal love.

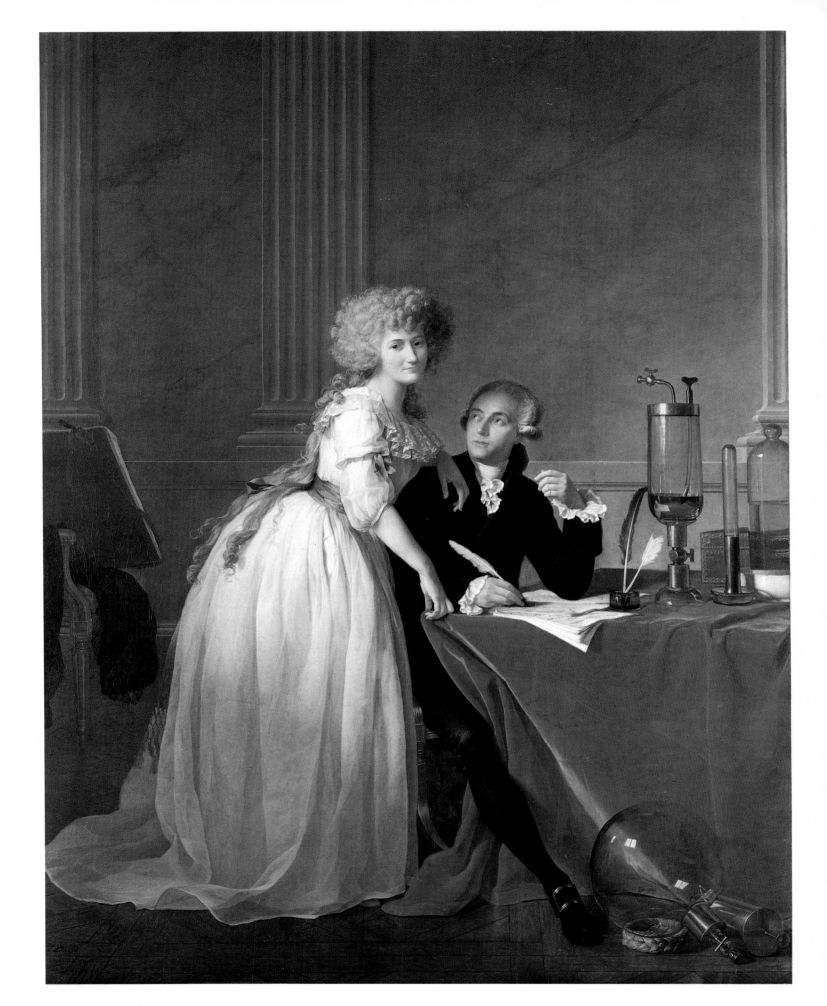

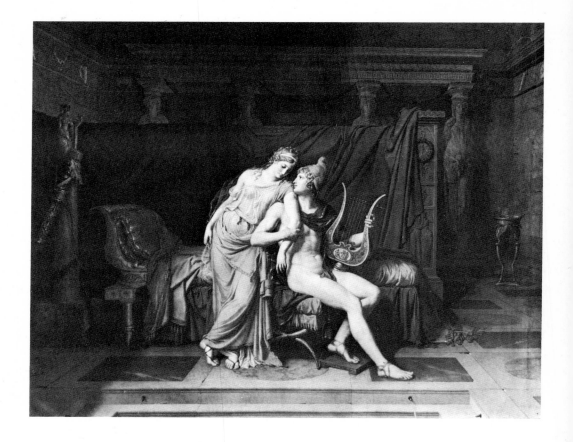

In 1788, too, David had the honor of painting a picture for the king's brother, the Comte d'Artois, the future Charles X. This was *Paris and Helen* (Musée du Louvre, Paris) often overlooked because it seems so far removed from *The Death of Socrates* and the *Brutus*, but vitally important for an understanding of a whole area of David's work, especially his later paintings. Here the painter is not looking for a classical "example of virtue" but for a couple in love. Much later, in 1820, when David was advising Gros to paint a historical picture, he made out a double list of subjects, on one side Alexander, aged eighteen, saving his father, Philip, Camillus punishing Brennus, the courage of Clelia going in search of Porsenna, Mucius Scaevola, Regulus returning to Carthage knowing "the torments that awaited him there", but also Theagenes and Chariclea, who "are not to be despised" any more than Daphnis and Chloë, Phaon and Sappho, Ismenes and Ismene, "and many of the nice romances of the fourth century". Antiquity was a complete world whose interest was not confined to the fierce virtues found in it. As we have the tender poetry of women, the necessary counterweight to the hardness of men, in *The Horatii* and *Brutus*, the whole of David's work is full of amorous elegies, more highly prized for being set in the prestigious classical world. In some ways these pictures have an even greater archaeological content than the plain "Roman" paintings: here David—following directly in the wake of Winckelmann—was looking for a pure, ideal beauty, which may be found in the careful pursuit of a flowing sinuous line. Paris, as Delécluze has pointed out, was David's first major nude (apart from the studies, of course), whose beauty echoes the image of the water in the foreground—pure, limpid and calm. In spite of the difference in

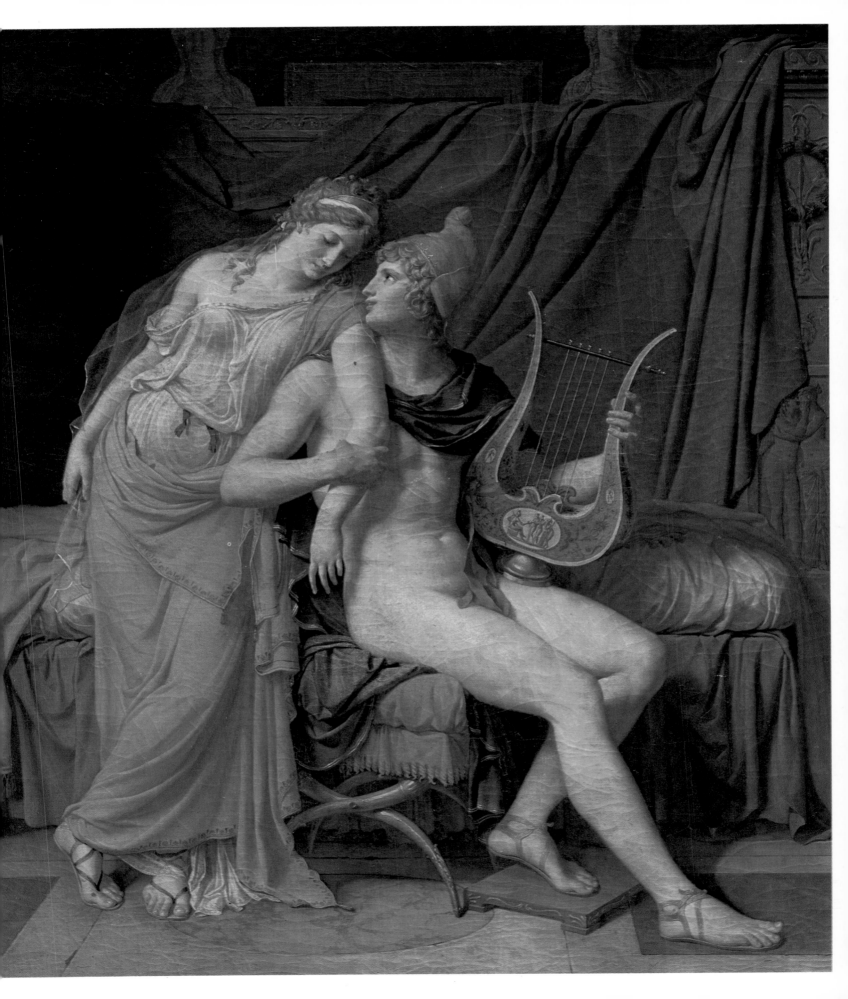

subject, David would return to this quest in such major works as *The Sabines* and *Leonidas*. It is not surprising therefore that the figures and the background are steeped in classical mementos.

In 1788 the mania for the antique was invading the everyday life of Paris society, the circles in which David moved. It was the year when the scholarly Abbé Barthélemy published *Le Voyage du jeune Anacharsis en Grèce (The Journey to Greece of the Young Anacharsis)* which, despite the weight of its four quarto volumes, was a best seller, and David used it when he was planning his *Leonidas*: fiction might be used to relieve a—supposedly accurate—picture of classical Greece. Mme Vigée-Lebrun's famous Greek supper was arranged on the spur of the moment after her brother had read her a passage in which the Abbé describes the seasonings used by the Greeks, and particularly Spartan broth. After telling her cook to prepare two sauces, one for the chicken and one for the eel, Mme Vigée set the stage: a huge screen covered with a drapery, "attached at intervals as in Poussin's paintings" and a host of "Etruscan vases" borrowed from her neighbor, the Comte de Paroy. The lady guests—Mme Chalgrin, Mlle de Bonneuil, and Mme Vigée—were dressed in Greek costumes; Lebrun, the poet, in keeping with his nickname Pindarus, wore a laurel wreath and a large purple cloak; the Marquis de Cubières carried a lyre; Ginguené, Chaudet and M. de Rivière were also in fancy dress. All these smart people sang Gluck's "the God of Paphos and of Guido" to welcome the Comte de Vaudreuil, who was enchanted by the soirée, at which Lebrun recited a succession of the Odes of Anacreon which he had translated. The Comte de Vaudreuil, a famous collector of paintings, was an intimate of the Comte d'Artois, who stayed with him at his castle of Gennevilliers. Here light operas were performed with amateur actors, including Mme Vigée-Lebrun, as well as professionals. This fondness for the theater was also found in the circle of the Duke of Orléans, described in the memoirs of the Comtesse de Genlis. Thus at the castle of Saint-Leu plays by Mme de Genlis were performed as well as dumb-shows taken from such works as La Harpe's *Voyages*. David himself "arranged these ephemeral tableaux" performed by the prince's children, whose "tutor" Mme de Genlis had become, and adjudged the prizes in the drawing contests arranged for them. *Paris and Helen* would be very much to the taste of this elegant cultivated milieu; the Princess Lubomirska, who belonged to it, made David promise to paint her a replica of it in the following year (it is now in the Musée des Arts Décoratifs, Paris). *Paris and Helen* consists of two equally important parts: the couple itself and the setting in which they are placed. A drawing in a Roman album recently

discovered in Paris confirms that the source of the composition is the *Recueil des Antiquités étrusques, grecques et romaines tirées du cabinet de M. Hamilton* (Anthology of Etruscan, Greek, and Roman Antiquities in Mr. Hamilton's Collection), which we mentioned in connection with David's first stay in Rome. Paris is seated on a chair, facing in the direction opposite to that in the definitive version, and Helen is standing beside him, leaning on a pedestal, her hand on his shoulder. But there is another drawing, in Stockholm, in which Paris is standing, leaning on the foot of an enormous bed, while Helen is sitting down, turned towards him. Another possible source for the couple has recently been pointed out: a Roman bronze medal struck in 149 B.C. The definitive position of Paris is exactly the same as that on a second vase in the Hamilton Collection showing the contest between Apollo and Marsyas. It seems that David used the antique sometimes as a starting point for a composition but more often to define more precisely a figure which he had already considered at length. He also used it—though it is not always easy to identify his sources—for the details of the setting. Thus the Eros and Psyche on the mounting of the pole are derived from a group at the Capitol and the statue of Aphrodite on which Paris has so casually hung his bow and arrows (an allusion to Love) is copied from the Barberini or "Victorious" Aphrodite. Many other details confirm David's fondness for antique reliefs, vases and statues—a fondness attested by his early notebooks and kept alive by constant reference to the available collections. More surprising, though, was his choice as his main decorative feature of a venture into the classical by Jean Goujon, namely the "balcony of caryatids" decorating the Salle des Cent-Suisses in the Louvre.

This rather strange assortment of different aspects of classical culture was given unity by the skill of the coloring. Never before had David managed to harmonize the cold tones (the mauve of the bed, the blue of Paris' drapery, the blue-grey of the hangings in the background) with the warmth of the pinks, the red and the orange in a smooth, almost glazed finish reminiscent of a Lagrenée, with genius added.

From November 1785, after the success of *The Horatii*, there was talk of a second painting for the king. According to a letter written by Drouais in August 1786, David had originally thought of the story of Damocles, who had flattered Dionysius so blatantly that the tyrant resolved to teach him what a prince's life was really like by making him feast with a naked sword suspended above him by a horsehair. (David went back to that idea later when he painted Lepelletier de Saint-Fargeau.) In the following year he mulled over the subject of "Regulus

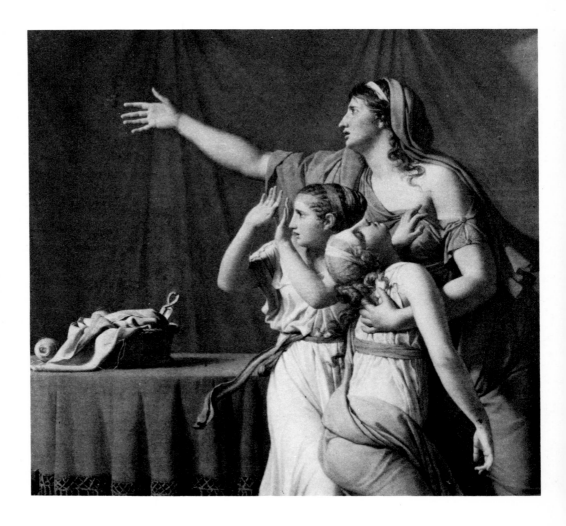

43 *Lictors Bringing Brutus the Bodies of his Sons.*
Detail of Pl. 44.
One cannot but admire the quality of the moulding
and the sensitive rendering of expression in this
group of women overcome by horror or despair.

tearing himself away from his family to return to Carthage, where torture awaited him"; he kept two preliminary drawings until his death, one of which has recently turned up, of sculpture-like figures against a bare background, not unlike those of the large frieze drawn in 1780. D'Angiviller asked him in preference to use the subject of Coriolanus, which David had also suggested. He is believed to have worked on it at the beginning of 1788, though no trace of it has been found.

Finally, in circumstances of which we know nothing (did he even inform d'Angiviller?), David chose the subject of Brutus. Two episodes in the version by Plutarch and Livy aroused his interest. Here we should perhaps recall that, at the end of the sixth century B.C., the son of Tarquin the Proud, the last king of Rome, raped the virtuous Lucretia, the wife of his cousin Collatinus. To vindicate her honor, she committed suicide in the presence of her father, and of Brutus, nephew of Tarquin; the latter was living at Tarquin's court, although the king had killed several of his relatives, and to ensure his safety was pretending to be an idiot. At this point this sombre drama took a political turn: Brutus tore the dagger from Lucretia's body and, with others, swore on her corpse that he would rid Rome of the Tarquins and the monarchy. This is the episode shown by G. Hamilton and by Beaufort; it contributed, as we have seen, to *The Oath of the Horatii.*

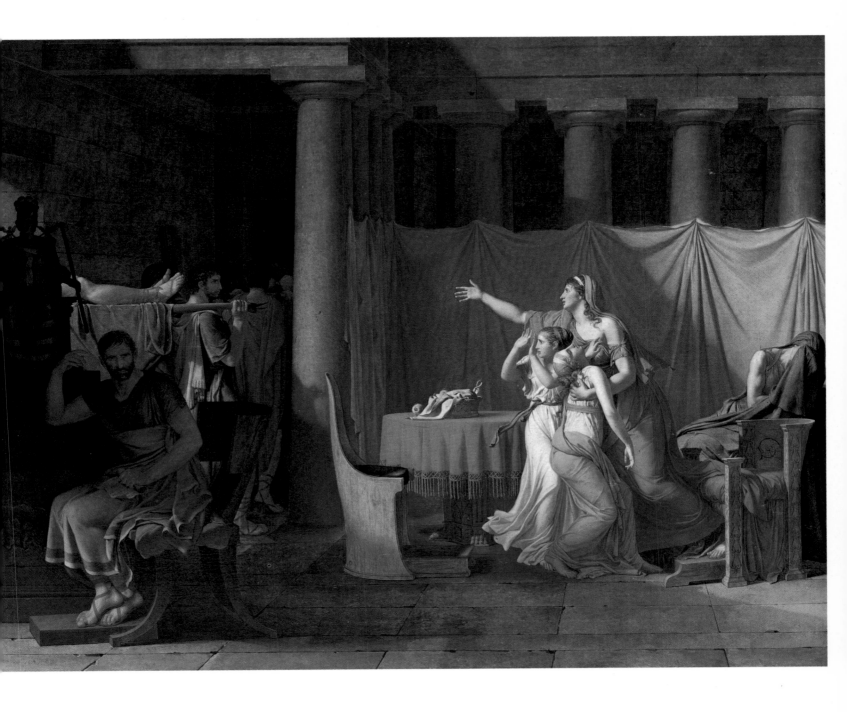

David selected a dramatic incident that happened somewhat later in the story: the Roman Republic was founded, Brutus was made consul, but soon heard that his sons, Titus and Tiberius, were involved in a plot to restore the monarchy, whereupon he had them condemned to death and executed. In a drawing he kept until his death, David made an initial study of the execution of the two sons under their father's eyes, but rejected this idea in favor of the following, which he described on June 15, 1789 in a letter to his pupil Wicar, then settled in Florence: "I have done a picture which is purely my own invention. It is Brutus, the man and father who has deprived himself of his children and withdrawn to his home, where his two sons are being brought for burial. As he sits grieving at the foot of the

44 *Lictors Bringing Brutus the Bodies of his Sons.* Signed and dated 1789. Oil on canvas. 325×425 cm. Musée du Louvre, Paris.
This picture was painted for the king and finished at the moment of the storming of the Bastille. Because of its intensely republican theme, it was to take on, in the years that followed, a political significance that it does not seem to have had originally. In any case, David's ideas—like those of so many of his contemporaries—seem to have changed appreciably between 1789 and 1793.

45 *Lictors Bringing Brutus the Bodies of his Sons.*
Drawing in black crayon. 14.5×19 cm. Musée
Bonnat, Bayonne.
This drawing and the two that follow enable us to
trace the development of the composition in its two
main features, positioned at the outset: Brutus in
the foreground, and the group of women to the
right.

46 *Lictors Bringing Brutus the Bodies of his Sons.*
Drawing in black crayon. 21.5×33.5 cm. Musée
Bonnet, Bayonne.

statue of Rome he is distracted by the cries of his wife and the fear and fainting of
his eldest daughter."

As we see, David did not make allusion to any possible political meaning—any
more than the critics did at the Salon of 1789, where the picture was shown over a
month after the fall of the Bastille; it was only in the years that followed that its
political significance was brought to light. Needless to say, in 1788, when David
was beginning work on the painting, he was not a republican (we know that there
were hardly any in France before 1791); besides, the episode he chose put less
emphasis on the republican convictions of Brutus than on his patriotism. What the
painter exalts is the strength of mind, the stoicism, in the pure tradition of "events
illustrating virtues" such as painters had been producing in increasing numbers
during the last fifteen years in the king's service.

David must nevertheless have been aware of the political implications of the
choice of such a subject in 1788. The whole story of Brutus has a subversive
undercurrent, linked as it was with the tragedy by Voltaire, whose anti-absolutist
nature is obvious. Did David see the sole contemporary performance of Voltaire's
play on January 25, 1786? Was it more or less semi-officially banned, which would
explain why it was performed only on that one occasion until its revival in 1790?
In any case David did know it. The topicality of Brutus is shown at that same time
by Wicar's two drawings now in the Musée des Beaux-Arts, Lille, one, dated 1788,
showing Brutus condemning his two sons (a subject for which David began to
make a large drawing—sold after his death—and then abandoned), the other of
Brutus swearing to drive out the Tarquins. Above all the great Italian playwright
Vittorio Alfieri, who was in Paris at the time, published his *Bruto Uno* and *Bruto
Secondo* at the beginning of 1789. (He left Paris after August 10, 1789 and became
as intensely reactionary as he had been liberal earlier on.) The first of Alfieri's plays
is dedicated to Washington. The recent American War of Independence, in which
the liberal French nobility had played a far from negligible part, would give an
additional significance to the story of Brutus. It is not surprising that on
August 10, in a letter to Vien, Cuvillier, Director d'Angiviller's "clerk",
complained that David's picture was not yet finished on the eve of the opening of
the Salon (in fact, it was shown a few days late). But the picture that worried him
most and that he thought should not be shown was the portrait of Lavoisier: the
famous chemist was in charge of the Gunpowder department and, as a result of
some misunderstanding over loading explosives at the Arsenal, had almost been
lynched in a popular riot on August 6.

47 *Lictors Bringing Brutus the Bodies of his Sons.* Drawing in black crayon. 15.5×21 cm. Musée Toulouse-Lautrec, Albi.

Like *The Oath of the Horatii* or *The Departure of Regulus*—and like *Coriolanus*, who was persuaded by his wife and mother to raise the siege of Rome—the story of Brutus provided a contrast between the ruthless decision of a man and the sorrow and tenderness of women. This contrast is forcibly brought out in the preliminary drawings, many of which have survived; but whereas in these drawings the figure of Brutus, influenced by an antique bust at the Capitol of which David possessed a copy, is very much to the fore, in the final version the painter puts him in the shade, lower than the legs of his sons stretched out on the bier, and draws attention to the group of women, to whom he has now added the marvellous figure on the right, the maid hiding her face in the folds of her dress. The composition is less rigid, less incisive, but no less effective than that of *The Horatii*, inscribed in strict geometrical squares, subtly disturbed by the slight slant of the furniture: the whole

built round the workbasket which stands abandoned on the table, testifying to the indestructible reality of everyday life.

The political point of *Brutus* may have been ambiguous in 1789, but events soon made it abundantly clear.

IV. THE REVOLUTION

David and the revolutionary crisis. The malcontents in the Academy. The Tennis Court Oath and its commemoration. David's preparatory notebooks: antiquity and the present, realism and idealism. David's election to the Convention. Unfinished portraits. David as pageant-master of the Revolution: Voltaire's inhumation in the Panthéon; fête in honor of the mutinous Swiss guards (April 15, 1792); fête of August 10, 1793; fête of the Supreme Being (June 8, 1794). Design for "The Triumph of the French People". David and the administration of the arts. Commemoration of the "martyrs of the Revolution": Lapelletier de Saint-Fargeau, Marat, Barra.

There is no doubt that David was delighted by developments at the outbreak of the Revolution. We know very little about his previous political opinions but his hostility to academic privileges either predisposed him to a "leftist attitude" or was actually the result of one. It was not until the revolutionary festivities of 1791, and especially after autumn 1792, when he was elected to the Convention, that he became closely involved with French political life, and until 9th Thermidor he played a far from negligible role in it. We know that on September 7, 1789 Mme David (who did not move as far to the left as her husband) was one of a delegation of twenty-one women artists or artists' wives led by Mme Moitte who went to Versailles to hand over to the president of the Assembly a casket containing their jewels, which they presented to the nation.

In this they re-enacted an incident from Roman history told by Rollin, after Plutarch, in his *Histoire Romaine (Roman History)*, published from 1738 on and reprinted several times; d'Angiviller's program of reviving virtue had given it fresh topicality. At the Salon of 1785 Brenet exhibited the *Piety and Generosity of Roman Ladies*, which was explained in the *livret* as follows: "At the capture of Veii the Romans had made a vow to send a golden chalice to the Apollo of Delphos; when the military tribunes were unable to obtain any gold because it was so scarce, the Roman ladies sacrificed their jewellery to provide the material needed for the votary gift..." Nothing could better illustrate that close link with antiquity, which the artists had done so much to forge, and which would become almost an obsession during the Revolution. Across centuries of decadence, man—regenerated and renewed—reached back to Classical man, or rather, through an incredible reversal of History, himself became a Classical man.

David came to politics by way of artistic and professional problems, and it was in this realm that his actions assumed true importance. In September 1789 the

Academy was split by a conflict: originally it concerned the status of the non-privileged or rather the less privileged members, the simple members and *agréés*, but the quarrel spread and grew into a challenge to the whole idea of privilege and ultimately to the very existence of the Academy itself. The whole question of art teaching was raised, from the evaluation of talent to State patronage.

The "aristocratic reaction" that had crystallized within the Academy on the eve of the Revolution aroused heated arguments. The young artists who were already *agréés* or liable to become candidates were deeply disturbed by the return to a strict enforcement of rules, which we have already mentioned in connection with the French Academy in Rome, and the increasingly severe terms for recruiting new members—measures that implemented the policy mapped out by d'Angiviller, whose zeal for the Academy paradoxically was to hasten its downfall. From about 1785 the increasing restrictiveness was unmistakable: admission to the Academy was difficult, achieved, if at all, by dint of a narrow majority or after a second round of voting (Le Barbier, Bilcoq, Forty), and several candidates were rejected altogether—generally painters of landscapes (Pau de Saint Martin, Moreau the Elder in 1788) or of portraits (Ducreux had his third rejection in 1787). In fact, the number of rejections was even greater since it had been customary to sound out the members by means of visits before becoming officially a candidate. More serious still, "a relatively new and very harsh rule stipulated that an *agréé* whose *morceau de réception* was rejected would be struck off and his *agrément* withdrawn". This was actually an enforcement of existing regulations, which could have very serious consequences since it entailed expulsion from the Salon. This is what happened in January 1789 to Monsiau, whose *morceau de réception* was rejected but who subsequently had a successful career. This rule was so cruel that it had to be suspended. The diary of J. G. Wille, the engraver, for August 29, which we have just quoted, went on: "It was agreed to take a vote to decide whether this rule should be suspended or not: it is suspended until further notice." But the threat of it remained and helped to set the whole class of *agréés* against the "officers" of the Academy. The malcontents gained strength by uniting in a party of "dissidents", which included a fair number of academicians who joined the *agréés*, and which won support among artists who were not academicians; their cause was further strengthened by having a leader whose artistic talent was universally acknowledged—David. In autumn the conflict came to a head over a symbolic case, that of a deceased artist, J.-G. Drouais, David's favorite pupil, from whom great things had been expected, but who died at the beginning of 1788

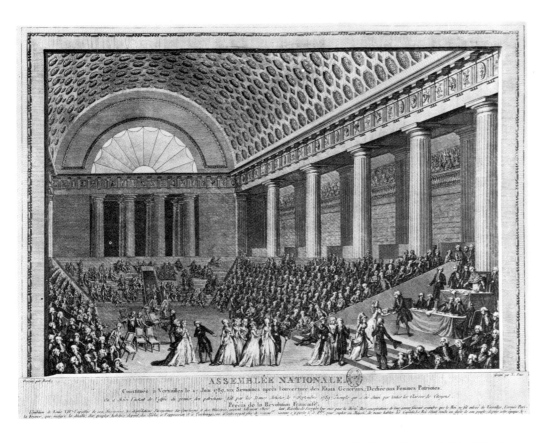

ASSEMBLÉE NATIONALE

when he was still a *pensionnaire* in Rome. If we are to believe David, his *Marius at Minturnae*, exhibited privately at his mother's home in 1787, had created a stir throughout Paris.

The pupils of the Academy—and there is no doubt that the most active and brilliant among them were David's disciples—asked, among other things, that Drouais should be admitted to the Academy posthumously so that his work could be shown at the next Salon. David strongly supported this request at a time—the beginning of October—when it had no more than a purely symbolic significance since there would be no Salon until the summer of 1791.

In December the all-out attack was launched by some twenty academicians led by David, who demanded that the venerable statutes of the Academy should be revised. Vien, who had been director since May, managed to avoid an open breach,

49 *The Oath of the Tennis Court*. Engraving "executed on the spot by Flouest". Cabinet des Estampes, Bibliothèque nationale, Paris.
While David did go to see the hall (still in existence) where the oath took place, the engraver seems to have represented the scene more exactly by placing Bailly in the center of the crowd rather than opposite it, as in David's grouping, which owed more to the theater than to reality.

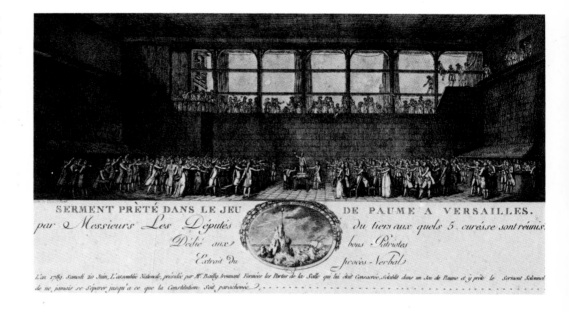

SERMENT PRÈTÉ DANS LE JEU DE PAUME A VERSAILLES.

but there was no truce in the continual skirmishes between the officer corps and David's party, who were joined by the *agréés* in February 1790. They sought the support of the Commune of Paris, then of the National Assembly, and finally of the Jacobin Club; before long they were able to argue that the privileges of the Academy contravened the Constitution of 1791, which abolished guild masterships and guilds of professions, arts and crafts. In summer 1790 a memorandum published by the "dissident" or "protesting" academicians suggested that the Academy should be replaced by a "free and universal" Commune or Society of Fine Arts. And on September 27 the "Commune of Arts based on Drawing" held its first meeting.

The Academy managed to survive until August 1793, when all corporations and privileged bodies were abolished, but by 1791 it had lost its trump card, the Salon. The first breach in its monopoly was made by Le Brun, the art dealer, who had held an exhibition each summer since 1789 on his premises in rue de Cléry. A group of artists who had taken part in this exhibition in July 1791 presented a petition to the Assembly asking to be allowed to exhibit freely at the official Salon, which was to open in August; they were supported by David, who threatened to withhold paintings he had previously shown (an allusion to the *Brutus*, whose

popularity grew continously, and also to *The Horatii* and *The Death of Socrates*) if these artists did not receive satisfaction. On August 21, according to the report by Barère, the Assembly voted a law of which article I stated that "all French or foreign artists, whether or not they are members of the Academy of Painting and Sculpture, shall also be free to exhibit their works in the part of the Louvre destined for that purpose"; Article II read: "the Exhibition this year will not begin until September 8." Under Article III its organization was entrusted to the Directory of the Department of Paris.

The latter at once constituted a commission, presided over by Talleyrand and composed of Quatremère de Quincy, the painters David and Vincent, the sculptor Pajou, the engraver Bervic, and the architect Legrand. All the artists were invited to submit their works, stating their order of preference in case the influx of submissions made a selection necessary. Over 250 artists, of whom only sixty were members of the Academy, participated in this first free Salon, which had 794 exhibits instead of the 321 anticipated by the Academy.

But this freedom itself and the number of works shown to the public created the problem of selecting the best. It would be unreasonable to suppose that, at the very moment when the traditional patronage of the king, the great aristocratic families, and the Church had collapsed, all these artists and aspirants could actually live by their art. Thus it was essential to help the best among them and to see that the truly great were not swamped by the mass of the mediocre. This help took the form of money prizes and commissions through which the prize winners would also become widely known. Quatremère de Quincy, one of the moving spirits in elaborating the new art policy, in his *Considérations sur les arts du dessin ... (Thoughts on the Arts of Drawing ...)*, which he published in that same year, had foreseen the difficulties created by the novel situation. The Commune of Arts protested against the fact that some of the commissions (for the Panthéon, the Church of Saint-Sauveur, and the Tribunal de Cassation) had been given directly to the artists, and asked for "a kind of competition that would give all citizens an equal right to public works".

On September 17, five days after the actual opening of the Salon, the Assembly had voted a credit of 100,000 francs in the form of "works to encourage artists" to be shared out among the best exhibitors by a commission consisting of members of the Academy as well as of twenty exhibitors who did not belong to it. Endless quarrels broke out, as the Academy did not want to give up its old monopoly, and the non-academicians complained that the Academy had been given the lion's

share. At the beginning of December the new Assembly had to adopt a new system: the jury was to be composed of forty artists, half of whom had to be chosen from among Academy members, the other half from outside it. The officers of the Academy continued to reject the system, and the academicians elected to the jury all belonged to David's party. In February 1792 the jury was at last constituted, but the judgment it finally delivered revealed a fresh, almost inevitable difficulty, which Quatremère de Quincy had actually foreseen: the prizes for the category of historical paintings (about 40% of the total, with the same sum assigned to sculptors, and the rest divided among genre painters, engravers, medallists and architects) all went to members of the jury. Embarrassed, David refused his prize, which was divided among three other painters.

In September he was elected a deputy to the Convention, but he had already been playing a quasi-political role since 1790 as propaganda artist of the Revolution. The first occasion was the commemoration of the Oath of the Tennis Court. Let us briefly resume the facts: the States-General had met on May 5, 1789 at Versailles, in the large hall of the Hôtel des Menus Plaisirs, which no longer stands. June 17th marks the real beginning of the Revolution: the third estate, in view of the fact that it represented 96% of the nation, declared that it was constituting itself into a National Assembly and authorized the provisional collection of existing taxes, but subjected all future taxation to a special vote by the Assembly.

On the 19th, by a majority of a few votes, the clergy decided to join the third estate, not without protests from the higher clergy. On the following day Bailly, the famous astronomer and historian of astronomy, a member of the Academy of Sciences and of the French Academy, who was chairman of the Assembly, had got up early, and when he arrived at the Hôtel des Menus Plaisirs he found the doors locked and guarded. The following proclamation was affixed to the entrance: "The King having resolved to hold a *session royale* at the States-General on June 22, the preparation of the three halls for the assembled orders makes it necessary to suspend all assemblies until the meeting of the said session. His Majesty will announce in a new proclamation the time at which he will go to the Assembly of the Estates on Monday." As the other deputies began to arrive, there was a great uproar. Should they go to Marly, where the king was staying? Should they meet on the parade ground in front of the palace? It was Guillotin, who became famous for other reasons, who suggested the Tennis Court, a hall built in the days of Louis XIV a short way from the palace and used for court entertainments

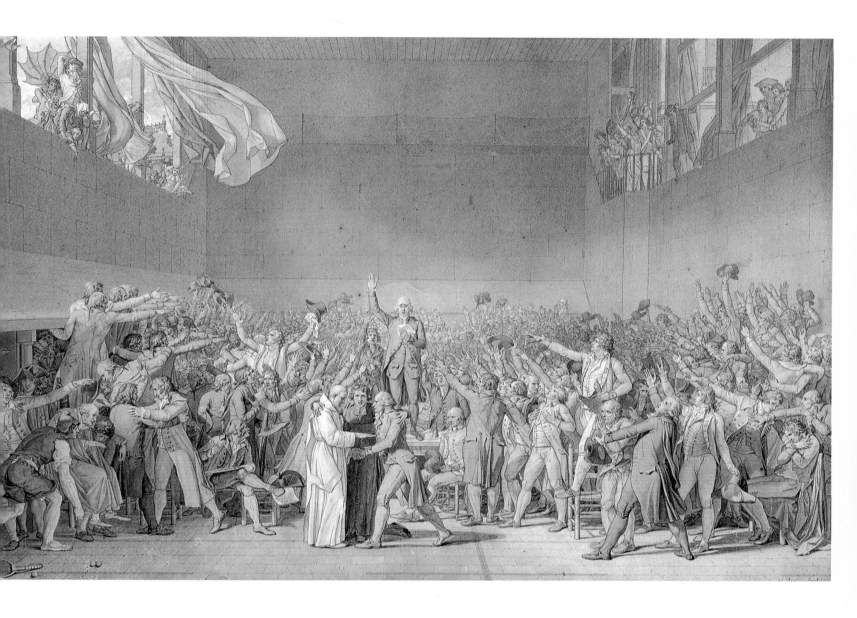

(although it was privately owned). Measuring about thirty metres by twelve, with a net dividing it into two parts, it was painted black so that the white ball should show up better. The ceiling was painted blue with golden fleurs-de-lis, and a carved sun decorated the space above one of the two doors. It was obviously not equipped to accommodate an assembly of several hundred people. Chairman Bailly's desk was a door placed across two barrels, and the two secretaries, Camus and Pison du Galland, used carpenter's benches. The session began at half past ten; the idea of the oath came from Mounier (who emigrated in the following year), and the text was drafted by Barnave and Le Chapelier (who would both be guillotined during the Terror):

> Since the National Assembly has been called upon to set up the Constitution of the realm, to effect the restoration of public order and to maintain the true principles of the monarchy, nothing can stop it from continuing its deliberations in whatever place it may be compelled to meet and [declares] that, finally, wherever its members are meeting, there is the National Assembly.

50 *The Oath of the Tennis Court.* Signed and dated 1791. Pen drawing with sepia wash. 65×105 cm. Musée du Louvre, Paris; on loan to the Musée national du château (RF 1914), Versailles.
This famous drawing, with the main groups in the foreground, is the essential part of what remains of David's great project. Some idea of the intended color scheme may be gained from a slightly smaller painting (now at the Musée Carnavalet), which was probably the work of a collaborator of David's.

It is decided that all members of this Assembly will now take a solemn oath not to disperse but to meet wherever circumstances demand, until the Constitution of the realm has been set up and consolidated on firm foundations and that the members, when they have taken the oath, shall confirm their unswerving resolution by their signature, given by each individually.

That day not only had direct political consequences but witnessed the first conscious expression of an intrinsic aspiration felt by the men of the Revolution, which was to recur almost obsessively, at least until 9th Thermidor—namely the yearning for a nation bound in a patriotic union, a union which went far beyond the conglomerate will of so many individuals, and which was incarnate in the climax of the oath. The oath was also the basic assertion—and this cannot be repeated too often—of a new social contract at a time when all the fundamental institutions were tottering. It was a moment of love and strength, when each man went beyond self, and surpassed self by merging in an invincible community.

Soon after the day of the Oath of the Tennis Court, the movement of Federation began, in conjunction with the "great fear" that gripped the countryside at the end of July and led to the formation of municipalities and national guards. The first great assembly was held at Etoile, near Valence, on November 29: those present swore to "remain united for ever, to protect the traffic of essential supplies, and to uphold the laws passed by the Constituent Assembly". The movement, which spread through the whole country, came to a head in the vast commemoration ceremony of July 14, 1790, when fourteen thousand deputies of the national guards gathered in Paris: in their name La Fayette took the oath of allegiance to the Nation, the Law, and the King, and swore to uphold the Constitution.

Contemporaries fully understood the import and significance of the day in the Tennis Court. Gilbert Romme, the author of the revolutionary calendar, who was to play an important part in the Montagne party at the Convention, was compromised in the abortive Jacobin coup of May 20, 1795 (1 Prairial Year III) and would finally commit suicide in prison, celebrated the first (and only) anniversary commemoration by founding a society, which took the name of Society of the Tennis Court on June 20, 1790. On the 19th it presented a bronze plaque to the Assembly with the text of the oath, and on the following day set it, together with some fragments of the Bastille, in the wall of the Tennis Court; they asked that the building should be preserved exactly as it was then. On that

51 *The Oath of the Tennis Court.* Left-hand part. Oil on canvas. Overall dimensions: 400×660 cm. Musée national du château, Versailles.
The original canvas, intended for the Hall of the Assembly, measured about 5.50×9.50 metres. It was reduced to its present size when it was sold after David's death, in 1826. On the left-hand side are the figures of Barère, sitting with his legs crossed, and the group of three ecclesiastics whose support of the Revolution was welcomed: Dom Gerle (who was not present for the oath), Abbé Grégoire, and Pastor Rabaut-Saint-Etienne.

occasion, Citizen Anaclet, an unfrocked Franciscan who had been a member of the delegation, made a speech which started with a reference to the oath taken some five hundred years earlier on the Rütli, on the shores of Lake Lucerne, by representatives of the cantons of Uri, Schwyz, and Unterwalden, vowing to free their country from Habsburg domination—an oath which laid the foundation of the Swiss Confederation.

The allusion is doubly interesting: first for its political significance, since the Oath of the Tennis Court seemed to be a sort of re-creating of France, united at last in the symbolic fusion of her representatives; then artistically, because in 1779-81 Füseli had done a famous painting for Zurich Town Hall. David probably knew it, as the Mirabeau he placed in the foreground of his composition corresponds fairly closely to one of the figures by Füseli; and one of Füseli's preliminary drawings, now at Weimar, bears a striking resemblance to David's preparatory studies, in which the figures are nude.

On the 20th, after affixing the plaque in the Tennis Court, all those present "ecstatically reiterated" the civil oath decreed on February 4 of that year. M. Lefèvre, an engraver and member of the society, suggested that some poor citizens of Versailles should be called upon to take the oath, including the worthy M. Delsaux, "an old man of over eighty, very sick and very poor". They launched enthusiastically into a collection for these old men, which brought in 298 francs and 8 sous. At the end of the day, they moved on to the Ranelagh in the Bois de Boulogne (this was a place for public dancing, for which admission was charged, very fashionable since its creation in 1774) to have a party, at which Robespierre and Danton were present. It culminated in a banquet, at the end of which a model Bastille was demolished; from its ruins arose the spirit of France to distribute wreaths of oak-leaves and declarations of the Rights of Man. During these ceremonies "a famous artist, a member of the Assembly, offered to use his graving tool to transmit to posterity the likeness of these unshakeable friends of the public weal. His proposal was accepted with the enthusiasm it deserved." Contrary to what has been said, that artist must have been Lefèvre, whom we have mentioned above, not David.

But the idea was in the air and David himself seems to have thought of it earlier. His important notebook with preparatory material for the *Oath*, now at Versailles, has on the first page: "this March 14, 1790, on the eve of my departure for Nantes". At Nantes David was to take part in the Federation and watch a procession of "patriotic child soldiers" taking the civil oath instituted in February,

which David himself had already taken. Another notebook, recently discovered and purchased by the Louvre, has a note by David on the third board of the binding: "For my Nantes pictures I have to buy in Paris the corners of Michelangelo's Sistine Chapel and also the Massacre of the Innocents from Raphael's tapestries," which also suggests that David had begun to prepare a picture of *The Oath of the Tennis Court* in connection with his journey to Nantes, perhaps for a commission of which we have no other evidence. As this plan was obviously abandoned, it was most probably revived in a new form by the Society of the Friends of the Constitution, better known after the name of the old Jacobin monastery where they met, of which David was a member.

On October 28, 1790 Dubois-Crancé, or rather Dubois de Crancé, a soldier

52 *The Oath of the Tennis Court.* Right-hand part.
Oil on canvas. Overall dimensions: 400×660 cm.
Musée national du château, Versailles.
The only heads painted in were those of Dubois-Crancé (top), Père Gérard, Mirabeau and Barnave (left to right).

53 *Study for "The Oath of the Tennis Court".*
Drawing in black crayon and pen, with two
washes. 66×98 cm. Fogg Art Museum, Cambridge
(Mass.); Grenville L. Winthrop Bequest (1943-
799).

This very important drawing, whose architectural
perspective was probably worked out by the archi-
tect Charles Moreau, shows David's working pro-
cedure, with the groups at two different stages:
preliminary figures in crayon, clothed ones in ink.
Despite the precision of the finished figures,
reproduced almost unchanged in the drawing
exhibited at the Salon in 1791, David did further
nude studies of them on the final canvas.

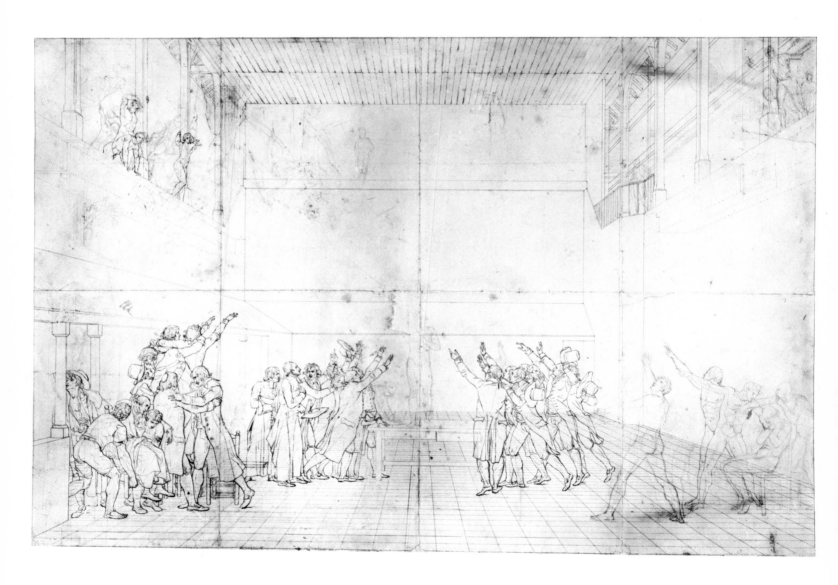

and member of the Constituent Assembly, made a speech from the Jacobin
rostrum:

Following our example, the whole world will be free one day ... Let us
therefore start by wiping so many centuries of error from our chronology; let
us forget the tyrants and the victims ... France Regenerated dates from

June 20, 1789 ... I propose that this society should send an address to the National Assembly asking it to place the Tennis Court at Versailles under its protection, to order that this public monument should always remain unchanged, as it is today, and even rebuilt as it is today when time threatens to demolish it..., and that the National Assembly go there every year, at the opening of its session, to reiterate the oath that saved France ...

But, gentlemen, can we be satisfied with asking that a decree should immortalize such a memorable event? Not all men are able to come to that temple of patriotism to find their greater self. Let us therefore offer the most distant regions the chance to make the pilgrimage at their pleasure to that majestic ideal.

Those bare and blackened walls, like a prison, those boards that served as seats, that folding table on which 600 deputies but one signed their immortal oath, that sky which they could call to witness glimpsed only through the vault, that vast attentive silent crowd filling the streets as if it could have heard them through the walls, what a sight! ... Well, gentlemen, let the liveliest brush, the most skilful engraving tool pass on to our grandchildren what France has done

54 *Study for "The Oath of the Tennis Court"*. Drawing in black crayon. 20×13 cm. Musée national du château (sketchbook MV 7800, folio 34 verso), Versailles.
This drawing and the eight that follow belong to a sketchbook of some sixty pages, which was started "today, March 14, 1790, the eve of my departure for Nantes" and devoted entirely to studies for *The Oath*. This page, in the middle of the sketchbook, shows the hall as David must have seen it on an ordinary day, with the tennis-net in place.

55 *Studies for "The Oath of the Tennis Court"*.
Drawings in black crayon. Each leaf: 20×13 cm.
Musée national du château (sketchbook MV 7800,
folios 9 verso and 10), Versailles.
These sketches are for two groups on the left, in the
second rank of the composition, of whom only the
heads and busts would be seen. These are probably
studies from life.

56 *Studies for "The Oath of the Tennis Court"*
(sketchbook MV 7800, folios 52 verso and 53).
The drawing on the left is particularly interesting
for the way it links contemporary events with the
ancient world. The warrior with his hands on his
chest, represented without weapons in the right-
hand drawing, appears with very little change in
the foreground of the final drawing and is usually
identified as Robespierre. The figure in front of
him on the drawing is further to the right in the
final composition, but in the same pose: it is none
other than Mirabeau.

110

57 *Studies for "The Oath of the Tennis Court"* (sketchbook MV 7800, folios 51 verso and 52). The drawing on the left is a wonderfully lively study for the figure (Prieur de la Marne) in the center of the crowd on the left, in the third rank.

58 *Studies for "The Oath of the Tennis Court"* (sketchbook MV 7800, folios 41 verso and 42). The drawing on the left does not seem to have been used in this form in the final project (there are two similar figures on either side of Bailly, but neither is identical with this one). The figure in the right-hand drawing ("aristocrat eaten up with jealousy of Barnavé and Mirabeau") was finally placed just behind Mirabeau.

111

for them after ten centuries of oppression. Let this truly sacred image be the first thing they see; let them do homage to it each day from childhood, and even as they learn to lisp the sweet word father, let them learn the rights and duties of man ...

To put our thoughts on canvas we have chosen the author of *Brutus* and *The Horatii*. This patriotic Frenchman, whose genius anticipated the Revolution ..., Sieur David, shall be invited here and now to say if he accepts the honorable trust of this assembly and if he is willing do a painting, thirty feet by twenty, showing the Oath of the Tennis Court [to be hung in the hall of the National Assembly]. The Society will choose an engraver from among the best French artists with whom it will contract for an agreed number of prints, and then the plate will be broken.

The Jacobins estimated an outlay of 72,000 francs, to be covered by a subscription of 3,000 shares at 24 francs, each to be valid for one print.

As we have said, David had already started work. Had he himself been present at the Oath of June 20, 1789? Virginia Lee thought so, basing her conclusion on notes in the painter's handwriting in the Versailles album. We cannot agree with her. The view of the hall drawn in folio 34v°, which shows it in its customary state, with the net dividing it, proves that David went to see it—but after the event, at which he had in any case no reason to be present. This sketch shows the view he used in his picture: to put it in perspective, he then—according to Delécluze—enlisted the help of Charles Moreau, the architect; no doubt the large drawing in the Fogg Art Museum shows evidence of that collaboration.

To go back to the notebook, the phrases we find in it show the artist in the feverish state of creator, not spectator; he jots down a string of ideas, of subjects to illustrate: "... those who arrive last should be drenched, with dishevelled hair, carrying umbrellas, to show that the weather is bad", "remember to show the deputies moved to tears and holding their hands to their eyes", etc. The only phrase that might suggest that David himself had been present at the scene is the following: "Many people take the oath by raising their hats in the air [as] I have seen them do, with their hats on the end of their canes" (fol. 65), but this general remark applies to the countless oaths taken daily all over France. Everything suggests that the notebook really dates from 1790, as David himself indicated on the first page, and that he had not himself been present at the scene; this is also proved by the phrase, "remember the dust that the movement of the action must have raised" (fol. 65v°).

In his effort to show the spectators, the deputies and the chief protagonists, the artist betrayed the historical painter's traditional concern with expressing feelings: "Some serious and frowning, some laughing as if filled with delight, some respectful, some looking fiercely patriotic", or "when a man says something important his brows rise from the start and wrinkle his forehead". Three of the chief actors of the day are characterized as follows: "Mirabeau, great energy, strength, vehemence, Sieyès, depth, Barnave, calm." At the same time there are a number of clues that show the desire for realism, such as "jugs of lemonade on the barrels", "remember the bell" (in fact, it would be shown prominently on the table at Bailly's feet).

Even more fascinating in this notebook, in which we catch the artist at work, is

59 *Study for "The Oath of the Tennis Court".* Drawing in black crayon, 18×11 cm. Cabinet des Dessins (sketchbook RF 36942, folio 99), Musée du Louvre, Paris.
This drawing and the one that follows belong to another sketchbook, of some fifty pages, which was recently rediscovered and acquired by the Louvre. It contains several sketches for the spectators at the windows in the upper part of the composition.

60 *Study for "The Oath of the Tennis Court"* (notebook RF 36942, folio 94).
This sketch, executed with such verve and accuracy, is for a character of whom only the head and shoulders appear in the definitive drawing.

the confusion that comes about so naturally between the deputies of the Assembly and warriors of antiquity (this has been interpreted—wrongly, I think—as a later reversion to the notebook for *Leonidas*), a confusion that is further enhanced by David's custom of doing studies of his figures in the nude and by the fact that the Oath seemed like a grandiose episode from Plutarch miraculously re-enacted one fine day in June 1789. Thus one of the group, on the left in the middle ground, in which a deputy in a coat helping another to climb on a bench while he supports himself on a colleague's shoulder, was the subject of successive studies (fol. 9 and 9v°), first in the company of a warrior holding a round shield, then from the opposite view (the final one), simply naked. Nothing is more striking than fols. 52v° and 53: on one side are nude but helmeted warriors, some brandishing their sword or shield, on the other the two chief figures, without weapons, undergoing metamorphosis are already recognizably Robespierre and Mirabeau, whom David subsequently moved slightly apart from each other for the definitive version.

It is no wonder that David used some ideas from his studies for *The Oath of the Tennis Court* again for *Leonidas at Thermopylae*: there is no basic difference between the heroism of the Spartan fighting men and the patriotic courage of the deputies of 1789.

For this marvellous revival of antiquity David would find a rich source in the drawings of his Roman albums and in his own wide classical culture of which we have ample evidence: thus there are several studies of Barère in different positions influenced by the Sistine Chapel, and his final pose is taken from a figure seated on the left in Raphael's *Parnassus*. Some drawings that were not used, or were modified, were also taken from the ceiling of the Sistine Chapel. David also used *The Deluge* for the figures shaken by the storm in the upper and left windows, and *The Last Judgment* for Père Gérard and Maupetit.

Nor is it surprising that David took some liberty with historical facts. At the Salon of 1791 the hardly credible grouping of the scene aroused comment: one critic remarked that Bailly "is too much in front where there are few people, whereas there are masses behind him". The central position shown in the engraving we reproduce is more likely to be accurate. And David certainly did not mean to show only half the deputies present—there were about 640—since, in a strange text we shall quote later, he himself estimated that he had shown about one thousand or twelve hundred people, or that this would be the number in the definitive picture. Since the end of the last century, historians of *The Oath* have had the

61 *Studies for "The Oath of the Tennis Court".*
Drawing in black crayon and pen with Indian ink
wash. 46 × 56 cm. Musée national du château
(MV 7124), Versailles.
Some of these isolated figures and groups were
used unchanged (the two groups surrounding the
table, the embrace between Rewbell and the priest
Thibaut on the left), while others were modified
(the porters with the ailing deputy, the group round
Martin d'Auch, Père Gérard, Prieur de la Marne),
or left out (the seated figures recovering their
breath).

115

impression that "considerations of theatrical effect overrode all others" (A. Brette) in the painting, and there can be no doubt that David, who took a great interest in the theater, had a stage performance in mind. Whereas on June 20, 1789 Bailly had his back to the audience of deputies and addressed the south wall opposite him, in the "scene" created by David he is looking straight at the spectator, at each one of us. When Bailly is reading the formula of the oath, he no longer addresses, or at least no longer addresses solely, the deputies crowded more or less anonymously behind him, but is speaking to the deputies of the Assembly in which the large painting was to be hung, to the three thousand families who would buy the engraving and, through them, the whole nation, called to witness the historic moment. Indeed, for the French schoolchild the dramatic scene of the Oath is perpetually re-enacted in the numerous reproductions everywhere—down to postage stamps—of David's work.

In the light of all this, the straining of the truth here and there seems very unimportant. In the foreground of the picture the main group, whose symbolic and didactic significance is obvious, consists of representatives of the regular clergy, the secular clergy, and of the Protestant Church: Dom Gerle, in Carthusian habit, Abbé Grégoire, and the Protestant minister Rabaut-Saint-Etienne. In fact Dom Gerle, an acting deputy, did not arrive in Paris until December 1789 (together with other deputies who had been absent on June 20, he took the oath on February 17); although five parish priests took the oath, not a single member of a monastic order had done so.

Yet the exact identity of the actors in the drama of the Oath was not considered immaterial: a list had been prepared to go with the engraving, besides the bronze plaque affixed in the Tennis Court. The portrayal of these people, at least of those David had placed in the foreground, posed a problem to an artist who wanted to be accurate. The large drawing (over one metre wide) intended as the model for the engraving was completed towards the end of May 1791 and exhibited to the public at the painter's studio before being taken to the Salon. The Salon opened late because of the campaign, actively supported by David, to make it freely accessible to all artists. This freedom was decreed on August 21 by the Constituent Assembly and the Salon opened on September 15. Item no. 132 of the *livret* lists David's drawing, now in Versailles, with the following remark: "The author has not intended to show a true likeness of the Members of the Assembly", although he certainly means to do so in the definitive painting.

Meanwhile the subscription, which the Jacobins had hoped would be covered

62 *Head of Abbé Grégoire.* Oil on canvas. 56×45 cm. Musée des Beaux-Arts, Besançon. The museum at Besançon has three studies of heads (put up for sale after David's death) connected with *The Oath.* This one must have been painted in November 1791, when David was working on the transfer of the drawn composition to a large canvas. Grégoire was a notable figure of the Revolution, to which he remained devoted without giving up his Catholic faith.

63 *Head of Prieur (de la Marne).* Oil on canvas. 56×45 cm. Musée des Beaux-Arts, Besançon. This magnificent study, of which there is a replica at Versailles, certainly seems to be for the figure in the center of the left-hand part of the composition (see also Pl. 57).

entirely by their own members in Paris and the provinces, had failed. We know the precise results from a letter David himself wrote to the *Moniteur*, published on November 28, 1801: only 652 shares had been sold, and of those the painter himself had taken a hundred, of which he managed to sell "only a small part". On September 27, 1791 Barère had proposed that the large painting should be paid for by the State, and this proposal was accepted on the following day. The Assembly had the deconsecrated Church of the Couvent des Feuillants, beside the Tuileries, fitted out as a studio for David. The painter published a notice asking "the deputies who were present at the meeting and whose likeness he had not been able to paint

to send him their picture; unless, of course, they could undertake the journey to Paris during the time when he would be working on his painting, which he supposed would be about two years, and in that case would they kindly come to his studio of Feuillants, where he will paint them from life" (the deputies to the Constituent Assembly had agreed that they would be barred from sitting in the Legislative Assembly, hence the reference to a possible journey to Paris).

We also have a note dated November 20 in which David asked Abbé Grégoire to come to his studio on the following day. The sketch now in the Musée des Beaux-Arts, Besançon, must therefore date from that day. It shows the *curé* of Embermesnil—who, while remaining loyal both to his Catholic faith and to the Revolution, became a successful writer and politician until his death in 1831—in the same pose in which he is presented in the large drawing of *The Oath*. This also applies to a few other surviving studies of heads, like the Prieur de la Marne and "Père Gérard", both in the Musée des Beaux-Arts, Besançon. The latter, we know, was a well-to-do Breton farmer who liked to sit in the Assembly in peasant costume. He became a legendary figure and from 1792 on was popularized by the *Almanach du Père Gérard*, published by Collot d'Herbois, which was a huge success. One might also mention the so-called *Kervelegan* in the Louvre, which for many years was referred to as *Bailly*, although the model is still unknown and bears no certain link to *The Oath of the Tennis Court*.

According to the painter himself he was working actively on his great project until his election to the Convention in September 1792. Some light is thrown on his working methods by the draft of a report to the Directory, his note to the *Moniteur* in 1801, and the large, barely sketched canvas now at Versailles. Although he had done first nude and then clothed studies of his figures for the drawing of 1791, on that canvas he again sets out nude figures: "Each day I paid a new model for drawing nudes of my characters. I always employed three collaborators." This last piece of information is rather surprising, seeing that only the main figures in the center are sketched and four heads painted, those of Mirabeau, Dubois-Crancé, Gérard and Barnave. David's political activities, his role as stage manager and propagandist of the Paris Revolution, engrossed him increasingly. Moreover, political developments very quickly made the presence of some of the heroes of June 20, 1789 extremely embarrassing. To mention only those in the foreground, Mirabeau had died at the beginning of April 1791, just in time to avoid being completely discredited by his support of the king, and his ashes were unceremoniously removed from the Panthéon in 1793. Bailly, who had

64 *Head said to be "of Kervelegan".* Oil on canvas. 49×33 cm. Musée du Louvre, Paris.
The subject of this superb sketch, similar in technique to those in Besançon, was formerly identified as Bailly and later—on the basis of the inscription on a copy (Cailleux Collection)—as Kervelegan, an obscure Breton deputy, but in fact it remains something of a mystery.

65 *Study for a Portrait of Louis XVI and the Dauphin.*
Detail. Drawing in black crayon. Overall dimensions: 18×11 cm. Cabinet des Dessins (sketchbook RF 36942, folio 38 verso), Musée du Louvre, Paris.

Before breaking up at the end of September 1791, the Constituent Assembly decided that there should be a portrait in the Assembly Hall of Louis XVI "showing the royal Prince... his assent" after he had accepted the Constitution. David, continuing his progress towards the political Left, later denied having started work on such a portrait, but the sketchbook in the Louvre contains half a dozen sketches for it.

66 *Portrait of Mme d'Orvilliers.* Signed and dated 1790. Oil on canvas. 131 × 98 cm. Musée du Louvre, Paris.

To paint the two Rilliet sisters, the daughters of a wealthy financier, both recently married (one being the Comtesse de Sorcy and the other the Marquise d'Orvilliers), David evolved a type of three-quarter-length portrait, with the subject seated in front of a bare wall. The austerity of this arrangement did not exclude a contrasting treatment of the features.

presided over the session and had become mayor of Paris in July 1789, had to resign after he had used troops to disperse the crowds that demanded the removal of the king on July 17, 1791. He withdrew to Melun, but was arrested and guillotined on November 28, 1793, ten days after Barnave. Barnave had retired to his native province and become mayor of Grenoble, but he was compromised by his correspondence with the king, which was discovered in the "iron chest" after the fall of Louis XVI. Some days later Rabaut-Saint-Etienne was guillotined for having committed the error of being a Girondin at the Convention. Finally, on the day after 9th Thermidor, it was the turn of Robespierre himself.

Thus the vast canvas lay abandoned at the Feuillants studio, where a little later Topino painted his *Caius Gracchus*; but a few years later, David thought he would finish his picture. The draft of his report to a minister of the Directory, which we have mentioned above, is not dated; could it have been connected with the proposal made by Garat to the *Conseil des Anciens* (Council of Elders) on September 9, 1799 to ask David to finish his painting? This text throws an unexpected light on David's realistic outlook. The lapse of time may account for the rather wild estimate of "one thousand or twelve hundred people", but the postscript is worth quoting: "At present I can no longer see the people who formed the legislative body at the time, and as most of them—between ourselves—are of no importance to posterity, I intend to replace them by all those who have distinguished themselves since and who will therefore be of much greater interest to our descendants. Admittedly, this is an anachronism, but they will thank me for it. It is an anachronism such as famous painters have used before without worrying about the unities of time and place; at least no one will be able to reproach me on that score."

He reckoned that it would take him three years to finish the huge undertaking; whether it was the absurd changes proposed or the extent and cost (150,000 francs) of the task that discouraged David and the authorities, the upshot was that the picture was definitely abandoned. It was rolled up and deposited in the Louvre in 1803, and recuperated by David in 1820. Before it was—unsuccessfully—put up for sale in 1826, it had been cut and reduced to its present dimensions of about 4 by 6.60 metres; "the rest of the canvas, which contains some marks, has been taken off with the utmost care and will be delivered to the purchaser, who will easily be able to restore it to its pristine state". It was at the second sale, in 1835, that the mutilated canvas was acquired for the future museum of Versailles.

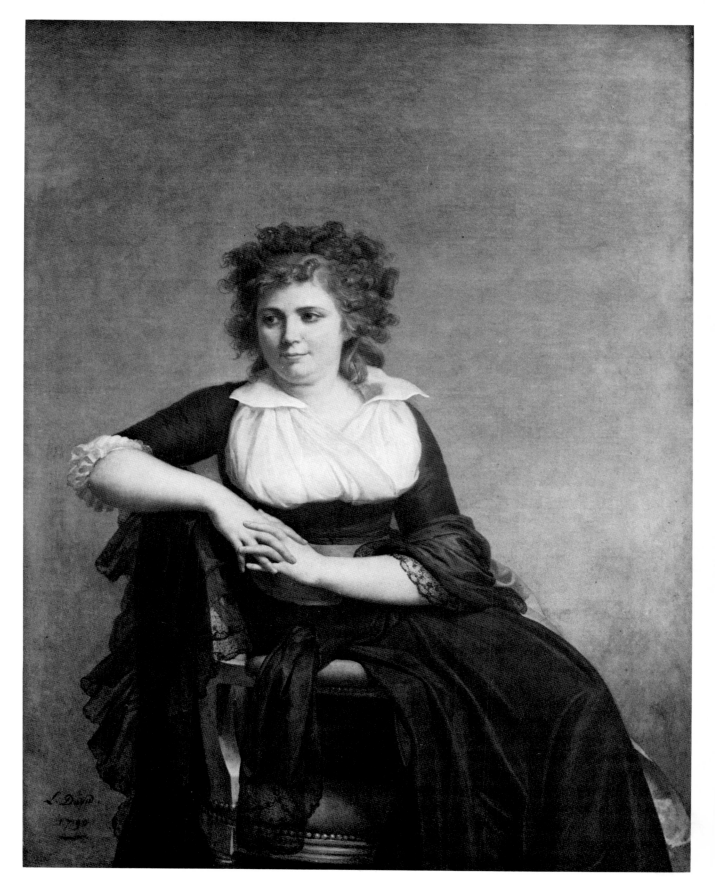

For a time the project for *The Oath of the Tennis Court* had an unexpected concomitant about which David himself—whose own opinions had undoubtedly changed in the meantime—subsequently kept silent. On September 29, 1791, on the eve of breaking up, the Constituent Assembly asked the king "to make a gift to the Legislative Body of his portrait to be placed in its meeting room, and to have himself painted at the moment when, having accepted the Constitution, he is showing his royal assent to his son, the Prince Royal". It was not until March 3, 1792 that the *Chronique de Paris* makes mention of this portrait: "The king is having himself painted handing the Constitution to his son, the Prince Royal, and has asked that the patriotic brush of the famous David should execute the portrait."

For a long time this was thought to be a journalistic error: how could a fierce revolutionary like David have agreed to such a commission at so late a date? When he was imprisoned after 9th Thermidor, David prepared a speech in his defence in which he gave a reply to the accusation of "having solicited the agents of Capet to give him the job of painting a picture showing him teaching the Constitution to his son". Although a letter under the king's seal from Laporte, his valet, was found asking him to do the portrait, David claimed to have replied nobly, in a strong voice, "I'll have you know that the painter of *Brutus* was not made to paint kings!", a phrase he subsequently wrote on Laporte's letter. But in his defence David protested too much: "I notice that almost a year has passed since the proposal made to me by Laporte and the revolution of August 10, and that therefore the painting I am supposed to have solicited would exist or at least have been begun, if I had intended to do it" (Archives Nationales, AA45-1352A). A notebook recently discovered and acquired by the Louvre contains a large number of drawings for *The Oath of the Tennis Court* and some for *The Sabines*, and there are also at least half a dozen drawings of *The King Showing the Constitution to his Son*. David must have realized better than we, who should not be surprised by the fact, that neither the revolution nor the men in it were as steadfast as a rock, and David at least had the excuse of pressing circumstances.

Political circumstances also explain why some of the most delightful portraits of the period remained unfinished. David never neglected his portrait painting. Before his election to the Convention he had painted or agreed to do several portraits. At the beginning of 1790 he painted the portraits of the Rilliet sisters, daughters and wives of rich financiers: one sister had married, two years previously, Jean Isaac Thélusson, the new count of Sorcy, whom David also

67 *Portrait of Mme de Sorcy-Thélusson*. Signed and dated 1790. Oil on canvas. 131×98 cm. Bayerische Staatsgemäldesammlungen, Munich.
Nothing could be farther from the easy-going appearance of her sister than the *hauteur* of Mme de Thélusson, whose portrait—with its very simple color scheme and dazzling execution—is one of David's masterpieces.

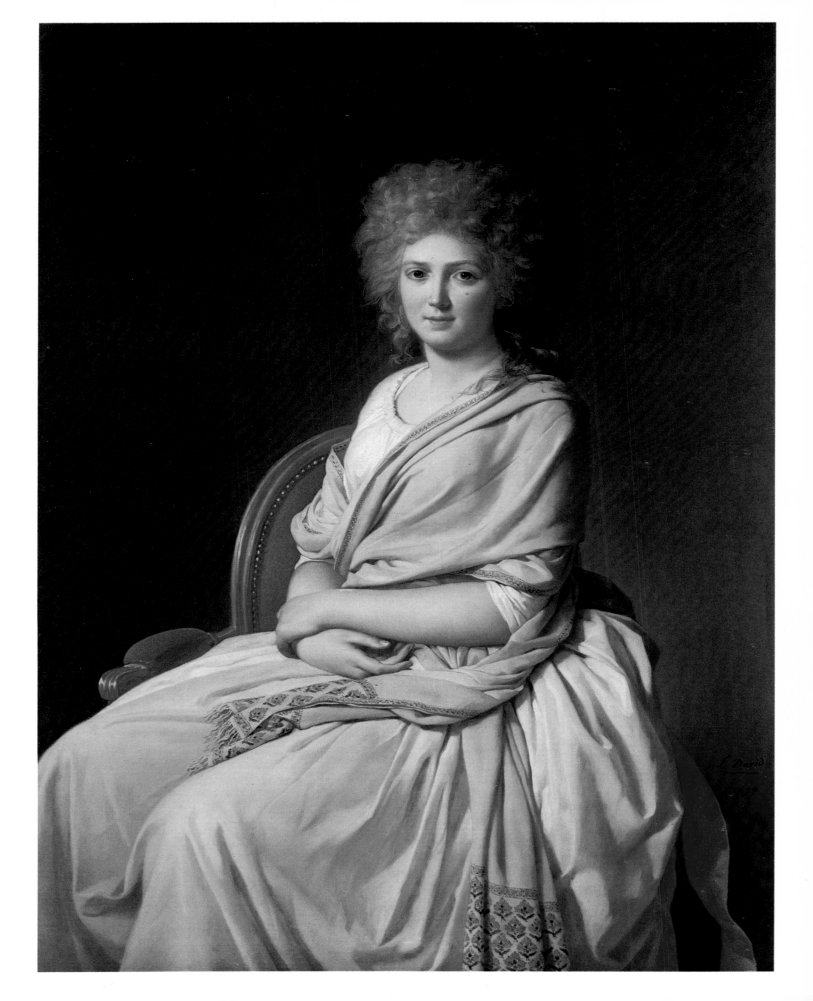

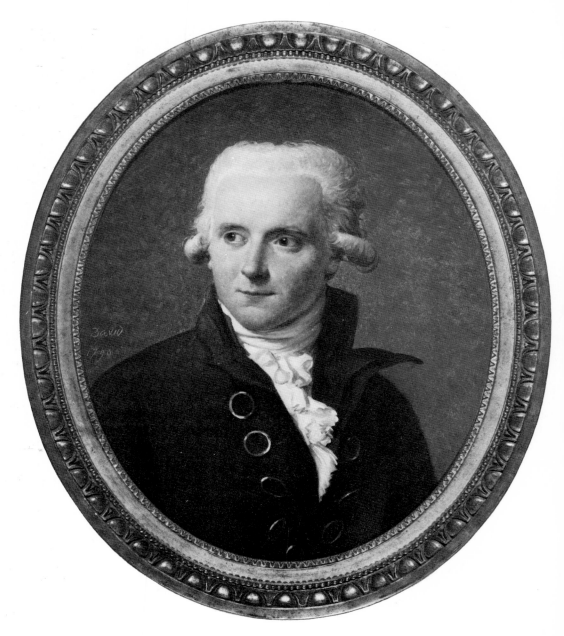

68 *Portrait of M. Sériziat.* Signed and dated 1790. Oil on canvas. 55×46 cm. National Gallery of Canada, Ottawa.
Here David portrays his brother-in-law and friend, a magistrate, in a small-scale painting executed so rapidly that the scumbling is apparent and it remains more or less in the nature of a sketch. Later David painted a less informal portrait of his brother-in-law (Pl. 101).

69 *Self-portrait.* Oil on canvas. 64×53 cm. Galleria degli Uffizi, Florence.
Painted in 1790 or 1791, this fine self-portrait is also slightly sketchy in parts, but is remarkable for the haunted intensity of the gaze, emphasized by the dishevelled hair.

painted in 1791 on an oval canvas, now in the Wendel Collection; the other sister became the Marquise d'Orvilliers in 1789 through her marriage with the son of a district tax collector who until 1776 had been called simply Tourteau.

The type of portrait perfected by David has been so much admired and imitated that it is difficult for us today to be aware, not of its beauty, but of its originality. In a traditional medium-sized format, four by three feet, the painter placed a figure cut off above the knee, seated before a completely bare wall, with just the slightest variation in the lighting—hardly enough to enliven it. Its charm lies in the play of arabesques, the equilibrium between accuracy and freedom in its execution, in the vitality of the two sisters, who were so different, one a fat hearty girl, the other elegant, stiff, assuming a pose with her eyes riveted on the painter and the viewer. From the same year, 1790, dates a small oval portrait of David's

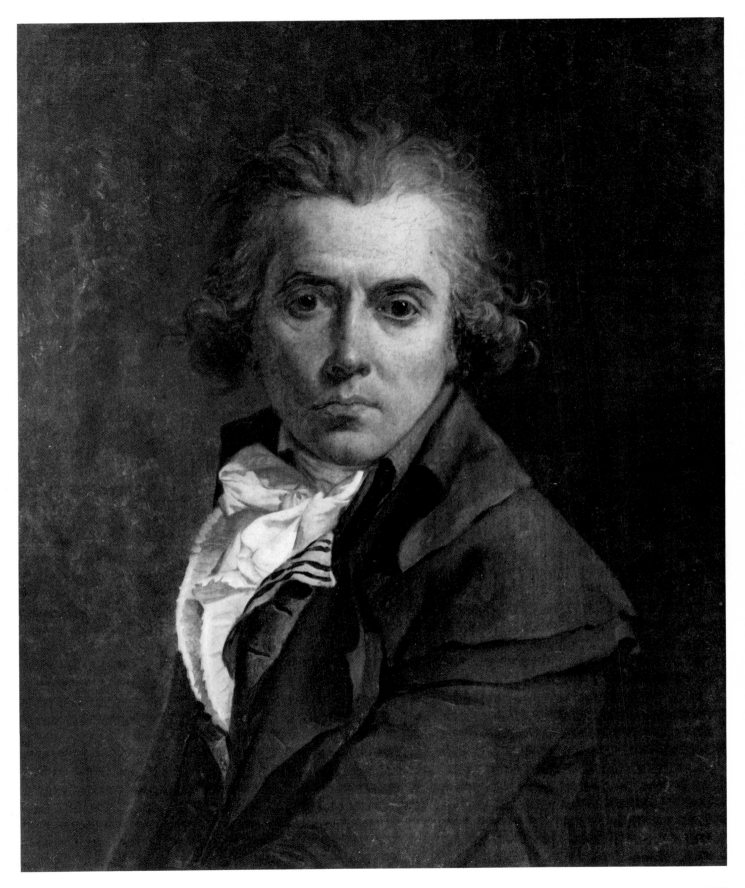

70 *Portrait of M. de Joubert*. Oil on canvas. 126×93 cm. Musée Fabre, Montpellier.
This portrait is generally dated 1786 or even 1783, but the fact that it is unfinished is probably explained by the death of the sitter in March 1792. M. de Joubert, treasurer of the States of the Languedoc, was a patron of the arts and had assembled a large collection in his town house in Place Vendôme, Paris.

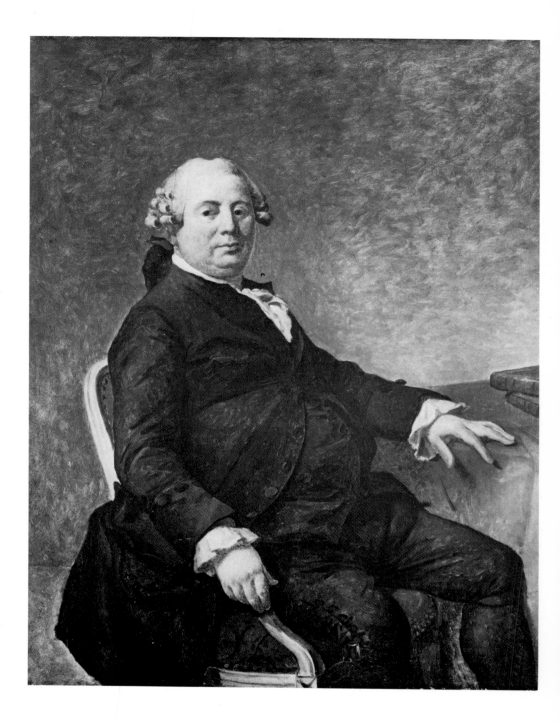

brother-in-law, Sériziat, which the National Museum of Canada, Ottawa, acquired a few years ago. Sériziat, who was on very friendly terms with his brother-in-law, was a magistrate. In October and November of the following year, David used all his influence with Quatremère de Quincy and then with the Minister of Justice to obtain his appointment to the Tribunal de Cassation. Unlike the much more elaborate portrait of 1795, this one remains sketchy; in the face and costume, as well as in the completely bare background, we can clearly see the scumbling that was characteristic of David's technique—but always less obvious in the major paintings. Scumbling, which adds vibration to the background and integrates the

71 *Portrait of Mme de Pastoret.* Oil on canvas.
133×100 cm. Art Institute, Chicago.
Another unfinished portrait which, like the one
that follows, remained in David's studio and must
have been painted round about the same time. The
model is the wife of Emmanuel Pastoret, a future
Chancellor, and the mother of Amédée Pastoret, a
future Councillor of State and member of the
Institute, who can be seen in the cradle (he was
born at the beginning of 1791). The charm of this
picture, so alive and so close to us today, is
enhanced by the delicacy of the monochrome,
heightened with a few touches of color.

figure portrayed in it, is also very visible in David's first self-portrait, now in the
Uffizi, dating either from 1791, as suggested by an inscription on the back of the
canvas, or from 1790, if we are to believe Delafontaine, one of David's pupils who
owned the picture after Gérard. This again is a rather small canvas, free and rapid
in the treatment both of the clothes with the triple collar and the ruffled hair; the
artist looks tense, piercing, and the expression is very different from that usual on
his sitters.

Three famous and unfinished portraits, all left in David's studio and sold after his death, seem to date from 1791 or 1792. First, the picture of Philippe-Laurent de Joubert, treasurer of Languedoc, an art connoisseur and honorary member of the Academy of Painting and Sculpture and an art patron, who lived in a fine mansion in Place Vendôme and financed the publication of the *Galerie de Florence*; this was started by Wicar, David's pupil, Lacombe and Masquelier in 1787, and the first volume appeared in 1789. The unfinished painting, now at Montpellier, has often been dated around 1786, even 1783-4. In fact it seems that only the death of the sitter on March 3, 1792 can account for the fact that the picture was not finished; its dimensions and layout are also the same as those of the portraits of Mesdames d'Orvilliers and Thélusson on the one hand and of Mme de Pastoret on the other.

The latter, now in the Art Institute, Chicago, is particularly enchanting because of its intimate character. We are taken into the home of a magistrate, Emmanuel de Pastoret, the descendant of an old family (the noble *de* dated only from the Restoration), whose portrait by Delaroche is now in the Fine Arts Museum, Boston. Born in Marseilles in 1756, at the time of the Revolution, he was the receiver of judicial petitions and official attorney general of the Seine district. During the Restoration he became president of the House of Peers, minister of State, then Chancellor of France. His wife, a woman ten years younger, whom he married in 1789, was to play a considerable role in the history of social welfare: in 1800 she introduced infant schools in Paris—the ancestors of today's crèches—to which she dedicated large sums of money. Under the Empire and the Restoration her *salon* was one of the foremost in Paris. There is a story that she had painting lessons from David. Amédée de Pastoret, whose head is visible in the cradle, was born on January 2, 1791. He, too, had a distinguished administrative and literary career; he had his portrait painted by Ingres, whom he greatly admired, a superb painting now in Chicago. David did not finish his portrait of Pastoret either—probably owing to political circumstances—and it remained in his studio until the Pastorets bought it after his death. Emmanuel de Pastoret emigrated immediately after the fall of the king, and his wife, who was imprisoned at one point, had more urgent worries than her portrait, especially at a time when David was starting his political career on the side of her opponents.

The third portrait, in the Louvre, again in the same format and in a similar pose, is that of Mme Charles-Louis Trudaine de Montigny, who had married one of the Trudaine brothers in 1789. They were sons and grandsons of high state

72 *Portrait of Mme Trudaine.* Oil on canvas. 130×98 cm. Musée du Louvre, Paris.
At the beginning of the Revolution, David was still on very close terms with the Trudaine brothers, the younger of whom (Charles-Michel) had commissioned *The Death of Socrates.* The model was the wife of the elder of the two (Charles-Louis), who was guillotined with his brother in 1794. This uncompleted portrait may date from 1792, when political events had not yet created a breach between David and the Trudaines.

128

73 *Portrait of a Young Man.* Signed and dated 1793.
Oil on canvas. 72×58 cm. Private collection,
Paris.
This delightful portrait, ostensibly little more than
a sketch, must represent a close acquaint-
ance—perhaps a pupil—of David's.

officials (their father, who died in 1777, was a great friend of Turgot's) and in turn became King's Counsel at the courts of justice in Paris and Councillors in Parliament. They were closely connected with David: Charles-Michel Trudaine had commissioned *The Death of Socrates* when he was very young. Towards the end of 1790 and the beginning of 1791 their relations were still very friendly, since we know from a scrawl in the Versailles sketchbook that the Trudaine brothers had subscribed for two prints each of the engraving of *The Oath of the Tennis Court.* As with André Chenier, who was a friend of the Trudaine brothers, the rupture probably dated from the *fête* of the Swiss Guards of Chateauvieux, organized by David in April 1792; it could not have been later than the time of Louis XVI's death sentence. In any case the two Trudaine Brothers were guillotined together in July 1794, on the eve of 9th Thermidor, when they were not yet thirty.

But let us turn to the delightful portrait of a young man, signed and dated 1793, now in a private collection in Paris and the only known non-political picture painted between David's election to the Convention and 9th Thermidor. Among those left frankly in the form of a rough sketch, it is the only one that is signed and dated. No doubt the sitter was one of David's intimate circle, perhaps a pupil, sketched rapidly in a casual pose, as if caught in flight, and rendered in a simple light-brown monochrome highlighted by a few pink touches.

It was on the occasion of the removal of Voltaire's body to the Panthéon in 1791 that David began to play a part among the pageant-masters of the Revolution. Mona Ozouf and a number of other historians have pointed out the role of *fêtes* in the history of the Revolution. Here we are concerned only with the *fêtes* organized by local or municipal authorities and not the spontaneous, violent celebrations that accompanied the revolutionary "Days". As with the commissioning of *The Oath of the Tennis Court*, the initiative was taken at the local level. In the winter of 1789-90 towns and militias began to join together in federative pacts. Each of these pacts was sealed with an oath and accompanied by celebrations. In the same way the first great *Fête de la Fédération*, held by the government in Paris on July 14, 1790, included an oath and something that was to become an essential feature of all subsequent *fêtes*, namely a parade. These occasions proliferated from 1792 onwards, but David was already helping with them in 1791.

When Voltaire died in 1778 the Paris clergy refused him a religious funeral and the fact that he was buried at the Cistercian Monastery of Scellières, near Romilly

(Aube) was due to his nephew, Abbé Mignot, abbot *in commendam* of the monastery.

When ecclesiastical property was nationalized in 1789, Voltaire's friends, headed by the Marquis de Villette (another of his nephews) and Condorcet, demanded the return of his body to Paris. On December 21 of that year Villette proposed that he should be buried in the Panthéon. The movement gained impetus on November 17, 1790 with the first performance since the Revolution of Voltaire's tragedy *Brutus*, an event so fraught with political significance that members of the audience were forbidden to carry weapons or even walking-sticks. The theater had in fact become a perpetual battleground for Royalists and revolutionaries, particularly when plays with a strong political content were given, such as Marie-Joseph Chénier's *Charles IX* and *The Trial of Socrates* or *The Regime of Ancient Times* by Collot d'Herbois. The first of these two plays, written in 1788, had been rejected by the royal censorship since it clearly showed that a king had been responsible for the St. Bartholomew's Day massacre and contained denunciations of the Pope and the clergy. A public campaign at the regular performances of the Comédie-Française, starting in August 1789, provoked a counter-campaign by the clergy and the Sorbonne, but finally led to the production of Chénier's play on November 4 of that year. The part of the king was given to a young, as yet unknown, member of the troupe, François-Joseph Talma, who was to become an intimate friend of David's and shared his radical views. On the opening night the packed house included a delegation from the Assembly, headed by Mirabeau. Campaigns for and against the play (even the actors disagreed about it) continued into the following year. Mirabeau asked for a performance to be given for the deputies from the provinces on the evening of the *Fête de la Fédération*, but his request was refused. Chénier, however, stirred up such a row a few days later that the play had to be put on on July 23, and this in turn created such an uproar that troops were called in to disperse the audience. Similarly, at its first performance on November 7, the play by Collot d'Herbois caused a considerable disturbance, which was repeated on an even greater scale ten days later when Voltaire's *Brutus* was revived; the play had, however, been only moderately successful since its first appearance in 1730, about ninety performances being staged up to 1786. Once more Mayor Bailly of Paris had to ask La Fayette to send in the National Guard to prevent a riot. The production was above all a triumph for Mirabeau, then at the height of his popularity: he was identified with the character of Brutus, as is shown by an anonymous portrait of the orator in the Hamilton Collection, in which a bust

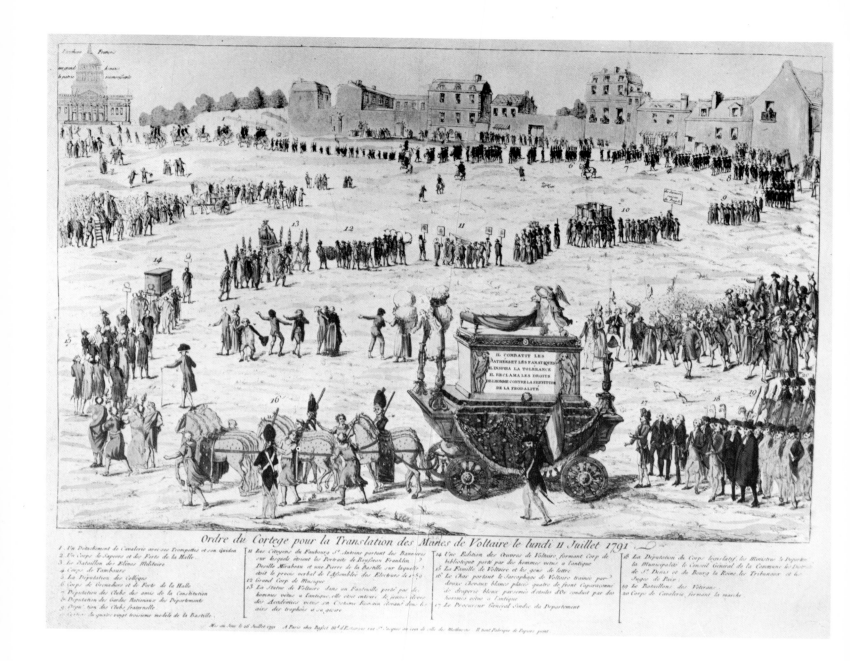

Ordre du Cortege pour la Translation des Manes de Voltaire le lundi 11 Juillet 1791

74 *Transfer of Voltaire's Body on July 11, 1791.*
Popular engraving published on July 26, 1791.
Cabinet des Estampes, Bibliothèque nationale,
Paris.
The principal components of the procession can be
seen as it wends its way to the Panthéon. This
ceremony, which took place shortly after the king's
abortive flight to Varennes, was the first of many in
which David collaborated until the events of
9th Thermidor.

of Brutus stands on the table in front of him and a rough version of David's canvas
hangs on the wall. The uproar reached its height at the moment when Brutus,
sending his son to defend the walls of Rome, exclaimed: "In my declining years the
gods have given me only useless courage but I shall see you conquer or shall die like
you, an avenger of the name of Rome, still free and without a king."

Cries of "Long live the King" drowned out counter-cries of "Long live the
Nation". At the end of the performance a bust of Voltaire was carried in by two
volunteer riflemen and the actors crowned it with a laurel wreath. At the second
performance the stage was flanked by busts of Voltaire and of Brutus, the latter
lent by David who, according to the *Mercure de France*, had brought it back from
Italy (this was almost certainly a replica of the bust belonging to the Vatican, of
which there is also known to be a drawing on tracing paper, by or after David).

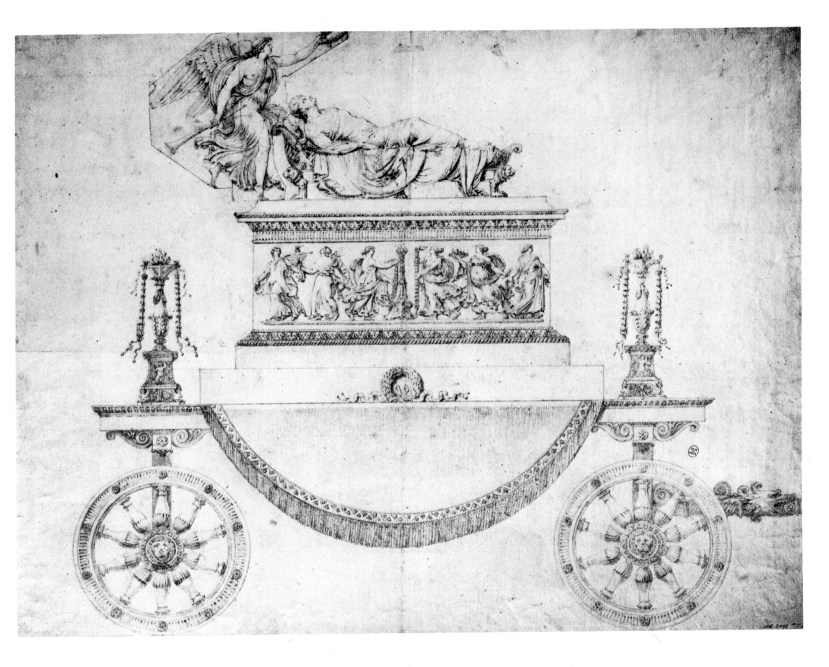

The closing scene was staged in a new way: Brutus, who had just sentenced his son, collapsed into a Roman-style armchair, while four lictors went past in the background, bearing the body of Titus aloft. According to a German traveller everyone in the audience immediately recognized the allusion to the picture by David that had been such a success at the Salon the previous year. Thus David's *Brutus* was now being interpreted in a revolutionary, indeed republican, sense. The same was true of *The Oath of the Horatii*: at the beginning of the same month (November 1790) Mirabeau and Brissot observed that it prefigured the Oath of the Tennis Court and in the previous July it had inspired the decorative treatment of the Altar of the Nation erected on the Champ-de-Mars for the *Fête de la Fédération*. At the same time the painter's links with the theater were growing stronger. We have already noted the interest he showed in dramatic art well before the

75 *Design for the Hearse Bearing Voltaire's Sarcophagus.* By Jacques Cellerier (1742-1814). Graphite drawing. 46.8×57.5 cm. Musée Carnavalet, Paris.

David's exact contribution is unknown, but he might well have inspired this design (which was simplified in the execution of the vehicle), in particular as regards the idea of Immortality crowning the deceased, treated in a way that we shall find repeated for Lepelletier de Saint-Fargeau.

Revolution, the probable influence of performances of Corneille's plays on *The Oath of the Horatii*, and the manifestly theatrical aspects of *The Oath of the Tennis Court*. Robert Herbert has also pointed out the influence of Moreau's engravings illustrating Voltaire's plays. Reciprocally, David's friend Talma gives him credit for the movement towards greater historical accuracy and restraint on the stage—innovations that Talma himself boasted of having introduced in regard to costume and acting. "The theater should to some extent provide young people with a course in living history", he wrote, adding that in his youth (he was born in 1763), he had imagined the heroes of history dressed as they were on the stage:

> I saw Caesar squeezed into a splendid white satin coat, his flowing hair tied back with ribbons ... I believed that such materials as silk and velvet were as common in Athens and Rome as they were in Paris and London ... It was only when our own celebrated David appeared that, under his inspiration, painters and sculptors ... began to look into such matters ... I became a painter in my fashion; I had many obstacles and prejudices to overcome, not so much on the part of the public as on that of the actors, but finally my efforts were crowned with success ... Lekain could not have vanquished so many difficulties, the time was not yet ripe.

(This passage comes from the "Reflections" with which Talma prefaced *Lekain's Memoirs*, published in 1825.) "Would he have dared to appear with bare arms, in long draperies, in garments of wool?"

And, in fact, it was in a costume of this kind that Talma astonished the public when he played the supporting role of Proculus in the revival of Voltaire's *Brutus*. Thus David helped to change the fashions of his time, both directly through his pictures and indirectly through his influence on Talma. According to Delécluze "it was with the appearance of this work *[Brutus]* that people stopped wearing powdered hair, that women—and later men—adopted flowing hairstyles". He goes on to speak of new styles in furniture and in etiquette at court and in the city: "The principal cause of these changes in manners and dress was undoubtedly the great political revolution that was already under way, but the revolution that had taken place in the arts also did a great deal to facilitate the changes in manners and dress to which everybody was naturally drawn." David even contributed directly to the new style in furniture; he had designed the furniture used in his *Brutus* and, at about the same time, he did some designs for a classical-style bed for the Duke of Orléans.

The success of Voltaire's tragedy, which was also given widely in the provinces—at Bordeaux, Lille, and Nantes, for example—in encouraging a spirit of patriotism facilitated the removal of its author's body to the Panthéon. Such a measure was again proposed by Villette on the occasion of the third performance. The suggestion, made to the Jacobin Club, was supported by Anacharsis Clootz, "the orator of the human race", by Marie-Joseph Chénier, and by Camille Desmoulins. The campaign was helped by the interment in the Panthéon of Mirabeau, who died suddenly on April 4, 1791, and in particular by the Pope's denunciation of the Civil Constitution of the Clergy. In May the Assembly decided to transfer Voltaire's remains to Paris and bury them in the Panthéon. The sarcophagus was transported in triumph from Scellières to Paris on a carriage surmounted by a canopy. In the meantime the king's flight to Varennes had increased political tension and led to comparisons of Louis XVI with Tarquin. Originally scheduled for July 4, the ceremony took place a week later in a downpour of rain. David's role, though attested to in various contemporary writings, is not known with certainty, but the most striking conception, that of the hearse—designed by Jacques Cellerier, an architect from Dijon—was reproduced exactly in the commemorations of "martyrs of the Revolution" organized or painted by David in 1793. The hearse was drawn by twelve white horses and had perfume-burning candelabra at each corner. On it lay a sarcophagus which, according to the original design, should have been decorated in bas-relief—in the event, quotations from Voltaire were used instead. On the sarcophagus was a classical-style bed, on which reclined an effigy—probably in painted plaster—of Voltaire, with the torso half-naked and the winged genius of Immortality hovering, crown in hand, above the head.

The *fête* itself, like most of the great revolutionary *fêtes* that followed it, consisted in the main of a huge parade with halts at intervals, as in traditional Catholic processions. It was a parade in which the people, simultaneously actors and participants, provided their own spectacle. The procession, which left from the Bastille, included representatives of the Assembly, of the National Guard, the Municipality and Department, the schools and theaters, the Jacobins, and workers of the Faubourg Saint-Honoré. Among the items carried by the various groups were a replica of Voltaire's statue by Houdon, banners bearing quotations from the writer, and busts or medallions of Rousseau, Franklin and Désilles, a "martyr of the Revolution". The whole production, down to the details of the costumes and the musical instruments, was conceived in the spirit of classical antiquity.

The first halt was at the Opéra, where extracts from Voltaire's *Samson* were recited and a bust of the great man was crowned. The second stop was at Villette's house, where Voltaire had died (on the quay that bears his name today); here an amphitheater had been set up, roofed over with leaves and branches and occupied by fifty young women in white dresses and wearing crowns of roses. Musicians and singers executed a hymn to Voltaire composed by Chénier and Gossec. Mme de Villette, accompanied by Calas's daughters, placed a wreath on Voltaire's statue, and actors dressed as characters in Voltaire's plays laid offerings at its feet. Because it was so dark and wet, the ceremony at the Panthéon (Sainte-Geneviève), where the sarcophagus was placed on a granite plinth, had to be curtailed.

The *fêtes* that were entirely organized by David were of a similar kind. The first, on April 15, 1792, was in honor of the mutinous Swiss guards in the regiment of Châteauvieux. On March 24 a delegation, consisting of David, Marie-Joseph Chénier, Collot d'Herbois, Tallien, and Mlle Théroigne de Mericourt, had invited the municipal authorities to join in celebrating these mutineers of August 1790 and their liberation from the galleys of Brest, to which the "repression" of Bouillé had consigned them. Since then their mutiny against their officers—now considered aristocrats and counter-revolutionaries—had come to be considered as a demonstration of their civic spirit: "May the people's magistrates, by their presence, set the seal on the victory of these martyrs to the people's cause; even in chains, they preserved that inner moral freedom that all the kings in the world cannot snatch away. On their chains their country has engraved the words 'Live free or die', as it has engraved them on the nation's pikes, in your hearts, in our hearts, and in the hearts of all true Frenchmen."

On this occasion part of Voltaire's funeral conveyance, namely its wheels, turned up again on the "chariot of Liberty" designed by David. The sides of this vehicle were decorated with bas-reliefs, one showing Brutus sentencing his son, the other William Tell—a double allusion to the fate awaiting the king if he were to take part in another plot, as well as a celebration of the courage of these two heroes. The figure of Liberty on the chariot wore a Phrygian cap and held a lance in one hand and a terrestrial globe in the other. In front of the chariot, which was drawn by twenty horses, were six daggers poised to strike down enemies of liberty. The procession opened with four citizens bearing the Declaration of the Rights of Man engraved on two tablets of stone. These were followed by busts of Voltaire, Rousseau, Franklin and Sidney—who had preferred to die rather than submit to King Charles II of England. Next came two sarcophagi designed to recall the

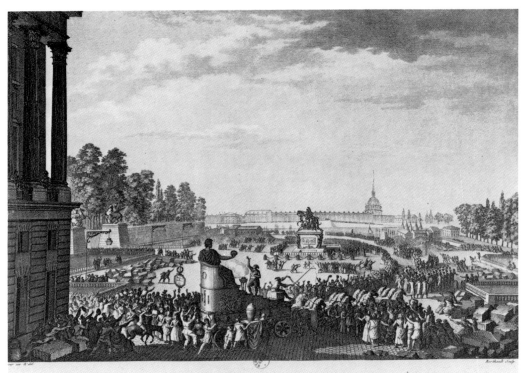

PREMIERE FÊTE DE LA LIBERTÉ A L'OCCASION DES SUISSES DE CHÂTEAU-VIEUX
le 15 Avril 1792.

76 *Fête for the Swiss Guards of the Regiment of Châteauvieux, April 15, 1792.* Engraving by Prieur and Berthomet. Cabinet des Estampes, Bibliothèque nationale, Paris.
The regiment in question had mutinied against its officers in August 1790 and the ringleaders had been sent to the galleys, but were now free again. The *fête* was the first of those entirely organized by David, who must have been responsible for the form and decoration of the chariot—a design for a very similar vehicle occurs in a sketchbook recently bought by the Louvre (RF 36942, folio 50).

massacre at Nancy in 1790 (which the unfortunate Désilles had tried to avoid), then the chains of the freed galley-prisoner suspended from trophies and carried by white-clad women citizens. Finally, there were forty Swiss guards side by side with volunteers and regular soldiers. The only touch of carnival in this solemn commemoration was the figure of Stupidity, which followed the chariots on horseback, striving in vain to find fault with the procession.

David organized a number of other *fêtes*, more or less on the same lines. The most interesting, in staging and in explicit content, was that of August 10, 1793, whose ephemeral artefacts David and the Committee of Public Safety wanted to immortalize in marble and bronze. The abstract side of the Revolution is very clear from David's preliminary report, presented on July 11, which celebrates eternal symbols rather than the actual events of the Revolution.

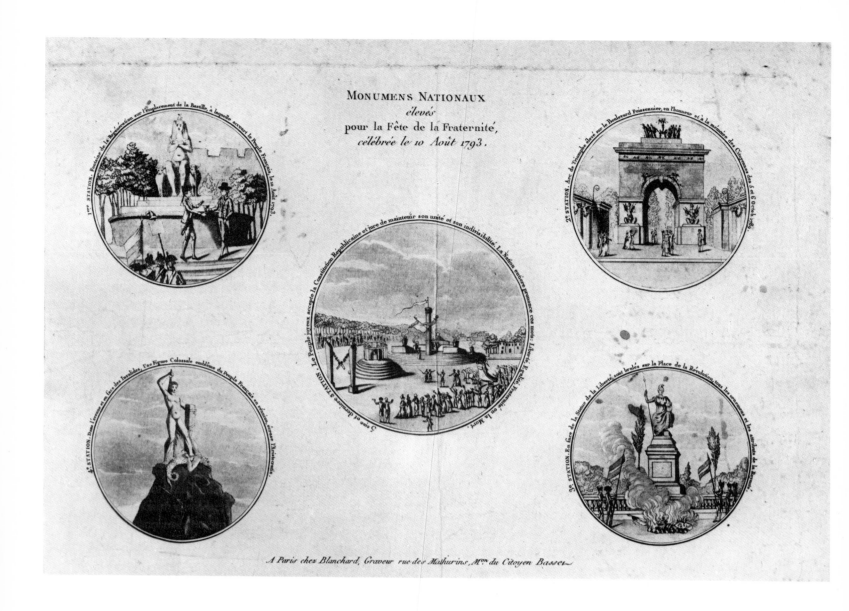

MONUMENS NATIONAUX
élevés
pour la Fête de la Fraternité,
célébrée le 10 Août 1793.

A Paris chez Blanchard, Graveur rue des Mathurins, Mᵐᵉ du Citoyen Basset

77 *Designs for the Five Halts of the Procession at the Festival of Brotherhood, August 10, 1793.* Popular engraving published by Blanchard. Cabinet des Estampes, Bibliothèque nationale, Paris.
The procession, organized by David, assembled at the site of the Bastille, then halted at: Boulevard Poissonière, where the events of October 5 and 6 were commemorated; Place de la Concorde, where Louis XVI had been executed; Place des Invalides, where the fall of the Girondins was celebrated; and, finally, Champ-de-Mars, where the participants swore to defend the new Constitution.

The ceremony started with a great gathering on the site of the Bastille, where the first halt took place: "In the midst of its rubble will rise *The Fount of Regeneration*, represented by the figure of Nature. Her hands will press her fruitful breasts, from which an abundance of pure, healthy water will gush, and this will be drunk in turn by eighty-six deputies from the delegations of the Primary Assemblies, that is, one for each Department. The oldest will be given preference, and one cup will serve for all." This is clearly a transposition of Christian ritual: as Hérault de Séchelles said in his speech on the day of the *fête*, taking up the exact words of the preamble to David's report: "the Almighty is going to see men equal and free again, just as they were when they left his divine hands."

The procession set out, headed by the people's clubs bearing "a banner on which will be painted the eye of Surveillance penetrating a thick cloud". Next came members of the Convention carrying an ark containing the Rights of Man and the Constitution, and finally the heterogeneous mass of the public surrounding "a truly triumphal chariot consisting of a simple plough on which will be seated two

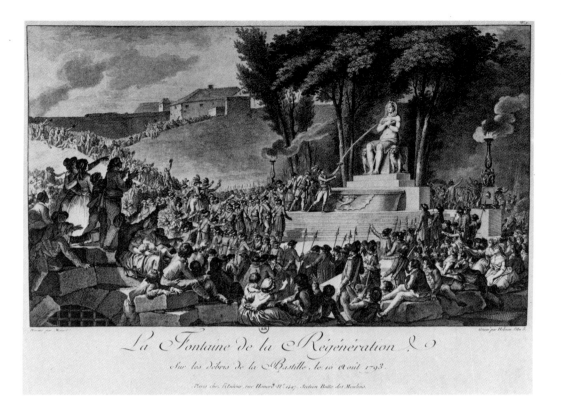

La Fontaine de la Régénération &c

Sur les débris de la Bastille, le 10 Août 1793.

Paris chez l'Auteur, rue Honoré N° 1147, Section Butte des Moulins.

old people, husband and wife. It will be drawn by their children, thus affording a touching example of filial piety and veneration for the aged". The bucolic, rustic, Rousseauesque aspect of the whole parade was striking from the start, for the future Place de la Bastille was to be decorated with "a richness ... derived from nature". The procession ended with a group of soldiers pulling a chariot containing an urn, "the depository of the ashes of heroes who have died gloriously for their country"; this was in contrast to the smaller vehicles that followed, "laden with the remains of the vile attributes of royalty and all the childish toys of the ignorant nobility".

The second halt was at Boulevard Poissonnière, where the events of October 5 and 6, 1789 were commemorated: the heroines of these events were seated on cannons under a triumphal arch. After being crowned with laurel by the President of the Convention, they joined the procession again and it proceeded to the Place de la Révolution (now the Place de la Concorde), where Louis XVI was executed on January 21, 1793. There the events of August 10—in other words, the fall of the monarchy—were celebrated. There, too, history was evoked in allegorical rather than factual terms: on the pedestal where Bouchardon's equestrian statue of Louis XV had stood until 1792, a statue of Liberty was unveiled. It was shaded in rustic fashion by oak-trees, in front of which were burnt "the impostorous attributes of royalty, while thousands of birds were set free and soared into the air".

At the fourth halt, in the Place des Invalides, the defeat of federalism on the previous May 31, i.e. the fall of the Girondins, was celebrated. On an artificial mound stood a colossal statue representing the People, the new Hercules, clubbing

79 *The Mound Erected at the Champ-de-Mars for the Festival of the Supreme Being, June 8, 1794.* Engraving published by Chéreau. Cabinet des Estampes, Bibliothèque nationale, Paris.
The last *fête* staged by David ended on this artificial hill with a regular concert, including a hymn to the Divinity, orchestral music, and a martial song: "Before we lay down our victorious swords, let us swear to wipe out crime and tyranny."

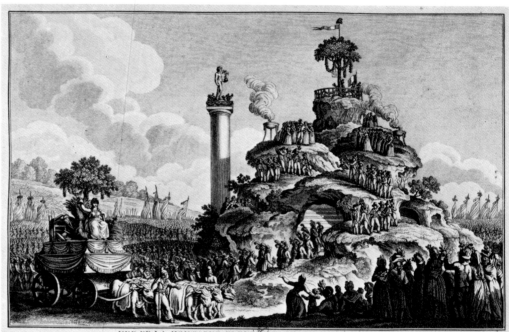

VUE DE LA MONTAGNE ELEVÉE AU CHAMP DE LA REUNION
pour la fête qui y a été célébrée en l'honneur de l'Être Suprême le Decadi 20 Prairial de l'an 2.e de la République Française
A Paris chez Chéreau Rue Jacques, aux deux Colonnes, près la Fontaine Severin, N.º 257.

"ambitious federalism emerging from its slimy marsh". As the meaning of the tableau was not immediately obvious, Hérault de Séchelles had to explain it in his speech.

Finally the procession reached the Champ-de-Mars, where the people—after passing under an egalitarian "national arch"—decorated the altar of the homeland with "the fruits of their labors" and "the tools of their craft or art", then swore to defend the new Constitution to the death. The laurel-wreathed urn containing the ashes of those who had died for their country was deposited "in the designated spot, where a superb pyramid will subsequently be erected". The day ended with a frugal meal eaten in the open air or in tents. "Finally, a huge theater will be built, in which the principal events of our Revolution will be presented in pantomime." This grandiose project was somewhat modified, since in fact all that was presented was a simulacrum of the bombardment of Lille, for which a fortress was built between the Champ-de-Mars and the Seine.

The last *fête* planned by David that actually took place—though he did prepare another, for Barra and Viala, scheduled for 10th Thermidor—was that of the Supreme Being, held on June 8, 1794. Before a crowd of onlookers in the Tuileries, Robespierre set fire with the "torch of Truth" to a cardboard group representing Atheism, which burned away to reveal the image of Wisdom. The procession then went on, as usual, to the Champ-de-Mars, where representatives of the different sections of Paris, together with musicians, assembled on the sides of an artificial mound, the top being occupied by deputies of the Convention. The *fête* concluded with a hymn to the Divinity and a song, taken up successively by the older men and the youths, the women, and finally the choir. The refrain ran: "Before we lay down our victorious swords let us swear to wipe out crime and tyranny."

Alexandre Lenoir, writing in 1835, has provided some details on the temporary sculptures, both statues and bas-reliefs, suggested by David or drawn by him in his usual allegorical spirit. Among the bas-reliefs, of which Lenoir owned smaller versions by Baltard the Elder, were representations of the Tenth of August, in which the People were contrasted with the Tyrant chained to their chariot; of the Republic, seated on a throne, one hand holding the Rights of Man and the other holding the fasces—the haunting symbol of Unity, always desired, always needing to be recreated; of the reign of Philosophy, at whose feet Fanaticism and Superstition lay dying; and, finally, of the triumph of Wisdom, whose chariot was preceded by Renown and drawn by Rousseau, Mably and Descartes.

All this pageantry demanded collaboration between the various arts. David was in charge of a whole team that included architects like his brother-in-law Hubert (who had married Constance Pécoul), Durand and Serangeli, Duplay, the carpenter at whose house Robespierre lodged, and musicians and composers such as Bruni, Sarette and Méhul. In the *fête* planned to honor Barra and Viala the ballet from the Opéra, under the direction of Gardel, was to have played an important part.

But *fêtes* are ephemeral things. To keep their memory and, above all, their message alive, what better means than sculpture? It was decided at first, following a report on the subject by David, to strike a simple bronze medal (gold and silver were excluded in the interest of austerity); one side was to show the Fount of Regeneration, the other the Ark of the Constitution and the fasces, "the symbol of unity and indivisibility". Later David, who had become a member of the

80 *The Triumph of the French People.* Drawing in black crayon, pen and Indian ink. 21×44 cm. Cabinet des Dessins (RF 71), Musée du Louvre, Paris.

While the citizens are engaged in exterminating tyranny, the chariot—in which the people are represented by Hercules—is followed by the heroes and heroines of liberty, including Cornelia, mother of the Gracchi, Brutus, and William Tell with his son. This drawing and the next are designs for a production at the Opéra—probably *The Meeting of the Tenth of August* by Bouquier and Moline, which was performed for the first time on April 5, 1794.

Committee of General Safety on September 13, 1793, suggested that a monument be erected to the glory of the French people. On November 7 he made a speech in which he proposed that fragments of the royal statues that had been demolished in the preceding year, or removed from the façade of Notre Dame, should be gathered together in the Place du Pont-Neuf and that above them should be raised "the image of the giant people, the *French People*. On the forehead of this imposing image should be written, in huge letters, *Light*; on its chest, *Nature* and *Truth*; on its arms, *Strength*; on its hands, *Work*. On one of its hands, the figures of Liberty and Equality ... should show the world that they depend solely on the genius and virtue of the people. In its other hand this upstanding image of the people should hold the real and deadly club of which that of Hercules was only a symbol." The project was set out in a report: the statue was to be cast in bronze captured by the soldiers of the Revolution from "the despots in coalition". Two competitions would be held, one for the model (which could obviously take as its inspiration the plaster statue created for the *fête* of August 10, 1793), the other for the actual

81 *The Triumph of the French People.* Pen drawing with Indian ink wash. 32×70 cm. Musée Carnavalet, Paris.
Finished version of the preceding drawing. Additional heroes behind the chariot include Pierre Bayle and, in particular, Beauvais de Préau, who appears to be strangling himself with his own neckcloth—a brand-new martyr of liberty, strangled on March 27, 1794.

executor of the project, to be selected from among the sculptors of the four best models. From the beginning of 1794 a veritable program for the embellishment of Paris, accompanied by the education of the people in revolutionary thought, gradually took shape. The Committee of Public Instruction was asked to study "ways of having suitable bronze monuments of Liberty made, together with busts of the great martyrs of the Revolution". In April, David and Fourcroy the chemist were specially entrusted with this task and set to work in collaboration with Barère and a parliamentary deputy named Granet. With the aid of four architects, including Hubert, they proposed a series of transformations in the neighborhood of the Tuileries, where the Convention met (it was as a result of this program that the Marly Horses were installed at the entry to the Champs-Elysées), and a number of competitions for painters, sculptors and architects. Among the monuments proposed we once more find that of the French people overcoming federalism, Nature regenerated on the ruins of the Bastille, the Triumphal Arch of October 6, and the figure of Liberty on the Place de la Revolution.

82 *The Legislator on Duty*. Drawing in ink and watercolor. 29×20 cm. Paris, Musée du Louvre, on loan to the Musée national du château (MV 5290), Versailles.

83 *The Judge*. Drawing in ink and watercolor. 24×20 cm. Musée du Louvre, Paris; on loan to the Musée national du château (MV 5292), Versailles.

All these projects, which took shape in April and May 1794, were published in the *Moniteur* of June 9. They would be halted by the events of 9th Thermidor, but taken up again—at least in part—by Paris town-planners of the nineteenth century. David, with the support of the Republican Society of Arts, at least had time to ensure adoption of the principle of competitions for artistic works commissioned by the state (though this was maintained only briefly) and that of "prizes of encouragement", which was applied until 1801 and then taken up again by Napoleon in the "Decennial Prizes". In November 1793 David presented a report on the constitution of the jury that was to replace the Academies (now dissolved) in awarding prizes for painting, sculpture and architecture. On this occasion he laid down a veritable program for the arts, which were:

to contribute to the progress of the human spirit, to propagate and transmit to posterity the striking example of the sublime endeavors of a great people, guided by reason and philosophy, in restoring to the world the reign of

liberty, equality and law. Thus the arts have a powerful contribution to make to the education of the public, though they first need to be regenerated. The spirit of the arts should be worthy of the people it enlightens. It should always go hand in hand with philosophy, which will provide it with nothing but great and useful ideas ... It is not only by delighting the eye that great works of art achieve their purpose, but by making a deep impression, akin to reality, on the mind: if the qualities of heroism and civic virtue are set before the eyes of the people, they will galvanize their souls and implant in them a passion for glory and an ardent devotion to the salvation of their country.

Thus all the arts were to contribute to a type of indoctrination, exercised from primary school onwards, that nowadays would be considered as totalitarian.

From all this feverish activity very few designs by David himself remain; he seems to have contented himself mainly with furnishing ideas for his team. At the Louvre and the Musée Carnavalet, however, there are two designs which he drew "for a curtain for a special program at the Opéra in consequence of a political event" (A. Lenoir). This "Triumph of the French People" is closely linked with the floats and processions of the *fêtes* organized by David, and with good reason. In fact both the performance and the political event, so coyly referred to by Lenoir, who was writing under the July Monarchy, can perhaps be identified. On April 5, 1794, *The Meeting of the Tenth of August*, or *The Inauguration of the French Republic* had its first performance at the Opéra. It was described as a "*sans-culottide* play in five acts, in verse interspersed with orations, songs, dances and military displays" and was dedicated to the Sovereign People by Gabriel Bouquier, Deputy to the Convention, and P.-L. Moline, its Registrar. Bouquier, himself a painter, had links with David. On November 25, 1793, they were both asked to prepare a report on a proposal by the minister of the Interior that the main features of the *fête* of August 10 should be perpetuated in paintings and drawings. It is possible to establish quite precisely the date of the two David drawings by the appearance on the second (the one at the Musée Carnavalet) of two figures who are identified in a study now at the Fogg Art Museum: one is Pierre Bayle, holding chains, the other, who seems to be strangling himself with his neckcloth, is Beauvais de Préau—the latter was in fact strangled at Montpellier by order of the British on March 27, 1794.

The *sans-culottide* libretto exactly echoed the *fête* devised by David and described above: the five acts corresponded to the five stages of the procession, and each of the five settings is described in terms almost identical to those of David's report.

EXPLICATION.

Ce Gouvernement est représenté sous la figure d'un Diable écorché tout vif, accaparant le Commerce et revetu de toutes les décorations Royales, le Portrait du Roi se trouve au derriere du Gouvernement le quel vomit sur son Peuple une multitudes d'impôts avec lesquelles il le foudroye. Cette prérogative est attaché au sceptre et à la Couronne.

We shall quote only the first of these descriptions: "The setting is the site of the Bastille. Amidst the rubble one can see the Fount of Regeneration, symbolized by Nature pressing her hands to her fruitful breasts whence gush two streams of clear water …"

In David's final drawing the People are represented by Hercules, with Liberty and Equality on his knees, seated behind Science, Art, Business and Plenty in a chariot, drawn by a team of four oxen, which is crushing tokens of royalty beneath its wheels. It is preceded by two patriots on the point of stabbing a king overthrown on the ground, and is followed by Cornelia and the Gracchi, Marat displaying his wound, Lepelletier staunching his wound with his hand, Chalier with the guillotine blade, and Beauvais strangling himself with his neckcloth. There are also historical figures symbolic of freedom, including Pierre Bayle and Jean Fabre, a Protestant, who in 1756 deliberately sought imprisonment in place of his father, who had been sentenced for practising his religion in spite of the edicts against it.

86 *The English Government*. Engraving. Cabinet des Estampes, Bibliothèque nationale, Paris.
The drawing for this engraving was supplied by David in 1794, together with a no less scatological caricature representing the "Royal Crackpot Army" (the English army).

In the spring of 1794 the Convention commissioned David to design costumes for officials of the Republic. A few of these designs, touched up in watercolor and engraved by Vivant Denon, later Director of Museums, are now in the Musée national du château, Versailles. David also sketched a civilian uniform for the French, as the Regeneration could hardly neglect its citizens' appearance, and later he also designed costumes for the Consuls of the Republic. David was not above caricature, and two anti-English engravings based on drawings he made in 1794 have survived. The first shows *The Royal Army of Crackpots* under the command of George III, whom Pitt, in the shape of a turkey, is leading by the nose while, on the left, excrement is gushing from *sans-culotte* buttocks in sufficient quantity to smash some of the English "crackpots". The second is also scatological: a rear view of the English Government as a crowned devil overwhelming its people with taxes. These minor graphic works could hardly be compared with his portraits of luminaries of the age, such as the oft-sketched Danton, and especially his deservedly famous and amazingly effective lightning sketch of Marie-Antoinette on her way to the scaffold (October 1793).

With his political functions and his reputation as an artist, David could have had a lot of say in administering the arts during the Convention, but he did not have enough spare time. To art lovers the great success—and also the great tragedy—of the Revolution was the census of the nationalized artistic heritage (property taken over from the clergy, refugees and the king), and the selection of works for the new museums, whose foundation led to the disappearance of most of the existing ones, a process begun long before David was elected to the Convention. The Commission for the Preservation of Monuments, reorganized in the autumn of 1793 as the Temporary Arts Commission, did most of the work, in collaboration with the Museum Commission that was set up after the king had been overthrown. However, David castigated the members of the Museum Commission, who included the painters Jollain, Vincent and Regnault, on overtly political grounds, because they were connected with Roland and also because he felt that the paintings were being restored badly. (The Museum was none other than the Louvre, opened on August 10, 1793.) David submitted two reports in succession and managed to reorganize the Commission at the beginning of 1794, under the name Conservatory of the Museum. He put several of his pupils on it, including Wicar, as well as old friends from Rome like the sculptor Dupasquier and the painter Bonvoisin, who "had in his favor his talent, his virtues, and a rejection from the former Academy".

Rev. de Paris. Honneurs rendus à la mémoire de le Pelletier. N°. 185. P. 226.

Jeudy 24 Janvier 1793, le Corps du Martyr de la Liberté, sorti de la maison de son frere et couvert à demie sur son lit de mort, fut exposé sur le piédestal de la Statue de Louis XIV. Place des Piques ci devant Place de Vendôme.

87 *Homage to the Memory of Le Pelletier.* Anonymous engraving in the *Révolutions de Paris*, Vol. 15. Cabinet des Estampes, Bibliothèque nationale, Paris.

As a representative of the nobility at the States-General and then as a deputy to the Convention, Lepelletier de Saint-Fargeau had voted for the death of the king. He was assassinated on January 20, 1793, the eve of Louis XVI's execution. Before being brought to the Panthéon, his body was put on view in Place Vendôme, on the pedestal of Louis XIV's statue, which had been destroyed some months earlier. The pedestal was flanked for the occasion by steps bearing candelabra and incense-burners. The *mise en scène* resembled that of the ceremony in honor of Voltaire and inspired David's picture.

David was obviously as hostile as ever towards the old Academy, though he had finally secured its abolition in August 1793, after a speech which developed into a tirade against all academies: "We must expose the moving spirit behind them, the petty jealousy of their members, the cruel means whereby they stifle budding talent, and the monkish revenge they constantly resort to if the young man they are after is unfortunate enough to have natural talent that puts him beyond reach of their tyranny."

Luckily for posterity, there was more to Davids's political activity during the Convention than the planning of ephemeral *fêtes*, since he also commemorated on canvas the sacrifices of the "martyrs of the Revolution". The first of these was Lepelletier de Saint-Fargeau, a member of an old noble parliamentary family, who was one of the presidents of the Paris Parliament before the Revolution. A typical representative of the liberal aristocracy active at the beginning of the Revolution, he was elected to the States-General and was among the few whose revolutionary ardor was not cut short by the overthrow of the monarchy. He was elected to the Convention and voted for the king's death a short while after putting forward a

plan, based on Condorcet, to organize public education. On January 20, the day before Louis XVI was executed, Lepelletier was murdered by Pâris, a former royal guard; the latter had originally intended to murder Philippe-Egalité, Duke of Orléans, a better known regicide, but was unable to track him down and so fell back on Lepelletier, whom he had encountered at one of the restaurants that opened at the Palais-Royal following the Revolution and were a great novelty at the time.

When the Convention met, Barère requested that Lepelletier be buried in the Panthéon. Marie-Joseph Chénier invoked Barnevelt and Sidney, earlier martyrs in the cause of freedom, and asked David to arrange the funeral at once with the musician Gossec. David himself had also voted for the king's death without appeal or delay. Chénier then suggested that Lepelletier's body be put on public view, with all his wounds visible and his blood-stained clothes also in evidence. The service was arranged for January 24 and was held in the presence of the entire Convention, the Executive Council, and the "administrative and legislative bodies". Lepelletier's last words were inscribed on his headstone: "I gladly spill my blood for my country. I hope it will consolidate liberty and equality and expose their adversaries." This contained a lesson for all good citizens, namely that it was sweet to die for one's country, as well as a warning to all traitors that they would be unmasked. It was explained in an address to the public that every citizen was aimed at by the murderer, and so were the life of the nation, public freedom and popular sovereignty.

The murdered deputy's body, its torso uncovered, was put on view on a couch placed on the pedestal of the statue of Louis XIV in the center of the Place Vendôme, a telling piece of symbolism—the statue itself had been pulled down in 1792, along with the other royal statues in Paris. David had flanked the pedestal with steps, on which stood classical candlesticks and enormous burners from which incense fumes were wafted. During the service the President of the Convention crowned the dead man's head, just as the figure of Immortality had crowned that of Voltaire fourteen months earlier. Afterwards, the body was taken to the Panthéon, the victim's bloodstained clothes being borne aloft on a pike garlanded with cypress and laurel leaves, followed by banners inscribed with Lepelletier's last words and the text used by the Convention in decreeing a Panthéon funeral. The dead man's brother, Félix Lepelletier, presented his sister-in-law and Suzanne, his eight-year-old niece, to the Convention. The Assembly decided to adopt the child, and Barère, going from the particular to the

general, proposed a law reviving the Roman custom of adoption, whose first beneficiary would be "Lepelletier's only offspring". David then suggested "a marble monument to show posterity how Lepelletier looked as you saw him yesterday, when he was being carried to the Panthéon". David obviously decided immediately afterwards that he himself would present posterity with the likeness of the martyr, because on March 29 he described his painting to the Assembly in a short speech as follows:

> The true patriot must seize any opportunity of enlightening his fellow citizens and must constantly show them the sublime face of heroism and valor ... I shall have done my duty if one day I cause an aging patriarch, surrounded by his large family, to say, "Children, come and see the first of your representatives to die for your freedom. See how peaceful his face is—when you die for your country, you die with a clear conscience. Do you see the sword hanging over his head by just a hair? Well, children, that shows how much courage Michel Lepelletier and his noble companions needed to rout the evil tyrant who had oppressed us for so long, for, had they set a foot wrong, the hair would have broken and they would all have been killed. Do you see this deep wound? You are crying, children, and turning your heads away! Just look at this crown; it's the crown of immortality. The nation can confer it on any of its children; be worthy of it."

> ... I ask the Convention to accept the homage of my unworthy talent. I would feel my reward all too great if it deigned to welcome it.

The Convention decided that the canvas would be not only hung in its meeting room but also reproduced as an engraving (Devosge's drawing, now in the Musée des Beaux-Arts, Dijon, was done to that end) and as a Gobelin tapestry. The canvas was returned to David in February 1795 and kept in his studio, but came to a mysterious and romantic end. Lepelletier's daughter renounced her father's convictions and became an ardent Royalist. Just after David's death, a few days before the sale of his studio (the catalogue of the auction included this painting), she bought the canvas from the painter's heirs for the vast sum of 100,000 francs and took it to the château de Saint-Fargeau, where it disappeared; it was probably burnt. (The sale on April 17, 1826 brought in only 60,000 francs, as David's popularity was at its nadir. The *Portrait of Mme Récamier* fetched barely more than 6,000 francs, the marvellous *Portrait of Mme de Pastoret* 400 francs, and that of *Barra* 2,000 francs.) David's heirs foresaw the danger and tried in vain to arrange for the painting to be shown to them once every six months, but Mme Lepelletier de

88 *Lepelletier de Saint-Fargeau.* By Anatole Devosge (1770-1850). Drawing in black crayon. 38×33 cm. Musée des Beaux-Arts, Dijon.

This is the principal vestige that remains to us of one of David's greatest masterpieces. The original painting, withdrawn from the Convention after 9th Thermidor and returned to David, was bought back after his death by the family of Lepelletier de Saint-Fargeau, who were by then ardently royalist, and seems to have been destroyed. Immobilized under the suspended sword, the dead hero—heir to both Hector and Christ—presents an unforgettable image. The diligent copyist gives us a hint of a remarkable still life formed by the sheets and pillow (carefully tied with a ribbon), whose whiteness would have been dramatically streaked with blood.

LEPELETIER de SAINT FARGEAU
Dessin d'Anatole DEVOSGE
d'après DAVID

Mortefontaine had even spirited away the plate and the whole printing of Tardieu's engraving, so Devosge's drawing, exhibited at the Salon in 1793, is almost all that remains of the masterpiece. The martyr's half-naked body—reminiscent, of course, of traditional pictures of Christ brought down from the Cross—is shown on its couch in the same position as Hector in David's admission piece for the Academy. The tremendous power of the picture is due to David's repudiation of the horizontal layout, so widespread among neo-Classicists, that the deathbed scene apparently called for. In *Andromache Mourning Hector*, David had already strongly emphasized the verticals cutting across the main horizontal. Here the geometrical structure of the work is stressed even more emphatically by the sword of the royal guard piercing the paper on which is written "I vote for the tyrant's death" and ready to repierce both Lepelletier's body and those of the good citizens incarnated in the deputy's body and symbolized by it. The hackneyed image of the Sword of Damocles is re-endowed with fascinating immediacy by its exact division of the canvas. As usual, the power of David's painting lies in the realistic details—the white sheets, the pillow-case tied with tapes, the anatomical accuracy, and the dead man's face. According to Delécluze, there was an impressive yet brief inscription at the bottom of the picture, "David to Lepelletier", and the date January 20, 1793, a procedure that would be repeated with the *Marat*.

Was Lazowski also a martyr to the cause of freedom? After his sudden death there was talk of poisoning, but this time the quarrel was among the revolutionaries themselves, since Vergniaud had already publicly denounced Lazowski's part in the anti-Girondin riots on March 8-10. Lazowski, the son of a rich Pole, had joined the Commune of Paris and was instrumental in sparking off the attack on the Tuileries on August 10, 1792. David was put in charge of the arrangements for the funeral on April 28. The din of the crowd was punctuated by anthems composed by Gossec as the people's sections, armed with pikes, marched behind the body—which lay on a bed of tricolor flags—from the City Hall to the Place du Carrousel, where it was buried at the foot of a Tree of Liberty, roughly at the point where Lazowski had ordered the onslaught of August 10.

The following month General (formerly Marquis) de Dampierre was killed by a cannonball at the walls of Valenciennes. He was a military hero whose aristocratic origins lent extra weight to his revolutionary beliefs. He played an important part in the Battle of Neerwinden which Dumouriez had lost in March, and, after Dumouriez's betrayal, had succeeded him at the head of the Northern

89 *Study for a "Dampierre"*. Drawing in black crayon. 19.7×17.7 cm. Nationalmuseum, Stockholm.
Despite his origins, the Marquis de Dampierre served the Revolution loyally as the general commanding the army of the north. He was killed by a cannonball at the walls of Valenciennes in May 1793. The Convention awarded him the highest honors and David thought of devoting a painting to him, of which this was a foretaste. However, the project never went any further.

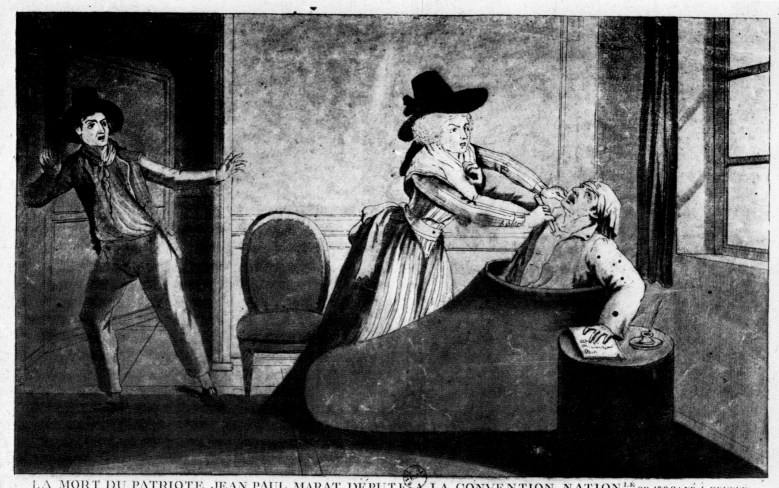

LA MORT DU PATRIOTE JEAN PAUL MARAT DÉPUTÉ A LA CONVENTION NATION.LE en 1792, NÉ A GENEVE:
Assassiné le 13 Juillet 1793, etant dans son bain, par Marie Anne Charlotte Corday ci-dev.t de S.t Amans, native de S.t Saturnin des Lignerets, Départem.t du Calvados.

Peuple, Marat est mort, l'amant de la Patrie
Ton ami, ton soutien, l'espoir de l'affligé

Est tombé sous les coups d'une horde flétrie,
Pleure, mais souviens-toi qu'il doit être vengé.

A Paris, chez Basset, M.d d'Estampes, rue S.t Jacques, au coin de celle des Mathurins.

90 *The Death of Marat.* Popular engraving. Cabinet des Estampes, Bibliothèque nationale, Paris. Unlike David, the anonymous artist shows Charlotte Corday at work in a well-lit room, which is hardly any more realistic than the insubstantial space in which David was to set his Marat.

Army. The Convention showered him with the highest honors; not only was he buried in the Panthéon, but a bust of him was put in the meeting room next to those of Brutus, Lepelletier and (later) Marat. David must have planned a painting to commemorate Dampierre's death, because there are two drawings in the Nationalmuseum, Stockholm inscribed "For Dampierre", in which the general is seen on the ground, clinging to his dead horse, calmly keeping his right leg—severed below the knee—raised in the air.

Was the project interrupted by a more important drama, Marat's assassination? On July 13 Charlotte Corday, who had arrived from Caen and Argentan two days earlier, managed to gain access to Marat by a letter in which she promised him information. After sitting down beside the bath-tub where he spent hours every day to soothe the itching caused by a skin disease, she started to write out a list of Girondin and counter-revolutionary deputies hiding out in Caen, then stabbed him with a knife. She had another letter on her, written after she had been turned away that morning, but which in the end she did not need. However, it made its mark:

91 *Funeral of Marat in the Cordeliers Church.* Anonymous. Oil. 59×73 cm. Musée Carnavalet, Paris.
Although poor in quality, this work gives us the *mise en scène* we have already encountered in connection with Voltaire and Lepelletier, using the same allegorical and classical idiom, enhanced in this case by the presence of the fatal bath and the wood block with the ink-well.

Chabot quoted it, slightly amended, at the meeting of the Convention, and it was this letter that David placed in the murdered Marat's hand, carefully inscribing the last sentence, which had by then been twice amended. The original version, clearly promising information, read: "I have some secrets to tell you that are vital to the safety of the Republic. I am being persecuted for the sake of Liberty; I am wretched; that alone gives me a right to your protection."

News of the murder soon reached the Jacobin Club, of which David himself had been president since June 16. He congratulated the neighbor responsible for Charlotte Corday's arrest (she was guillotined four days later) and embraced him like a brother. The news of the death of "the people's friend" spread like wildfire and caused much grief. In the Commune Hébert immediately asked that Marat be buried in the Panthéon, and the sculptor Beauvallet was commissioned to take a cast of his head for a bust.

At the Convention on the next day delegations from the Paris sections in turn denounced Charlotte Corday and paid tribute to the dead man. Requesting a torture worse than mere death for the murderess, Guiraud, spokesman for the Social Contract section, said:

We are not here to sing your praises, immortal legislator! We have come to mourn you and pay tribute to the splendid actions of your life. Liberty was engraved on your heart in indelible letters. So foul a deed! A parricide's hand has bereft us of the people's boldest champion, whose only crime was that he constantly sacrificed himself for the sake of freedom. Our eyes seek him among you still. He is—dreadful to behold!—on his deathbed. Where are you, David? You gave posterity the picture of Lepelletier dying for his country, and here is another painting for you to do. David replied: "I shall do it."

Deputy François Chabot gave details of the murder and even re-enacted it with the aid of a bloodstained knife; he also read Charlotte Corday's second, amended letter, in which the last sentence had become: "I need only make you see how wretched I am to have a right to your esteem." On July 15 the Convention decided to put David and Maure in charge of the funeral, after David had said: "The day before Marat's death the Jacobin Club sent me and Maure to see how he was. I was struck by the way I found him. He had beside him a wood block with paper and ink on it, and he had one hand out of the bath-tub in order to write down his latest ideas for the people's safety. Yesterday the doctor who embalmed him sent to me to ask how his body was to be displayed to the public at the Cordeliers' Church. As you know, parts of his body can't be shown because he had a kind of leprosy and his blood was inflamed. But I thought it might be interesting to show the way I saw him, writing for the people's happiness."

Next day David changed his plans: "We have decided to show his body covered with a damp cloth to represent the bath-tub; this will be wetted from time to time to prevent putrefaction. He will be buried at five o'clock this evening under the trees where he so enjoyed dispensing advice to his fellow citizens. His grave will be simple, as befits a staunch Republican who died in honest poverty." However, according to the memoirs of the engraver J.-G. Wille and to a mediocre painting at the Musée Carnavalet, Marat's body was placed on a pedestal, the upper part bared to show his wound, with the bath-tub, wood block, and ink-well arranged on a step beneath the body. David probably did the marvellously economical pen drawing of Marat's head (now in the Musée national du château, Versailles) between July 14 and 16; it was popularized the following spring by Copia's very faithful engraving. As Marat had not yet been buried in the Panthéon, he was entitled only to a slow procession made up of members of the public "gathered beneath the banners of the sections", the Convention, the Commune, the Department and the people's societies.

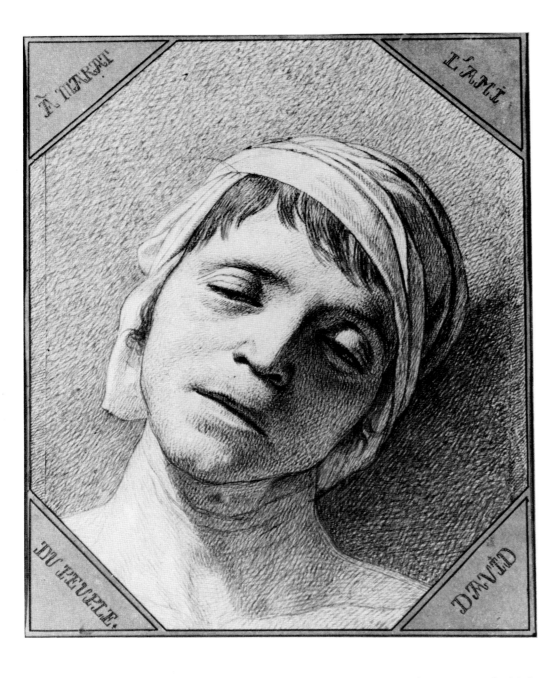

92 *Head of the Dead Marat.* Pen drawing.
27×21 cm. Musée du Louvre, Paris; on loan to the
Musée national du château (MV 5288), Ver-
sailles.
This superb drawing, an engraving of which was
widely circulated, employed a technique that was
relatively rare for David, though not unusual at this
point in his career. In one of the most moving
images of the whole Revolution, it shows how the
finger of Death had already erased any trace of the
angry passions of the "Friend of the People".

It was left for David to ensure him his true immortality in the canvas of which
he announced the completion to the Convention on October 14. He displayed it to
3 the public in his own studio and then in the courtyard of the Louvre, together with
the famous bath-tub and the portrait of Lepelletier, and presented it to the
Assembly on November 15.

Hurry, all of you! Mothers, widows, orphans, downtrodden soldiers, all
whom he protected at the risk of his life, draw near and gaze on your friend; he
who was so vigilant is no more; his pen, the bane of traitors, his pen has
slipped from his fingers! Grieve, for your untiring friend is dead!

He died giving you his last crust of bread; he died without even the means
to pay for his funeral. Posterity, you will avenge him; you will tell our
descendants what riches he could have had if he had not preferred virtue to

wealth ... To you, my colleagues, I present my tribute in paint; as you scan Marat's livid, bloodstained features, you will remember his goodness, which you must never cease to emulate ...

In the same speech David asked that Marat be buried at the Panthéon. The Convention acceded to his request and decided that the paintings of Lepelletier and Marat should be reproduced as engravings, and that a thousand of each should be sent to the people's representatives and the Departments.

The canvas is roughly the same size as the Lepelletier portrait (165 by 128 cm) and was designed as a pendant to it, the two figures facing in opposite directions. The paintings of the two martyrs hung in the Convention's meeting room until February 1795 when they were returned to the painter. We have mentioned the sad fate of the Lepelletier portrait; the Marat stayed in David's family and has been in the Brussels Museum since the end of the last century. The French have to make do with studio copies, the best being the one at the Musée national du château, Versailles.

By comparing that version with the original, it is possible to understand the importance of the empty yet vibrant background against which the figure stands out. It is an incredible example of pure painting, in which David left the scumbling visible as he had done in the earlier unfinished paintings. This bleak background, substituted by David for the actual decoration in Marat's bathroom (wallpaper with a design of fake pilasters, at least one map of France and a brace of pistols) helps in building up the picture by the play of light: the dark area on the left emphasizes the brightly lit head and arms of the "martyr", while the lighter area on the right balances the mass of the wood block, which in turn balances the bust of the dead man.

It has often been said that, in this painting and the Lepelletier portrait, David called on the religious feeling that was still so strong in France and that also imbued the processions at revolutionary *fêtes*. The "martyrs of the Revolution" were modern versions of the Christ that earlier painters had so often depicted at the moment of the descent from the Cross; there is more than just a similarity of treatment, for both Lepelletier and Marat gave their lives for the salvation, politically speaking, of their fellow men. But the picture is great enough to transcend time, because the political meaning is overshadowed by the moral allegory. David was extolling the qualities of poverty and charity, qualities that caused Marat's death because Charlotte Corday, a latter-day Judas, had appealed to them. The letter he is holding in his hand has been amended yet again and is more

93 *Marat Assassinated*. Signed and dated Year II (1793). Oil on canvas. 165 × 128 cm. Musées royaux des Beaux-Arts, Brussels.
Jean-Paul Marat, principal representative of the left wing of the Montagnards, was assassinated by Charlotte Corday on July 13. David, who organized the obsequies, finished the picture in October, exhibited it to the public, and presented it to the Convention on November 15. *Lepelletier* and *Marat* adorned the Hall of the Convention until February 1795—not just two masterpieces of Revolutionary painting, but two masterpieces in their own right.

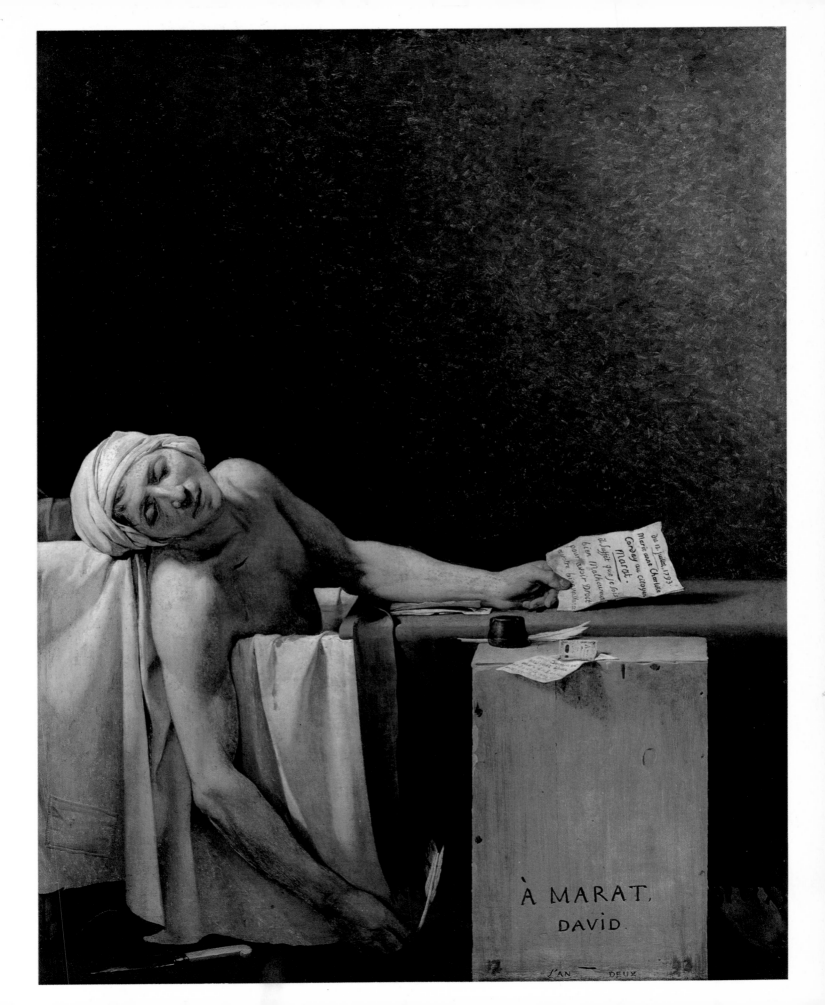

eloquent than ever: "It is enough for me to be truly wretched to have a right to your kindness." Behind the pen and ink-well on the wood block by the bath-tub are a banknote and a covering letter that reads: "You are to give this money to this mother of five whose husband died for his country." The generosity thus attributed to Marat (this moving detail was not mentioned at the trial and was probably the painter's own invention) contrasts with the monastic poverty in which David has placed him, symbolized not only by the wood block but by the darned sheet on the left. The wood block is the most fascinating item in the picture, immobile, hardly affected by the letter balancing on the edge, bearing eternal witness to the martyr's alleged qualities, and inscribed with a dedication that is truly classical in its brevity: "To Marat, David."

Marat's many virtues make his spilt blood all the more horrifying: in the foreground its bright red marks the knife with which the crime was committed, as it trickles from the gaping wound beneath the collarbone on the right to stain the sheets and the paper. But death was omnipresent in those revolutionary days; it dogged the patriot ready to die for his country as well as the public enemy plotting in the shadows. Most of the great *fêtes* of the Revolution were given a funereal turn by the presence of the ashes of dead heroes, and David's commemorative masterpieces of 1793-4 strike the same note.

Maybe Marat was nothing more than an impassioned demagogue, but he nevertheless inspired this marvellous picture in which stylistic simplicity harmonizes with the virtues attributed to the dead man in a way that continues to fascinate us. Sparing us none of the details, David transformed a grisly murder into that astounding interplay of the real and the ideal which constitutes the basis of his art: Marat's face is finally at peace beneath its turban of damp cloth. In 1846 Baudelaire wrote: "This painting is as ruthless as Nature, yet it exhales idealism. Where is the ugliness that hallowed Death erased so quickly with the tip of his wing? From now on Marat can compete with Apollo, for Death has kissed him with loving lips and he slumbers in the peace his metamorphosis has brought. This work is both tender and touching; in that cold room with its cold walls, around that cold, coffin-like bath-tub, there hovers a soul."

The list of official martyrs was not yet complete. On December 8, 1793 General Desmarres, who led the Republican troops against the Vendean rising at Bressuire, sent the Convention an account of the heroic death of a child called Joseph Barra from his own native Palaiseau, who had followed the army for a year, "mounted and fitted out as a hussar. The whole army watched in amazement as the

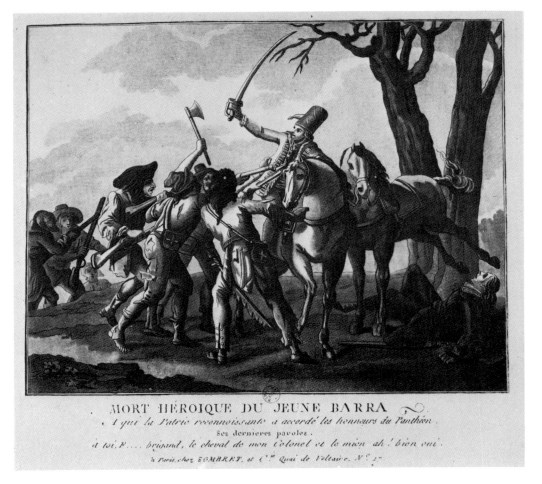

MORT HÉROIQUE DU JEUNE BARRA

A qui la Patrie reconnoissante a accordé les honneurs du Panthéon.

Ses dernieres paroles.

à toi, F..... brigand, le cheval de mon Colonel et le mien ah! bien oui.

à Paris chez SOMBRET, et C.ie Quai de Voltaire. N.º 25.

94 *Heroic Death of Young Barra.* Anonymous engraving. Cabinet des Estampes, Bibliothèque nationale, Paris.
At the beginning of December 1793 Joseph Barra—a youth serving as batman to the leader of a Republican army in Vendée—was killed by the Chouans for refusing to let them have two horses he was leading along. The caption to the engraving reproduces his last words (see main text) as reported by his chief.

thirteen-year-old boy confronted every danger, always charging at the head of the cavalry. Once we saw him, with only his boy's strength, strike down and capture two bandits who had dared attack him. Yesterday this brave child was surrounded by brigands and chose to die rather than give them the two horses he was leading. He was good as well as brave, for he stinted himself of food and clothes to give everything he could get hold of to his mother, who is left with several daughters, a young invalid son and no means of support. I beseech the Convention to save this unfortunate mother from the horrors of poverty. She lives in Palaiseau, near Versailles.''

Barère read this out to the Convention on December 15, and the Assembly immediately decided to help the deserving mother and grant her an allowance. However, Robespierre apparently realized afterwards the leverage that could be gained from publicizing a death rather like Marat's as seen by David, because it displayed not only patriotism but the domestic virtues. On December 28 he requested a Panthéon funeral for the young hero, whose rather banal death was thus transformed: "Surrounded by brigands who threatened to kill him and ordered him to cry 'Long live the King!', he died shouting 'Long live the Republic!'." Here too Christian influence can be discerned, if the story of Barra is compared with the tales of earlier martyrs who preferred to die rather than make sacrifice to idols. Robespierre added: "This small child supported his mother on his earnings; he divided his loyalties between his filial affections and his country. It would be impossible to find a more perfect example to kindle the love of glory, country, and virtue in young hearts." He then suggested that David should arrange the transfer of the body to the Panthéon.

Barère, who was entrusted with "cultural affairs" in the Commission of Public Safety, spoke after him: "His courage will be an example to every child in the Republic, his picture painted by the celebrated David will hang in every primary school ... I should like the Assembly to order an engraving of the heroic action and filial devotion of Joseph Barra (of Palaiseau) to be done at the expense of the Republic ..."

A second letter from General Desmarres (who was arrested a few days later and executed) was read to the Convention of January 10, 1794. He had been told about the plan and detailed the circumstances of Barra's death as David ought to paint them: "I think he should be shown as he was when he received the final blows, on foot, holding two horses by the reins, surrounded by brigands, and replying to the man who had come forward to try and make him give up the horses: 'You damned brigand, give you the horses, the commander's horses, and mine? Certainly not?' Those were the words, repeated several times, that cost him his life." The engraving that Sombret published shows this scene just as General Desmarres described it and reproduces Barra's words.

For some reason the plans of Robespierre and Barère were delayed. Meanwhile another young prodigy had died for his country in similar circumstances. On February 4 *Le Républicain* reported the heroic death of young Agricol Viala, killed while attempting to cut the cable of the ferry on which rebels from Marseilles were trying to cross the Durance. On May 7 Robespierre mentioned both boys together

in his famous speech acknowledging the Supreme Being and requested that they be buried at the Panthéon. The two burials were originally scheduled for June 18, then postponed until July 28, i.e. 10th Thermidor, and therefore did not take place, though David, once again in charge of the funeral arrangements, spoke to the Convention on the subject on July 11. His description of Barra's death corresponds exactly to the unfinished painting that Horace Vernet gave to the Musée Calvet, Avignon in 1846. "The heroic thirteen-year-old Barra, who kept his mother, was here surrounded on all sides by the butchers of humanity and fell alive into their ruthless hands, overcome by their numbers. Goodness shines especially brightly in times of danger. When the brigands ordered him to say 'Long live the

95 *Joseph Barra*. Oil on canvas. 118×155 cm. Musée Calvet, Avignon.
At the end of December 1793 Robespierre seized on a minor military incident and transformed the unfortunate Barra into a symbol of all the revolutionary virtues, requesting that he be given the honors of the Panthéon. Ordered to cry "Long live the King!", Barra had preferred to die crying "Long live the Republic!". David was asked to portray the scene, but did not have time to finish it before 9th Thermidor.

King!', the child shook with indignation and cried 'Long live the Republic!', whereupon he was run through and fell, clutching his red, white and blue cockade to his heart."

This departs considerably from General Desmarres's account. David, with his vivid imagination, played down the political propaganda and idealized the whole scene, transforming it completely. The brigands are reduced to an insignificant blob at the far left of the canvas, and even the wounds and blood, so much in evidence in previous pictures of "martyrs", are missing. There is nothing left but the boy lying naked in the solitude of death, clutching his tricolored cockade to his breast with both hands. It has been suggested that David painted clothes on to the corpse in the finished picture. This is plausible enough, considering that David used to draw the figures naked on his final canvas for a picture and then add the clothes, as shown by the enormous sketch for *The Oath of the Tennis Court*. However, the rather detailed drawing of the body suggests that the boy was also naked in the final version and reminiscent of some ancient god, a further manifestation of the fascinating fusion of the present and the distant past that typified the art of the Revolution. This patriotic child, also "kissed with loving lips" by Death, lies frozen in a silvery network of brush strokes, akin to the supple Hellenistic statues that inspired David's pupil Girodet to paint his *Endymion*, exhibited at the Salon in 1793.

By stripping away anecdotal detail, David here produced a pure allegory of patriotism. To quote Lenoir: "Judging by his light brushwork and elegant drawing, I would say that the painter wanted to stir up both tenderness and pity over the boy's tragic remains. His pain ended with his life; it is still etched upon his face and so well drawn that, while the painting is impressive, you feel repelled by it as well as drawn to it. It reminds me of Hyacinth, the image of perfect beauty, struck on the head and felled by Apollo's discus." Once again, albeit for the last time, the classical spirit and the Revolution were in harmony.

V. RETURN TO ANTIQUITY

David and 9th Thermidor. His imprisonment. Portraits of the Sériziats, Mme de Verninac *and* Mme Récamier. *David's election to the new Institute. His studio at the Louvre.* The Sabine Women. *First studies for* Leonidas at Thermopylae.

David was not at the meeting of the Convention on 9th Thermidor, and this probably saved his life. If we are to believe his unpublished speech to his fellow deputies, drafted round about the autumn of 1794, "I was so far from foreseeing the events that took place that I had set the day aside to take an emetic." Nevertheless, he had said something the previous day that was to be one of the main indictments against him. When Robespierre had finished his address to the Convention, he cried "All I can do now is to drink hemlock"; in a classical outburst of passion, so typical of the Revolution, David replied "If you drink hemlock, I'll join you." Between 10th and 12th Thermidor Robespierre and about a hundred of his followers were guillotined. Luckily it was not until 15th Thermidor that David was arrested and the Committees for Public Safety and Legislation were asked to take up the case against him.

He was first imprisoned, in fairly pleasant conditions, in the old Fermes Générales building in rue de Grenelle-Saint-Honoré, where he was allowed to have visitors and his pupil Delafontaine brought him painting materials. According to Delafontaine, it was there that David painted his second self-portrait (now in the Musée du Louvre, Paris), which he later gave to Isabey, another pupil. After a month he was transferred to the Luxembourg, remaining in prison until December 28. However, the campaign against him continued, and on May 2 the Museum Section brought a charge against him on seventeen counts. On May 28, 1795 David was again imprisoned, this time in the Quatre Nations, as a result of the Montagnard riots of 20-21 May and the reaction to them. He was freed for good on August 4, and his fears were allayed on October 26, 1795 when the Directory took over.

There were two sets of charges against him. His political position was precarious because of his obvious connection with Robespierre and his group, and because he had belonged to the Committee for Public Safety and signed a number of arrest warrants. David defended himself convincingly to his colleagues, claiming that he wished only "to further the cause of the People" and then recalling how he had always supported those who seemed to him "to love freedom most"; "until he was unmasked, Robespierre was undeniably able to gain support

◁ 96　*Self-portrait*. Oil on canvas, 81×64 cm. Musée du Louvre, Paris.
The second of David's self-portraits, more relaxed than the first (Pl. 69), was nevertheless painted during his imprisonment, which lasted until the end of 1794.

97　*View of the Luxembourg Garden*. Oil on canvas, 55×65 cm. Musée du Louvre, Paris.
After a month's confinement in what used to be the Farmer General's town-house, rue de Grenelle-Saint-Honoré, David was transferred to the Luxembourg. There he painted his only surviving landscape—a realistic scene organized in geometrical fashion.

98 *Head of a Young Woman.* Drawing in black crayon. 37×26 cm. Private collection.
This drawing, which came on the market in Paris in 1975 and later on in London, bears the inscription *J.-L. David faciebat in vinculis*, which enables us to date it. Inspired both by classical sculpture and by Raphael, it is one of the most astonishing creations of an artist whose talent for drawing has often been underestimated.

from anyone genuinely dedicated to the success of the Revolution, for he seemed to embody every Republican quality in all the guises he assumed so cleverly ... you trusted him and constantly applauded him in this very room, and he was celebrated throughout France."

The specific charges against David were rather contrived. The claim that the crowds assembling to honor Barra and Viala were to be used by him to support Robespierre's "conspiracy" was highly unconvincing. It was blatantly untrue that David had drawn up lists of artists to be denounced, and he easily proved that the list found at his house was the one he had just put forward to the Ministry of Public Education giving the jury of artists that was to judge the competition for monuments organized the previous month by the Committee for Public Safety. David could point out that "none of the artists with whom the public judged me fit to compete" had been bothered during the Terror. "I explicitly testify that I have never caused any artist's arrest, on the contrary ... I busied myself helping a number of those who had sided with my enemies." It was harder to follow him when he claimed that he was "almost completely ignorant" about what went on in the Committee for Public Safety, as a good many arrest warrants bearing his signature have survived. But it is true that his role as pageant-master of the Revolution—which nobody held against him, though there were grumbles about expenditure—had quite different implications from his activities on the Committee for Public Safety. When accused of being "the tyrant of the arts", he boasted that he had, on the contrary, overthrown the institution of the Academy, which stifled budding talents, and that he had been in favor of competitions. All in all, the charges drawn up by the Museum Section emphasized words not deeds, and David defended himself with vigor.

In the Luxembourg prison he was reconciled with his wife, whom he had divorced the previous March, presumably for political reasons. Some of his drawings from this period are inscribed *David faciebat in vinculis*; they include a large pen-drawing of a head reminiscent both of classical art and of Raphael and an extraordinarily vivid circular portrait of Jean bon Saint-André, a fellow member of the Convention, also imprisoned (Art Institute, Chicago). These may be compared with two other crayon portraits of similar format, both in the Louvre.

David also painted his only known landscape in the Luxembourg prison—a realistic work with a strictly geometrical layout (Musée du Louvre, Paris). According to Delafontaine and Delécluze, he also did the first rough sketch for *The Sabine Women* there and gave it to the sculptor Espercieux at the beginning of 1799

99 *Portrait of Jean bon Saint-André*. Pen drawing with brown wash, touched up with gouache. Diameter: 18.1 cm. Joseph and Helen Regenstein Collection (1973-153), Art Institute, Chicago. David went to prison for a second time from May to August 1795, and it was then, as the inscription on the mount indicates, that he drew this portrait of his colleague Jean bon Saint-André—sailor, pastor, regicide—who ended up as a Prefect and a Baron of the Empire.

(Cabinet des Dessins, Musée du Louvre, Paris). However, his most important project, mentioned in his letters, was *Homer*. On September 15, 1794 he asked if he could have models visit him "to finish a painting". On November 8 he wrote to M. de Mainbourg: "I'm very bored right now, because my *Homer* is completely mapped out. I'm dying to get it down on canvas, because I feel it will be a step forward for art. I'm so inspired, and here I am in irons. I'm not allowed to go back to my studio which, alas, I should never have left." Two projects are in the Cabinet

des Dessins at the Louvre. One shows two girls bringing gifts to the sleeping Homer and the other, which is much more finished, shows the poet reciting to a small crowd. The overall arrangement of the architecture is the same in both cases, with an enormous pillar taking up more than half the composition, but the first drawing is based on the actual architecture of the Luxembourg with its arcades between double pilasters, double columns, balustrades and well-defined triglyphs. The second has been modified in "classical" style, the decorative details erased, and the volumes simplified. However, the arrangement of the scene and its space on opposing, heavily stressed diagonals, which today look baroque rather than neo-classical, is the same. This is the complete opposite of what *The Sabine Women* was to be. The asymmetrical arrangement with the key figures on an upper level is further emphasized by the contrasting values of an Indian ink color-wash.

After his second stretch in prison David was sent to stay with the Sériziats at Saint-Ouen, near Tournan-en-Brie, where he had already gone after his first imprisonment. There he painted a half-length *Psyche*, which has now disappeared but was probably intended as a pendant to *The Vestal Garlanded with Flowers*, now in Los Angeles, as David mentions them both together in the two catalogues he compiled himself. More important, he also painted portraits of his sister-in-law and brother-in-law, the first in August and the second in September; both are on wood, which is unusual for David. Perhaps, as often happens, the unfamiliar backing explains the technical refinements in which he apparently took such pleasure, notably in the treatment of the bunch of wild flowers his sister-in-law is holding and his brother-in-law's splendid suit. The *Portrait of Mme Sériziat* and her child is similar to the portraits of the revolutionary period in layout and because of its bare background, in which light rubbing has perhaps made the vibrant brush strokes more obtrusive. The painter's joy in his work is communicated to the spectator in the free yet accurate disposition of the bunch of flowers, the bright green and blue ribbons, and the different thicknesses of paint on the neckline of the dress and the scarf around it that make the dress stand out. Joy likewise spills out from the *Portrait of Pierre Sériziat*, represented—unusually for David—out of doors. Here the treatment of nature is in fact abstract—a rock over which a coat is spread, a tuft of foliage, and a vast insubstantial sky defined only by an occasional patch of blue. This unrealistic view of nature is compounded by the discolored foliage at Sériziat's left elbow, which could be either a badly covered-up mistake brought out by time or cleaning or else a quite deliberate device. At any rate it produces a fascinating effect as the transition between the few detailed fragments

100 *Homer Reciting his Verses to the Greeks*. Drawing in black and red crayon and pen, with an Indian ink wash. 27×34.5 cm. Cabinet des Dessins (RF 789), Musée du Louvre, Paris.
While in the Luxembourg, David decided to return to traditional historical painting, choosing this subject, which he later relinquished in favor of *The Sabine Women*. A first sketch, also in the Louvre, had an architectural background inspired by the Luxembourg, redone here in classical style.

of vegetation and the almost empty vastness of the sky. The main yellow-blue harmony (reminiscent of the *Portrait of Count Stanislas Potocki*) is equally fascinating, and so is the interplay of corresponding curves in the legs and coat, suit, hat and whiplash. Did Ingres, not yet in Paris at the time, see this portrait later? All his portraits of 1805-6 give the impression of being built around a similar use of arabesque (*La Belle Zélie, Les Rivières*). Gérard openly acknowledged his debt in the fine La Révellière-Lepeaux portrait of 1797 (Musée des Beaux-Arts, Angers), though the detailed pastoral setting makes it a little banal.

The *Portrait of M. Sériziat* was not quite finished on September 23, according to a letter from David to Mme Huin, so it was probably submitted rather late to the Salon, which opened a few days later, as the catalogue mentions only the *Portrait of Mme Sériziat*. Both were well received. David painted a few more portraits that year, including the enchanting rosy likeness of Mlle Tallard, with a doleful inscription on the back telling us that this "pious, charitable person whose

struggles and misfortunes are well known" was painted by David in 1795 when she was twenty-two. He also painted portraits of Blauw and Meyer, plenipotentiary ministers of the Batavian Republic newly established in Holland after the French victory in the winter of 1794-5. The portrait of Blauw was removed from Musée des Beaux-Arts, Dijon, after a court decision and belongs to an international company, while the portrait of Meyer is in the Louvre. There is a strong contrast between them—Blauw looks informal and friendly, apparently caught unawares while writing a letter, whereas Meyer, in a luxurious armchair, poses solemnly for posterity in a fine red waistcoat. The model never fetched his portrait, which remained in David's studio until his death.

During the next few years David was absorbed in painting his *Sabine Women* and did hardly any portraits. The only known one is *Mme de Verninac* of 1799 (Musée du Louvre, Paris), the model being Eugène Delacroix's elder sister, the wife of the Prefect of the Rhône. Here David harks back to the layout of his portraits of the revolutionary period, especially the one of Mme Trudaine, since he paints a rudimentary background in the lower part, with a skirting-board and tiles. The wall, however, is plain, enlivened by perceptible scumbling and a skilful effect of gradually diminishing light—a marvellous foil for the smart young woman, transformed into a lithe Greek statue by her costume and neo-classical chair. In mid-June the following year, David inaugurated a completely new method in his *Portrait of Mme Récamier*, transposing the stark arrangement of so many neo-classical portraits into a very elegant, contemporary setting. The slender vertical of the candlestick from *The Death of Socrates* is still there, but the deathbed has become a fashionable Jacob couch belonging to the studio, but not unlike the one the young woman actually had in her Chaussée d'Antin apartment. The barefooted figure that reclines on it already has some of the lissome grace of Ingres's *Grande Odalisque*. David uncharacteristically hollowed out his space, so that his model floats in the corner of an empty room, whose walls and floor never got beyond the scumbling stage, as the portrait was never finished. According to complementary accounts by Delafontaine and Delécluze, Mme Récamier found the painter too slow and the sittings too long and too numerous, so she threatened to go to Gérard instead, whereupon David refused to continue. The story is rather more complicated, however, according to a letter dated September 28 from the painter to his model, in which he asked if he could take up the portrait again in a more brightly lit setting, as he was dissatisfied with it. In fact he kept the unfinished painting in his studio until his death. His genius is obvious when his work is compared with the

101 *Portrait of Pierre Sériziat*. Oil on wood. 129×96 cm. Musée du Louvre, Paris.
The model—Mme David's brother-in-law—was a magistrate and very attached to the painter, who went to stay at Sériziat's place in the country on being released from prison. The portrait and its companion-piece (Pls. 102 and 103) were exhibited at the Salon of 1795.

176

102, 103 *Portrait of Mme Sériziat*. Oil on wood. 129×96 cm. Musée du Louvre, Paris.
With its indoor setting, this is an elegant companion-piece to the outdoor portrait of the husband. The detail gives a better idea of the high technical quality—a combination of precision and control—displayed in the treatment of the hair and the ribbons.

104 *Portrait of Mlle Tallard*. Signed. Oil on canvas. 64×54 cm. Musée du Louvre, Paris.
This small portrait of a "person... celebrated for her troubles and misfortunes" was also painted in 1795. As was his custom, David used scumbling to create a vibrant background against which the model stands out.

105 *Portrait of M. Blauw*. Signed. Oil on canvas. 91×72 cm. Private collection.
The sitter, who (very unwisely!) failed to take delivery of his portrait, was a plenipotentiary minister of the "Batavian Republic".

portrait Gérard finally painted (Musée Carnavalet, Paris), for instead of David's legendary coquette who was to hold Lyons and Paris in thrall with her charms for the next fifty years, Gérard has merely painted a pretty woman in the rather sophisticated setting of a loggia that is almost as much the focal point as the sitter is. David, however, transcends everyday reality, creating a universal image that haunts us even now, something rare in a portrait.

On November 16, 1794, while David was still in prison, he thanked Boissy d'Anglas for intervening with the Convention in his favor and attributed his long incarceration to spite on the part of the academicians. "But don't you agree that the Academies have never produced more than minor talents? ... We have not had a truly great man, properly speaking, since the Academy was founded; as genius is shackled on all sides, it cannot take wing."

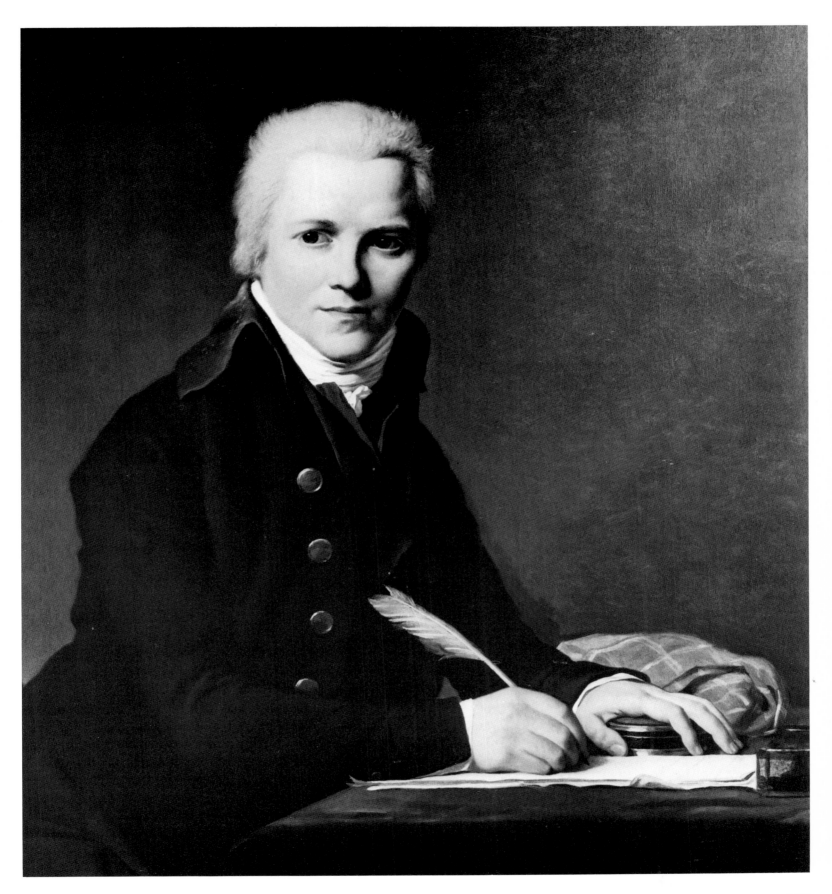

106 *Portrait of M. Meyer.* Signed and dated Year IV (1795). Oil on canvas. 116×89 cm. Musée du Louvre, Paris.
The model was also a representative of the "Batavian Republic" in Paris, but this rather solemn portrait presents a contrast to that of Blauw.

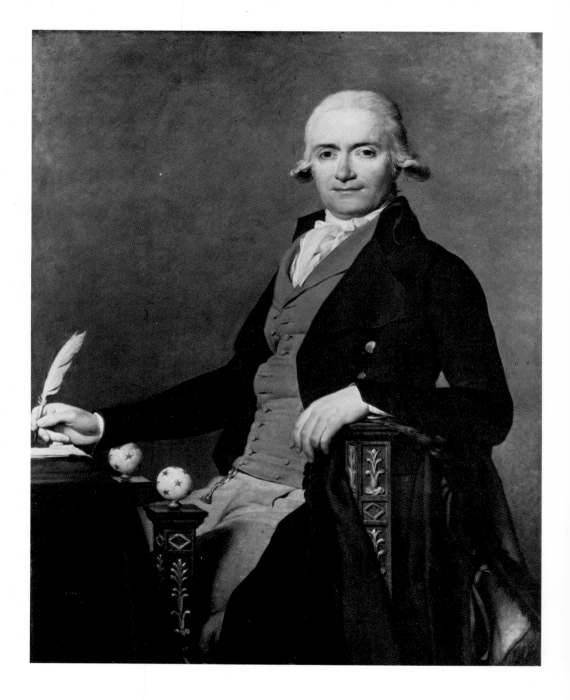

107 *Portrait of Mme de Verninac.* Signed and dated Year VII (1799). Oil on canvas. 145×120 cm. Musée du Louvre, Paris.
Mme Raymond de Verninac, wife of the Prefect of the Rhone, was the eldest sister of the painter Delacroix. Here David reverts to the lay-out of the unfinished portrait of Mme Trudaine but, by maintaining a certain distance between himself and his model, transforms an elegant young lady into a sort of lithe classical statue.

A year later, after the amnesty that ushered in the Directory, David accepted a place in the new Institute—an intriguing paradox since the recruitment of the new academicians was more stringent than that of the old ones had been, or rather membership had become restricted on the lines of such exalted bodies as the French Academy. David's only specific complaint about the old Academy, apart from its obsession with hierarchy, had been that the lessons were parcelled out among twelve teachers acting in turn. The new Institute had nothing to do with teaching, although it administered the *Prix de Rome.*

Daunou's report of October 19, 1795 on public education, which was at the origin of the new Institute, somewhat optimistically saw it as "a microcosm of the

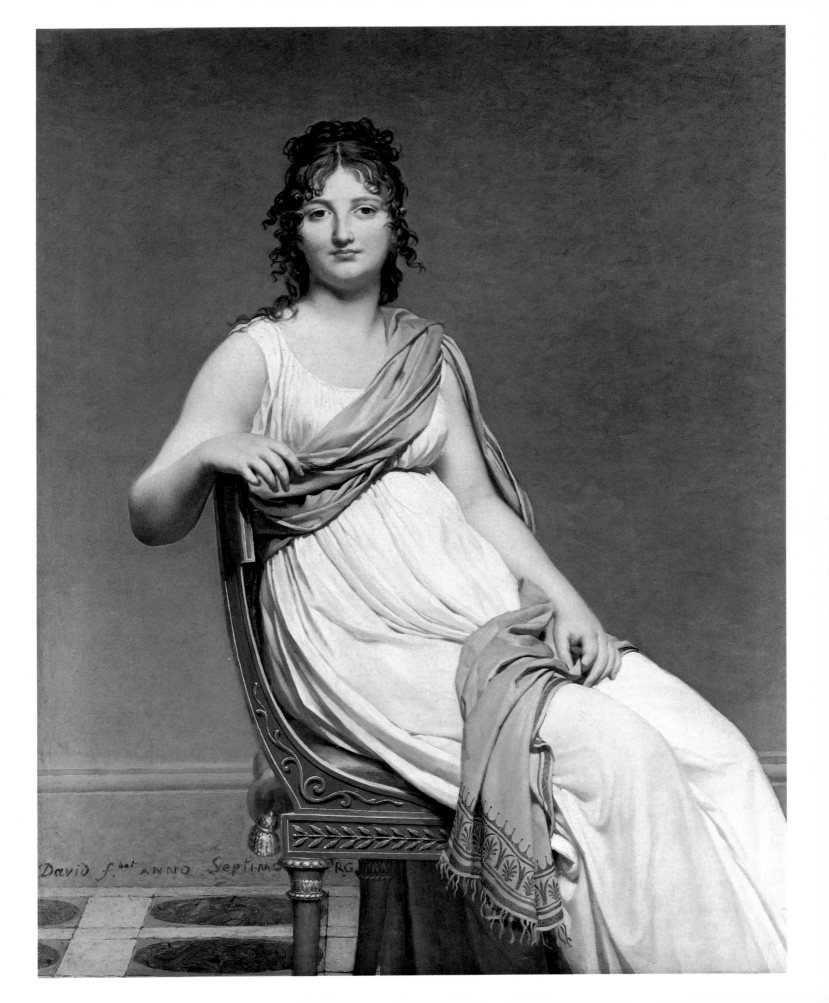

David f.^{bat} ANNO Septimo RG

world of wisdom, the representative body of the republic of letters, the honorable goal of all scientists and talented people. In many ways it will be a national temple whose doors will always be closed to intrigue and open only to those of well-merited reputation." In fact they were open only to a small élite, consisting of 144 members divided into three groups, each further divided into sections, so that the literature and fine arts group actually comprised eight subgroups, each with six members. The Directory elected one-third of the members, who then co-opted the other two-thirds. David was elected on December 6 with Van Spaendonck, the flower painter—a sign of the paradoxical yet inevitable rise of minor genres at the expense of the history painting of the revolutionary period. The collapse of traditional patronage forced artists to accede to the wishes of new customers who preferred portraits, flower pieces and landscapes to *The Devotion of Mucius Scaevola* or *The Meal at the House of Simon the Pharisee*. Amazingly, even Gérard was won over to portraits, in spite of his brilliant but financially unrewarding success with history paintings at the Salon during the Revolution.

Vien, Vincent, Regnault and Taunay, the "Patriarchy", were also elected at the same time as David and Van Spaendonck. The first general meeting was held on April 4, 1796 in the Caryatid Room at the Louvre (which inspired the setting for *Paris and Helen*), in the presence of the government and foreign ambassadors. David loved going to the subsequent meetings, although he was busy with preliminary work on *The Sabine Women*. However, he had learnt from experience, both of the old Academy and of the Revolutionary societies, to stay away from any purely artistic group, and in November 1800 he turned down a ministerial invitation from Chaptal to found a "free society for arts and drawing": "I know well enough from experience that the decline of the arts both in Italy and France is due to such meetings of artists."

David had put aside his *Homer* to get on with *The Sabine Women*, which was to occupy him until the end of 1799. It was a daunting task, partly because the work was so huge, almost four metres high and over five metres wide; the canvas had to be specially ordered from Flanders. It presented David and his pupils with a number of problems, both theoretical and practical. Thanks to Delécluze's lively account and the many preliminary drawings, now in the Louvre, we know quite a bit about the early stages of the work. When Delécluze, as a very young man, became David's pupil in or about October 1796, the painter had acquired a new and larger studio at the Louvre, next to the present Pont des Arts, but still had the use of two other studios at the north corner of the colonnade; the upper one (the

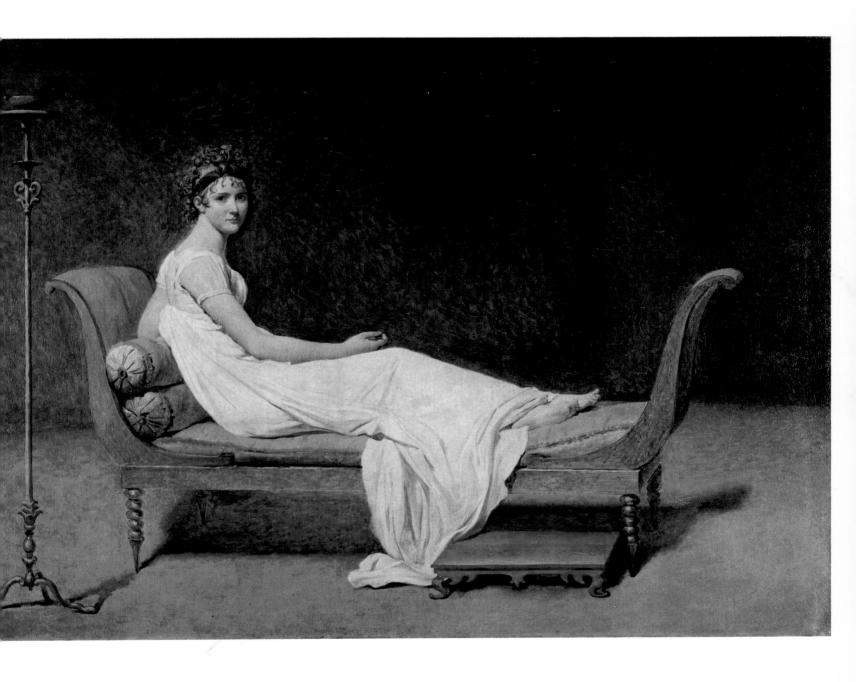

"Horatii" studio) was the private studio he lent to Charles Moreau, his pupil and collaborator, while his pupils worked and his models posed in the lower one. Every Monday, all the artists, including David himself, drew lots for their places—a democratic procedure contrasting with the hierarchical system of the old Academy—and then proceeded to draw a nude figure from life. From the seventh to the ninth day of the ten-day session the pupils drew a head, for which each of them posed in turn or paid a model to do so, and on the tenth day they rested. David positioned the models in natural attitudes and forbade the use of the ropes and wedges that in most studios held models in a chosen position. Delécluze gives a vivid description of the studio, where young painters with wildly divergent backgrounds and political opinions coexisted—the *crassons* led by Robin, the

108 *Portrait of Mme Récamier*. Oil on canvas. 175×244 cm. Musée du Louvre, Paris.
The portrait of the most famous nineteenth-century coquette was painted in 1800, when she was only twenty-three years old, and is one of David's most ambitious ventures in the genre. He has created a type whose fascination we can still feel today, despite—or perhaps because of—the painting's unfinished state; this, it appears, was due to the slowness of the painter and the impatience of the sitter.

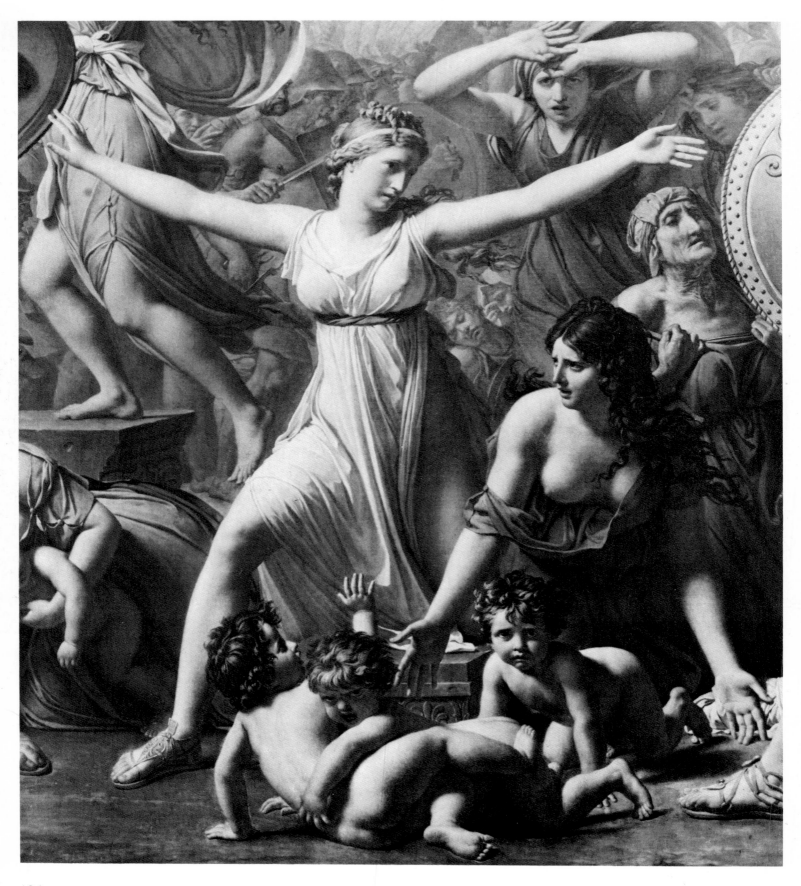

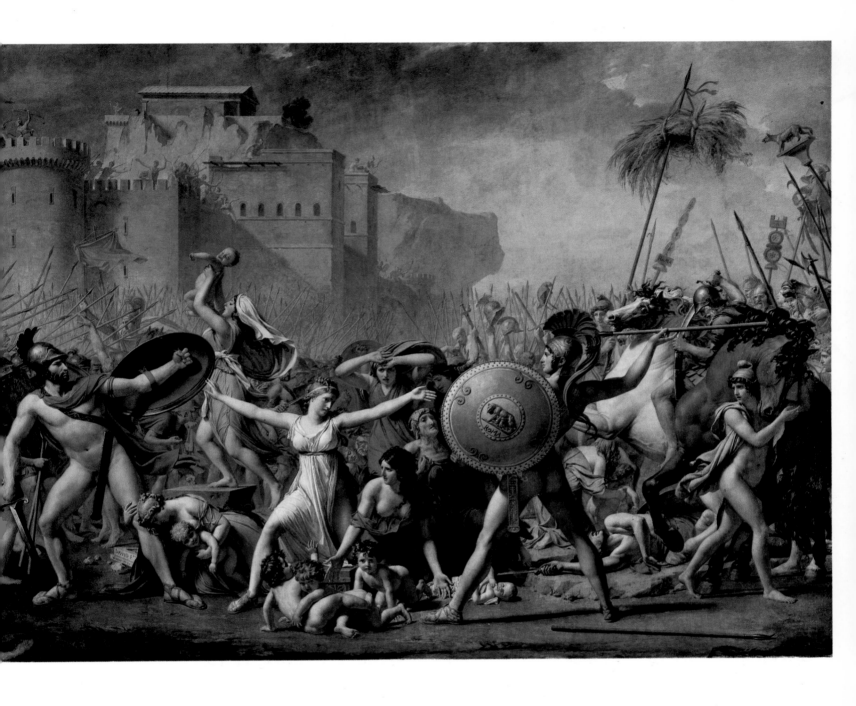

◁ 109 *The Sabine Women*. Detail of Pl. 110.
The group of Sabine women, slightly left of center,
divides the whole composition through the gesture
of the poetic figure of Hersilia, whereby the Sabine
men are thrust to the left, behind Tatius, and the
Romans to the right, behind Romulus, who stands
protected by his shield's perfect circle in a pose
chiming in with that of Hersilia.

110 *The Sabine Women*. Signed and dated 1799. Oil
on canvas. 385×522 cm. Musée du Louvre,
Paris.
After two years devoted to the Revolution and its
celebration, David returned to the painting of
large-scale historical and classical scenes with his
Sabine Women. This is not the traditional "rape", but
the moment when the Sabine women separate the
Romans from the Sabine men who have come "to
exterminate the ravishers".

"leftists" including the Franque brothers, twins who had started off as shepherds in the Drôme and been put in David's charge by the Legislative Assembly at the beginning of 1792, together with Jean Broc, Mulard and Gautherot. The "aristocrats" included Forbin, Delavergne, Fleury Richard and Revoil from Lyons, Ducis, Roland, Moriès, and later Granet. The "angelic" Grandin, the studio treasurer, had to muster all his qualities to keep the peace.

Many of the pupils were fascinated by the ancient world and by archaeology. Like Vien before him, Paillot de Montabert was trying to revive the art of encaustic painting. Duqueylar was an Ossian enthusiast, while Lullin and Delécluze himself were particularly interested in Greece.

David, who suddenly decided during the painting of *The Sabine Women* to go back to "real" antiquity, encouraged them. Delécluze recorded the painter's ideas:

> I'm going to do something completely new; I want to revive in art the rules followed by the Greeks. When I did *The Horatii* and *Brutus*, I was still influenced by Rome. But, gentlemen, without the Greeks the Romans would have been barbarians when it came to art. So you must go back to the source, and that is what I am trying to do just now. I'm going to surprise a lot of people: all the figures in my painting are naked, and I shall draw the horses without bits or reins.

Thus a minor revolution occurred when the work was already in progress, which is one reason why it took so long. According to Delécluze, David had apparently already painted several figures, including Tatius, on the left of the picture, when he decided to "undress" them. The two surviving drawings of the overall picture, both in the Louvre, show the soldiers still dressed. From the start the focal point of the composition was obviously the central figure thrusting apart two warriors, whose bodies are bent backwards in reaction to this intervention. It has been said that the idea could have been inspired by one of Flaxman's illustrations of 1793 for the *Iliad*, *The Battle for the Body of Patroclus*, and also by Annibale Carracci's *Perseus and Phineas* in the Farnese Gallery. Oddly enough, the figure of Hector in the center of Flaxman's picture turns up in reverse as David's final Romulus, the likeness being far more noticeable than in the first drawing.

From the earliest stage the composition included the background, slightly reminiscent of Domenichino's *Martyrdom of St Andrew* at S. Andrea della Valle, as well as the marvellous figure of Hersilia separating Tatius the Sabine from Romulus the Roman. The idea of putting the horses on the right was also an early

one, but they and all the minor figures were completely transformed thanks to David's extensive research and numerous studies of detail, which resulted in the second finished project, a large drawing also in the Louvre. There may have been a third, for Delécluze mentions "two preliminary sketches, one showing the figures dressed, the other showing them naked". There are other deviations from the final work—for instance, David had not yet conceived the figure of the cavalry general putting his sword back in its sheath.

It would be possible to analyse all the painter's borrowings and the works that influenced him, but this would be an arduous and unrewarding task. One is almost tempted to undertake it in the light of David's remark to Delécluze: "I want to create *pure Greekness*; I feast my eyes on ancient statues, and I even mean to copy some of them." But this would be to sidetrack the main issue, namely the new and powerful synthesis that David achieved of elements that were not confined to the classical, in spite of what he said. A study (now in the Art Institute, Chicago) for the inclined horse's head on the far right bears an inscription in David's own hand to the effect that it is based on an engraving by Agostino Veneziano, the pupil and collaborator of Raimondi, Raphael's engraver. In fact David's striking image of the woman advancing on the spectator, almost in the very center of the picture, derives from Raimondi's engraving after a Raphael drawing, *The Massacre of the Innocents.*

A group of young idealists among the pupils in David's studio disliked his lack of cultural dogmatism and his persistent interest in artists like Raphael or Carracci. The painter had helped launch the movement with his talk about Greek purity, but it soon grew beyond him with the appearance of this group of "Beardies" or "Meditators", which fascinated Delécluze and Charles Nodier at the time and of which George Levitine has recently done a study. The leading light was Maurice Quay, who died very young and whose satellites included the Franque brothers and Broc. Nodier wrote movingly about him:

> Maurice Quay ... was on too high a plane to adapt to commonplace thought or action, to take any interest in the pursuits of the rabble, or to have faith in its devices. He rejected it when he was twenty; he only lived to twenty-four, and I have often wondered how much further he could have gone as he got older and became caught up in the irresistible momentum of things ... Maurice Quay was a splendid-looking man. Nature had decided that his exterior should be as impressive as his genius, and as she does not confer such perfection without atoning for her masterpiece, she allowed us only a glimpse

111 *The Sabine Women.* Drawing in black crayon and pen, with Indian ink wash, touched up with gouache. 26 × 34 cm. Cabinet des Dessins (RF 5200), Musée du Louvre, Paris.
The gestation of *The Sabine Women* was a lengthy one. In this preliminary overall sketch, the earliest known, the arrangement differs very little from the final version, but the various parts were all worked over at length.

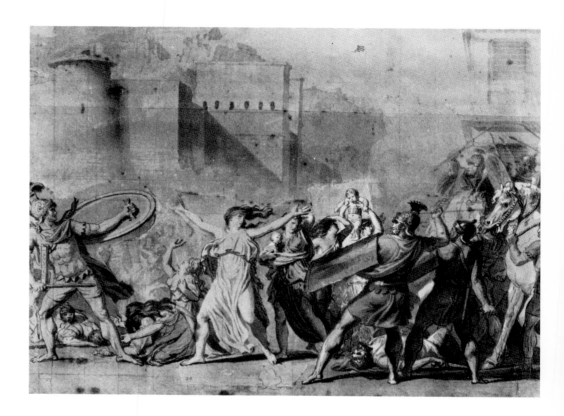

of him. He died before reaching manhood ... the building of which he was the cornerstone crumbled over him, and the society of "Meditators" descended unknown into the grave of the unknown Maurice.
Earlier he described their philosophy in general but clear terms:

Going beyond the reform of painting and of society, [it] entered the realm of metaphysics; the general emotion which at first took the place of religion for them ... was a love of art and an obsession with it. By perfecting this and refining it in the furnace of their souls, they attained the pinnacle of nature in all its grandeur and sublimity, and during this second phase art was no more to them than a subject of comparison, an occupational resource. Nature herself finally dwindled in their minds, for the sphere of their ideas had widened. They perceived something wonderful and incomprehensible beyond the last veil of Isis, and they withdrew from the world, for they had gone mad, that's the only

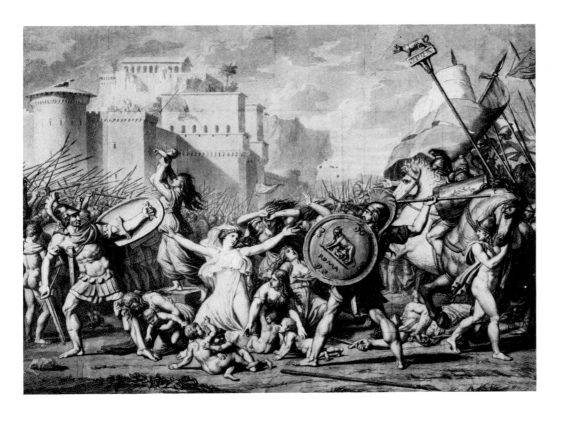

112 *The Sabine Women.* Drawing in black crayon and pen, with Indian ink wash, touched up with gouache. 47.5 × 63.5 cm. Cabinet des Dessins (Inv. 26183), Musée du Louvre, Paris.
This large drawing, which belonged to Ingres, is close to the final painting, although Tatius and Romulus are still clothed and the painter had not yet had the idea of showing the cavalry general putting his sword back in its sheath.

word for it, mad like therapeutists and saints, mad like Pythagoras or Plato. They still went to the studios and galleries, but no longer produced anything.

As J. Rubin has commented, their ideas were rather like those that André Gleizes expounded, somewhat hazily, in *Les Nuits Elyséennes (Elysian Nights)*, published in 1800: "The world is something more than it appears to be; something holy lurks beneath its surfaces, and this is what the questing soul is seeking." But not all the "Beardies" took their "meditation" to its self-destructive limits, and several of them remained at the first, artistic stage of the process. They are singularly representative of the tendency towards "primitivism" so widespread in the arts of all neo-classical Europe—a tendency discussed a few years ago in an excellent study by Robert Rosenblum. It was manifested in architecture by an interest in prehistoric huts, ancient Egyptian monuments and pure geometrical

forms, and in art by an admiration for Mantegna and the painters before Raphael, a taste for the naive, the simplification or rejection of color, and an obsession with line, which is brilliantly demonstrated in Flaxman's drawings.

This Rousseau-like desire to return to primitive purity was associated with a crushing condemnation of the weaknesses of the painters of the past, which gradually spread to most contemporary painters. "Rococo" (a term which, according to Delécluze, was coined by Maurice Quay in 1796 or 1797), "Van Loo" and "Pompadour" became terms of abuse that survived into the nineteenth century. Sophocles was treated "with the deference due to a disciple of Homer", but poor Euripides suffered at Quay's hands, along with Voltaire, for the young man believed only in the Old Testament, Homer and Ossian(!). David himself came under fire, with other contemporaries. Delécluze said that Quay told his friends "that David had actually begun the huge task of art reform, but that his indecisive character and limited ideas had diverted him into politics and he did not have the energy to complete the revolution needed in art ... As long as the schools tolerated models in poor taste, such as those taken from Italian, Roman and even Greek art, going back exclusively to Phidias, there would be no improvement in art studies."

The influence of this cult was furthered by the development of Greek archaeology. Stuart and Revett's *Antiquities of Athens*, which started publication in 1762 and went on until 1816, was all the rage at the time, and the classical spoils Bonaparte had carried off from Italy arrived at the museum after a triumphal entry into Paris on July 27, 1798. Though classical—or so-called Etruscan—vases were few and far between at the museum before Charles X's many purchases, there was plenty of literature about them, and the four folios of the second Hamilton Collection were published between 1791 and 1803 under the direction of W. Tischbein.

Tempers were getting frayed in the little *entresol* at the Louvre where the Franque brothers worked, which had become a meeting place for the "Beardies". They criticized *The Sabine Women*, still in progress, for its insufficiently primitive style, and David had to get rid of Pierre Franque, his assistant, and replace him with Langlois in order to finish the painting. All the same, the "Meditators" did have some effect, for as soon as the huge picture was finished, David started *Leonidas* with the express intention of travelling further along the road of classical simplicity by passing from a Roman subject to a Greek one. Before he had even finished his *Sabine Women*, David had arranged for it to be exhibited at the Louvre,

starting on December 21, 1799, in a large gallery (formerly used for sessions of the Academy of Architecture) put at his disposal by the Directory. The charge of 1.80 francs for admission was considered a shocking innovation, even though the painter carefully explained it in the catalogue. First, he cited such precedents as Zeuxis in ancient days and the English from Van Dyck onwards. He spoke of the very real difficulties faced by a history painter and then, very cleverly, made paying exhibitions out to be a means of giving the public a share in art by eliminating the need to sell paintings or sculptures to rich people, usually foreigners. In fact the exhibition was successful, for it lasted five years and brought David a tidy sum of money, which was later practically doubled when he sold the painting to Louis XVIII in 1819-20.

In the same catalogue, which was handed out with the tickets, the painter justified the nudity of his heroes, starting a surprisingly lively controversy. "It was an accepted custom among the painters, sculptors and poets of classical antiquity to show gods, heroes and male subjects in general in the nude." He went on to give examples—statues, bas-reliefs, paintings at Herculaneum, and finally a medal showing Romulus himself. With some humor, he called his fellow artists to his defence: "They know better than anyone how much simpler it would have been for me to dress them; they could tell you how much easier it is to make clothed figures stand out on the canvas." But David had wanted to "paint ancient customs so accurately that any Greek or Roman seeing my works would have assumed I knew their ways".

The whole of Paris was up in arms. Malicious rhymes were addressed to the "Raphael of the *sans-culottes*". In mocking contrast to the *Brutus* of 1791, the Opéra Comique put on a one-act burlesque entitled *The Painting of the Sabines*, which opened on March 30, 1800. The plot concerns a mother who considers the painting unsuitable for the innocent eyes of her daughter, Laura, but goes to see it herself. To her distress her daughter is carried off by a lover, who is duly set upon, and a battle takes place on the stage in the course of which Laura rushes forward, separating the fighters just as Hersilia does in the painting.

Archaeologists derided David's ignorance in stripping his horses of harness, since originally ancient statues and bas-reliefs showed it. A more serious debate arose about the suitability and decency of the painting, for soldiers are unlikely to be naked, after all. Guizot took up the subject again as late as 1810 in an account of the Salon, criticizing nudity in the very name of art: what is permissible in a sculpture, where the material is "a cold, white block that cannot be misappre-

hended by the eye" showing a "motionless, passive state" is not permissible in painting, an art of illusion depicting action; the painter "cannot, without considerable effrontery, take away the accessories that necessarily accompany that action". In 1824, when Romanticism was in the ascendant, Stendhal grew bored with "large paintings consisting of thirty naked bodies copied from ancient statues" and put it more sharply: "If *The Sabine Women* came out today, we'd find its characters lacking in feeling and consider it absurd to go into battle without one's clothes on in any country ... the Greeks liked nudes: for our part, we never see them and I will go so far as to say that they repel us."

David's booklet is mainly devoted to the subject of the painting. He tells how Rome was founded, stressing the divine origin of Romulus and Remus, their "air of nobility and greatness", their "extraordinary height". As for the Sabines, a people living a few leagues from Rome, their women were "already famous for their beauty and modesty". David then relates the subterfuge devised by Romulus, the alleged discovery of an altar to a Sabine god, which was made the occasion for a great feast during which the Romans rushed on the Sabine women and carried them off. In a footnote, David observes: "Poussin, to whom the modern Romans defer as a god, dealt with the actual rape in his moving, severe way. I decided to deal with its sequel, the moment when the Sabine women rush out to separate the Roman and Sabine armies", that is, three years later, when Tatius, leader of the Sabine troops, marched on Rome "to exterminate the ravishers". No words could be more applicable to David's own large history paintings than "moving and severe", which could well describe the contrast he shows us once again between male aggression and female tenderness and humanity. In spite of the variation in the subject, there are faint echoes of Poussin's *Rape of the Sabine Women* (Metropolitan Museum of Art, New York), in the foreground of which a child lies on the ground, propped on his outstretched arms, an older woman kneels, and another woman clutches a soldier's knee—all themes that David reused in a different form. Hersilia is the most impressive figure in the painting, but it is hard to trace her development through the few preliminary drawings that survive (her pose was apparently there from the beginning), though she could well have been derived from the dancing Bacchante in the center of Poussin's *Worship of the Golden Calf* (National Gallery, London).

David concludes by describing the moment chosen for the picture. "Suddenly, the Sabine women the Romans had captured rushed on to the battlefield, dishevelled, clutching their naked babies to their breasts, through the piles of dead

warriors and the horses excited by the fighting." This description actually corresponds more to the preliminary drawings, including both of the large ones in the Louvre, and a number of studies of details than to the final canvas, on which only one dead man can be seen clearly and the women's hair has been tidied. "Filled with pity, the fighting men made way for them. Hersilia, wife of Romulus, by whom she had two children, was among them and darted forward between the two leaders, crying 'Sabines! What are you doing in front of the walls of Rome?'" Then she launches into a speech, culled from Plutarch's *Life of Romulus*, which struck a chord in every heart.

Some of the women with her laid their children at the soldiers' feet, and the men dropped their bloodied swords; others held their nurslings aloft like shields against the forest of pikes, which were lowered at the sight. Romulus stayed the javelin he was about to hurl at Tatius, and the general of the cavalry put his sword back in its sheath. Some of the soldiers raised their helmets in a gesture of peace, as feelings of paternal, conjugal and brotherly love spread through the ranks of the two armies, and soon the Romans and Sabines embraced, becoming henceforth one people.

It was the great originality of the picture that appealed to the author of a perceptive description published in 1810, at the time of the decennial competitions: "M. David really puts his talent to full use here. The basis of the subject, or rather the subject itself, is the *suspension of arms*; this is what demanded to be painted and this is precisely what he has painted, with almost unprecedented skill. Where could you find a picture that better expresses immobility immediately following a great deal of movement, or rather, complete inaction taking the place of fury suddenly cut short?" And indeed nothing is more striking than the three main characters, who determine the whole composition. Frozen in a kind of motionless dance, yet still beings of flesh and blood, they stand out from the crowd, which is unified by the dust the battle has raised and suggested rather than shown, for (apart from the children and the silhouettes on the walls of Rome) there are only about fifteen people of whom more than the heads are visible. However, the overall picture with its careful bas-relief effect, discreetly hollowed in the center where the Sabine women are passing through, bristles with pikes and standards between which several heads and helmets appear—an officer on horseback halting the soldiers' progress, a horse's head. All the figures are swept up in the drama except the children in the foreground, most of whom are looking straight out of the picture with no trace of fear, serving the same purpose as the workbasket in *Brutus*,

113 *Study for "The Sabine Women"*. Drawing in black crayon. 18 × 11 cm. Cabinet des Dessins (sketchbook RF 36942, folio 54), Musée du Louvre, Paris.
The sketch belongs to an album, recently purchased by the Louvre, which is largely devoted to *The Oath of the Tennis Court*. Inspired by a figure in *The Massacre of the Innocents*, engraved by M.-A. Raimondi after Raphael, it is a study for the woman placed at the center of the composition. The final version, however, is rather less expressive.

a sign that life goes on. In spite of David's habit of painstakingly painting each of his figures in succession, the incomparable charm of the picture lies in its chromatic unity, based on a broad harmony of orange and blue, toned down by the impalpable grey dust of the battle.

Though the painter had already made great strides in his search for classical beauty and his studies of smooth, supple nudes, he wanted to go still further. More than ever he felt, as Delécluze puts it, "that there is no art unless you have devoted yourself to the search for the proportions constituting visual beauty", as long as you have not yet found and confirmed "the most harmonious proportions of the human body". He then embarked on the long hard task of *Leonidas*, first contemplated in 1800 but not completed on canvas until 1814. Like *Paris and Helen*, far more than *The Sabine Women*, *Leonidas* has a place in that long dalliance with classical beauty which, in French art, began with Vien and was carried on by David's contemporary and former pupil Girodet.

Thanks to Delécluze we have a fairly clear idea of what David was hoping to achieve when he started his studies for *Leonidas*. Though his staple diet was the ancients, he also liked painters before Raphael such as Giotto, Fra Angelico, and especially Perugino, whose system of composing "on a single plane" he studied.

> He had the idea of reducing composition to this classical simplicity and of involving the spectator by drawing his attention to each figure in turn because it is so perfectly painted, rather than by sacrificing everything to dramatic effect as painters have been doing since the seventeenth century... It was not by assaulting the emotions in a dramatically structured scene that Raphael created masterpieces, but by making each of his figures, set almost in isolation and linked with the others by a feeling rather than a stance or an expression, gradually enter one's vision and then one's soul, instead of appealing to one's passion.

Here David was simply setting down a principle that he had in fact adopted at the time of *The Oath of the Tennis Court* and applied in his detailed, untiring study of each figure. There are very few overall drawings for the closely linked *The Oath of the Tennis Court*, *Sabine Women*, *Leonidas*, and *Distribution of the Eagles*, but a few of the many preparatory drawings of one or two figures briefly described in inventories, or in the catalogue of the artist's studio after his death, have survived or are known about. To be more precise, we feel that certain drawings have some bearing on *Leonidas*, even if they are not direct studies of any of the figures on the final canvas.

We are often puzzled because several figures in the painting have their arms raised, as in *The Oath of the Tennis Court*, and also because David did nude figure studies for all his paintings and not only for *Leonidas*.

Here, more than ever, the artist uses drawings from life. In fact, he admitted to his pupils that "it was impossible for him to make the slightest suggestion, the

simplest sketch, of a figure without a model". It was undoubtedly thanks to this fortunate incapacity, this obstinate attachment to nature, that David—even in *Leonidas*—never just painted rows of gesturing classical statues, but always of men.

For a brief period David had held a monthly competition for his students. The subjects were chosen from Greek history, and those who did the best drawings of them were rewarded with books or engravings. Around 1800 he set *Leonidas at the Pass of Thermopylae*, and young Delécluze showed the hero giving his soldiers the signal to take up arms and march into battle. David explained to him that his own aims were different:

> I want to make this scene more weighty, more awesome. I want to paint a general and his soldiers preparing for battle like real Spartans, knowing full well that they will not come back alive: some of them absolutely calm, others plaiting flowers for the banquet they will eat with Pluto. I want neither movement nor any trace of emotion except in the figures around the man inscribing these words on the rock: *Passer-by, go and tell Sparta that her children died for her* ... To do that, I must cut out all the emotions that are not only alien to it but would detract from its sacredness ... [My Leonidas] will be calm; he will contemplate with joy the glorious death awaiting him and his fellow soldiers ... Like the artists of antiquity, who always chose the moment just before or just after a great event, I shall show Leonidas and his soldiers before the battle, calmly looking forward to immortality.

Probably telescoping his memories a bit, Delécluze next relates how David told him about an ancient engraved gem depicting the madness of Ajax—not just when, beside himself, he slaughtered sheep in the belief that he was killing the Greeks, but "during a momentary return to sanity, when he meditated sadly by an altar, drooping with exhaustion and sick at heart". The figure of Leonidas, as we see him in the painting, is in fact directly based on a Hellenistic engraved gem reproduced in Volume II of the *Monumenti antichi inediti* by Winckelmann, an author to whom David seems to have been very close, judging by his comments on how the ancient artists selected moments of calm. Thanks to numerous drawings, now in Montpellier, Lille and the Louvre, we know that David did not finally, probably in 1813, adopt this version of the figure until he had completed a series of studies; these could be arranged in sequence, not necessarily correctly but without any gaps, starting with the first sketch (Musée Fabre, Montpellier) in which

Leonidas, not yet in the center, sits with both legs placed towards the left. Nevertheless, starting with Album 9137 at the Louvre, which contains a number of preparatory drawings for *The Sabine Women*, there are in fact sketches in which the figure is shown full-face or turning to the right. It looks as though the engraved gem prompted David to choose one of the alternatives sketched out in his own drawings.

The Montpellier drawing, which must date from 1800, shows a whole swarm of figures, whereas in the final painting David kept only a handful of significant people and groups; although some of them did not appear until a very late stage (for instance, Leonidas' kinsman Agis, seated at his feet, and the soldier right behind him brandishing his bow), many of them were there early on and were more or less modified later. David used literary sources in which he found ideas that he combined with his own. The most important of these sources was Book VII of Herodotus, which relates the episode and describes the site. What

116 *Leonidas at Thermopylae.* Drawing in black crayon. 32×42 cm. Musée Fabre, Montpellier. Immediately on finishing *The Sabine Women*, David embarked on a picture which, he hoped, would be worthy of its classical inheritance both in form and subject. The picture was eventually completed, in a much altered form, in 1814 (see Pl. 176).

David shows is different, because the Pass of Thermopylae lies between the mountains and the sea; Herodotus mentions the temple, the altar to Hercules, and the wall the Greeks built to barricade the pass, all of which are in the painting.

This shows the third day of battle. After two days of fruitless attacks by the Persians, the scales have tipped; Xerxes' troops have found a secret road and can now take the Greeks from the rear. The Spartans' allies have deserted their posts, leaving Leonidas' three hundred men as the only defence. Contrary to recent opinion, it seems that the convoy of mules vanishing into the distance on the right does not allude to the departure of the faint-hearted. *The Explanation of the Thermopylae Painting*, published anonymously in 1814 and at least inspired by the painter, says only "Leonidas has sent the baggage of the army back to Sparta; slaves and mules are bearing away the sacrificial instruments and all the other objects now rendered useless. Henceforth the Spartans will have no more to do with mortals, for they are going to sup with Pluto."

David also borrowed the idea for the group on the left from Herodotus. Leonidas had ordered blind Eurytus to go, but the latter made his helot bring him back to fight and die. David did a study for a variation on this theme, in which a blind father is upheld by his two sons, drawn before he turned to classical sources. Martin Kemp recently showed that David must also have known Xenophon's *Spartan Constitution*, in which the preparations for Spartan battles are described: when the enemy came in sight, trumpets were sounded and the soldiers unfurled garlands and cleaned their weapons. But David stressed the darker aspects, for his soldiers are plaiting flowers "for the banquet they will eat with Pluto". The positioning of some figures and groups is reminiscent of *The Oath of the Tennis Court*—not only the young men coming forward and holding out their wreaths of flowers, but also the soldier writing the inscription on the rock and the older man saying goodbye to his son—a group very like the one on the left in *The Oath of the Tennis Court* in which a deputy is helping one of his colleagues to climb up on a bench. The author of the *Explanation* already quoted was probably aware of the links between the pictures, and describes the young men holding out their wreaths as follows: "Four young Spartans, four friends standing close together, embrace each other for the last time and, proffering their wreaths, vow to fulfil by their glorious deaths the obligation imposed by these words [the inscription on the rock]." However, their movement and that of the young men on the right hurrying to grab their arms from the branches are the same as the impetus by which the colonels are carried forward in *The Distribution of the Eagles*.

Clearly David was less concerned with mere contemporary reality than with the timeless reality represented by the return to the glories of the classical past and love of country—an emotion rather forgotten in France since Richelieu's time, and one of the mainsprings of the Revolution. In a man like David it was bound to resurface with renewed force after the general collapse of political convictions, and it explains his enthusiastic support of Napoleon.

VI. DAVID AND NAPOLEON

David rallies to Napoleon Bonaparte, heir to the Revolution. Bonaparte Crossing the Great St. Bernard. *Napoleon's consecration; preparations for the ceremony. David at work: the portraits of the Emperor and the Pope; artistic licence and realism. Plans for other commemorative paintings.* The Distribution of the Eagles, *the classical and the contemporary in the preliminary sketches.* Portrait of Napoleon in his study. *Portraits of dignitaries and friends.* Phaon, Sappho and Cupid. Leonidas at Thermopylae.

Like so many other Jacobins, David rallied to Napoleon swiftly, enthusiastically and definitively. Nobody nowadays attaches much importance to plebiscites yielding 99% in favor, but Bonaparte's rapid assumption of absolute and hereditary power met with virtually no opposition from the Left. In full awareness, the people chose a government and then a dynasty founded on personal worth and, what is more, on military merit, which always satisfies patriotic feelings (we know how much the Montagnards favored war), in preference to the old monarchy based on birth. The choice cost them a few passing regrets for democracy and also a few lives, including that of Topino-Lebrun, a pupil very close to David, who was implicated, without the slightest evidence, in the repression of Babouvism.

In any case tyranny (which is an ancient word) was not incompatible with the Republic. The Senate created the First Empire on May 18, 1804 with these words: "For the glory of the Republic and its happiness, from this instant the Senate proclaims Napoleon Bonaparte Emperor of the French..." Bonaparte won support all the more easily for having, as was said officially at the time, consolidated, not destroyed, the Revolution by confirming civil equality and, more prosaically, by conferring legitimacy on the acquisition of seized estates by private citizens. From this point of view, the execution of the Duc d'Enghien, which shocked Europe, was good domestic policy.

How could David doubt that Bonaparte was heir to the Revolution when he approached him in January 1800 and asked for the bust of Brutus to be put in his study in the Tuileries? The following month Lucien Bonaparte, minister of the Interior, offered him the post of "Government Painter", which David refused (though in December 1804 he did accept the title of "First Painter to the Emperor"). In August the first of a long series of financial wrangles took place between David and the ministers of the Consulate and Empire; the painter claimed a reimbursement of part of the expenses he had incurred in arranging the gallery in the Louvre where he exhibited *The Sabine Women.* The Bonapartes nevertheless consulted him about their plans for the Invalides in Paris and for erecting in each

117 *General Bonaparte.* Oil on canvas. 81×65 cm. Musée du Louvre, Paris.

While painting *The Sabine Women*, David decided to do a large portrait (about 3 metres wide) of Napoleon holding the treaty of Campo Formio (October 1797) in his hand and accompanied by his horse and an escort party. The general only came to his studio once and David was able to paint only the head, which was cut out later.

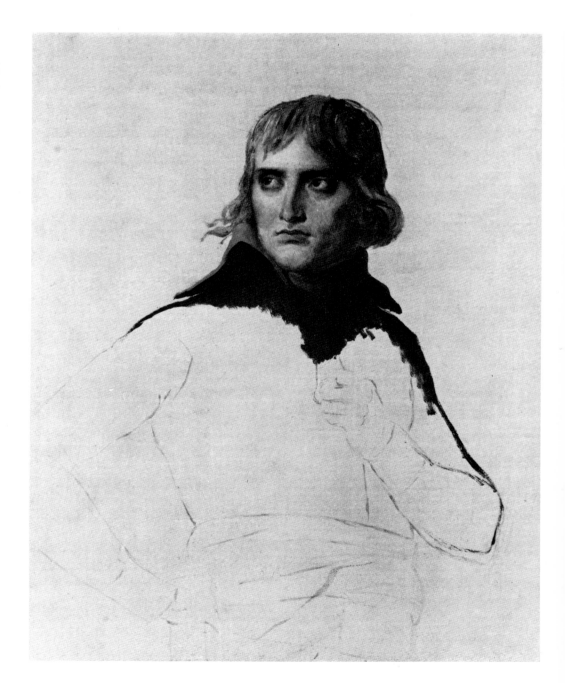

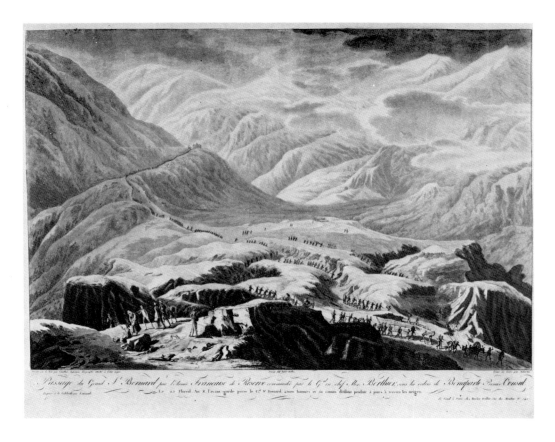

Passage du Grand St. Bernard par l'Armée Française de Réserve commandée par le Gal en chef Mr. Berthier sous les ordres de Bonaparte Premier Consul

118 *The Crossing of the Great St. Bernard.* Engraving by Aubertin after a drawing by Gauthier, "geographical engineer attached to the General Staff" and Bacler-Dalbe. Cabinet des Estampes, Bibliothèque nationale, Paris.
This exploit, which enabled the French army to break through to Italy and cut off the Austrian army in the rear, was carried out between May 15 and May 20, 1800, a month before the difficult but decisive battle of Marengo. Bonaparte crossed the pass on a mule.

departmental capital a column bearing the names of soldiers who had died for their country. The first stone of the Paris column was laid in the Place de la Concorde on July 14—how could anyone doubt that the Revolution was still alive? Admittedly endless arguments ensued, in which even Bonaparte intervened in 1803, deciding to place a statue of Charlemagne on top of a column inspired by that of Trajan; in the end the column in the Place Vendôme was built after Austerlitz, to the glory of the *Grande Armée*, in bronze from cannons captured from the enemy. An ironic twist, as David had once suggested that his monument to the French people should be built in bronze from battle trophies.

David soon had a chance to paint the First Consul's portrait, but biographical accounts do not tally with the few surviving documents. According to Delécluze, Bonaparte himself commissioned a portrait after the decisive victory at Marengo.

But it seems more likely that the idea was due to Charles IV of Spain, who commissioned from David the first version of *Bonaparte Crossing the Great St. Bernard*. Bonaparte immediately ordered copies of it, and in September 1801 David exhibited two versions of the picture, side by side, one for the King of Spain and the other for the First Consul, in the gallery where he had shown *The Sabine Women*. Three more versions followed, two of them—according to the catalogue David compiled himself—for Bonaparte, with a few changes, notably in the horse's color. The painter was, of course, helped by pupils; he charged slightly less for the copies than for the original (20,000 francs instead of 24,000). The version now at Malmaison is probably the original one painted for the King of Spain and recovered by Joseph Bonaparte during his brief spell of royalty, and the copy in Charlottenburg Castle in Berlin, also signed Year IX (which ended in September 1801), is probably the second version. There are two further copies, signed and dated Year X, in Vienna and in Prince Napoleon's Collection (recently acquired by the French government), and several copies by his pupils. The picture shows the French army crossing the Great St. Bernard Pass in May 1800. Biographers say that it was Napoleon's idea to be seen "calm on a rearing horse" rather than sword in hand in battle, but surely David, who never showed a battle, only its supsension or the preparations for one, must have had a part in the choice. The transformation of the subject into an allegory of the Hero was doubtless made easier by the fact that David did not know the natural setting and by Napoleon's refusal to pose. The painter showed the horse rearing over a large slab of rock which echoes the lines of the horse's body; the name Bonaparte is carved in capital letters above those of Hannibal and Charlemagne—an eloquent kinship. The bleak icy peaks draw the army into their folds; only a few men pushing and pulling cannons stand out, with a handful of bayonets and the tricolor, while the hero, fully mastering both his nervous horse and the hostile mountains round about him, points to some distant unspecified summit towards which he is sweeping not only the army—already victorious because of the exploit it is accomplishing—but the whole of the French people.

The actual event, in which Napoleon rode on a mere mule, is transformed by the painter's epic allegorical vision, but David stayed firmly rooted in reality. He asked Constant, the First Consul's valet, to bring him the uniform Napoleon had worn at Marengo, complete with sword, boots and hat, and dressed a dummy in them; like the horse's harness and the veins beneath its hide, these clothes are depicted in painstaking detail.

119 *Bonaparte Crossing the Great St. Bernard.* Signed and dated Year IX (1801). Oil on canvas, 272×232 cm. Musée national du château, Malmaison.
This portrait is said to have been commissioned by the king of Spain, and there are several replicas painted in part by David himself. It shows the new hero, "calm on a spirited steed", joining the glorious line of Hannibal and Charlemagne.

"This equestrian portrait", said Delécluze, "took up all David's time for quite a while, because he had several copies made under his supervision and retouched them frequently and carefully. He attached particular importance to this painting." In fact he abandoned *Leonidas* for it, though not completely; he never stopped doing drawings for *Leonidas*, but did not really get back to it until 1813, when his great Napoleonic works were done and his great Napoleonic hopes dissipated. Nor did he do any more portraits—except for the beautifully structured one of Penrose (Timken Art Gallery, San Diego, California)—until 1804, when he painted Mlle Lepelletier de Saint-Fargeau and Comte Estève.

David's relationship with Napoleon and his government was never straight-forward, partly because of the painter's financial demands and partly because neither he nor the officials took the precaution of noting commissions and their cost down on paper. In a letter dated 1819 David said that he had agreed to do four canvases of the December 1804 ceremonies—a huge task—after a casual conversation with Napoleon who, he said, had agreed to pay 100,000 francs for each of them. Denon and other officials thought this exorbitant and refused to pay more than 40,000 francs for any one painting. Hence the endless correspondence with Lebrun, the chief treasurer, with Fleurieu, Napoleon's Chief Intendant whom Daru replaced in June 1805, and with Denon, head of the Musée Napoleon, all of which was humiliating and often disappointing for David.

There were plenty of rewards, though; at the end of 1803 David was made a knight of the Legion of Honor, and at the end of 1804, as we have seen, he was named First Painter to the Emperor. In June 1805 he signed a petition with a project in eight parts, in which only the space showing the remuneration was left blank; according to this the First Painter, whose office had been revived from the time of Le Brun under Louis XIV, became a virtual overseer of the arts. It was already understood before the ceremony of December 2 that David would paint it and probably other events as well. We know he started work on *The Arrival at the Town Hall* practically at the same time as on *The Coronation*, but the commission was unclear, for nobody seems to have decided where the enormous canvases were to go when they were finished, though it was obvious that it would be a long time before they were ready. David did not specify the subjects of the four works in progress until June 1806, in answer to Daru's very belated enquiry. He mentioned his price of 100,000 francs for each painting: "I have a fifth and sixth painting in my head, but I won't discuss them with you until the first lot is finished."

Meanwhile he had failed in his dogged attempt to sell *The Sabine Women* to the

120 *Bonaparte Crossing the Great St. Bernard.* Detail of Pl. 119.
We know from Delécluze that David took great pains over this portrait. With equal objectivity and without excessive detail, his brush renders the embroidery on the uniform, the cockade, and the hero's hair and horse's mane swept forward by the same epic wind.

Emperor for 72,000 francs. Later Napoleon refused the price of 100,000 francs and, worse still, rejected the full-length portrait which Lebrun had commissioned the year before for the Law Court at Genoa. These incredible financial arguments went on until 1810, when David finished the second (and last) of the huge paintings of the December 1804 ceremonies which he had hoped to do.

The metamorphosis of General Bonaparte into the Emperor and the history of his coronation have been decribed in Frédéric Masson's classic work and, more recently, by H. Gaubert and J. Cabanis, so we will simply outline them. When Napoleon was granted the consulship for life in August 1802 by a plebiscite with three and a half million assenting votes to a few thousand against, he very soon thought of transforming it into a hereditary monarchy. At the beginning of 1803 he discreetly sounded Louis XVIII about his renunciation of his right to the throne, but met with a public rebuff in March. The plan did not really get under way until the following spring. In April 1804 the Council of State suggested that the title of Emperor might be less jarring to Republicans than that of King; as we have seen, Charlemagne's memory was in people's minds. The idea of a consecration ensuring divine protection for the new dynasty was mooted on the 24th in a letter by Fontanes, a member of the Legislature and the Institute, future "Grand Master" of the University and lover of Elisa, one of Napoleon's sisters. On May 4 the Tribunate voted a motion "that Napoleon Bonaparte... be elected Emperor and be entrusted in this rank with governing the French Republic". On the 18th the Senate's decree was made public and the Empire, or rather the Emperor, proclaimed. The Cardinal Legate, Caprara, a rich well-born septuagenarian who regarded Napoleon as the best bulwark against revolutionary ideas, had already been discussing the coronation with the Pope for the past week, and throughout the difficult negotiations that followed he showed himself skilful and flexible.

At the same time the Council of State, which included several former Jacobins, was deliberating at length about the form the coronation and the anointing (the *sacre*) should take. Should it be in Paris or in the provinces? Once Paris was chosen they debated whether it should be held on the Champ-de-Mars, one of the main places associated with the Revolution. Napoleon made it clear that he did not want a large popular gathering and that a sheltered spot had its advantages in case of bad weather. The councillors of State suggested St. Louis des Invalides, but finally agreed on Notre Dame, Napoleon's choice.

121 *Portrait of Cooper Penrose.* Signed and dated Year X (1802). Oil on canvas. 130×97 cm. Timkin Art Gallery, San Diego (Calif.).
Cooper Penrose (1736-1815) was a Quaker businessman belonging to an English family settled in the south of Ireland. During a visit to Paris, he had his portrait painted by David for a fee of 200 gold louis. The austerity of the painting, barely relieved by the yellows and whites, corresponds to that of the sect to which the sitter belonged.

Who was going to crown and anoint the Emperor? Napoleon felt that the archbishop of Paris was too lowly a personage and wanted the Pope, with whom he was already negotiating. Two of the councillors, Treilhard and Regnault de Saint-Jean d'Angély—who proposed that the two ceremonies should be held separately—expressed disagreement, but finally the Council gave in. The date was set for 18th Brumaire (November 9, the anniversary of the *coup d'état*); in the event the ceremony was postponed twice.

Meanwhile the rather difficult negotiations with Rome continued. Pope Pius VII Chiaramonti, a former Benedictine monk, then Bishop of Tivoli and Cardinal Archbishop of Imola, had become Pope in 1800 after Pius VI's harsh treatment and death. He was elected over the Austrian candidate, had been friendly towards the French since the difficult days of the Cisalpine Republic in 1796, and showed his political flexibility during the negotiations for the Concordat of 1801, which re-established religious peace in France. He leaned on Cardinal Consalvi, a brilliant Secretary of State, but Caprara's rashness put the two men in a difficult position. The French negotiators were Talleyrand, the Foreign minister, Portalis, minister of Worship, Bernier, a reformed Royalist rebel and chief negotiator of the Concordat, after which he became Bishop of Orléans, Abbé de Pradt, and above all Cardinal Fesch, Napoleon's mother's half-brother, who became Archbishop of Lyons in 1802, after several years away from the Church, and from 1803 Plenipotentiary Minister to Rome, where he spent his leisure time collecting paintings.

Rome and Paris were on uneasy terms (though Rome probably hoped to recover the legateships of Ferrara, Bologna and Ravenna, lost in 1797), because of the "organic articles" Paris had inserted in the published text of the Concordat in 1802; the disagreement concerned especially the fate of the constitutional bishops, still considered rebels, from whom Rome demanded absolute submission. In June Talleyrand told the Pope that Napoleon had decided to swear a constitutional oath before the Pope during the service, which would be worded like those "organic articles", mainly in that it would provide for freedom of worship. Although the canon lawyers accepted civil toleration of non-Catholic forms of worship, they could not accept religious toleration. The only point on which the Pope was adamant, and which he finally carried, was the stipulation that the oath was to be sworn in his absence after the religious ceremony.

Cardinal Caprara rather rashly agreed that the residual problems could be sorted out in Paris after the Pope's arrival. It was agreed that he should set out at

the beginning of September, and three conditions were set: the Pope was to perform both the crowning and the *sacre*; the oath was to be separate from the rest of the proceedings; and the constitutional bishops were to adhere to the Concordat and submit to the Pope.

Further difficulties arose when Napoleon had the official invitation, which was extremely evasive about the points agreed, delivered by an artillery general (instead of two bishops, as planned). Pius VII finally gave in, but postponed his departure until November 2, after All Saints' Day, so that the ceremony had to be put off again (invitations for November 25 had already been sent out). The Pope was accompanied by only six cardinals, plus Fesch, four bishops and half a dozen prelates: with their suites about a hundred people arrived in Fontainebleau, where Napoleon met them, on November 25, and in Paris on the 28th.

In Paris preparations were going ahead smoothly. First, a new court had to be formed which did not bear too much resemblance to that of the *ancien régime*. As Napoleon had no children, the problem of the succession cropped up at the outset and the possible adoption of nephews was considered. Two of his brothers—Lucien, who had played such a prominent part in his rise to power, and Jérôme—were discarded because they had both recently married humbly and without Napoleon's consent, but Joseph and Louis remained in line of succession. Titles were showered on them as well as on other relations and close friends. Joseph became Grand Elector and Louis High Constable, with the titles of Prince and Highness. Cambacérès and Lebrun, the other two consuls, became chief chancellor and chief treasurer. In July Caulaincourt was appointed Grand Master of the Horse, Duroc Grand Marshal of the Palace, Berthier Master of the Hunt, and Talleyrand High Chamberlain. Eighteen marshals were created, who were given good places at the coronation. A decree on the order of precedence, issued on July 13, outlined the ceremonial for the entire administration. Louis-Philippe de Ségur, a descendant of an old aristocratic family, a soldier and diplomat who had been round all the courts of Europe, was to be grand master of ceremonies, assisted by Rémusat. The painter Isabey and two architects, Percier and Fontaine, were to decorate the buildings and see to the costumes. The architects, who later compiled the sumptuous Book of the Coronation, prepared Notre Dame and its precincts; in partly clearing the parvis they demolished the chapel of the old chapter and the house of the choristers. They hid a great deal of the façade beneath a sort of triumphal arch studded with figures representing the cohorts of the Legion of Honor and with Napoleon's armorial bearings: in July he had officially

chosen the eagle as his emblem, but bees were swarming everywhere; this was one of Cambacérès's ideas, for the hive was surely the symbol of the new France, the Republic endowed with a leader. This monument was held up by four pillars, two symbolizing the old Merovingian and Carolingian dynasties with effigies of Clovis and Charlemagne, the other two representing the thirty-six "fine cities" of France. The arch was lined inside with green velvet and Gobelin tapestries, and so was the wooden portico which wound round the cathedral to the archbishop's palace, where a tent was set up, where the Imperial procession was to arrive and where dignitaries would put on their robes for the coronation.

Inside Notre Dame the choir and side-altar railings had been removed and stands erected all along the nave and in the choir. Velvet draperies and carpets were scattered everywhere and, above all, an enormous platform stretching as far as the organ loft blocked off the nave between the fourth and fifth pillar. Over it rose a triumphal arch bedecked with eagles above a red velvet dome; beneath it stood great thrones for Napoleon and Joséphine, reached by a wide, straight step. The small thrones with prayer-stools in front were near the altar, on the same level as the raised pontifical throne at the side.

Percier and Fontaine (who depicted their decorations in a fine book published in 1807) had also transformed the façade of the Ecole Militaire on the Champ-de-Mars, where the distribution of eagles was to take place the day after the coronation; it was actually held on the 5th. Their huge ephemeral structure, with draperies and columns topped with eagles, was prolonged by a wide flight of steps on which the eagles would be aligned; they were to be carried by the colonels and the presidents of the 108 electoral bodies of the departments.

De Ségur arranged all the guests in order of precedence for the coronation: ministers, generals and councillors of State on the twenty-four steps of the throne; senators, representatives of corporate bodies and of the towns were all in the nave. The clergy were beside the transept, and behind them the invited princes and dignitaries. The cardinals sat in the choir, facing the Pope; representatives of the diplomatic corps, families of high dignitaries, members of the Institute and delegations from the general staff and the prefectures were in the stands. The religious service could be seen from the stands in the choir, where David was, though he must have had some difficulty in following the actual enthronement which took place on the *petits trônes* side.

On his arrival in Paris the Pope was put up in the Flore pavilion just beside the Tuileries. To his great surprise the Parisians welcomed him warmly and came in

Plan de l'Eglise Métropolitaine de Notre Dame, du Palais Archiépiscopal et des dispositions qui ont été faites pour le Couronnement de LL. MM. II. et RR. Napoléon I.er et Joséphine son Auguste Epouse.

122 *Plan of Notre Dame de Paris*, arranged for the coronation ceremonies. Engraving in the album by Ch. Percier and P. F. L. Fontaine entitled *Description of the Ceremonies and Festivities that Took Place on the Occasion of the Coronation of Their Majesties Napoleon ... and Joséphine...*, Paris, 1807. Cabinet des Estampes, Bibliothèque nationale, Paris.

The "small thrones" are in the choir (18), while the "great throne" is at the end of the nave (23). In his painting David cut out the *prie-dieu* in front of each "small throne".

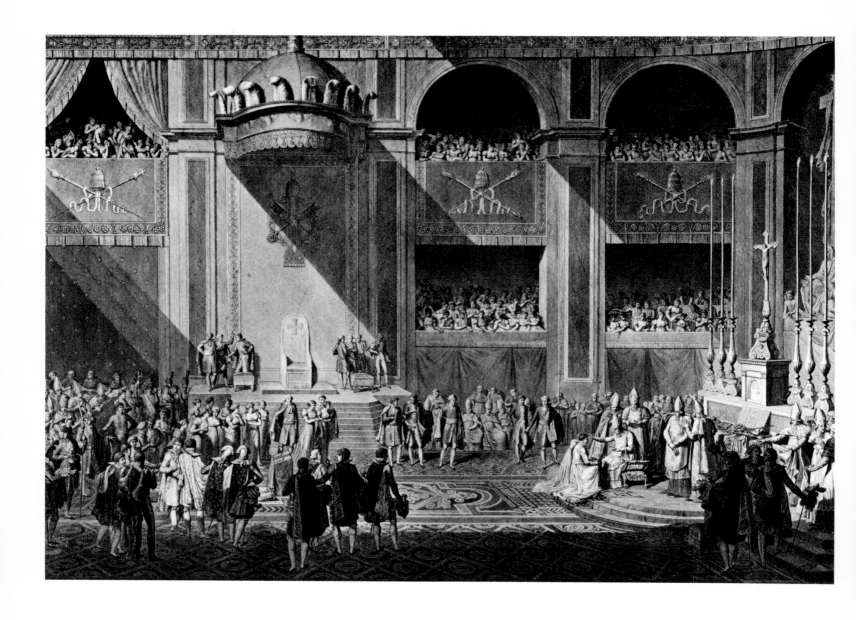

123 *The Anointings.* Engraving by Delvaux after drawings by Isabey and Percier, in the album by Percier and Fontaine, Paris, 1807.
The ceremony of December 2, 1804, which lasted for several hours, was in several parts, organized by Portalis, Abbé de Pradt and Mgr Bernier as regards the liturgical aspect, and by Ségur, the Grand Master of Ceremonies. The actual consecration was reduced to three anointings instead of the seven that had been traditional at the consecration of kings of France.

crowds to be blessed when he walked through the great gallery of the Louvre. On November 30 he was given an official reception with speeches that must have amused anyone who remembered the events of the last fifteen years. François de Neufchâteau, President of the Senate, a former member of the Convention, a rabid anti-clerical and founder of the cult of the Decadal, made an enthusiastic speech, as did Fabre de l'Aude, the President of the Tribunate and a known freemason. The Pope was profoundly dismayed when on the day before the coronation he heard that Joséphine and Napoleon had only had a civil marriage, so Fesch improvised a religious blessing without witnesses or even a parish priest.

Meanwhile more problems had arisen. The Pope had to be reconciled to the liturgy revised by Monseigneur Bernier, as there was no question of simply using the Rheims or even the Paris pontifical for crowning the kings of France. At a time when a high proportion of the ruling classes was anti-clerical, Napoleon, who claimed to be the heir to the Revolution, could not appear to accept the crushing

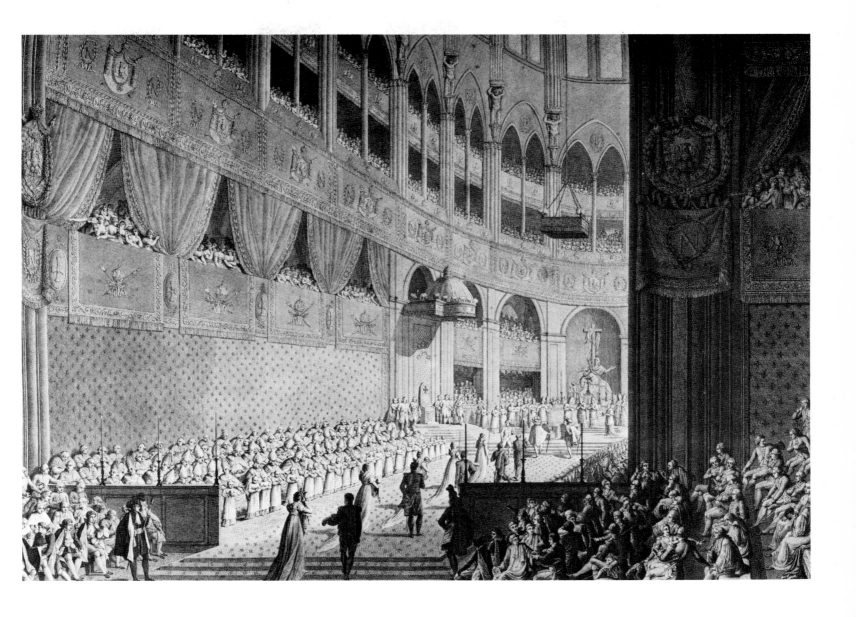

predominance of the Church so conspicuous in the traditional rites, in which the king underwent a virtual inquisition from the officiating cleric and prostrated himself before him repeatedly. During the final negotiations Napoleon decided after some hesitation that he would crown himself, although the Pope had made it clear that he intended to proceed with both the anointing and the crowning. The first printed order of service states that the Pope would crown the Emperor, which is why it has often been mistakenly assumed that Napoleon decided to crown himself on the spur of the moment during the ceremony.

The Pope made many more concessions. He may not have much minded abandoning the *sedia gestatoria* or entering the cathedral on foot, but he must have been distressed to discover that Napoleon would not take Communion. Bernier had carefully revised the text of the religious oath, which raised a delicate problem in connection with the national properties acquired by private citizens (for the constitutional oath guaranteed that the sale was irreversible). The passage in which

124 *The Offerings.* Engraving by Simonet after drawings by Isabey and Percier, in the album by Percier and Fontaine, Paris, 1807.
The ceremony was punctuated by various comings and goings to and from the altar or the "great throne". In addition to the offerings, the "honors" of Napoleon and Joséphine, which were carried by high officials to the altar and presented to the sovereigns by the Pope, involved a veritable ballet. This view, undoubtedly a faithful one, enables us to ascertain how far David modified the actual setting.

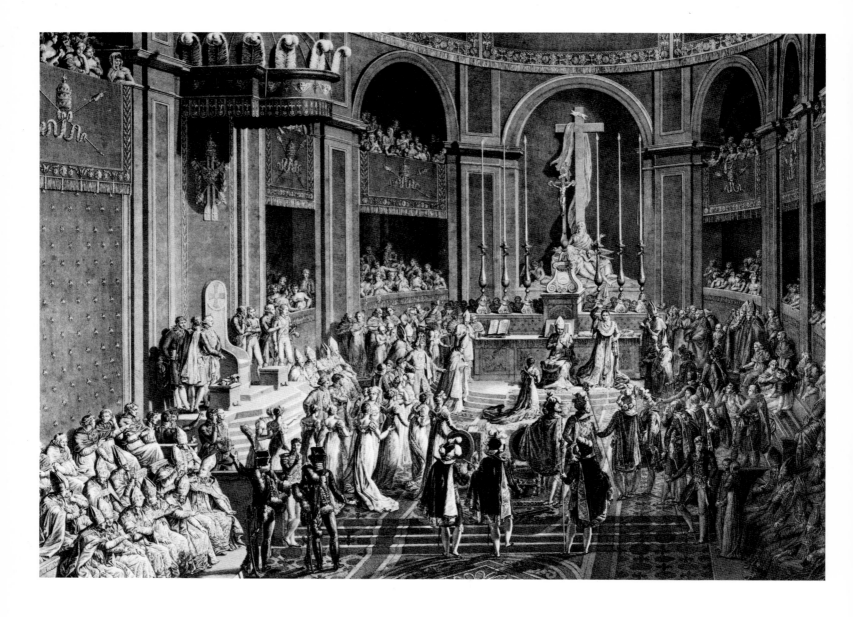

125 *The Coronation.* Engraving by Lavalé after drawings by Isabey and Percier, in the album by Percier and Fontaine, Paris, 1807.

The crucial episode of the actual crowning (not provided for in the program distributed on November 30) was the subject of delicate negotiation prior to the ceremony. The engraving shows Napoleon crowning himself, beside the Pope, which is how David originally planned to represent the scene.

the monarch swears to protect the rights of the Church was cut out, and Napoleon did not even say it; he remained seated and said only "Profiteor" (I agree), touching the Gospels. The wording of the prayers was also changed. The Pope had not "chosen" the Emperor but "must consecrate" him, and he "gave" him the sword instead of "granting" it. The anointing—the consecration proper—was also modified. The holy vial used for anointing the kings had been destroyed in 1793, and a less exalted holy chrism was used; instead of the sevenfold unction of Rheims Napoleon chose the threefold unction—head and hands—based on the consecration of bishops. Joséphine was also anointed, unlike the queens of France. The High Chamberlain should have wiped off the holy oil, but as that was none other than Talleyrand, a defrocked bishop, the Pope arranged for the Chief Almoner to do it.

As the traditional service had been heavily abridged, new rites were inserted. These played a very important role in section IV of the ceremony, published in the *Moniteur Universel* of November 30 (as "Ceremonies of the Anointing and

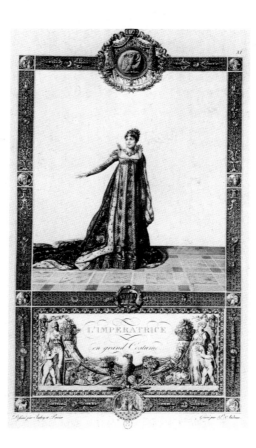

126 *The Emperor in Full Dress.* Engraving by
A. Tardieu after a drawing by Isabey, in the album
by Percier and Fontaine, Paris, 1807.
Napoleon, whose costume was faithfully portrayed
by David, is carrying the scepter and the hand of
justice, whose authenticity is more than doubtful
and which had to be restored for the ceremony.

127 *The Empress in Full Dress.* Engraving by
Audouin after drawings by Isabey and Percier, in
the same album.
David seems to have simplified Joséphine's
clothes—for example, the sleeves—to some
extent; and, as malicious tongues were quick to
point out, he also rejuvenated his model.

Coronation"): we are referring to the "regalia" of Napoleon and Joséphine, which
provided an excuse for a great deal of showmanship.

Napoleon was reviving the Carolingian Empire, and this idea was to be made
increasingly obvious. During the months before the coronation he had studied
Carolingian and Capetian regal adornments under the guidance of Alexandre
Lenoir, curator of the Museum of French Monuments and the most distinguished
archaeologist of his day. Crowns, scepters, scepters surmounted by hands of
justice, swords, spurs—some had been lost, some were broken, in others the fleur
de lys was too obtrusive. One set of items was restored and remade, and it was
decided that seven were to be used for Napoleon. They included three of
Charlemagne's regalia, which may not have been authentic, and perhaps for that
reason were kept rather in the background. Kellerman was entrusted with the
crown, which was completely remade; the sword went to Lefebvre, who had been
at Louis XVI's coronation when he was a plain sergeant, and the scepter to
Pérignon. They are barely visible at the far left of David's painting, where one can
just see Kellerman's hands and the crown reputed to be Charlemagne's behind
Louis and Joseph Bonaparte, and this was undoubtedly deliberate.

As for Napoleon's personal regalia, Bernadotte was entrusted with the collar,
Eugène de Beauharnais, Napoleon's stepson, had the ring, and Berthier the orb,
which was not utilized, any more than Charlemagne's regalia was; Talleyrand
carried the basket for the mantle. Napoleon entrusted the scepter, the sword, the
crown, the hands of justice and the mantle—the Imperial emblems proper—to the
highest dignitaries, his brothers and the former consuls, to be carried to the altar at

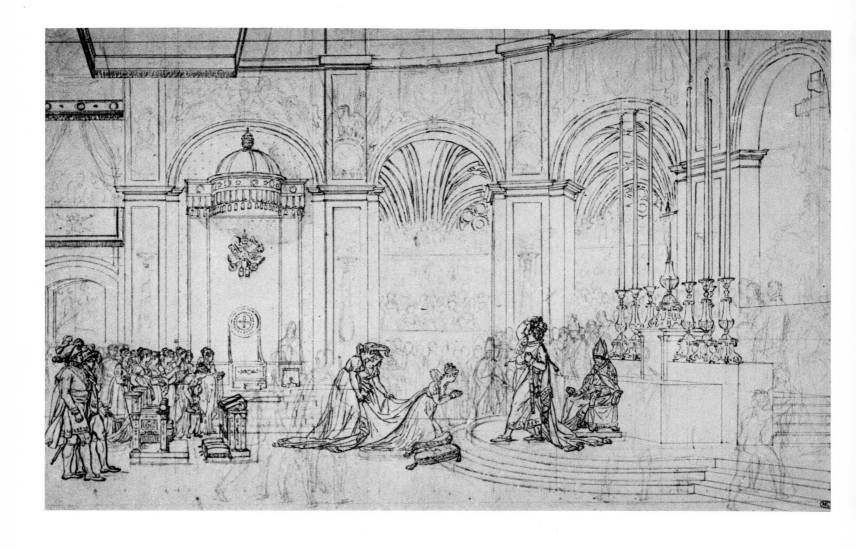

128 *Perspective Drawing for the Consecration and Coronation*. Drawing in black crayon and pen. 34.5×48.5 cm. Cabinet des Dessins (RF 4378), Musée du Louvre, Paris.

The scene presented in this important drawing—probably executed with the collaboration of Degotti—was to be transformed for the painted version. The lay-out would be compressed and even the subject-matter would be changed, since it would represent the next stage, i.e. the crowning of Joséphine by Napoleon.

the same time as the ornaments for Joséphine. She underwent a similar ritual, but reduced to just the ring and mantle, blessed by the Pope, who then returned them to the sovereigns.

Another innovation at the moment of the crowning proper was that Napoleon kept his sword; but before going up to the altar to crown himself he handed the scepter back to Lebrun and the scepter of justice to Cambacérès, whose back views can be seen in the foreground of David's painting.

There was a full rehearsal at the Tuileries in the Galerie de Diane, and the ceremony itself lasted three hours. It was marked by the constant coming and going of the Imperial procession between the large thrones and the small thrones, the anointing, the crowning, the offertory by the altar, the rest of the ceremony at the back of the cathedral, and above all the civil oath after the Pope had left.

David had naturally thought of doing two complementary paintings, the first two described in his letter to Daru on June 19, 1806, six months after starting work on the *Sacre*, as he called the painting, which actually showed rather the coronation. He was confronted with the history painter's perennial problem, the choice of the most significant moment in the uninterrupted flow of history-in-the-making. He chose the actual crowning.

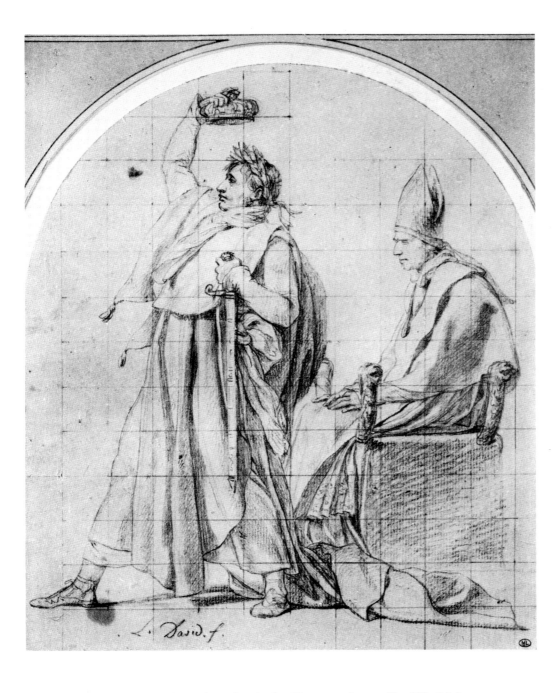

129 *Napoleon Crowning Himself.* Drawing in black crayon. 29 × 25 cm. Cabinet des Dessins (RF 4377), Musée du Louvre, Paris.
It was only at a late stage in the painting of the final version that David gave up the idea of showing Napoleon crowning himself and changed the pose of Pius VII, originally represented with his hands on his knees.

129 After the Pope has given back the Emperor's regalia, His Majesty goes up to the altar to take the crown; he puts it on his head with his right hand and clutches his sword tightly to his heart. This grandiose gesture reminds the spectators of the universally acknowledged truth that whoever can conquer something will be able to defend it. The stance, the gesture, the gaze of the affected crowd—all show the general feeling of awe. The Empress is kneeling at the foot of the altar, her hands clasped, waiting for the crown her august husband is about to place on her head. Her Imperial Highness, Madame [Napoleon's mother], seated apart with her appropriate suite, is taking part in an event as glorious as it is moving to a mother's heart...

In the same text David mentioned that "this painting is more than half

done and will be finished in six months", so he evidently changed the subject at a very late stage to show the moment that followed, the crowning of Joséphine. Rouget, who collaborated with David on the *Sacre*, told Delafontaine that Gérard was responsible for the change: "I must admit that I found the stance of the Emperor crowning himself and holding his left hand defensively on his sword not very felicitous. There is something histrionic about it which I don't think Napoleon would like very much. What about the Emperor putting the crown he has just received from the Pope's hands and taken from his brow on the Empress's head? I said that would perhaps be calmer and more graceful, with more of that elegant simplicity you like." The end product is reminiscent of Rubens's *Coronation of Marie de Medici*, especially the layout. (The Rubens gallery in the Luxembourg had come back into fashion since 1802, when a museum was organized around it with paintings by Le Sueur from the Carthusians, J. Vernet's *Ports of France* series, and later Vien's *Sleeping Hermit, The Horatii* and *Brutus*.)

Another change was attributed to Napoleon himself. Several early drawings show the Pope sitting behind the Emperor, with his hands flat on his knees. With P his usual abruptness Napoleon apparently said, "I didn't have him come all that way to do nothing", after which David showed him giving a blessing.

David could not have begun work on the canvas before the end of 1805. He was evicted from the Louvre with all the other artists—in any case, he would not have had enough room there—and had to find somewhere big enough for a canvas measuring more than nine by six metres. Once again he found a secularized church, the Church of Cluny, beside the Sorbonne chapel, and had it fitted up by an architect, de Gisors. We know he made models and mock-ups of the scene (those "implements appropriate to that sort of work" referred to in his report of June 1806). At the beginning of April he enlisted the help of Degotti, set-painter at the Opéra and therefore an expert on perspective. "I'll show you my first design for my composition and give you my ideas on how we can work together; you can do the perspective on the drawing, which I mean to redo on a bigger scale, and then on the actual canvas." This drawing may be the one in the Louvre (RF 4378), in P which the architectural features are expertly done. At the same time David was working on his fourth painting, *The Arrival at the Town Hall*, of which several overall drawings have survived. In September he told Daru that the architectural part was being drawn on to the big canvas.

In 1805 David also painted portraits of two of the protagonists of the coronation, though this posed problems. At the beginning of the year, apparently

12

𝒢𝒟𝓏

130 *Study for Pope Pius VII*. Drawing in black crayon. 24×18 cm. Fogg Art Museum, Cambridge (Mass.); Grenville L. Winthrop Bequest (sketchbook 1943-1815-12).
This admirable study was for the first version of the subject. It was at the request of Napoleon himself that David finally painted the Pope with his hand raised in blessing rather than in this somewhat listless attitude.

131 *Study for Vicar-General Léjeas*. Drawing in ▷ black crayon. 21×16 cm. Fogg Art Museum, Cambridge (Mass.); Grenville L. Winthrop Bequest (sketchbook 1943-1815-13).
The vicar-general, later the Archbishop of Liège, is leaning against the arm-chair that would be occupied, in the painting, by the aged Cardinal de Belloy, Archbishop of Paris.

132 *Study for the Emperor's Mother*. Drawing in ▷▷ black crayon. 21×16 cm. Fogg Art Museum, Cambridge (Mass.); Grenville L. Winthrop Bequest (sketchbook 1943-1815-13).
This splendid study—from life, according to the painter—could not have been done on the spot, since "Madame Mère" had fallen out with her son and was in Rome at the time of the ceremony. David nevertheless gave her a prominent place in the gallery, almost in the center of the picture.

at Fleurieu's request, he painted the Pope, who stayed in Paris until the end of April, and made two copies for Napoleon and Joséphine. In fact the Pope never received his portrait, which is now in the Louvre. A short time afterwards David was commissioned by Lebrun, the Grand Treasurer, to do a full-length portrait of

grand vicaire Le gras

Madame mère, sur Nature. J. D.

the Emperor holding the scepter and the scepter of justice for the Appeals Court at Genoa. The rough draft was finished in September; in February 1806 the copies of the portrait of Pius VII were ready and the large portrait of Napoleon was "all sketched out" with the head already done. It was finished at the beginning of June. The painter then presented his bill for the four pictures: a total of 37,000 francs—10,000 for the original of the portrait of Pius VII, 6,000 for each copy, and 15,000 for the large portrait to be sent to Genoa (according to David's grandson it was actually painted by Georges Devillers, a pupil).

David then had an extremely unpleasant experience when Napoleon had the four portraits brought to him at St. Cloud at the beginning of July and simply and plainly rejected his portrait (David tried in vain to reopen the question at the beginning of 1811, but Napoleon told him to forget it). According to Daru, the Emperor even asked "on whose orders" the three portraits of Pius VII had been painted.

All trace has been lost of the large portrait of Napoleon and it is hard for us to envisage it from the small reddish sketch in the Musée des Beaux-Arts, Lille. Napoleon is shown in a simple frontal pose and seems swamped by his vast Imperial mantle and somewhat bothered by the overlong scepter and hands of justice. The study of a head in the Bibliothèque Thiers which shows roughly the same pose should perhaps be associated with this portrait, or perhaps with the portrait painted for Jérôme, then King of Westphalia, in 1808. The portrait of the Pope, however, is justly famous, a masterpiece reflecting the deep affection the painter felt for his model, as Delécluze bears out. The Pope's intelligent distinguished face with the unforgettably penetrating eyes stands out from the stiff red velvet cape, the embroidered stole, and the heavy arm-chair, all painted very freely. With justifiable pride the painter signed it solemnly, *Napoleonis/Francorum Imperatoris/Primarius Pictor/Lud. David/Parisiis 1805*, adding the cross of the Legion of Honor to his name. The first three lines, so oddly formal in contrast to the brief inscription on the *Marat* eleven years earlier, were unfortunately rubbed out during the Restoration. It was apparently after this portrait that David produced his marvellous study of the Pope with Cardinal Caprara (McIlhenny Collection, Philadelphia).

David started work on the canvas of the *Coronation* on December 21, 1805. He drew it from the viewpoint of an imaginary dignitary sitting in the front row, in front of the cardinals' bench, which is not shown. The viewer virtually seems to enter the picture; Napoleon, when he saw the finished painting in the studio on

133 *Study for a Bishop.* Drawing in black crayon. 18.5×11 cm. Cabinet des Dessins (sketchbook RF 23007, p. 8), Musée du Louvre, Paris.
As was his frequent practice, David studied this figure—half-hidden by the Emperor in the actual painting—in the nude with the drapery roughly outlined.

134 *Study for an Oriental Personage.* Drawing in black crayon. 21×16 cm. Fogg Art Museum, Cambridge (Mass.); Grenville L. Winthrop Bequest (sketchbook 1943-1815-13).
This unidentified figure could be a first draft for the ambassador of the Sublime Porte who is to be found, but with moustache and beard, behind the farthest candlestick to the left.

January 4, 1808, said: "It's not a painting, you walk right into the picture." This impression is reinforced by the open sweep of the composition ending on the right with the back view of Cambacérès, Lebrun, Berthier and Talleyrand, who also help to create the depth of the scene.

In order to enable the viewer to see the scene, David cut out Napoleon's own brothers, Joseph the Grand Elector and Louis the High Constable, the two most important dignitaries, who should have been right in front of us. Louis chided David in a letter dated September 11, 1807.

As you know, I have every reason to complain about my place in it, because my brother Joseph and I are the only people not actually taking part in the ceremony. It is true that while the Emperor and Empress were kneeling we were to the right of the princesses, and so to the left in the painting as you look

135 *Study for "Third Consul" Lebrun.* Drawing in black crayon. 18.5×11 cm. Cabinet des Dessins (sketchbook RF 23007), Musée du Louvre, Paris. The former Third Consul, now arch-treasurer of the Emperor, is shown from the back, wearing a large feathered hat, in the foreground of the painting.

136 *Study for Cardinal Caprara.* Drawing in black crayon. 24×18 cm. Fogg Art Museum, Cambridge (Mass.); Grenville L. Winthrop Bequest (sketchbook 1943-1815-12).
Cardinal Caprara, legate in Paris and a somewhat imprudent negotiator, was ill on the day of the ceremony and did not take part in it. David nevertheless gave him a place of honor in his picture and made several studies of his heavy-eyed, impassive mien. He reappears in *The Distribution of the Eagles.*

at it, but while we were there the high dignitaries were on our left, and since you show them beside the altar with the scepters, taking part in the ceremony, the Grand Elector, who carried the Emperor's crown, and I, who held his sword high in my hand, should be there too.

In his reply, quoted below, David offered to retouch his painting but showed his anxiety: "... for, as you know, everything in a painting is worked out; changing one figure could have an incalculable effect and throw out one side of the picture, and often the whole work." Louis was certainly kind enough to desist.

Although David was not present in the Tennis Court nor, as we shall see, at the distribution of the Eagles, he was certainly present at the Coronation. The realism of the painting and its striking vividness create the impression that even if the viewer is not taking part in the action he is at least seeing an eyewitness account. The Empire crumbled to dust, but the *Coronation* did not, and its palpable reality still shines brightly. David's truth is more truthful than reality. Almost in the center of the picture, just above Joséphine, we are faced by Napoleon's mother, surrounded by her ladies-in-waiting, Mesdames de Fontanges and Soult, her chamberlains, the Comte de la Ville and M. de Brissac, and her Master of the Horse, the Comte de Beaumont; Her Imperial Highness, Madame Mère, sits enthroned, looking on with a contented, cow-like expression. In fact she hated the Beauharnais and was on rather bad terms with her son; far from being at the ceremony, she had been in Rome since March, where Lucien, whom she supported, joined her in May. A note in the official brochure (*The Consecration of HM the Emperor Napoleon in the Archiepiscopal Church of Paris on XI Frimaire Year XIII, December 2, 1804*) published after the ceremony tells us that Cardinal Caprara was ill and had therefore not been at the ceremony, where he was replaced at the Pope's side by Cardinal di Pietro, but David nevertheless showed him in a prominent place.

As David took some liberties with historical facts, it is necessary to compare his "eyewitness" version with engravings in official accounts and even with his own preliminary drawings. We can see that at the last minute he obviously changed the "centering" of the scene. He painted it from a much closer range than that in the drawing in the Louvre (RF 4378), and cut out the upper part of the building above the large arcades and also a fifth of the space on the left, though the groupings are the same. He clearly wanted to strengthen the cohesion between the figures, which he could do only by deviating slightly from reality. He brought the prie-dieu forward considerably and separated them from the small thrones, almost

Caprara

24

5P

92 le maître des enfans *de chœur*

230

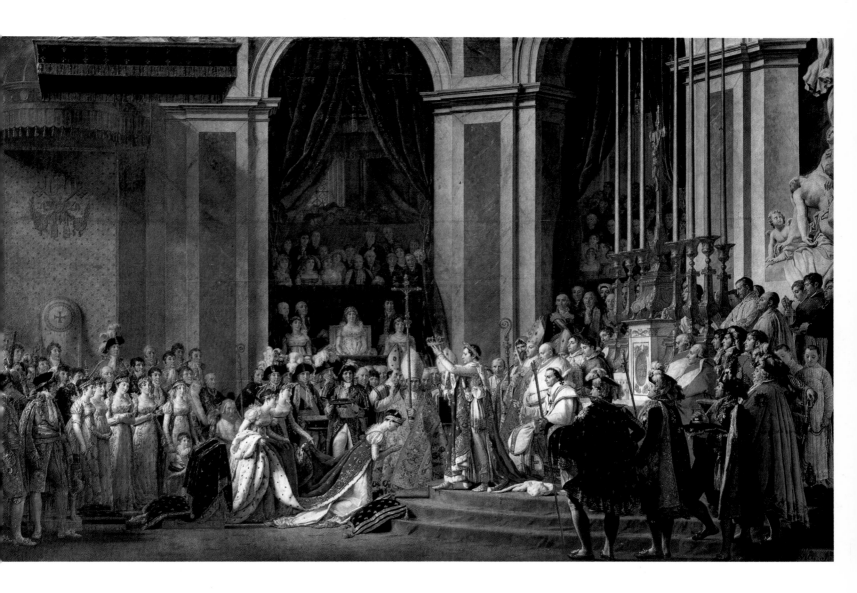

hidden in the painting. In reality the thrones and prie-dieu were set well back from the pontifical throne, whereas in the painting they are right beside the altar. David also lowered the Pope's throne a good deal, possibly so as not to show an empty seat, for in fact it was about two metres or eleven steps up from the ground. The change in the layout would have led to the disappearance of the canopy, which in the drawing can be seen hanging high above the small thrones, but David brought it down for pictorial reasons and for light balance.

The stands set up between the arches show a further straining of the truth. There were in fact two levels of stands, but the second one much higher, reaching up roughly to the base of the arches. The drawing is again far more accurate; the billowing green velvet draperies were only in the nave, not in the choir. However, from the drawing it seems that David had intended to put candle-holders between the arches, in front of the pillars, but finally omitted them.

This artistic licence does not detract from the scrupulous accuracy of the likenesses and the detail of the clothes. Several notes have survived in which David asks some participant or other to come to his studio to be painted or to lend him his

138 *The Consecration of the Emperor Napoleon I and the Coronation of the Empress Joséphine in the Cathedral of Notre Dame de Paris, December 2, 1804.* Signed and dated 1805 and 1807. Oil on canvas. 610×930 cm. Musée du Louvre, Paris.
After a year's preparation, this vast canvas was started in December 1805 and finished two years later. Accurate in parts, inaccurate in others, it offers an image of the ceremony and its protagonists that, even today, has a most powerful impact.

◁ 137 *Study for the Choirmaster.* Drawing in black crayon. 24×18 cm. Fogg Art Museum, Cambridge (Mass.); Grenville L. Winthrop Bequest (sketchbook 1943-1815-12).
This self-satisfied character is to be found, in a slightly different costume, at the extreme right of the picture.

231

costume. He appealed to one M. de Charette, of whom we see only "a portion of the head" (but "there'll be enough for you to imagine the rest"), as well as Louis Bonaparte, who lent him his uniform but asked in return that his likeness be touched up. David immediately asked him to come in person and bring "the head-dress, and especially the sword he had at his side, a vital item for a high constable. If His Majesty has no head-dress in Paris, he could send for that of the Prince de Berg [Murat]. He doesn't need to bring shoes, I'll be able to find suitable ones." The painter went on to say that Louis was to wear "ceremonial dress, with coat, cravat, *grand-cordon*, hat, sash and sword with belt". He also approached Talleyrand to borrow the Emperor's crown and mantle, and asked Metternich for a portrait, if possible, or failing that the details of the clothes and medals worn by the Austrian ambassador, the Count of Cobenzl (who appears with the Spanish, Italian, Turkish, and American ambassadors, behind Cardinal Caprara, half-hidden by the large candlestick on the altar). However careful he was, there were still tiny errors in the ceremonial dress. A painstaking historian has noticed that Napoleon and his brothers all wear the same order of the Legion of Honor decorated with bracketed eagles, but only one was ever made.

We do not know of many painted studies for the large canvas except Junot's head (the former Chevrier Collection) and a head of Mme de la Rochefoucauld, Joséphine's lady-in-waiting, holding the Empress's train, on the same canvas as a painting of Eugène de Beauharnais's hand (Musée Fabre, Montpellier: he is on the far right on the altar steps, just above Talleyrand).

However, there are plenty of drawings in the Louvre, in the Musée des Beaux-Arts, Besançon and in the Fogg Art Museum, Cambridge, Mass. It is difficult to tell which sketches were done on the spot, especially as nobody knows exactly where the painter was standing. He showed himself unobtrusively with his family, Vien, Mongez and a few other members of the Institute in the stands above Napoleon's mother, but he had actually hoped to be put beside Coustou's *Descent from the Cross*, and we do not know if he succeeded. At any rate he did not see the ceremony from the viewpoint of his painting, and most of the known drawings that correspond to the final work must have been done in the studio. These include the fine studies of heads, several inscribed "from memory", such as the charming sketch of the Marquis de Jaucourt, an indestructible soldier and politician who served every administration from Louis XVI to Louis-Philippe, and also the intelligent portrait of Duroc, Grand Marshal of the palace (Musée des Beaux-Arts, Besançon). Even the famous drawing of Joséphine inscribed "from life" (Musée

139 *The Consecration.* Detail of Pl. 138.
The real subject of the painting, after June 1806, became the coronation of Joséphine, around which the whole composition is organized, on either side of the cross held vertically by a bishop and of the crown, on which all eyes are fixed.

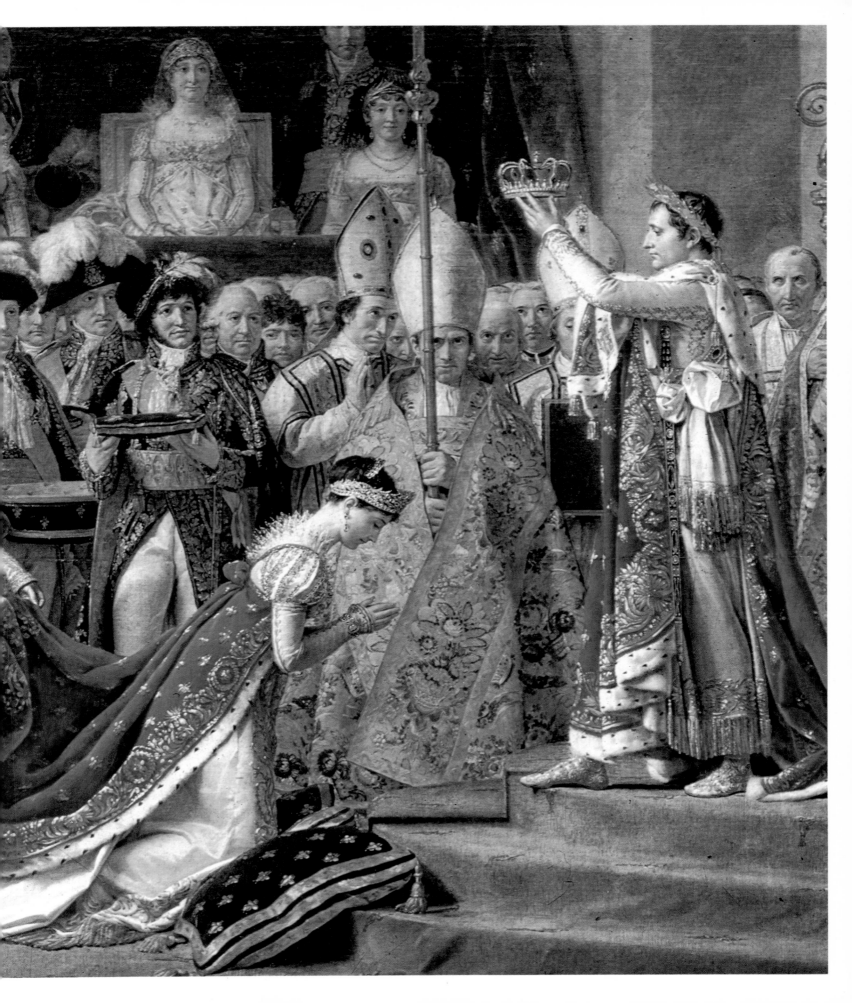

140 *Study of Mme de la Rochefoucauld for "The Consecration".* Oil on canvas. 54×46 cm. Musée Fabre, Montpellier.

One of the very few painted sketches for *The Consecration* that have survived. Mme de la Rochefoucauld is holding the Empress's train in the middle of the picture. The hand on the sword is that of Eugène de Beauharnais, at the extreme right of the picture.

du Louvre, Paris) may have been done in the Tuileries, though it corresponds to her stance at the coronation. This hypothesis is borne out by two more drawings of Joséphine, done in 1808 and 1809 (now in the Art Institute, Chicago) for *The Distribution of the Eagles*. One of them is a simple drawing inscribed "from life" and the other is a direct study for the painting, but the attitude is exactly the same, even though the costume and setting are different.

The Coronation is also a riveting portrait gallery of the heterogeneous new Napoleonic world. On the left we see Joseph and Louis, the jealous brothers and newly created Princes, then the circle of sisters and sisters-in-law: Caroline (ex-Annunziata) Murat, made Grand Duchess of Berg before she became Queen of Naples; Paulette, henceforth Pauline, Princess Borghese; Marianna, now known as Elisa Bacciochi, who was made Princess of Lucca and Piombino a few months later; Princess Hortense, née Beauharnais, Louis's wife and future Queen of Holland, and in front of her Prince Napoleon, her young son; Joseph's wife, who was to become Queen of Naples and then of Spain. Behind them is a whole attentive group, dressed in their best finery, dominated by the elegant figure of Duroc, a member of a noble family from the east of France, who became Napoleon's *aide-de-camp* and most loyal supporter until his death in battle in 1813. The aged Cardinal de Belloy, Archbishop of Paris (he was ninety-five) is seated with his thin, mournful vicars behind him. Behind the ladies-in-waiting holding Joséphine's train are Ségur, the Master of Ceremonies, Bessières, Moncey, Sérurier, and Murat, who looks pleased with himself; then there are the marshals, seemingly bewildered and laden down with the cushion, basket and salver bearing the Empress's regalia.

Behind the prelates we catch a glimpse of the brown, curly hair of the intelligent Estève, treasurer of the Emperor's household; David had just completed a fine portrait of him (and started another, larger, one which remained unfinished in his studio). In the stands above Napoleon's mother are a few members of the Institute, done cursorily in thin paint so as not to encroach on the foreground, with the venerable Vien, who was later made a senator, well in evidence; Napoleon commented on him when he went to see the painting at the beginning of 1808; at that time it was only just finished. Surrounding the altar and the exhausted Pope (who had arrived at ten in the morning, two hours before the Emperor) is the extremely life-like group of priests and clerics; among them are Cardinal Braschi, the Pope's nephew; Cardinal Caprara has his hands on his stomach; one sees a picturesque, heavily bearded Greek bishop, and on the far

Pages 236 to 241.

141 *The Consecration.* Detail of Pl. 138.
From left to right: Napoleon's sisters (Caroline Murat, Pauline Borghese, and Elisa Bacciochi); his sister-in-law Hortense, wife of his brother Louis, holding the hand of little Prince Charles; and Julie, wife of his brother Joseph. Not all the men at the back have been identified, but General Ducros, Grand Marshal of the palace, is to be seen in the top row and General Junot, of whom a painted study survives, is on the right, behind Julie.

142 *The Consecration.* Detail of Pl. 138.
Behind the Empress, whose train is held by Mme de la Rochefoucauld and Mme de la Valette, can be distinguished, on the left, the elderly Cardinal de Belloy (seated), his vicars-general, then Louis-Philippe de Ségur, Grand Master of Ceremonies, and Marshals Bessières, Moncey, Sérurier and Murat, who carried Joséphine's "honors". "Madame Mère" (who in fact did not attend the ceremony) is enthroned in the gallery between Mme de Fontanges and the wife of Marshal Soult.

143 *The Consecration.* Detail of Pl. 138.
This detail enables us to appreciate Joséphine's miraculous rejuvenation (she was actually over forty years old at the time) and, above all, contrasts in treatment that help to create depth—the gems, accurately rendered in impasto, standing out against the chasuble, which is treated more simply.

144 *The Consecration.* Detail of Pl. 138.
The figure of the Emperor stands out against a group of ecclesiastical dignitaries; those in the background have not been identified.

145 *The Consecration.* Detail of Pl. 138.
The Pope's entourage includes a bearded Greek bishop, then Cardinals Braschi and Caprara (who was, in fact, replaced at the ceremony by Cardinal di Pietro). In the foreground, the scepter is held by Arch-treasurer Lebrun (viewed from the back).

146 *The Consecration.* Detail of Pl. 138.
These dignitaries are (from left to right): Lebrun, High Chancellor Cambacérès (holding the hand of justice), Marshal Berthier (holding the orb) and Talleyrand. Above him (returning to the left): Eugène de Beauharnais, Caulaincourt and Bernadotte. On the far left, beyond the candlesticks: a group of ambassadors.

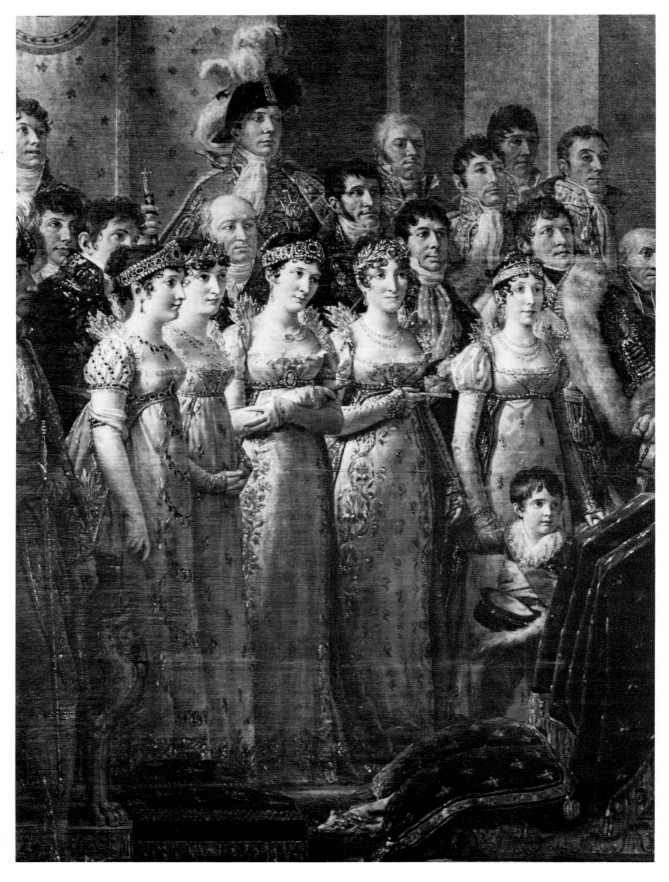

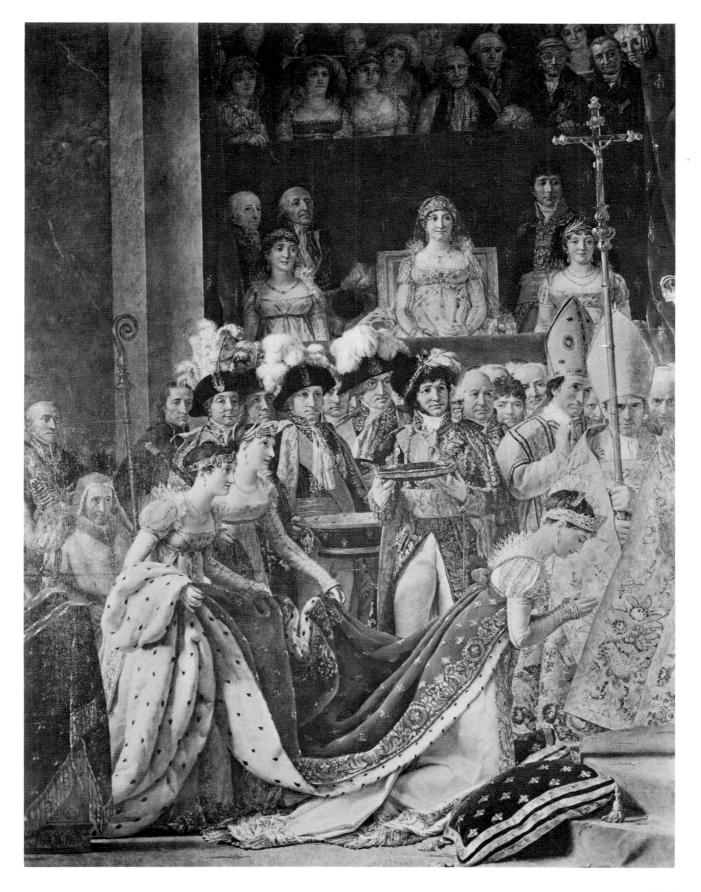

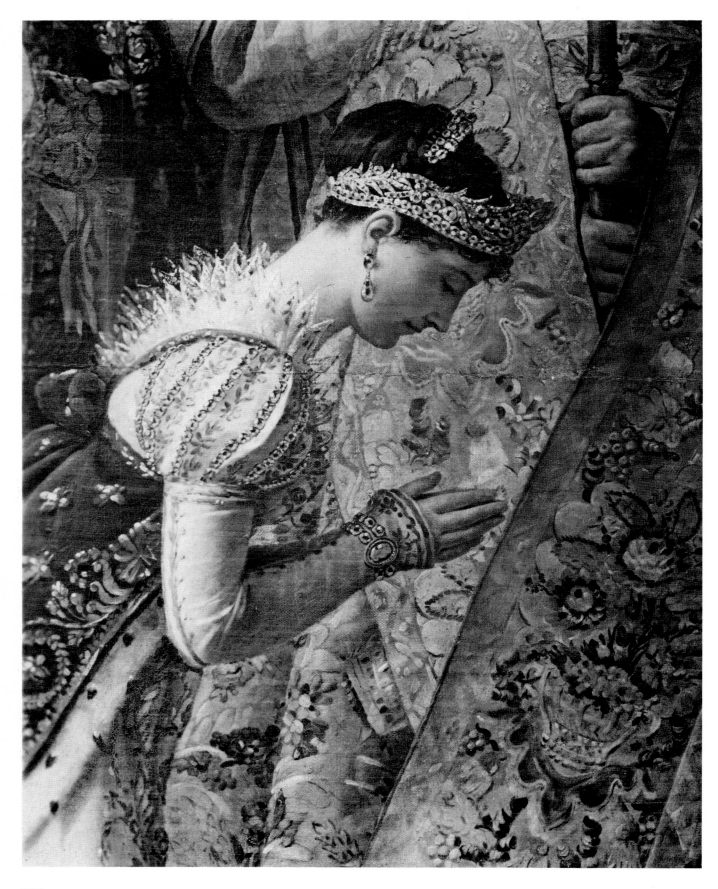

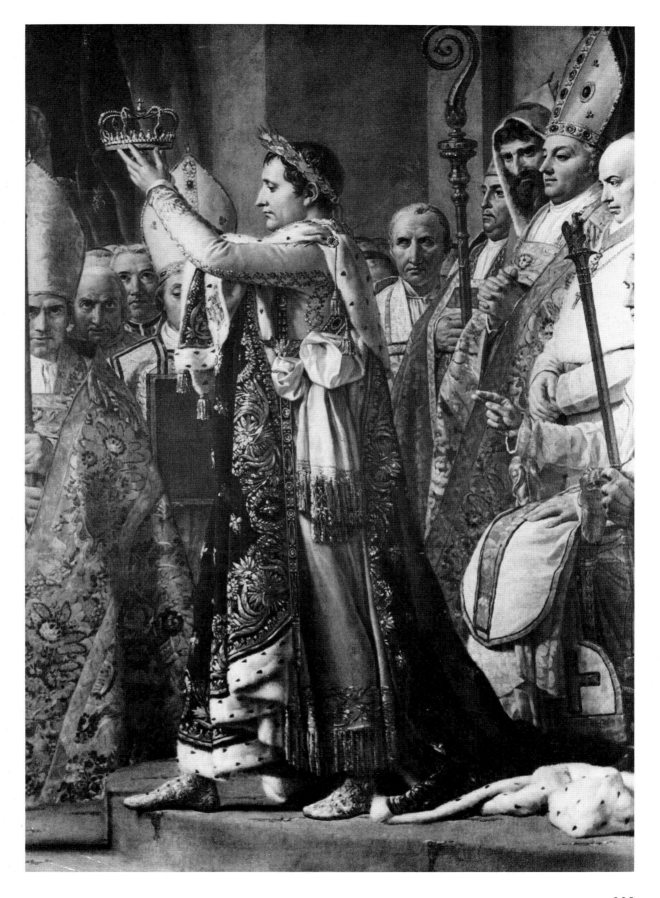

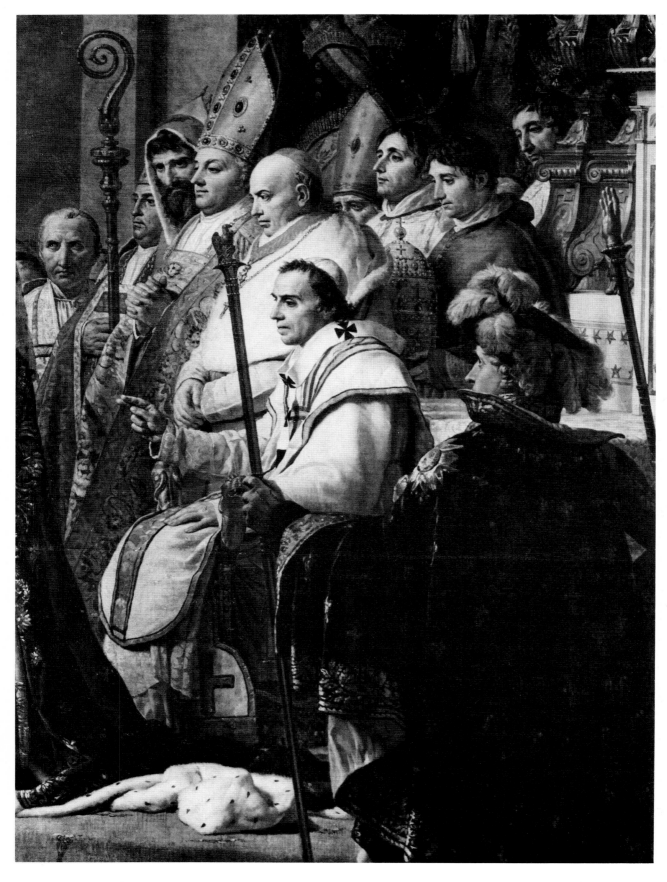

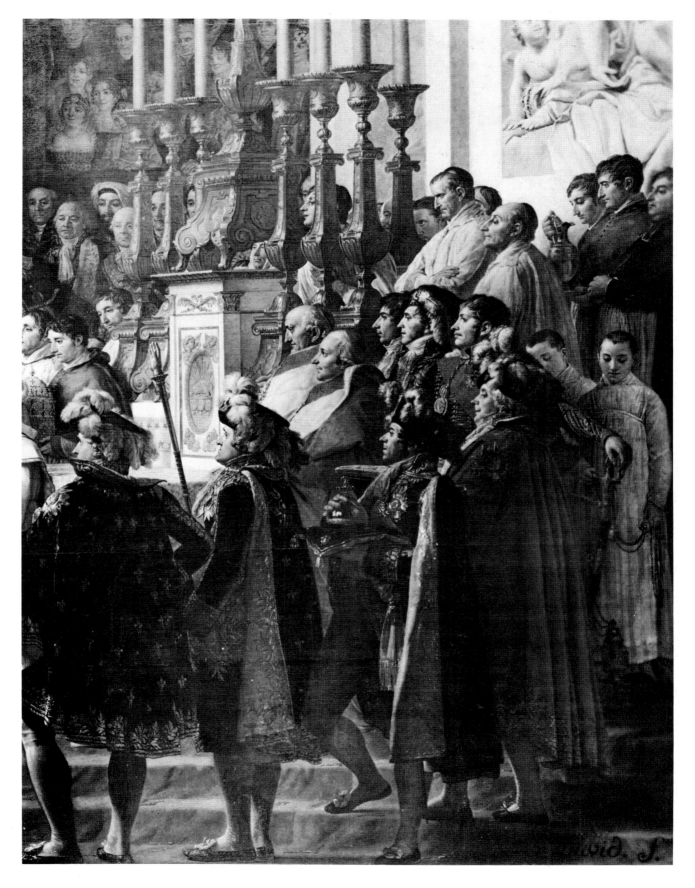

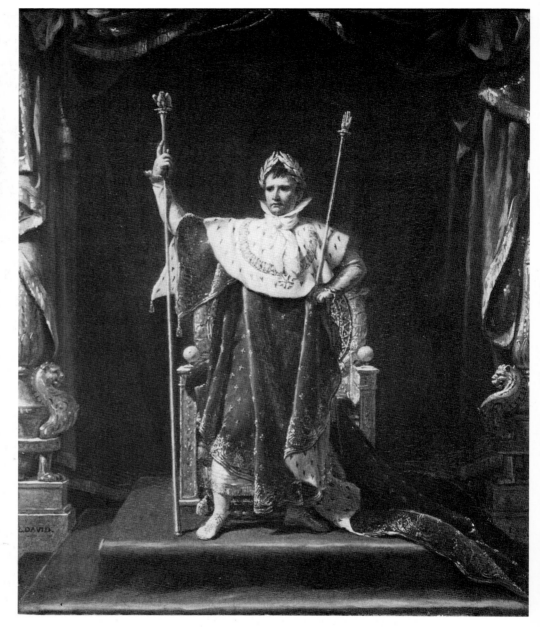

147 *Portrait of Comte Estève*. Signed and dated Year XIII (1804). Oil on canvas. 84×72 cm. Private collection.
David did two portraits of Comte Estève, Councillor of State and treasurer of the Emperor's household, who is also to be seen in *The Consecration* (behind Murat). The first was this homely work, the second a formal portrait, not quite finished, which remained in David's studio until his death.

148 *Study for a Portrait of Napoleon in Imperial Dress*. Signed and dated 1805. Oil on wood. 58×49 cm. Musée des Beaux-Arts, Lille.
This *modello* was for a large portrait to be hung in the audience chamber of the Appeals Court in Genoa. Painted mainly by a pupil, the full-scale work (now lost) was finished in 1806, but was refused point-blank by Napoleon.

149 *Study for a Portrait of Napoleon*. Oil on wood. 60×52 cm. Bibliothèque Thiers, Paris.
This little-known work could be connected with the preceding commission, on the evidence of the turn of the head, the head-dress, and the cravat. However, it may relate to another portrait, commissioned by King Jérôme in 1805, the fate of which is unknown.

right a choirboy who is fascinated by Eugène de Beauharnais's gleaming sword, just below a fat stage priest; another is thrusting out his neck and long pointed nose to see better; Cardinal Fesch looks attentive and contented. Coming back towards the viewer, we have the circle of the new court generals and high dignitaries: Bernadotte, son of an attorney in the seneschal court of Pau, the only one who was successful to the end and who, after starting out as a simple soldier, founded a dynasty of kings in Sweden; Caulaincourt, of the family of the Marquis of Caulaincourt, an officer discharged as an aristocrat in 1792, a soldier and statesman whom Napoleon made Duke of Vicenza; Eugène de Beauharnais, the Emperor's stepson, who became viceroy of Italy a few months later and had the wit to amass a vast fortune; Talleyrand, the former bishop, who blessed the

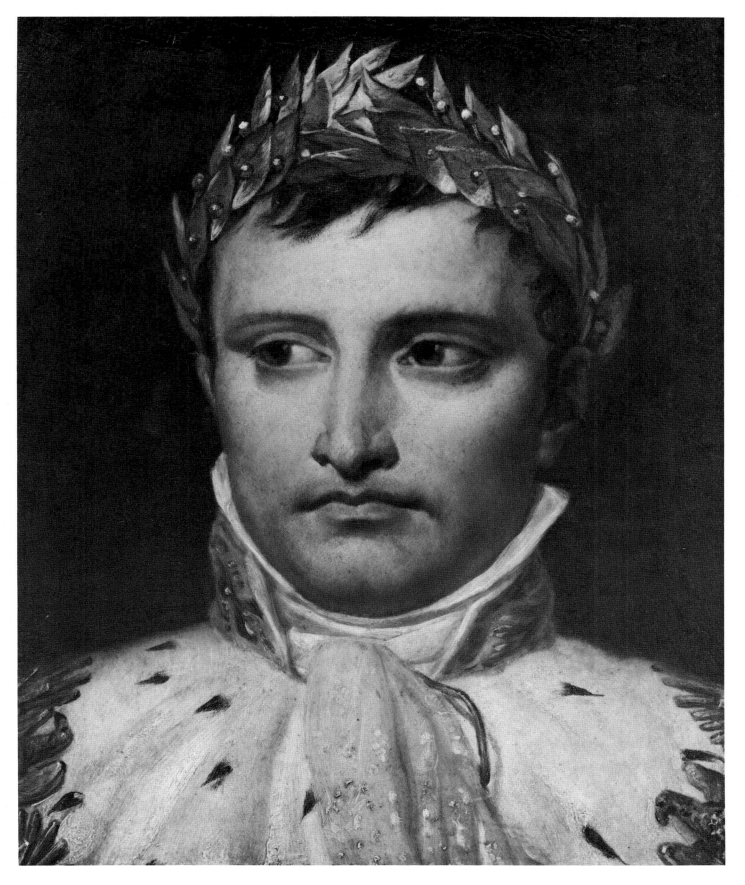

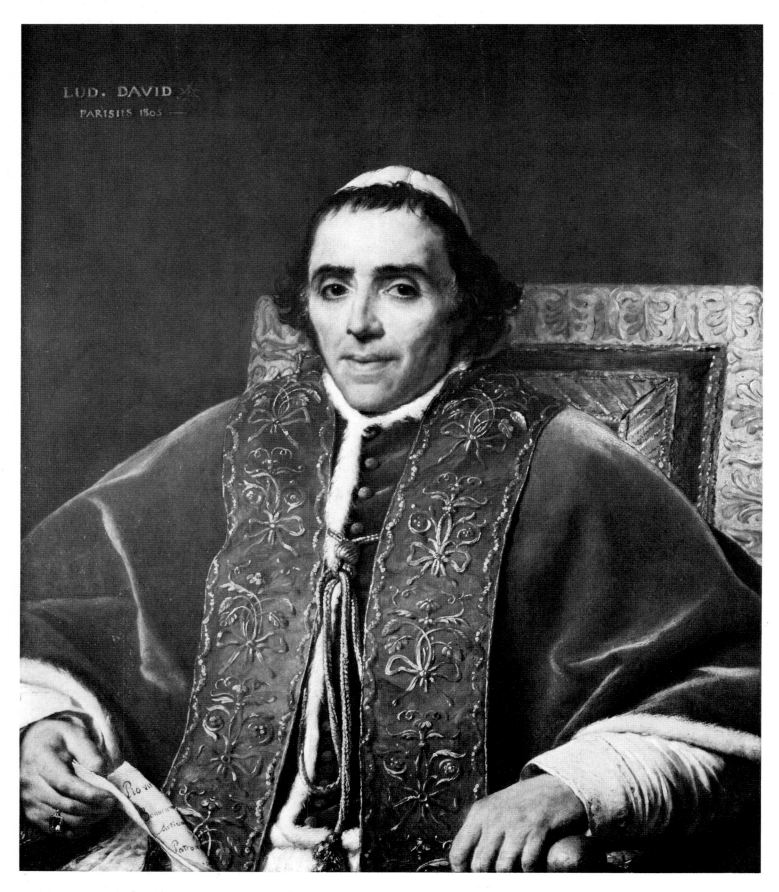

244

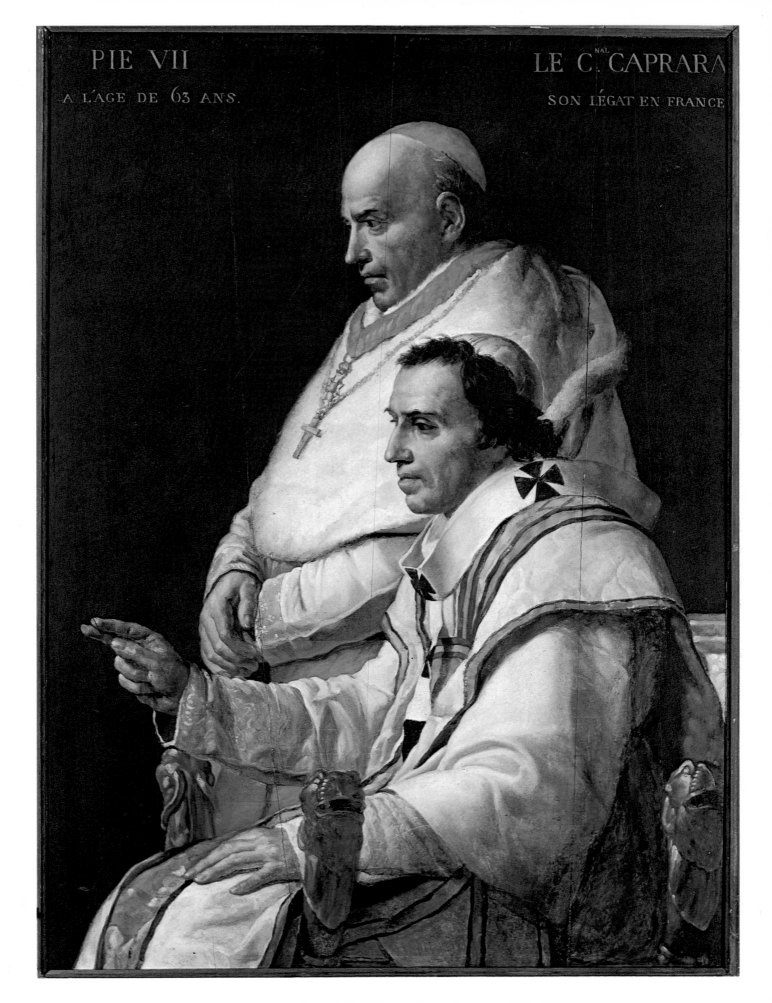

PIE VII
À L'ÂGE DE 63 ANS.

LE C.^{NAL} CAPRARA
SON LÉGAT EN FRANCE

150 *Portrait of Pope Pius VII.* Signed and dated 1805. Oil on wood. 86×71 cm. Musée du Louvre, Paris.
The Pope stayed in Paris until the end of April. Although he was not actually commissioned to do so, David painted this remarkable portrait, in which his avowed cordiality towards the sitter is apparent. He also painted two replicas, now at Fontainebleau and Versailles.

151 *Portrait of the Pope and Cardinal Caprara.* Oil on wood. 138×96 cm. McIlhenny Collection, Philadelphia.
A slightly enlarged, but otherwise scarcely altered, portrayal of the two dignitaries as they appeared in *The Consecration.* In 1824 David wrote to Didot: "I thought it would be interesting one day... to have a picture giving an accurate impression of the character and features of this head of the Church who found himself in such difficult and extraordinary circumstances."

Federates' flags on July 14, 1790 and was released from his vows after the Concordat, an indispensable Foreign minister, regarding the crowd with an ironic expression, his snub nose in the air; little Berthier, holding the orb like a good boy—one of the main organizers of the army, later Prince of Neuchâtel, who committed suicide when he could not make up his mind which side to back during the Hundred Days; Cambacérès, one of the most interesting political figures of the time, a member of the Convention that sentenced the king to death (but he voted for a reprieve), minister of Justice, Second Consul, whom Napoleon showered with titles such as High Chancellor, Grand Officer of the Legion of Honor, President of the Senate and then of the Council of State, and Duke of Parma; finally, Lebrun, holding the sword—a former lawyer, writer, suspected of Royalist leanings during the Convention, promoted to Third Consul, Arch-treasurer and later Duke of Piacenza.

The scene is closely knit but opens out on to the coronation, slanting upwards on the right to Coustou's sculpted group. It is a masterpiece, brilliantly arranged and painted. The play of light gives the composition rhythm and form and so does the general harmony between green and red velvet. The planes are graduated through the play of values as well as the paintwork, which becomes lighter and more sketchy as it moves into the background, whereas in the foreground it is beautifully thick and freely done. In spite of the brilliancy of the colors, very unlike that of *The Sabine Women,* its unity is so sustained that David had to use hardly any reflected light, so that each character and each detail has a strong definition and a life of its own.

The sovereigns liked the painting, especially Joséphine, who—as Mme de Genlis could not forbear to remark—had been made to look years younger. As he was about to leave the studio, Napoleon, "putting his hand to his hat and uncovering his forehead", deigned to honor David with a greeting; that is how David described the scene in a handwritten note. But the Emperor still found David's bill for 100,000 francs too high. This visit, incidentally, became the main subject of the short *Description of the Painting Exhibited at the Musée Napoléon depicting the Coronation of Their Royal and Imperial Majesties, Painted by M. David, Painter to Their Majesties,* published in 1808 and prompted by David, if not written by him.

The painting was a great success at the Salon of 1808, at which Napoleon made David an officer of the Legion of Honor. The bill had not been settled yet, nor had an annual salary been fixed for the First Painter, and the series of four large paintings remained to be finished. David wrote to Daru on October 25 that "His

Majesty the Emperor has told me to postpone the painting of the Town Hall I had started and wants me to hurry with the subject he likes best, the distribution of the Imperial flags on the Champ-de-Mars".

The report of June 1806 had planned the paintings in chronological order of events: *The Coronation, The Enthronement, The Distribution of the Eagles, and The Arrival of the Emperor at the Town Hall*. David's description of the Enthronement shows that he intended to paint Napoleon taking the constitutional oath on the large throne at the back of Notre Dame. There are no known studies for this painting, at most two or three sketches of the back of Notre Dame which could have been intended for it. However, David had already asked Degotti to prepare the large canvas for *The Arrival at the Town Hall*, of which quite a few drawings have survived. The event took place two weeks after the coronation, when the Paris municipal council gave a large party for the sovereigns at the Town Hall, extended for the occasion by two timber wings built by Molinos (one of the architects who had been employed by the Convention for revolutionary celebrations).

3

David described his subject, abandoned in 1805, as follows:

> This one is for the people and shows its first act of allegiance towards its Sovereign—the governor of Paris handing his Emperor the keys of the city. This is how I see it:
>
> The Empress, the Emperor and his brothers alight from their carriages, preceded by the pomp and followed by the procession that mark a major occasion. The governor of the city [Junot], attended by the departmental prefect and the twelve mayors, holds out the keys of the city of Paris to His Majesty on a salver. The Emperor has already climbed the steps of the Town Hall when citizens from every walk of life, burning with gratitude, throw themselves at His Majesty's feet, thanking him for the pardon they have received in advance for serious crimes their children have committed. Another group of people see the Empress alight from the carriage like a bountiful sun and throw themselves at her feet too, thanking her for all the help they have received for the relief of their families and for the acquittal of the nursing period. The populace watching this impressive and touching scene shows its delight with a general cry of "Long live the Emperor! Long live the Empress! Long live the Imperial family!", waving hats and bonnets in the air to express the admiration they feel.

The Arrival of the Emperor at the Town Hall.
Drawing in black crayon. 11×18 cm. Cabinet des
Dessins (sketchbook RF 36942, folio 30 verso),
Musée du Louvre, Paris.
In addition to *The Consecration*, David planned three
other large commemorative pictures. The only one
to be executed was *The Distribution of the Eagles*. In
another, it was planned to show the arrival of
Napoleon at the Town Hall (*Hôtel de Ville*) in Paris
for a reception given by the municipality two
weeks after the consecration.

With the Continental System and the Spanish insurrection to contend with,
Napoleon may at that point have thought the subject too "touching" and not
"impressive" or patriotic enough; in any case, he decided to have the tribute to the
army painted instead of the picture of the people, and David had to paint another
Oath whereby the regiments swore to guard the Eagles with their lives and to keep
them always "on the road to victory". David wrote in 1806: "Never was an oath
better kept. What a variety of stances and expressions! There never was a finer

153 *The Arrival of the Emperor at the Town Hall.*
Signed and dated 1805. Pen drawing with Indian
ink wash. 26×41 cm. Cabinet des Dessins
(Rf 1916), Musée du Louvre, Paris.
A temporary wing was added to the Town Hall for
the ceremony. The picture, which was sketched out
on the canvas before being abandoned, was
intended to mark the first act of obedience of the
people of Paris towards their sovereign, who was
presented with the keys of the city by Governor
Junot.

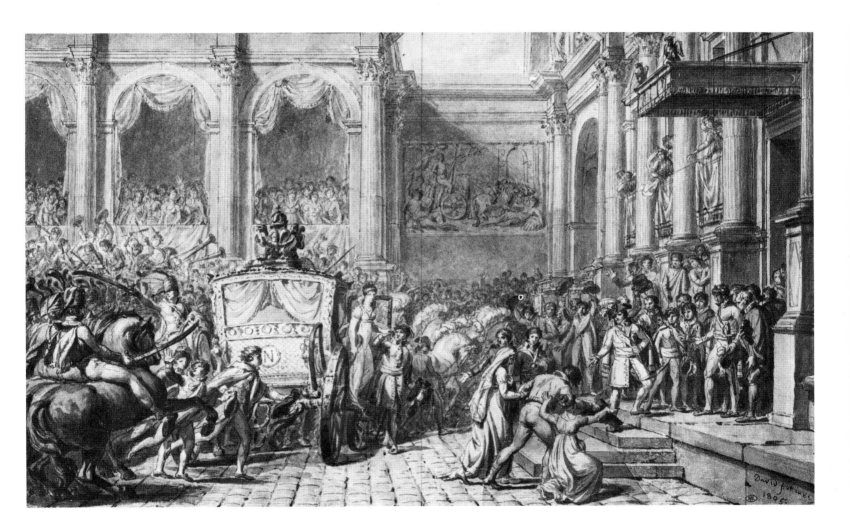

subject for a painting. How it fires the painter's imagination! It is the forerunner of
the immortal battles which marked the anniversary of His Majesty's coronation
[Austerlitz]. Posterity looking at this painting will be astounded and marvel, 'What
an Emperor!'"

Either David took particular trouble over a relatively, and unjustly, neglected
painting, or else a great many drawings for it have happened to survive, for there is
a great deal of preliminary work, especially in the Louvre and the Art Institute,

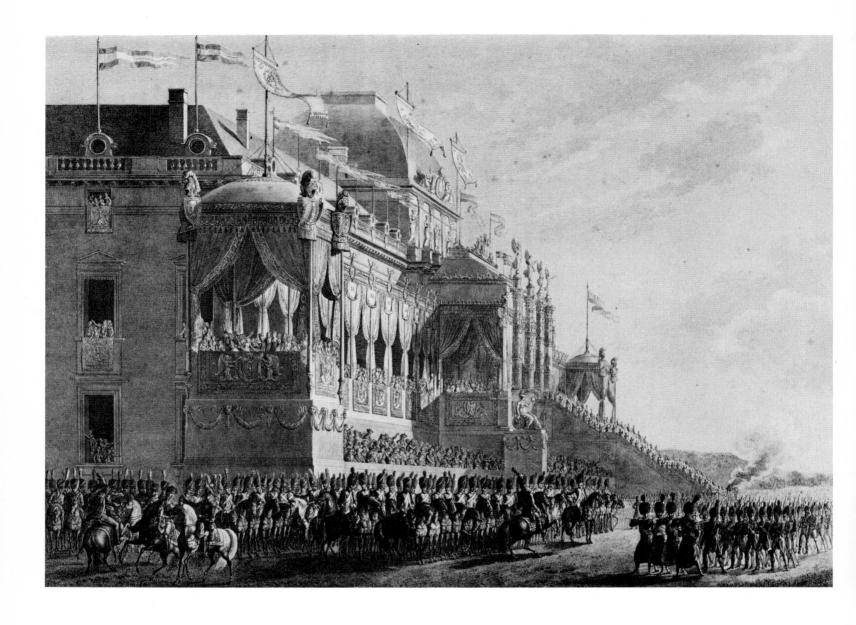

154 *The Distribution of the Eagles at the Champ-de-Mars*. Engraving by Malbeste after drawings by Isabey and Fontaine in *Descriptions of the Ceremonies that Took Place on the Occasion of the Coronation of their Majesties... after the Drawings and under the Guidance of C. Percier and P. F. L. Fontaine...*, Paris, 1807. Cabinet des Estampes, Bibliothèque nationale, Paris. For the ceremony, which took place in appalling weather on December 5, Percier and Fontaine had set up a huge grandstand against the façade of the Ecole Militaire.

Chicago, all preceding the large drawing dated December 1808, in which many details differ from the painting finished in November 1810. Two changes were made at the request of Napoleon himself: he asked David to remove the Victory hovering above the flags and scattering laurel leaves on them, which was actually an isolated and unsatisfactory echo of old allegories; above all, at the last minute, when the painting was finished (in October), Napoleon asked for the Empress Joséphine to be removed, as he had married Marie-Louise of Austria on April 2. This entailed removing all her ladies-in-waiting as well and replacing them with a picturesque grouping of a cardinal and ambassadors, including the bearded turbaned one from the Sublime Porte. Joséphine's own disappearance left a far more distressing gap, for you cannot put just anybody next to the Emperor. David brought forward Eugène de Beauharnais's leg as best he could in a very unnatural movement, the exact reverse of the original one which we know from the Chicago drawings. The other changes are especially interesting because the artist made

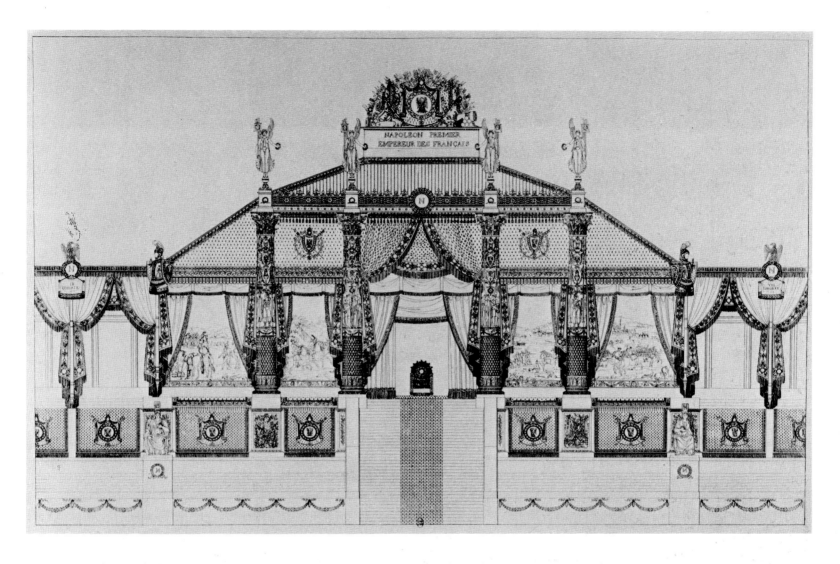

them himself, and they all result in a movement of the figures, who seem to be caught up in a bounding, enthusiastic excitement: here, with a similar subject, David revived the momentum of *The Oath of the Tennis Court*. It was still patriotic love of country that aroused a spirit of transcendent collective exaltation, but now the homeland—*la Patrie*—was military, not civil.

On December 5, on the Champ-de-Mars, Napoleon "presented flags to the corps of all branches of the army and to the national guards of the 108 departments and heard their oaths". As we said above, Percier and Fontaine had built an enormous portico complete with tents in front of the Ecole Militaire, with a central forepart also hung with voluminous draperies and reached by colossal steps. The forepart was surmounted by gilded Victories; the galleries on either side were each divided into eight sections representing the sixteen cohorts of the Legion of Honor, each bearing the emblem and Eagle of one of them. In the forepart, which was partially sheltered from the sleet that fell all day, "Princes, dignitaries, princesses, ministers, marshals, and the high civil and military officers of the Emperor's household will be placed on the right and left of the throne and behind it, according to custom. The Emperor's officers and the Empress's ladies-in-waiting will be behind Their Majesties" (*Le Moniteur*, December 4). To

155 *The Grandstand and Throne Erected before the Façade of the Ecole Militaire for the Distribution of the Eagles.* Engraving after drawings by Percier and Fontaine in the same album.
David reproduced the setting fairly accurately. The throne was placed at first-floor level, and the troops were massed in three columns at the foot of the structure. Napoleon pronounced the oath, in which the men swore to defend the Eagles to the death, and "the colonels holding the Eagles will raise them in the air and say: *We swear it.* The oath will be repeated by all the military and departmental delegations."

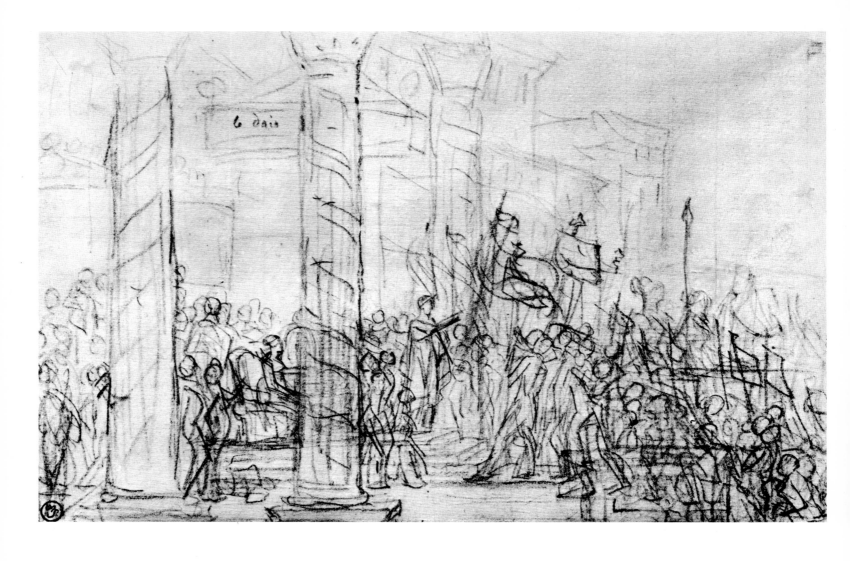

156　*The Distribution of the Eagles.* Drawing in black crayon. 14.5×22.5 cm. Formerly in the Ch. Saunier Collection, present whereabouts unknown. First overall draft, possibly drawn in 1805, for the picture completed in November 1810.

the right and left stood the diplomatic corps, foreign princes, the Senate, the Council of State, the Legislative Body, the Tribunate and the Supreme Court of Appeal... The Eagles were set out on the steps of the throne; each was carried by the colonel of the regiment, and the departmental ones by the presidents of the electoral bodies or, failing that, by the prefect. The army and the national guard formed into three columns and manœuvred in formation up to the throne, preceded by drums and music.

　　The Emperor will say, "Soldiers, here are your flags; these Eagles will always be your rallying point; they will be wherever your Emperor deems them necessary to protect his throne and his people. You will swear to guard them with your life and to uphold them constantly by your courage on the road to victory", at which point the colonels holding the Eagles are to raise them in the air and say, "We swear". The oath will be repeated by all the military and departmental deputations to the sound of artillery salvos. The soldiers will present arms and put their caps on the points of their bayonets, and stay in that position until the flags have gone back to their regiments.

　　We have quite a number of sketches of nudes for *The Eagles*, visibly after a model, so at first sight it is difficult to distinguish them from the studies for *The*

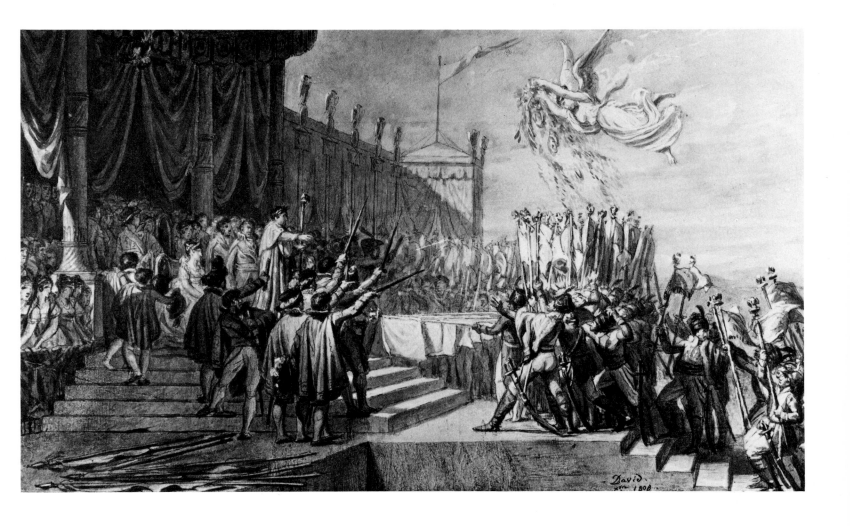

157 *The Distribution of the Eagles.* Signed and dated 1808. Pen drawing with Indian ink wash, touched up with gouache. 18×29 cm. Cabinet des Dessins (RF 1915), Musée du Louvre, Paris.
Among the changes made in the final painting were the omission of the Winged Victory and of the Empress Joséphine (who had just been repudiated), which meant that the whole left-hand side had to be altered.

Oath of the Tennis Court, and even more so from those for *Leonidas* (this album RF 6071 contains studies for both paintings). David's rendering of contemporary events was always imbued with the classical past; in some drawings in the Louvre, a helmeted, armed Minerva appears in the midst of four nude figures or figures in court dress. A strange drawing in album RF 23007, indubitably of Napoleon before his colonels, shows the Emperor naked under his toga, and his soldiers brandishing swords, and in an unused drawing for *Leonidas* (RF 6071 fol. 3v°), one of the two figures echoes Robespierre's stance in *The Oath of the Tennis Court*. It is not surprising that the colonel in the foreground of the drawing apparently balancing on the toes of one foot reappears almost unchanged in the final version of *Leonidas*. This connection appears clearly in album 23007, where this naked figure is shown first by himself and then entwined with the two other young men who hold out wreaths in *Leonidas*. On the opposite page (18 and 19) is a figure very like one of the marshals just beneath Napoleon in the 1808 drawing, but also reminiscent of *The Oath of the Tennis Court*, especially as it is beside a sketch almost identical to Mirabeau in the latter... but which here is a study for the colonel with the big saber in the foreground of the same drawing of 1808!

This shows how subjective David's reality was, how much it sprang from the artist's obsessions; it would be ridiculous to think that there were two different

158 *Study for "The Distribution of the Eagles".*
Drawing in black crayon. 17×11 cm. Cabinet des
Dessins (sketchbook RF 6071, p. 29 verso), Musée
du Louvre, Paris.
Classical echoes (doubtless fleshed out by studies
from life) seem to predominate, although the
patriotic zeal uplifting the naked warriors is similar
in kind to that of the deputies in *The Oath of the
Tennis Court.*

159 *Study for "The Distribution of the Eagles".*
Drawing in black crayon. 11×18.5 cm. Cabinet des
Dessins (sketchbook RF 23007, p. 11), Musée du
Louvre, Paris.
This interesting study shows how David's ideas
wander to and fro between antiquity, the memory
of an earlier work (*The Oath of the Tennis Court*), and
the new subject he is tackling.

painters in him, one dreaming of antiquity, the other observing the world he lived
in. We might be tempted into this error or to toy with the idea when it comes to the
Coronation, where he was present in person and made notes, but here he asserted his
freedom fully. He was not present at the distribution of the Eagles, any more than
at the oath in the Tennis Court, as we can gather from a series of questions he
jotted down in album RF 23007: "1. Ask how the soldiers swore their oath.
2. Whether I can show them with their unsheathed swords in the air. 3. If the flags
were given only to the colonels of each regiment. 4. If the Emperor was standing
while they swore the oath..."

David kept fairly faithfully to the setting as we see it in engravings after
Fontaine, and the weird columns adorned with bas-reliefs and the forepart in the
form of a tent are all authentic. At most, the painter added the eagle over the
oriflamme towards the center of the painting and slightly modified the shape of the
steps where he placed his figures. At the end of May 1810 he approached General
Lacuée de Cessac, the new minister in charge of the War Office, and asked him to
let him borrow some of the uniforms so that he could copy them. He may have
added the flags bearing the names of victories which decorated the Imperial tent
and were not in the earlier studies. The main part of the painting, the grouping of

the figures and their stances, is all his own, as we can see from the difference between the drawing of 1808 (done four years after the event!) and the painting of 1810.

It was easy here for the painter not to attempt the simple, pure forms of *The Sabine Women* and *Leonidas*, for it was not a question of showing the beauty of the nude. On the contrary, the layout was complex, a circle of dignitaries and marshals from which the histrionic figures of Berthier and Lannes stand out beside Napoleon, a circle which is elongated downwards by the row of marshals opposite the flags (these are lower than in the 1808 plan so that the figures are better defined). There is also the astonishing closely knit group of flags and colonels melded into an indecipherable, turbulent upward sweep, whereas in 1808 they were carefully arranged beneath the vertical of their flagstaffs. The painter probably strengthened this area and hoisted the flags upwards after the winged Victory was removed.

The series of four paintings stopped there. The decision was probably made around February 1810, when the painful problem of the price was resolved, and

160, 161 *Studies for "The Distribution of the Eagles".* Drawings in black crayon. 11×18.5 cm. Cabinet des Dessins (sketchbook RF 23007, pp. 18 and 19), Musée du Louvre, Paris.

The contagiousness of different themes extends also to *Leonidas*, which David would presently take up again. The figures studied here are very like the youths holding out their wreaths in *Leonidas*, while the one who appears to be dancing on one foot is a direct study for the colonel holding the flag of the first regiment of the line in *The Eagles*.

The next page in the sketchbook (19) contains a study of one of the dignitaries in the foreground, below Napoleon, in the preliminary version of 1808 (Pl. 157), but the figure underneath is purely and simply a repetition of the figure of Mirabeau in *The Oath of the Tennis Court*.

162 *Study for "The Distribution of the Eagles": the Empress Joséphine.* Drawing in black crayon. 24×19 cm. Joseph and Helen Regenstein Collection (sketchbook 1961-393), Art Institute, Chicago.

This study "from life" was made for *The Distribution of the Eagles*. The pose was slightly modified in the preliminary version of 1808 (Pl. 157). The delay in the painting of the picture, Napoleon's divorce, and his remarriage with Marie-Louise later obliged the painter to leave out Joséphine and her ladies-in-waiting.

18

GD . h°28

163 *Study for "The Distribution of the Eagles": Prince Eugène de Beauharnais.* Drawing in black crayon. 24×19 cm. Same sketchbook.
As the deletion of Joséphine left a gap in the composition, David was obliged to place greater emphasis on the figure of Prince Eugène. In the painting it is the right leg that is thrust forward. The drawing in Chicago was probably made from a live model.

164 *Study for "The Distribution of the Eagles".* ▷ Drawing in black crayon. 24×19 cm. Joseph and Helen Regenstein Collection (sketchbook 1961-393), Art Institute, Chicago.
A splendid study for one of the marshals facing the colonels in the center of the picture.

165 *Study for "The Distribution of the Eagles".* ▷▷ Drawing in black crayon. 25×19 cm. Musée national du château (MV 7690), Versailles.
Study, without any notable variation, for the grenadier at the extreme right of the picture. Once again David shows the nude figure beneath the uniform.

257

de Sorgis

259

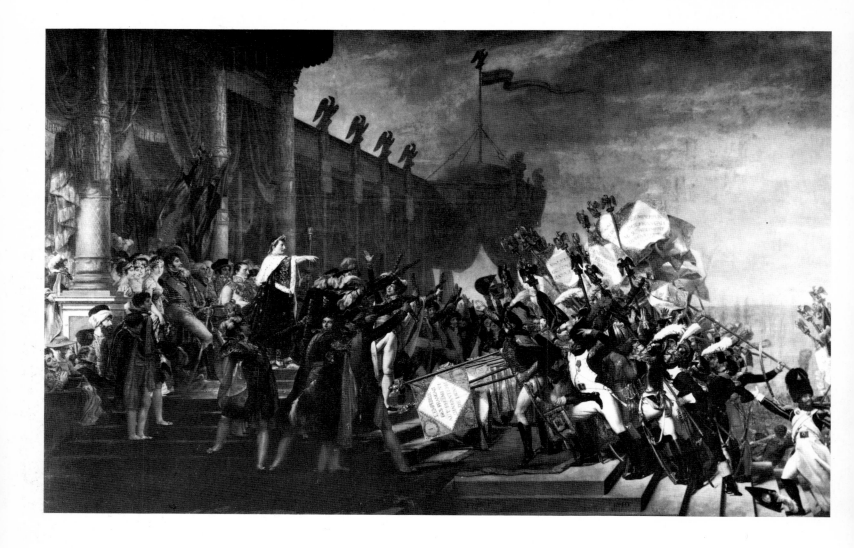

166 *The Distribution of the Eagles at the Champ-de-Mars, December 5, 1805.* Signed and dated 1810. Oil on canvas. 610×930 cm. Musée national du château, Versailles.
The subject is actually the oath of the army to the Emperor after the distribution of the Eagles—a military and monarchist counterpart to the Oath of the Tennis Court.

167 *The Distribution of the Eagles.* Detail of Pl. 166.
While the reproduction of the whole picture brings out the bold geometrical layout, along a diagonal, the detail shows the play of light on the principal figures, the brilliance of the colors, and the care with which the uniforms are depicted.

David was compensated for the interruption of *The Arrival at the Town Hall.* Too much time had gone by since the happy month of December 1804. David's attempts to give substance to his honorific title as First Painter to the Emperor amounted only to doing some drawings of furniture in 1811. In September 1812 he asked if he could do the pictorial decorations for the rooms being renovated at the Louvre, for which his drawings of *Wounded Venus Complaining to Jupiter* and *Hector's Departure* (dated from that year, now in the Musée du Louvre, Paris) were intended. The Chief Intendant of Crown Property replied rather drily that the head of the museum would choose the artists. David had definitely lost his secret battle against Vivant Denon, his former protégé, whom he had once asked to engrave his designs for Republican dress, for he received no more official commissions.

However, in 1812 he painted another portrait of Napoleon, paradoxically at the request of Alexander Douglas, an Englishman (though of Scottish descent), who became 10th Duke of Hamilton in 1819 and whose cousin was the well-known collector of antique vases. Alexander Douglas was a tireless eclectic collector himself; in spite of Napoleon's war against his country, he admired the Emperor immensely and owned a bust of him by Thorwaldsen, a present from Pauline Borghese. The commission was delivered by Bonnemaison, a painter who

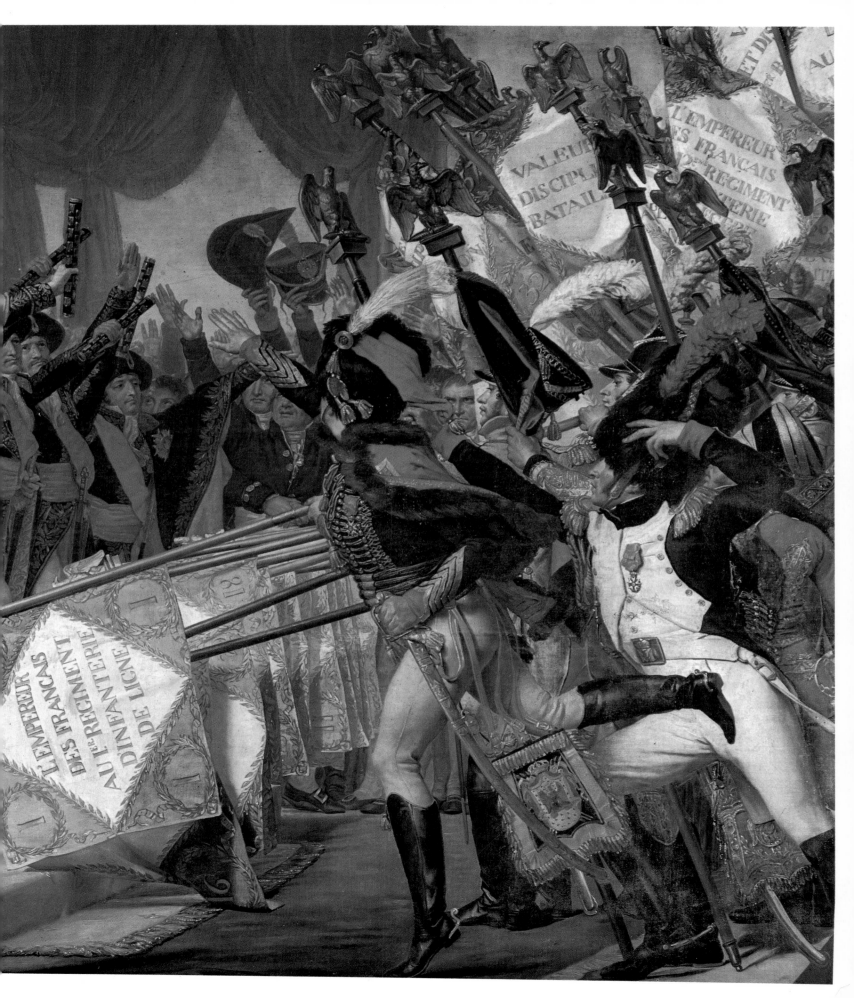

had kept in touch with England since his stay there as a refugee; David painted the portrait during the first three months of 1812.

According to Alexandre Lenoir, the life-size portrait (now in the National Gallery of Art, Washington) was the best likeness ever made of Napoleon, a virtual allegory of the Lawgiver and a perfect pendant to the hero of the Alps. David explained his painting to Lenoir: the Emperor had been up all night wrestling with the Napoleonic Code (another straining of the truth, for the Code was drawn up by a commission in 1800-1 and 1803 and had been in use since March 21, 1804, when it was known simply as the Civil Code). He is so absorbed in his work that he does not notice it is dawn until the clock strikes four. Then, without a moment's rest, he rises to gird on his sword and review his troops.

This interpretation must have come to David while the work was in progress, as there are no candles in the preliminary drawing (Musée des Beaux-Arts, Besançon), though the pose was the same. The strength of this flattering political allegory lies in its realism. Napoleon is shown as he was, his face pasty, his hair thinning and his figure thickening, a far cry from the trim soldier of 1797. The blue uniform of a Colonel of the Foot Grenadier Guards, the modelling of the arm-chair and its golden bees, the sword handle, the torch, and the key at the side of the clock—a fascinating detail worthy of Ingres's finest portraits—are all depicted with accurate craftsmanship but without pedantry. However, the realistic detail was subordinate to a skilful arrangement of the setting and the composition: the beautiful chair actually stood in the Grand Cabinet room at the Tuileries, not in the study. The clock did not belong to the study either, according to the inventory that has survived, but it is vital to the economy and meaning of the painting; the clock in the Besançon drawing, incidentally, is quite different. The composition, which seems so simple at first, is carefully arranged on the diagonal, indicated by the position of the chair and the glimpse into the adjoining room (the Topography Room) lined with books symbolic of the great man's intellect, a layout unusually reminiscent of many seventeenth-century Dutch paintings. The diagonal is cut by the majestic verticals of the pilaster, the clock, and Napoleon himself, in whose slanting posture the whole layout of the picture is concentrated, though he is absolutely central and parallel to the sides of the painting.

David painted a replica immediately afterwards for a client who has remained mysterious (he called him Huibans in his catalogues), in which Napoleon wears the green uniform of the Light Cavalry of the Guards and the clock stands at four sharp instead of four thirteen (the painting belongs to Prince Napoleon).

168 *Napoleon in his Study*. Signed and dated 1812. Oil on canvas. 204×125 cm. Samuel H. Kress Collection, National Gallery of Art, Washington. This portrait—a kind of allegory of the legislator—was painted for the Scottish nobleman Alexander Douglas, and there is a signed replica in the collection of Prince Napoleon (recently acquired by the French government). The Emperor, in the costume of a colonel of the Grenadier Footguards, has spent all night drafting the Napoleonic Code (actually promulgated in 1804) and is now leaving his desk to review his troops.

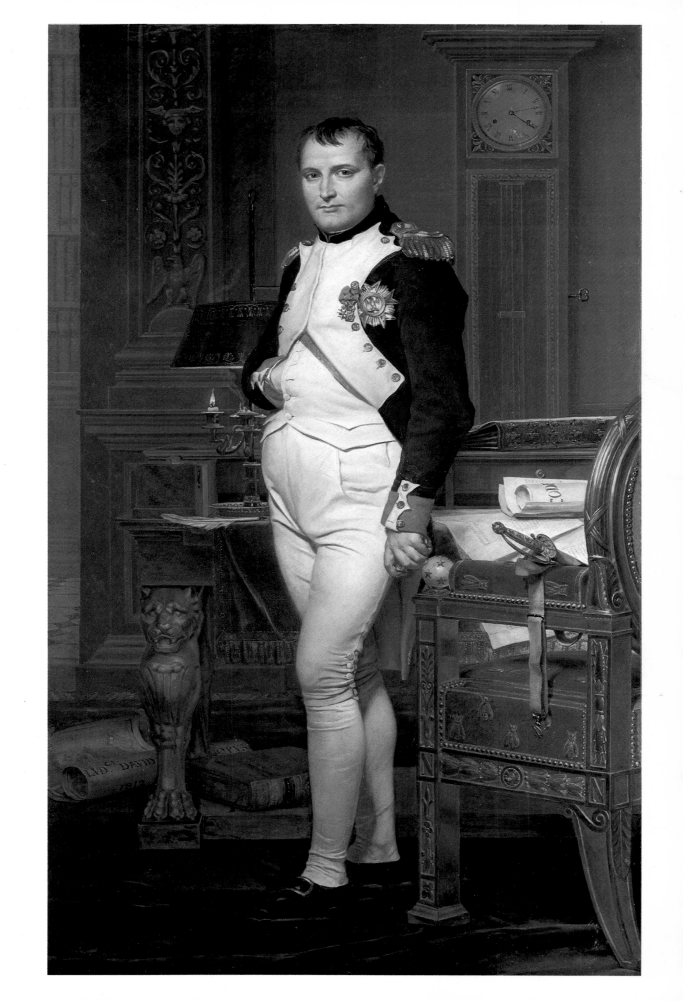

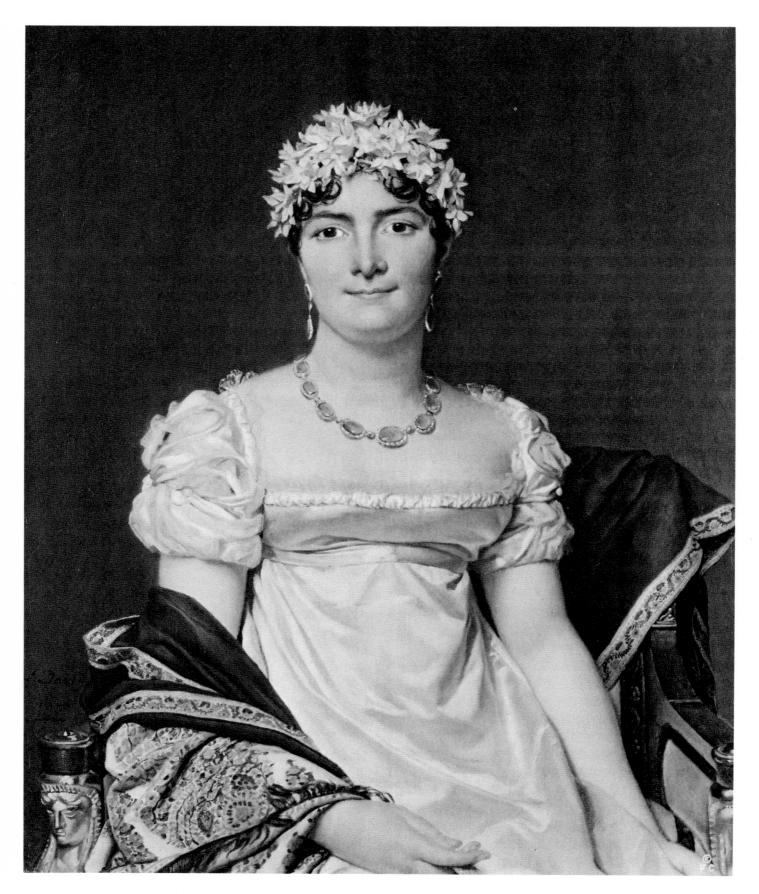

264

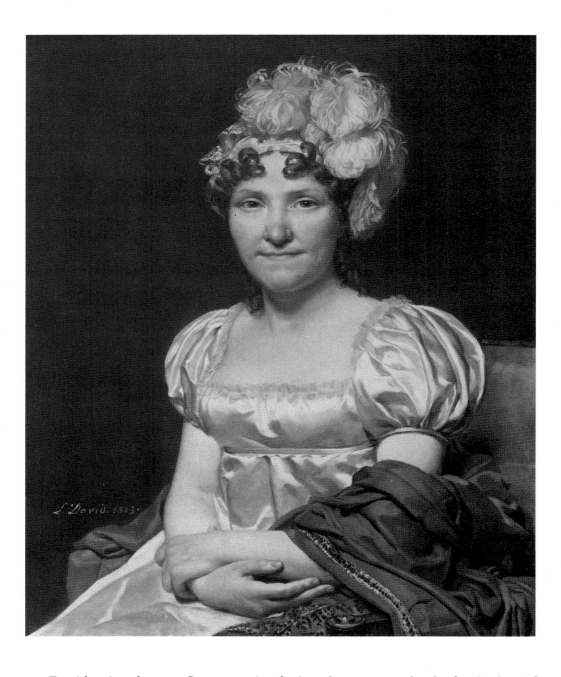

170 *Portrait of Mme David.* Signed and dated 18.13. Oil on canvas. 73×59 cm. Samuel H. Kress Collection, National Gallery of Art, Washington.
David's marriage had broken up at the time of the Revolution, but the breach was healed at the moment when the painter's freedom, if not his life, was threatened. This splendid portrait, in which the sitter—for all her plainness—is so intensely alive, is a sort of homely companion-piece to that of Mme Daru.

David painted some fine portraits during those years. At the beginning of 1810, probably to thank Daru for having put an end to the long drawn-out haggling over the payment for *The Coronation* and *The Eagles* (for which he got just over half of what he had asked) and to remain in his good books, he painted Mme Daru, free of charge and without her husband's knowledge, and at the end of March surprised him with the finished picture (Frick Collection, New York). Three years later he painted his own wife in a similar style, seen seated, almost full-face, in a satin dress with a square yoke and a shawl over her arm (National Gallery of Art, Washington). The painting is simple and cohesive, even though David seemed to linger over the embroidery on the shawl. He did several unfinished portraits of his daughters and sons-in-law around that time, but the brushwork is rather coarse and they are not as appealing as earlier unfinished

◁ 169 *Portrait of Mme Daru.* Signed and dated 1810. Oil on canvas. 73×60 cm. Frick Collection, New York.
Alexandrine Thérèse Nardot was the wife of Comte Daru. A future cabinet minister, Daru was then Quartermaster-General of the Emperor's household and David was constantly engaged in delicate negotiations with him over payment for his pictures. In March 1810 David painted this portrait of Daru's wife, without his knowledge, and then presented it to him.

portraits (Reinhard Collection, Winterthur; M. H. De Young Museum, San Francisco; Private collections).

The most delightful portraits that he painted during those last years of the Empire—for opposite reasons—are those of Français from Nantes (Musée Jacquemart-André, Paris) and of Antoine and Angélique Mongez (Musée du Louvre, Paris). The portrait of Français, painted in 1811, shows a man with a successful career behind him. It is worth summarizing his life story, which was like that of so many who feathered their nests under the new regime and survived all the political upheavals without too many shocks. Antoine Français was born in Beaurepaire in Isère in 1756, the son of a court solicitor. He was chief customs officer in Nantes when the Revolution broke out; he joined the Jacobins and became a member of the municipality and a deputy to the Legislative Assembly, where he inveighed against religion. "In country districts I have seen the fires of conjugal love shedding only a dim and sombre glow; I have seen the hideous skeleton of superstition crouching right inside the marital bed, insinuating itself between nature and a man and his wife to thwart the most mysterious of desires." Compromised with the Girondins, Français hid in his native province. Under the Directory he joined the Council of Five Hundred, opposed the *coup d'état*, but soon rallied to it. He became Director of Hospitals and in 1800 was made a prefect and a Councillor of State, a count of the Empire in 1808, a Commander and, in June 1811, a Grand Officer of the Legion of Honor. He was again deputy for Isère under Louis XVIII, and Louis-Philippe made him a Peer of France. When he retired he devoted himself to farming and wrote *Scenes from Rural Life or Agriculture Taught in a Dramatic Manner* (1829) and *A Small Manual for Shepherds, Swineherds, Cowherds, and Poultry-Maids*, published in 1831. In Year VI in Grenoble he published a *Quick Survey of the Customs, Laws, Contributions and Public Services... Public Institutions in their Dealings with the Representative Government and on all the Right Ways to Strengthen the Constitution of the Year III.*

David surely enjoyed painting the councillor's fine clothes, which he asked his sitter to lend him on April 29, as much as the portrait of the man who looks so self-satisfied. The unusual arrangement, seen slightly from below, actually thrusts into the foreground the embroidery, the enormous plumed hat and the large red Legion of Honor round which the picture is built, an exciting counterpart to the newly created count's ruddy face. What a contrast to the marvellous, warm token of friendship David painted in the following year for the loyal Mongez couple. Antoine Mongez, born in 1747, was a defrocked canon of Sainte-Geneviève and a

171 *Portrait of Comte Français, of Nantes.* Signed and dated 1811. Oil on canvas. 129×75 cm. Musée Jacquemart-André, Paris.
Former head of the Customs Office at Nantes, deputy at the Legislative Assembly and at the Council of the Five Hundred, and future peer under Louis-Philippe, Antoine Français is depicted in the magnificent costume of Councillor of State, which was brought along specially at David's request.

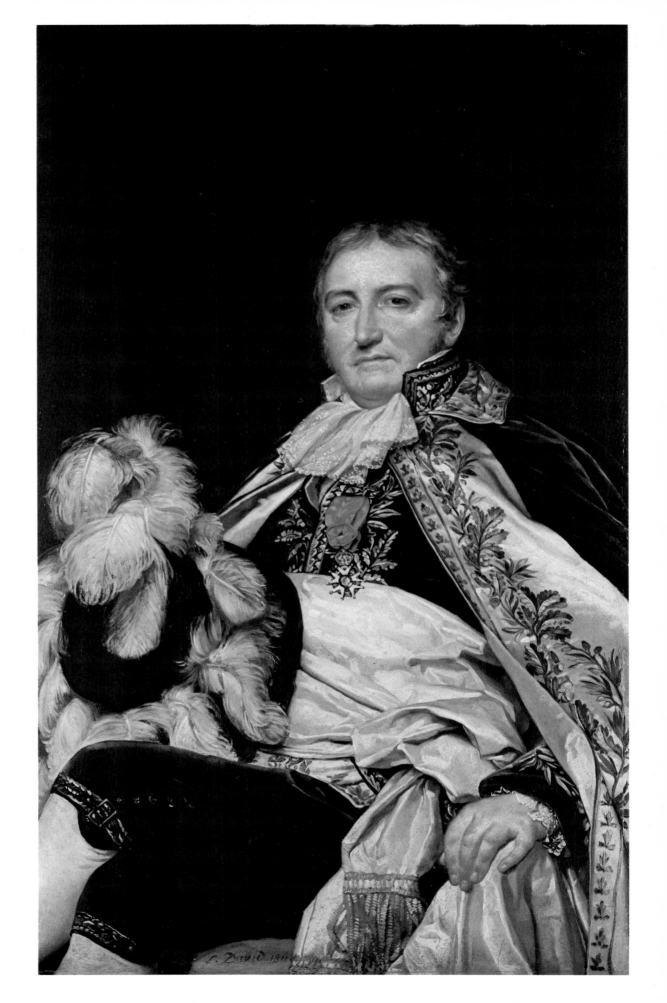

172 *Portrait of Antoine Mongez and his Wife Angélique.* Signed and dated 1812. Oil on canvas. 74×87 cm. Musée du Louvre, Paris.
This portrait of two close and loyal friends of David's is in complete contrast to the preceding portrait. Mongez (1747-1835) was a well-known archaeologist, numismatist and member of the Institute; his wife, nearly thirty years his junior, was a painter of real talent and a pupil of David's.

distinguished archaeologist who had contributed articles to the *Encyclopédie.* During the Revolution he became an active member of the Commission for Public Buildings, which dealt with the census and classification of nationalized works of art and science. He published various works, beginning with a solid history of Queen Marguerite de Valois, and then produced treatises on algebra, mathematics and *The Private Life of Cardinal Dubois,* as well as an annotated edition of La Fontaine. As an archaeologist he contributed to Wicar's publication of the antiquities of Florence; between 1808 and 1826, together with Visconti, he published the *Ancient Iconography or Collection of Genuine Portraits of Emperors, Kings and Illustrious Men of Antiquity.* He was an expert on coins, as shown by the one David made him hold, and, like the painter, had been one of the first members of the Institute; he was also a member of the Tribunate and, from 1804, director of the Mint. His wife Angélique was about thirty years younger, an excellent portraitist and historical painter who had been a pupil of David's. The couple remained close to David until his death. The simple frontal view of the two people, shown from the waist up, stresses the graceful arabesque of the clothes, while the predominant green enhances the bright details of the book, the braid of Mme Mongez's dress, and her fine shawl.

Although he was working on *The Eagles,* in those busy years David returned to what could be called the erotic works of antiquity. In 1809, reverting to the ideas that had fired Vien, his teacher (who died that year; David wrote a touching article about him), he painted *Sappho, Phaon and Cupid* for Prince Nicholas Yusupov, a major Russian collector and lover of French art who lived in Paris from 1808 to 1811, at the time of the Franco-Russian alliance. His collection, which included works by Guérin, Boilly, Taunay, Angélique Mongez, and Gros's portrait of his sons on horseback, also painted in 1809, is now scattered between his country home at Arkhangelskoye, the Moscow museum and the Hermitage, where David's painting is. At that time Sappho's fragments were very popular in France, where they were usually translated together with Anacreon's work. The painting was actually almost unknown in France; David himself wrote to the prince in 1814 to ask for a sketch of it, as he had kept no trace of it in Paris. Alexandre Lenoir, one of the few contemporaries who liked it, described it as follows:

Sappho of Mitylena, known as the tenth Muse, is sitting lost in poetic inspiration when she is suddenly surprised by Phaon. Venus' protégé stands behind his mistress's seat, but she does not see him; he lightly brushes her left cheek with his right hand. At that moment Sappho, visibly moved, drops her

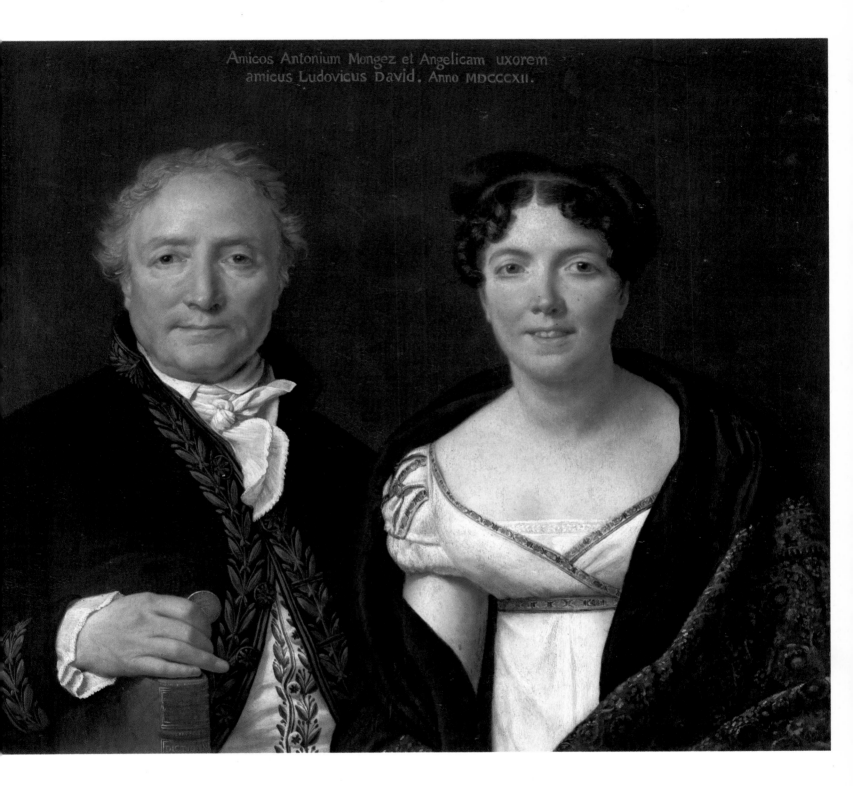

lyre, and Cupid, who is at her feet, strums it as he sings the hymn to Venus attributed to Sappho, which can be found in Anacreon's work... The drawing is graceful and accurate, the style severe, the expressions life-like, and the colors pleasant. I especially like the talented artist's skill in drawing and painting Phaon's hand on his mistress's cheek without detracting from her beautiful face... The color is rather reminiscent of *Paris and Helen* by the same

173 *Sappho, Phaon and Cupid.* Signed and dated 1809. Oil on canvas. 222×260 cm. Hermitage Museum, Leningrad.

This canvas was painted for Prince Nicholas Yusupov, a great art lover and connoisseur of contemporary French painting. This is an important landmark in David's career, demonstrating a continuity of inspiration between *The Loves of Paris and Helen* (Pl. 41), painted in 1788, and the works of his later years. The subject is taken from the story of the poetess Sappho, which was very popular at the time.

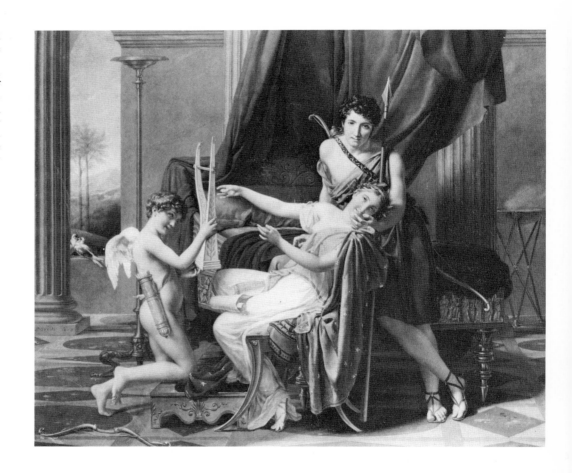

painter, but the figures in Sappho are far larger and the execution is more grandiose.

The comparison with *Paris and Helen* is apposite, for it also shows love and classical beauty and is painted with the same archaeological accuracy. The main difference lies in the bold color, as became obvious when the painting was cleaned recently, in the strident harmonies of blue and green contrasted with brown and red, which make the delicate harmonies of the picture painted almost twenty years earlier seem almost insipid. We find this boldness again in all the works of the Brussels period a few years later. In fact there is no gap between the great period of *The Sabine Women* and *The Eagles* and the later works. Besides *Sappho, Phaon and*

174 *Study for "Leonidas at Thermopylae"*. Drawing in black crayon. 11×17 cm. Cabinet des Dessins (sketchbook RF 6071, p. 37 verso), Musée du Louvre, Paris.

After giving up, in 1810, the series of pictures commemorating aspects of Napoleon's consecration and after failing to obtain a commission to do decorative painting at the Louvre, David took up work on his *Leonidas* again. Here we have one of a number of studies for a group that was not yet included at the time of the 1813 draft, but appears in the second rank of the final version.

Cupid, David completed the drawing for *Cupid and Psyche* in 1813, which he painted in Brussels and also started *Apelles Painting Campaspe in Front of Alexander*, which he took up again in exile but never finished (Musée des Beaux-Arts, Lille).

The last big painting of the Napoleonic era was *Leonidas at Thermopylae*, on which he was able to resume work, after a long interruption, when his official duties ended. Delécluze's account and the surviving drawings give us a fairly clear idea of the changes and additions he made to his original work. According to Delécluze, the young soldier fastening his sandal, the young men holding wreaths, the man writing the inscription, and the group with the old man embracing his son all go back to the first stage and were entirely painted then. In fact, judging from a drawing in the Louvre (RF 9136, fol. 19) and from the above-mentioned studies for *The Eagles*, the youths holding wreaths were added at a very late stage, or at least altered then. We can tell that almost all the foreground and the whole right-hand area were conceived in 1812-13. The background, behind Leonidas' shield, was under constant revision until the last minute, especially the warrior

175 *Leonidas at Thermopylae*. Signed and dated
1814. Drawing in black crayon. 40.5 × 55 cm.
Metropolitan Museum of Art, New York.
This large drawing is the last overall version
known prior to the actual painting, in which a
number of features in the background were
changed.

"dedicated to the worship of Hercules, whose arms and garments he wears"
(brochure of 1814), who was meticulously studied, probably after a vase with red
figures on it that A.-L. Millin had just made public: we have several drawings in
which he is shown as Hercules brandishing his club and then in his present form.
The blind soldier returning to battle with his helot, whose unsteady foot grips the
rock—a splendid detail—is the final upshot of a long series of studies, including
one of a blind man supported by his two sons. Again the painter seems to have
ended up with a classical source, this time a literary one (the incident is in
Herodotus) but which is often found in sculptured form too. As contemporaries
had already noticed, Leonidas is identical to an engraved gem reproduced by
Winckelmann, and we can see from David's tentative studies that he had in fact
been groping towards that for a long time (Delécluze's account, borne out by
numerous drawings, tells us how much trouble David had with the hero of that

picture). David's connections with archaeological sources were never straight-forward, even when he was blatantly copying.

The final composition is far less restrained than we might expect from David's words when he was outlining his ideas. Even if we disagree with Delécluze's severe criticism of the new parts of the painting, he was still right—as we can see from the example of a drawing—when he attributed the change in style to the influence of *The Coronation* and *The Eagles*, for most of the figures, though not that of Leonidas himself, are far more lively and realistic. The true-to-life attitudes of the young men jumping on the far right, in contrast to the fluid abstract figure of the soldier fastening his sandal, are also sheer David. Delacroix rightly saw in David's

176 *Leonidas at Thermopylae.* Signed and dated 1814. Oil on canvas. 395 × 531 cm. Musée du Louvre, Paris.
This is the culmination of David's preoccupation with the nude (both classical and realistic), patriotic fervor, and the domination of the passions by the will. The admirable linking of the figures, the mixture of superhuman idealism and realistic detail, and the rich greens and reds combine to make it David's last great masterpiece.

273

work "an unusual blend of the real and the ideal", a blend which we can try to analyse but whose components we cannot isolate. Leonidas' sword is an imaginary archaeological object, but the thread of light on the blade makes it incredibly real. The painter regarded it with the same almost naive openness with which he treated the Mongez couple, an openness that eliminates any intermediary between the painting and the viewer; all David's works have that immediacy.

According to an account published by the Comtesse Lenoir-Laroche in 1815, during the Hundred Days, the youths holding their wreaths towards the inscription *(Passer-by, go tell Sparta ...)*, who "embrace each other for the last time and vow to fulfil by their glorious deaths the obligation this inscription imposes on them", are akin to the members of the 1789 Assembly and to the colonels receiving their eagles. The real and the ideal are one and the same when David recreates the antique world or contemporary events, even if the ratio varies. Comtesse Lenoir-Laroche, in her patriotic fervor, was well aware of this; she wanted to put heart into the French troops at a moment when Napoleon's army was facing the combined strength of the Allies in a decisive battle whose outcome could only be defeat or even death. "If ever a monument is built to the French troops, and I hope it will be, I am sure this painting will hang in its precinct, and art will again become what it was in antiquity, the expression of a nation's gratitude. Soldiers will come to this painting to learn how to die for their country and its laws. And legislators to learn how to make laws for which soldiers are willing to die."

VII. EXILE

David's loyalty to Napoleon; the Hundred Days. Law against the regicides (1816). David leaves for Brussels. Portraits of exiles, Jacobins and Bonapartists; local dignitaries. The copy of the Coronation (1822). Mythological paintings: Cupid and Psyche; Mars Disarmed by Venus. *David's death.*

At the beginning of April 1814 the Allies entered Paris and the Empire crumbled. One of David's sons was a subprefect in Germany, the other a soldier, as were his sons-in-law. He had not finished *Leonidas*, but did so before the autumn and exhibited it in his studio along with *The Sabine Women.* The political caution of the first Restoration precluded any threats against him, and his one inconvenience was having to billet two Russian officers in his house in the rue d'Enfer, but he got on with them so well that he was sorry when they left, as he wrote to Prince Yusupov on May 31. He also had to suffer the petty hostility of his colleagues at the Institute, who were prompt to curry favor with their new rulers. Thus he was requested not to come to the September prize-giving as the Duc d'Angoulême would be there. He must also have worried about the attempts to bring back the old-style Royal Academy of Painting and Sculpture; Deseine, the sculptor, wrote against him, and the fourth class at the Institute demanded an increase in its membership from twenty-eight to forty, as in the old Academies. David did not submit *Leonidas* to the Salon, and in artistic circles it became a political issue: people who were still for the Revolution or the Empire loudly sang its praises, whereas others saw it as evidence of the painter's decline.

David would have been able to continue his career quietly in Paris if Napoleon had not returned from Elba. He was immediately reinstated as First Painter, and on April 6, 1815 the Emperor visited his Cluny studio to see *Leonidas at Thermopylae* and, as a good soldier, expressed surprise that the painter had not shown the actual battle but the moment before it. Nevertheless, he made David a Commander of the Legion of Honor. His son-in-law, Baron Meunier, was reinstated as divisional commander and his son Eugène as squadron leader, while Jules was promised a prefecture. The following month David went down to his local town hall to sign the "Addendum to the Constitution of the Empire" whereby Napoleon sought to make the regime more liberal (for instance, by bringing back universal suffrage). David could not have failed to approve of Article 67, which prohibited any attempt to restore the Bourbons, the old feudal nobility, feudal and seigneurial rights, tithes or any "privileged or dominant form

6

of worship" or to question the irrevocability of the sale of the confiscated estates. We know from the loyal Delécluze that David had no illusions about the future, for he "was among the many who considered Napoleon's fate sealed and also ... he was positive that if he abstained from signing the Addendum, he would be ensured peace for the rest of his days".

Waterloo supervened on June 18. On June 26 David applied for passports for England and Switzerland, and it was probably then (though Delécluze sets the episode in the first Restoration) that he took the precaution of sending *The Sabine Women, The Coronation, The Eagles, Leonidas* and his portrait of Napoleon "somewhere in the west" to await shipment. However, he left for Switzerland in July; there is a sketchbook recording his trip through Besançon, Pontarlier, Neuchâtel, Yverdon, Lausanne, Geneva and the valley of Chamonix, where he stayed for a time, afterwards returning to Geneva. Somewhat reassured by the royal edict of July 24 naming the nineteen officers who alone would be tried for treason by a military tribunal and the thirty-eight suspects to be held at the disposal of the courts, he went back to Besançon in August, crossed the Austrian lines with some difficulty, and reached Paris at the end of the month.

Delécluze has left us a doleful account of those last days in Paris.

David's last stay in France was a very sad one, and though he was too self-controlled to complain, even to his friends, it was still obvious to anyone who knew him, from some of his reminiscences and his unusual attentiveness and consideration to everyone around him, that he was in a highly emotional state. Some of his pupils were more zealous than ever during those sad days, but it was Gros more than anybody who obeyed the dictates of his generous heart on that occasion ... Concerned about the desertion of his master and worried about his future, Gros constantly sustained him with his staunch friendship and reassurance.

It was the government's intention to keep its word, and on December 8, the day after Ney's execution, the Duc de Richelieu suggested an amnesty. But the "Chambre introuvable", elected at the end of August, was not so generous and—at the instigation of La Bourdonnaye, once a loyal subject of Louis XVI and still ultra-royalist—considered the adoption of a law providing for the punishment of those who had supported the Revolution and the Empire. On December 27 the Comte de Corbière proposed a law that combined both approaches and stipulated the banishment of all regicides who had voted for the Addendum or accepted offices from the usurper. In spite of government resistance the two Chambers

passed the law more or less unanimously, and it came into effect on January 12, 1816. Article 7 applied directly to David: "Any regicides who, in spite of almost boundless leniency, voted for the Addendum and accepted work or offices from the usurper, thereby declaring themselves irreconcilable enemies of France and its lawful government, shall be banished from the Kingdom for ever and must leave it within a month ... They shall not enjoy any civil rights here or own any goods, offices, or allowances granted to them." Comte Decazes, minister of Police, had let David know that he could be exempted from this proscription, but the painter told him with dignity that he intended to obey the law. He tried unsuccessfully to go to Rome and finally settled on Brussels, where he and his wife arrived on January 27. The new Kingdom of the Netherlands, comprising Belgium and Holland, hospitably took in quite a few of the exiles.

Thus a number of former regicides were to be found in Brussels, including Alquier, Barère (who had been involved with all David's major undertakings during the Revolution and who remained in Brussels until the fall of Charles X), Cambon, Levasseur, Merlin of Douai, Prieur de la Marne (whose head David painted for *The Oath of the Tennis Court* and who died in Brussels in 1827), Ramel, Sieyès, Thibaudeau (exiled in Austria until his arrival in Brussels in 1823), Silvain Lejeune and Pierre Paganel (who died in Brussels in 1828, as did Vadier). King William I deserves some credit for giving asylum to all these Jacobins. Neither the French nor the Allies wanted them so near Paris, and direct pressure was put on him to get rid of them; the French ambassador was even recalled for a time in 1817.

Some of David's pupils, such as Odevaere and Navez, also lived there and welcomed him warmly; meanwhile in Paris his pupils, led by the faithful Gros, petitioned Decazes in his favor. David was sufficiently happy in Brussels to turn down the King of Prussia's flattering offer of "a pleasant life" in Berlin, where he could give advice on "setting up a new museum and improving studies in all branches of the visual arts".

In 1818 David became involved in difficult negotiations with his former pupil Comte de Forbin, now Director of Museums, and the French government, which was claiming three paintings left in Paris—*The Coronation, The Eagles* and *Andromache*, the last on the ground that it was an admission-piece for the Academy. David retorted that he had not belonged to the Academy for a long time and that "admission-pieces were done at the artist's own expense". In addition, Forbin wanted to buy *The Sabine Women* and *Leonidas*, both of which were still in the studio

at Cluny, for the king. Through the intermediary of a Paris lawyer acting for David, the sale was agreed on at the end of 1819, subject to the payment of 100,000 francs and the retrieval of the two great Napoleonic paintings for the king. A dispute ensued over the engraving rights, which were at least as remunerative for David as the sale of the paintings. David won, in spite of opposition from Comte de Pradel, minister of the King's Household, and the sale was concluded at the beginning of 1820. Though he was now on better terms with the French government, David stuck to the decision which he explained to his son Jules on January 1, 1819 as follows:

> All my colleagues are going back to France, and I should certainly go with them if I were weak enough to ask for my recall in writing. You know how proud your father is—could he do something like that? I was old enough to know what I was doing, I didn't act on impulse. Time will reveal the truth. In this country people who believe in uprightness and integrity respect me ... I'm valued in the country where I live, and I've turned down a great king who wanted me to organize a ministry of Arts in his Prussian states. I can rest here, the years are passing, my conscience is clear, what more do I need?

In spite of pressing pleas from Gros, David remained to the end deaf to all entreaties: the faithful admirer of Marat, Robespierre and Napoleon would not bend the knee to the Bourbons.

At least he was active in his exile. He resumed work on projects he had started in Paris. Thus he finished the portrait of his old friend Alexandre Lenoir, who—like David himself—had been a key figure in the art world during the Revolution and who had assembled many paintings and statues (particularly the latter) from Paris churches in his Museum of French Monuments, sometimes saving them from destruction. He was apparently very close to David, about whom he set down some useful "Historical Recollections" during the Empire. In 1810, when the question of "decennial prizes" led to bitter disputes in the art world, he wrote an enthusiastic pamphlet about *The Sabine Women*. In one drawing (Art Institute, Chicago) for the painting now in the Louvre, the archaeologist's strange, wide-set eyes make his face all the more striking.

David also went back to *Apelles Painting Campaspe in Front of Alexander*, a project dating from 1812 or 1813, though he did not complete this illustration of the tale told by Greek and Latin authors, notably Pliny the Elder, of how Apelles fell in love with Alexander's mistress while painting her portrait, whereupon the conqueror generously let him take her. This subject was a perennial favorite with

177 *Portrait of Alexandre Lenoir.* Signed and dated 1817. Oil on wood. 71.5 × 62.5 cm. Musée du Louvre, Paris.
Alexandre Lenoir (1761-1839), the distinguished founder of the Museum of French Monuments, was a personal friend of David's and has left us valuable recollections of him. This lively portrait of an ugly but likable man was started in Paris and, after a lapse of several years, completed in Brussels. Lenoir tells us that David redid the eyes several times in order to catch the right expression.

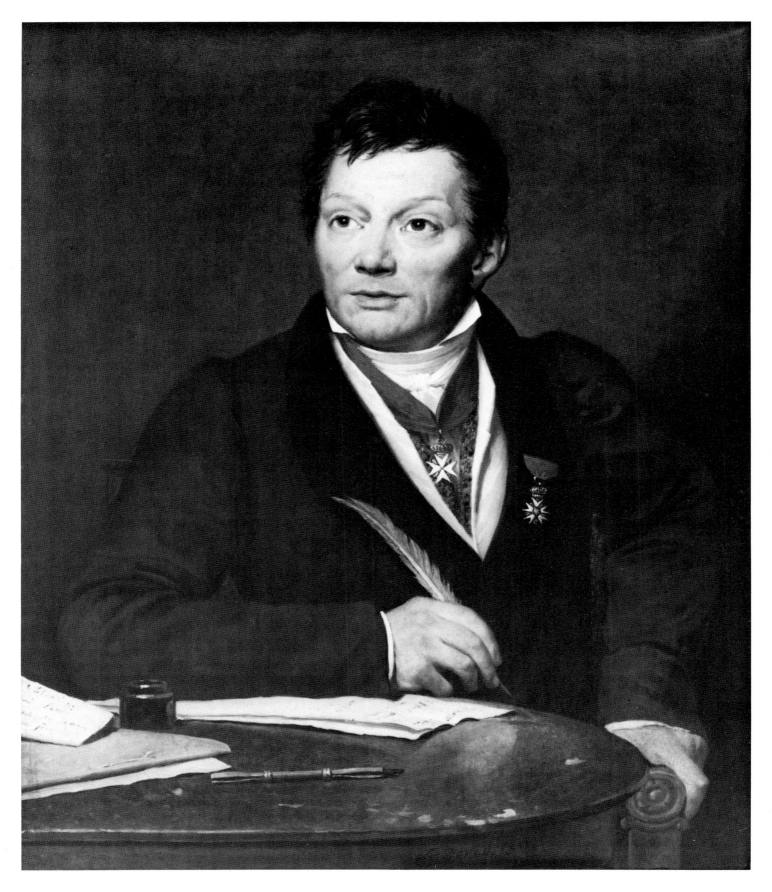

painters, some of whom—Lagrenée, for instance—treated it as an allegory of painting. It was popular with dramatists too, and the Opéra had staged a play on the subject in 1798.

This work again shows how concerned David was with giving classical antiquity an everyday appearance, as we can see from the crumpled sheets on which Campaspe lingers and especially the marvellous still life of the painter's equipment. The characters are rather swamped by the somewhat uncoordinated setting, in which the lines of the furniture are at variance, and they are not as authoritative as David's figures usually were, notably in the 1809 *Sappho, Phaon and Cupid*, the last picture in which he had treated a similar subject. However, there is a renewed interest in color, and the fine clear greens were to be typical of his later work.

In Brussels David painted a whole series of portraits of former revolutionaries and supporters of Napoleon, exiles like himself—portraits in which his genius shines intact. He started with a solemn, full-length, life-size portrait of General Etienne-Maurice Gérard, in a setting of marble and brocade opening on a landscape beyond a balustrade (Metropolitan Museum, New York). The sitter was born in 1773 and joined the army as a volunteer in 1791, taking part in the battle of Fleurus. At the end of the Revolutionary era he was Bernadotte's aide-de-camp, was wounded at Austerlitz, became a general, won the Grand Cross of the Legion of Honor, was created Baron of the Empire, and took part in the Russian, German and French campaigns. He went over to Louis XVIII, who awarded him a Cross of St. Louis and the Grand Cordon of the Legion of Honor, but could not withstand the appeal of Napoleon on his return from Elba. He accepted a command again, fought at Ligny, and was made a Peer of France on June 2, 1815. Relieved of his functions by Louis XVIII, he went to Belgium, but returned to France in 1817. He started a political career in the Liberal opposition in 1822 and reached new heights under the July Monarchy, becoming minister of War, Marshal of France, once again a peer, and Grand Chancellor of the Legion of Honor. He still had time to become a Senator in the Second Empire before he died. David thus painted the general at the single low point of a distinguished career. His square, stocky appearance is marvellously rendered, but otherwise the painting has the rather superficial elegance of the portraits by another Gérard, David's former pupil.

The portrait of the Comte de Turenne, now in the Ny Carlsberg Glyptotek, Copenhagen, is also dated 1816 and is a splendid piece of work. The subject does not look remotely like a soldier in his smart cloak, with his top hat—the lining of

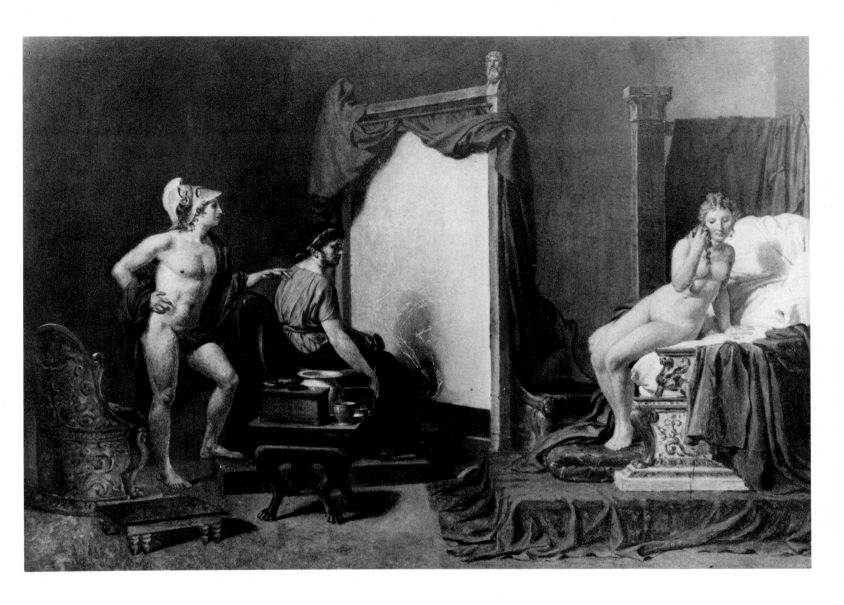

which shows his coat of arms—held under his arm. Count Henri-Amédée-Mercure de Turenne belonged to a distinguished family and was born a Knight of Malta in 1776. His father was a colonel in the cavalry, and he himself joined the army at an early age; a loyal follower of Napoleon, he became his Chamberlain and Master of the Wardrobe. He was a colonel during the Russian campaign and was made a Count of the Empire in 1813. He fought at Ligny and Waterloo and lost his rank during the Restoration, but rose to be a Peer of France in 1831.

The Count's fine figure is set against a curious background in which a rather perfunctorily painted column can be faintly discerned. The head is modelled meticulously, down to the shadow of the curls on the forehead, in contrast to the free but effective treatment of the clothes; the creases under the knees are especially interesting. David also did a half-length portrait of him, which is still in the family.

The portrait of Sieyès (Fogg Art Museum, Cambridge, Mass.), painted the following year, is very similar in layout and construction, but even finer. The prominent Revolutionary was now sixty-nine, according to the solemn inscription

178 *Apelles Painting Campaspe in Front of Alexander.* Oil on wood. 96×136 cm. Musée des Beaux-Arts, Lille.
Another work started in Paris (there is a sketch dated 1813) and taken up again in exile in Brussels, but left unfinished. This new variation on the theme of classical or mythological lovers is noteworthy, like all David's paintings of this type, for its emphasis on color.

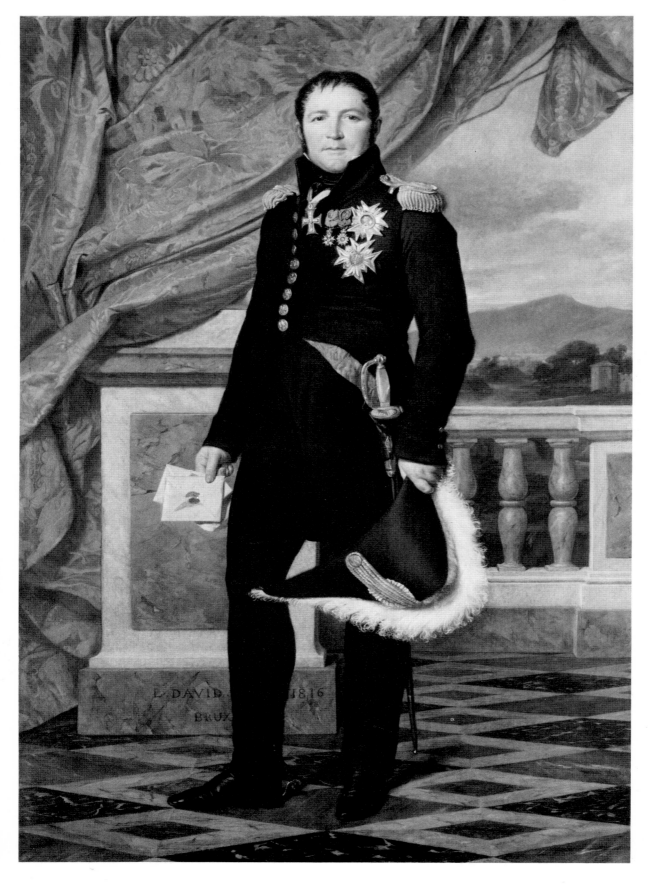

284

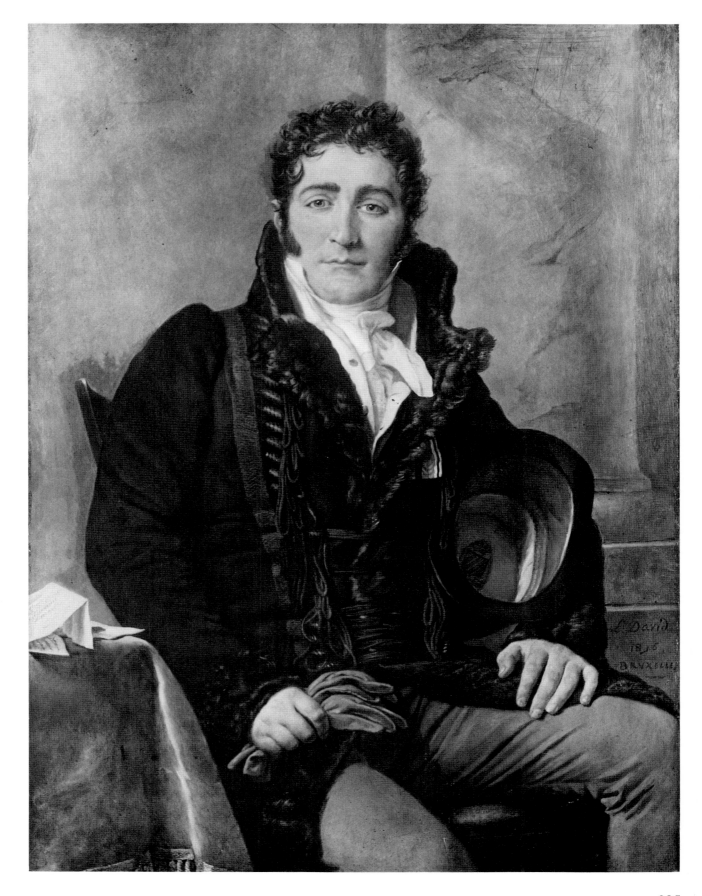

◁◁ 179 *Portrait of General Etienne-Maurice Gérard.* Signed and dated 1816. Oil on canvas. 197×136 cm. Metropolitan Museum of Art, New York.
The model, born in 1773, had had a distinguished military career under the Revolution and the Empire. Temporarily exiled for having rallied to Napoleon during the Hundred Days, he later had a brilliant political career. This very formal, traditional portrayal of him is unique in David's work.

◁ 180 *Portrait of Comte Henri-Amédée de Turenne.* Signed and dated 1816. Oil on wood. 112×83 cm. Ny Carlsberg Glyptotek, Copenhagen.
The Comte de Turenne had been a faithful follower of Napoleon, serving him as Chamberlain and Master of the Robes and also fighting for him at Waterloo. The artist's special attention to the details of the clothes and to the expression is emphasized by the casual handling of the background.

181 *Portrait of Emmanuel-Joseph Sieyès.* Signed and dated 1817. Oil on canvas. 86×72 cm. Fogg Art Museum, Cambridge (Mass.); Grenville L. Winthrop Bequest.
Undoubtedly the finest of the excellent gallery of portraits executed by David during his exile in Brussels. Abbé Sieyès (who would later relinquish holy orders) had played an important political role at the outset of the Revolution and by supporting the *coup d'état* of 18th Brumaire. It was only after the Revolution of 1830 that he returned from exile.

at the top of the painting. Emmanuel-Joseph Sieyès belonged to a middle-class family from the South of France and was in the Church before the Revolution. A canon in Brittany, then Vicar-General in Chartres, he published his still famous pamphlet *What is the Third Estate?* at the beginning of 1789. One of the leading lights of the Constituent Assembly and a less prominent member of the Convention, he voted (as did David) for Louis XVI's death without stay or appeal, before giving up his ecclesiastical status in Brumaire Year II. He was a member of the Council of Five Hundred, and a plenipotentiary minister in Berlin in 1798. On his return he was among those who were on the lookout for a strong leader; he first thought of Joubert, who was killed at Novi, then came round to Bonaparte and helped instigate the *coup d'état* of 18th Brumaire. The following day he became one of the first three provisional Consuls, along with Roger Ducos, but tried in vain to secure the adoption of a constitution that would effectively separate executive from legislative power. In January 1800 he broke with Bonaparte, but the First Consul was wise enough to shower him with money and honors. Sieyès was given the rich property of Crosne, was made a count, and won the Grand Cross of the Legion of Honor. Though he had voted to depose Napoleon in 1814, he was made a Peer of France during the Hundred Days. He moved to Brussels during the second Restoration and did not return to France until after the Revolution of 1830.

The portrait is stunningly simple, with a smooth, featureless background; the subject wears plain black clothes that recall his ecclesiastical past. There is nothing to distract the eye from the masterly rendering of the hands, tobacco-box, and checked handkerchief, and especially of the head with its immensely intelligent, asymmetrical eyes. The picture is discreetly balanced by the light that emphasizes the arms and back of the chair. David painted other regicides, including Alquier, a former lawyer who became royal attorney in the finance office at La Rochelle, a member of the States-General and president of the criminal court of Seine-et-Oise. As a member of the Convention he voted for the King's death, but recommended a stay of execution. He joined the Council of Five Hundred, became a diplomat in Tangiers, then Munich, and went as ambassador to Madrid, Florence, Naples, Rome, Stockholm and Copenhagen. He was made a knight in 1809. After a period of exile in Brussels he returned to France at the beginning of 1818. David's portrait of him has unfortunately been lost.

In 1820 David painted Ramel-Nogaret and his wife (Private collections). Ramel came from Aude and before the Revolution was royal attorney in the

EMM. JOS. SIEYES. ÆTATIS SUÆ. 69.

L. David
Bruxellis
1817

seneschal and presidial courts in Carcassonne. He served in turn on the Constituent Assembly, the Convention and the Council of Five Hundred, and became minister of Finance under the Directory. He stayed in the background during the Empire, but was foolish enough to become prefect of Calvados during the Hundred Days—hence his banishment to Brussels where, like David, he ended his days. The half-length portrait is less meticulous in its treatment than earlier works.

The women of Joseph Bonaparte's family came to Brussels in July 1820, and David knew them well. Joseph had settled in America, near Philadelphia, under the name of Comte de Survilliers, leaving behind him Queen Julie, his niece Juliette de Villeneuve, and his two daughters Zénaïde and Charlotte. Zénaïde married her cousin, Lucien Bonaparte's son, the young Prince de Canino, in Brussels on June 29, 1822. The wedding was the occasion for a great gathering of members of the Imperial family and Bonapartists, which worried the authorities in Brussels and was no doubt one reason why they forbade David to exhibit the copy of the *Coronation*—of which more later. In 1824 David painted a superb full-length portrait of Juliette de Villeneuve standing by her harp (Private collection), which shows that, one year before his death, the artist's talents were undiminished. On June 25, 1821 he sold three copies of a double portrait of Zénaïde and Charlotte for 6,000 francs—4,000 francs for the original and only 2,000 francs for the two copies. Oddly enough, one of the two known copies, in the Musée d'Art et d'Archéologie, Toulon, is signed and dated 1822, whereas the one in the Museo Napoleonico, Rome, which seems to be the original, is unsigned. Unlike the Toulon one, it has a pattern of bees, instead of crosses, on the red sofa. The third is in a private collection. David also gave Charlotte painting lessons; she went back to America before her sister's wedding and at the end of March thanked him in a friendly letter.

David also painted some local dignitaries. We have no complete list, because the second catalogue the painter compiled himself, which his grandson used for the monumental biography published in 1880, only goes as far as 1820. In 1816 David did a portrait of François-Rasse, Prince de Gavre, a member of one of the most illustrious families in Belgium, whose father was governor of the Netherlands at the time of the Empress Maria Teresa. He himself served Napoleon as chamberlain and prefect, then became the Grand Marshal at the court of William I, King of the Netherlands, and president of the Academy of Science and Literature in Brussels. In the same year David painted a beautifully polished portrait of Vicomtesse

182 *Portrait of Zénaïde and Charlotte Bonaparte.*
Signed and dated 1822. 130×100 cm. Musée d'Art
et d'Archéologie, Toulon.
In Brussels David used to visit the salon of Queen
Julie, wife of Joseph Bonaparte (who had settled in
the United States) and also did a portrait of her
niece Juliette de Villeneuve (Private collection).
This portrait of her two daughters exists in three
copies (paid for as early as 1821), two of
them—like this one—probably being the work of
pupils.

Vilain XIIII and her daughter. The subject was the wife of Philippe-Louis P
Vilain XIIII, who was descended from a notable family in Ghent; he had served
Napoleon loyally as mayor of that city and became a Count of the Empire in 1811.
His wife's father was Austrian minister to the court of Louis, King of Holland; she
herself was lady-in-waiting to the Empress Marie-Louise and had held the King of
Rome at his christening. Comte Vilain XIIII's title was recognized by William I in
1816, and he rose to be chamberlain to the King of the Netherlands.

A few years later, probably about 1820, David painted his fine portrait of
Wolf, alias Bernard, the author and actor (Musée du Louvre, Paris); he had a busy P
life, becoming head of the Théâtre de la Monnaie and ending his days in charge of
the New Orleans Theater. The basic approach is still more or less the same, but
there is an interesting change of technique, for the model is less clearly defined
than in the earlier portraits—this is oddly reminiscent of Greuze, whose career
had much in common with that of David.

David's spate of portraits did not stop him from going on with his historical
painting. We must single out the large copy of the *Coronation* (Musée national du P
château, Versailles), begun in Paris in 1808 in circumstances about which little is
known. Between March and April of that year, we find mention of three different
projects: one was for Louis, King of Holland, and was to be one-third the size of
the original, another was to be painted by David's pupils and reproduced as a
tapestry for the Tuileries, and the third was "for the Americans, who asked for it"
(*Journal de l'Empire*, March 21). The last project was possibly the one that had
already been started and was fairly far advanced; at any rate, the copy finished in
1822 was the subject of peculiar financial transactions and was shown at paying
exhibitions in London and America in 1826-7. We know nothing about the
negotiations of 1821, which were done through Gros and someone called
Duchemin, the latter acting on behalf of foreign clients.

David arranged for the large canvas he had started to be brought from Paris
and set up in a vast room, lent by the municipality, in Brussels Town Hall. Within
a few weeks, in the spring of 1822, he had finished it, with the help of Georges
Rouget, his chief collaborator on the original. Even taking into account the
restorations and natural wear and tear the canvas (now in the Musée national du
château, Versailles) has undergone, it is hard to share David's enthusiasm about it
fully. On April 30, 1822 he wrote to Gros that, in the copy, "the harmonies are
better done ... the group of princesses is more spritely; in fact, to tell you the truth,
I prefer it to the original".

183 *Portrait of Vicomtesse Vilain XIIII and her Daughter*. Signed and dated 1816. Oil on canvas. 95×76 cm. Private collection.
The Vilain XIIII family from Ghent had been of some importance in Napoleon's time: the husband was created Count in 1811, and the wife was a lady-in-waiting to the Empress Marie-Louise and had held the King of Rome at his christening. The subtle line and the distinguished appearance of the sitter make this one of David's most elegant portraits.

184 *Portrait of the Actor Wolf, known as Bernard.*
Signed. Oil on canvas. 125×85 cm. Musée du
Louvre, Paris.

This portrait is a contrast to the preceding one, if
only because of the slovenly appearance of the
sitter. Wolf was the director of the Monnaie
Theater, which was frequented by David, an
inveterate playgoer. As impecunious as he was
adventurous, Wolf ended up in charge of the
theater in New Orleans.

According to a curious account by the Attorney-General of Brussels, published
by D. L. Dowd, the painting was two-thirds finished when it arrived from Paris.
Apparently only the background needed doing, but as the painter had little of the
original documentation, he and Rouget used a great deal of artistic licence. The
figures in the background on the left are hardly like the ones in the original, and the
figure on the far left is entirely new. The spectators in the stands are very different:
not only are there new, anachronistic faces, but their·hair and clothes have been
updated, an effect as bizarre as the idea of finishing *The Oath of the Tennis Court* with
different men. The Brussels Attorney-General found it disconcerting from the
outset: "Madame de Survilliers comes into it as the Queen of Spain, and her

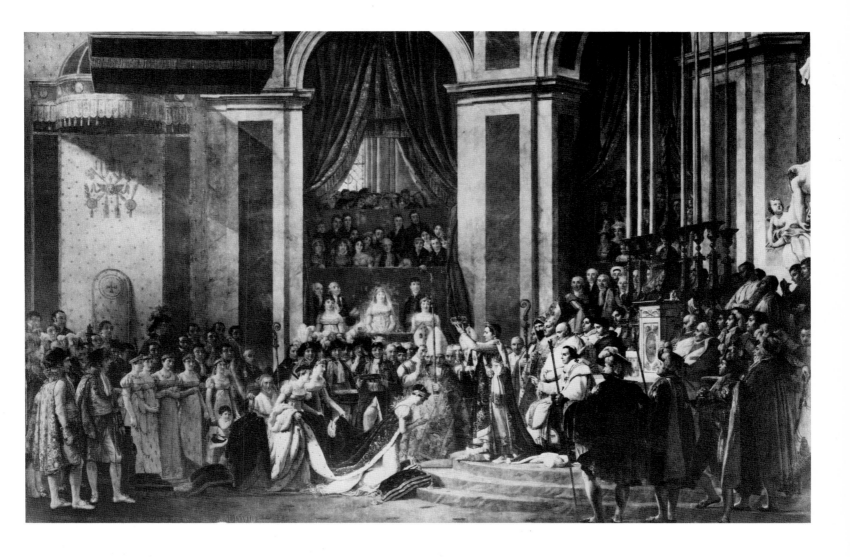

daughter, who has just married Lucien Bonaparte's son, is one of the ladies-in-waiting, as though replacing Madame de la Rochefoucault's companion. Odevaere, the painter, is in one of the stands (behind Vien, Grétry and Méhul, I think), wearing the Cross of the Belgian Lion with a ribbon in the colors of His Majesty King William I, King of the Netherlands." David depicted two different eras, almost twenty years apart, in the same painting. Moreover the copy is short on detail and poor in execution; embroidery has been simplified or deleted, and there is only a meagre scattering of stars behind the Pope's throne. David heightened the color of the princesses' dresses (the critics found them too drab in 1808) and painted that of Pauline Borghese pink, but he also simplified them. The strong sense of life and immediacy in the original is absent from the copy.

For political reasons the authorities wanted to keep in with the court in Paris, so David was not allowed to exhibit the picture in Brussels, though he had shown much of his new work there. He felt that the major works of his later years were his paintings of classical and mythological subjects, constituting so many variations on the theme of a pair of lovers. These have always been generally disliked by the critics. Obviously, they are not amazing masterpieces, but it is worth trying to understand them, bearing in mind that David had lost none of his technical ability,

185 *Consecration of the Emperor Napoleon and Coronation of the Empress Joséphine.* Signed and dated 1808 and 1822. Oil on canvas. 610×930 cm. Musée national du château, Versailles.
This replica was set aside in Paris, apparently with the whole of the background unfinished. With Rouget's aid, David resumed work on it and finished it in Brussels in the spring of 1822, not without considerable "modernization" in the costumes, the hairstyles, and even the persons represented. The simplification of the details by comparison with the original makes it look like a copy—an impression heightened by the wear and tear resulting from its widespread exhibition, for commercial purposes, in America and England during the nineteenth century.

as we can see from his later portraits, and that these "anacreontic" pictures are directly descended from earlier works like the 1809 *Sappho, Phaon and Cupid*—two facts that should temper any criticism.

Cupid and Psyche (Museum of Art, Cleveland), the first of the Brussels paintings in this genre, took up an idea originally conceived in 1813. It was done for Count Sommariva, one of the leading patrons of the time, a man who had made a fortune so fast and so ruthlessly by protecting French interests in the Cisalpine Republic that he deemed it wiser to settle in France. He commissioned works for his villa on Lake Como and his house in Paris from the greatest living artists, including Canova, Prud'hon, Guérin and David. *Cupid and Psyche* was exhibited at the Brussels Museum in August 1817 in aid of the Ursuline and St. Gertrude hospices. The picture gave rise to a certain amount of critical comment at the time, notably as regards the figure of Cupid, and this may perhaps shed some light on David's idea and on the distaste we feel for some of his later paintings. Frémiet, a friend of David (who gave his daughter, Sophie, painting lessons), wrote in *Le Vrai Libéral*, a paper for French exiles:

> I cannot praise the originality of this painting too highly. This is due to the simplicity of the idea—a rare thing in the arts, where oddity and complexity are too often the order of the day. Being a wise and educated man, M. David does not show Cupid as a child, for he was not one as Psyche's lover, but as a very young man, which is how he is depicted on engraved gems of the greatest antiquity... M. David, knowing the distinction drawn by the nature of things between literary and pictorial descriptions, felt that it is as hard for a painter to personify abstractions as it is for a poet to do an individual portrait. He therefore represented the myth as purely historical, without any allegorical *concetti*, any mingling of the real and the fictitious—a shocking and disparate combination that goes against all the ideas of coherence and conformity arising in our minds at the sight of beings of the same nature.

What jars on us are the means David employs to make the mythological seem real, as in *Sappho Phaon and Cupid*. The viewer is not swept into the ancient world as he is in *Paris and Helen*, *The Sabine Women* or *Leonidas*, but has the impression that this world is thrust upon him. Like Phaon, Cupid is no longer idealized and has therefore lost much of his beauty. If we compare the frankly distasteful drawing of 1813, which has recently come back on the market, with the abstract linear lyricism of Ingres's *Jupiter and Thetis*, it is immediately obvious that Cupid and Psyche are simply a nude couple sitting on the edge of a sofa; the composition is

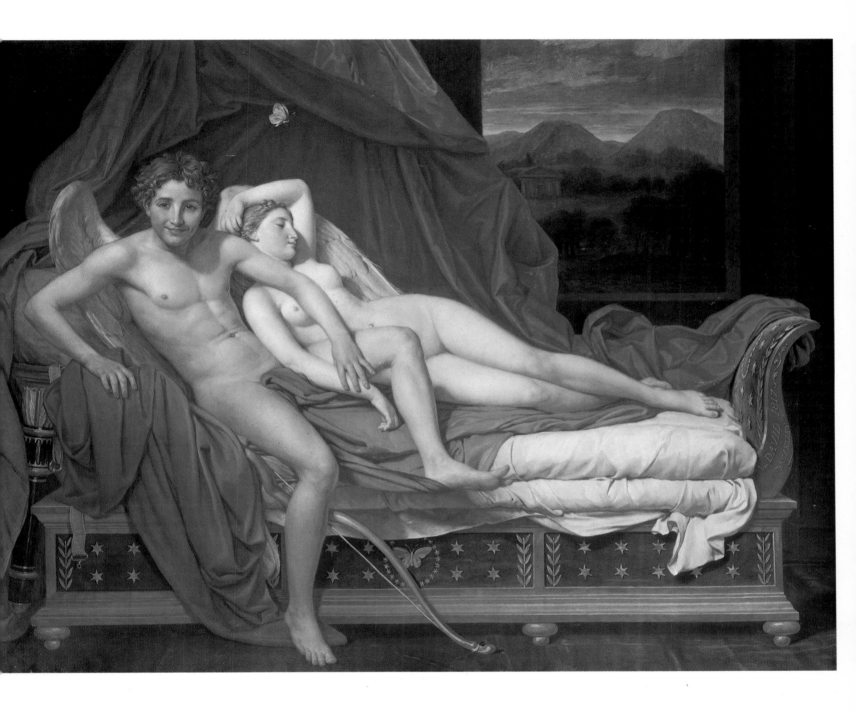

powerful, but myths can be recreated only by stylization and fantasy, for realism is alien to them.

On the other hand, the graceful arabesques of *The Farewell of Telemachus and Eucharis* are a source of unmitigated pleasure. Painted in 1818 for the Count of Schönborn, Vice-President of the Bavarian States-General, and last of a great line of art lovers and collectors, this picture was originally intended as an imaginary pendant to *Cupid and Psyche*. It was exhibited in Ghent on June 1 by the Fine Arts Society, to which David belonged, in aid of unemployed workmen. Cornelissen, secretary of the society, described the subject nicely (this is not in Fénélon's book):

186 *Cupid and Psyche*. Signed and dated 1817. Oil on canvas. 131×241 cm. Museum of Art, Cleveland; purchase, Leonard C. Hanna Jr. Bequest. Commissioned by Count Sommariva, this was one of the first mythological pictures executed by David in Brussels. There are, however, preparatory sketches dating back as far as 1813. David was to devote a great deal of time to the theme of classical lovers, in highly colored pictures, often extremely subtle in line, though they failed to attain the extreme idealization of which Ingres had already furnished examples.

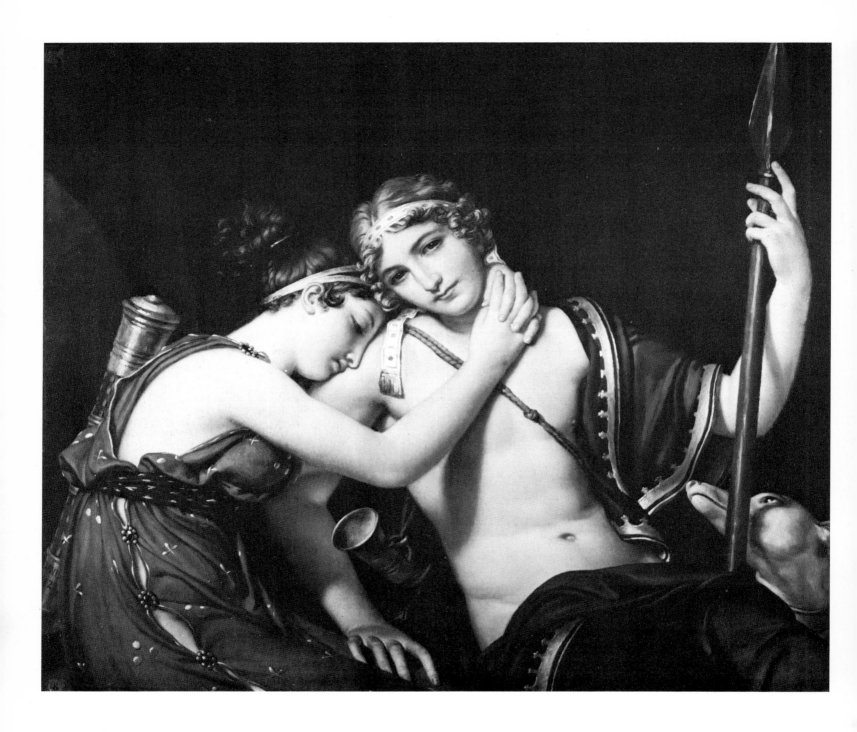

187 *The Farewell of Telemachus and Eucharis.* Signed and dated 1822. Oil on canvas. 90×105 cm. Private collection.
Replica of a picture painted in 1818 for the Count of Schönborn (Private collection) as a sort of companion-piece to *Cupid and Psyche* (Pl. 186). The delicate line and detachment from reality make this composition one of David's last great successes.

Eucharis and Telemachus have tricked both Mentor and Calypso—representing wisdom and jealousy—in order to indulge a mutual passion that is as yet chaste and pure. The time has come to part. Telemachus has already clasped Eucharis in his arms and bidden her the farewell that is to end their moment of happiness. He is about to rise and leave the cave when his beautiful and noble friend, unable to bear the terrible separation, throws her arms around her lover's neck and, probably for the first time, yields to the delightful feelings he arouses in her. Telemachus dares not look at her, for he is thinking of Mentor and feels that happiness is eluding him.

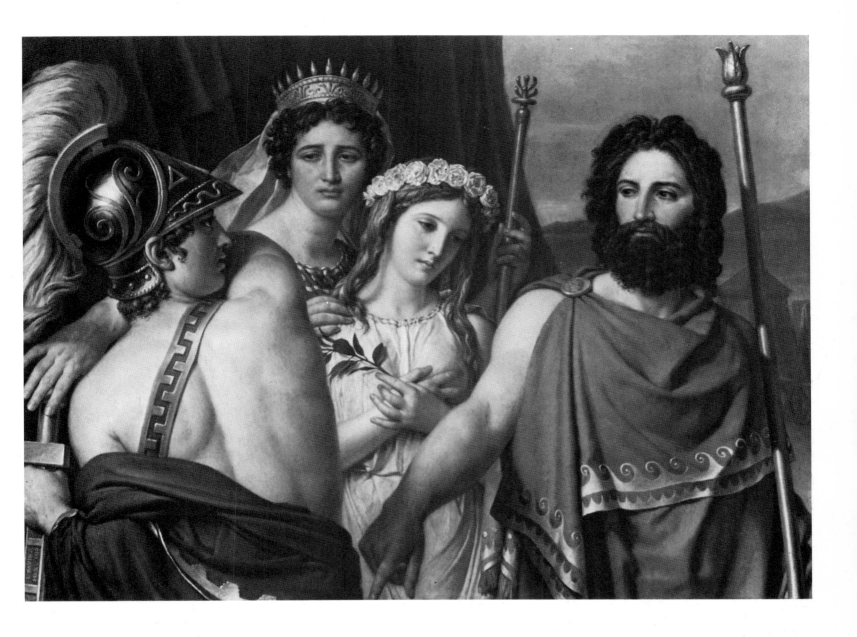

The painting was next exhibited in Brussels in aid of the Ursuline and St. Gertrude hospices. In collaboration with Sophie Frémiet, David did a copy of the painting (the original was sold in New York in 1950). He followed the same procedure with a new composition of four half-length figures, *The Anger of Achilles at the Sacrifice of Iphigenia*, painted in 1819 for Parmentier, an obscure art lover. It was exhibited in Brussels and Ghent; he made a copy of it in 1825 for Firmin Didot (the two canvases are in private collections).

The major work of David's last years was *Mars Disarmed by Venus and the Graces*, a canvas three metres high, begun in 1821 and finished in February 1824. Gros saw the rough draft when he went to Brussels in November 1821, bringing David a gold medal he had commissioned from Galle to commemorate the entry of *The Sabine Women* and *Leonidas* to the royal museums. David obviously attached great importance to the canvas: "It is the last of the paintings I want to do, but I want to

188 *The Anger of Achilles at the Sacrifice of Iphigenia.* Signed and dated 1819. Oil on canvas. 105×143 cm. Private collection.
In a half-length composition, David once again employs that uncertain mixture of realism and idealism that prevents us from considering his late mythological paintings as wholly successful. The poetic figure of Iphigenia is nevertheless a bewitching creation, anticipating some of the finest achievements of the English Pre-Raphaelites.

189 *Phaedra and Hippolytus.* Signed. Drawing in black crayon. 13.3×19.8 cm. Musée des Beaux-Arts, Rouen; H. and S. Baderou Donation.
A number of David's later drawings are in a new, heavy style with the emphasis on relief, the immediate effect being odd rather than pleasing.

190 *Mars Disarmed by Venus and the Graces.* Signed and dated 1824. Oil on canvas. 308×262 cm. Musées royaux des Beaux-Arts, Brussels.
David's last large-scale undertaking, under lengthy preparation from 1821, was exhibited in Paris in 1824 along with several works that had remained in the artist's studio. This picture, which is echoed in the ceilings by Ingres and Gros at the Louvre, was a source of puzzlement to the critics, who already had to deal with the first successes of the Romantics and were surprised by David's use of strong colors.

surpass myself in it. I will inscribe it with the date of my seventy-fifth year, and after that I never want to touch a brush again," he told the paper *L'Oracle* on December 8, 1823.

The artist's original idea can be gleaned from a drawing in the Fogg Art Museum in which the composition with two figures is reminiscent of *Cupid and Psyche*; Venus is shown almost full-face, taking off Mars' helmet. In 1822 the composition was completely changed, and the figures of the Three Graces were added on the right. David enlisted first the unassuming Du Pavillon, then Michel Stapleaux, a close friend at the end of his life, to prepare the underpainting for the final canvas. In March it was exhibited in Brussels as usual, but this time the family decided to go further, and in May they rented a three-room Paris flat in rue de Richelieu at the corner of boulevard Montmartre. There they hung some of the paintings David still owned, such as *Andromache* and the nude figures said to be of *Hector* and *Patrocles*. One room was draped with dark green and reserved for *Mars and Venus*, which was displayed facing a large mirror, and the third room was a rest

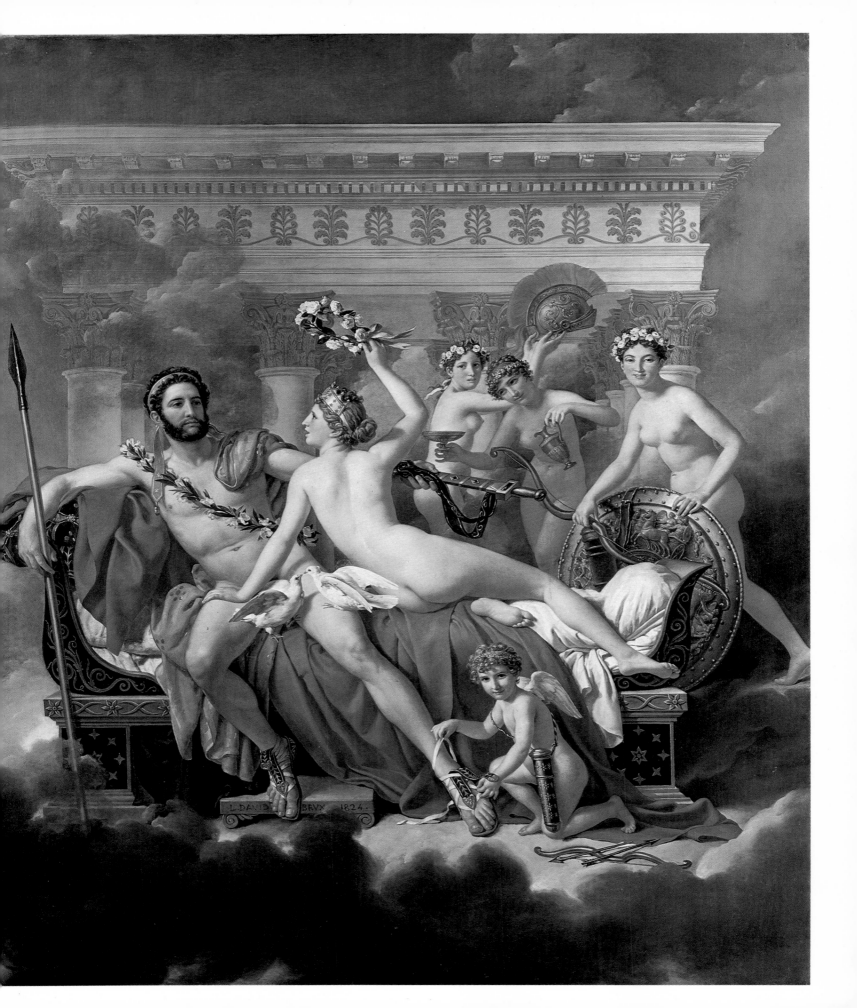

area. The exhibition aroused a great deal of curiosity; six thousand people were admitted during the first month, and David's still loyal friends and pupils sent him warm congratulations. The critics were more cautious, as we can see from Thiers's long article. The painting surprised him, probably because he had not seen David's three earlier history paintings and thought that the bold colors were an innovation:

If you go for linear beauty and dazzling color alone, even at the expense of veracity, this painting must be declared a masterpiece, because it marks the utmost limit of the road along which M. David is travelling. If you think that, on the contrary, style should not be pretentiously academic, figures should not be drawn like statues, and colors should not clash in a tiring manner, you will feel that M. David's work contains some fine painting, but would be a dangerous model to follow, that it marks the utmost limits of a system that was good when it was used as a corrective, but is not so good when it overreaches itself and has to be curbed in its turn.

... The drawing is very fine, and M. David, here as elsewhere, is the greatest known draughtsman... His color is brighter than ever, but so dazzling that it takes a minute to get used to it. The color is definitely the most amazing thing about the picture.

Thiers goes on to hail the energy and love of beauty that had led the aging artist to effect "a revolution in his talent" that brought him closer to "the color range of the Flemish and Dutch painters" than any French painter had ever been. He also missed the earlier style a bit: "However astonishing some parts of this picture are, I am not sure that the old color, that rather gloomy yellowish color he used in Italy to paint *Belisarius* and *The Horatii*, was not better suited to the rigor and grandeur of history and of his talent." David's bright colors were not as novel as Thiers thought, but they still produce a striking impression today, especially the electric blues and the vivid brick red of the drapery. Thiers justly admired the execution: "Never... has colored material, which consists of a blend of a myriad different shades, all carefully graduated, been so well conveyed."

Should we side with Thiers here? One cannot help admiring the boldness of that temple of clouds, that fabulous frontal vision, spanned by mists and standing out against a lurid blue, that is echoed and stressed by the vast, absolutely horizontal bed, and it is impossible not to be impressed by the masterly line. Nevertheless it is a disturbing picture, and one soon wishes that David had gone a little beyond the "utmost limit" and dropped the last, cumbersome vestiges of

191 *Portrait of J. L. David.* By Jérôme Martin Langlois (1779-1838). Signed and dated 1825 on the back. Oil on canvas. 88×75 cm. Musée du Louvre, Paris.
This fine portrait, painted by one of David's loyal pupils a few months before his death, shows the aged master at work on a composition that corresponds to the left-hand part of *Apelles Painting Campapse* (Pl. 178).

realism to achieve something of the pure, abstract poetry that his pupil Ingres had captured so excitingly in *Jupiter and Thetis* almost fifteen years earlier.

David's last attempts to renew his art influenced only the ever loyal Gros, whose late works like *Acis and Galatea* (Walter P. Chrysler Museum, Norfolk, Virginia) and the Louvre ceilings of 1827 are all imbued with the memory of *Mars and Venus*. As Stendhal said in 1824, "We are on the brink of a revolution in the arts", and in fact the Romantic revival had already begun with Géricault's *Raft of the Medusa*, which caused a sensation at the Salon of 1819 and was purchased by the State in that same year, 1824. Delacroix was enjoying his first successes and exhibited the *Massacre of Scios* at the Salon of 1824; its comtemporary theme and freedom of execution were poles away from *Mars and Venus*.

David died on December 29, 1825. His dignified funeral was followed on February 16, 1826 by an impressive memorial service, the French government having refused to let his body be transferred to Paris. Though his friends were as loyal as ever and published several pamphlets about him, the public was no longer interested, as can be seen from the failure of the sale of the works in his studio the following April. But David's spell in limbo was not a long one. As Théophile Gautier wrote, "David, whose glory was for a short while obscured by the dust raised round about 1830 by the clashes between Romanticism and Classicism, nevertheless remains—and will continue to remain—an unassailable master."

bliography

Chaussard, P.
*usanias français. Etat des Arts du dessin en France
erture du XIX^e siècle*. Art exhibition, Paris.
passage on David reissued in *Revue Universelle
rts*, XVIII (1863), with an appendix and
gue by J. du Seigneur.)

Anonymous
sur la vie et les ouvrages de M. J.-L. David.
els.

A. Th. (Thibaudeau?)
David, premier peintre de Napoléon. Brussels.

Coupin, P. A.
*sur J.-L. David, Peintre d'Histoire, suivi d'une liste
rages de David*. Paris.

Lenoir A.
souvenirs historiques (extract from *Journal de
ut Historique*, III, August).

Delécluze, E. J.
David, son école et son temps. Souvenirs. Paris.

Cantaloube, A.
essins de L. David', in *Gazette des Beaux-Arts*,
.

1882 David, J.
intre Louis David, souvenirs et documents inédits,
., Paris.

David, J.
*ues observations sur les dix-neuf toiles attribuées à
David à l'exposition de portraits du siècle à l'Ecole
aux-Arts*. Paris.

Saunier, Ch.
David. Paris.

Rosenthal, L.
David. Paris.

1913 *David et ses élèves*. Exhibition catalogue,
Paris, Petit Palais.

1913 Lanzac de Laborie, L. de
'Napoléon et le peintre David', in *Revue des études
napoléoniennes*, I.

1929 Valentiner, W. R.
'David and the French Revolution', two articles in
Art in America.

1930 Cantinelli, R.
Jacques-Louis David. 1748-1825. Paris.

1936 Humbert, A.
*Louis David, peintre et conventionnel. Essai de critique
marxiste*. Paris.

1940 Holma, K.
David, son évolution, son style. Paris.

1943 Maret, J.
David. Monaco.

1946 Brière, G.
'Sur David portraitiste', in *Bulletin de la Société de
l'Histoire de l'Art Français*, 1945-6.

1948 Dowd, D. L.
*Pageant Master of the Republic. Jacques-Louis David and
the French Revolution*. Lincoln, University of
Nebraska.

1948 Florisoone, M.
Catalogue de l'exposition *David*. Paris, Musée de
l'Organgerie.

1948 Maurois, A.
J.-L. David. 'Les Demi-Dieux' Collection, Paris.

1948 Brière, G.
'Les deux "Couronnements", par Louis David', in
Dessin, N° 13, March.

1953 Adhémar, J.
David, naissance du génie d'un peintre. Preface by J.
Cassou. Monte Carlo.

1954 Hautecœur, L.
Louis David. Paris.

1964 Wilhelm, J.
'Le visage de David vu par lui-même et par ses
élèves', in *Art de France*, IV.

1968 Calvet, A.
'Unpublished Studies for the "Oath of the Hora-
tii"', in *Master Drawings*, N° 1.

1969 Kemp, M.
'J.-L. David and the Prelude to a Moral Victory for
Sparta', in *The Art Bulletin*, June.

1969 Lee, V.
'Jacques-Louis David: The Versailles Sketchbook',
in *The Burlington Magazine*, April, June.

1972 Herbert, R. L.
J.-L. David: Brutus. 'Art in Context' Collection,
London.

1973 Verbraeken, R.
*Jacques-Louis David jugé par ses contemporains et par la
postérité*. Paris.

1973 Wildenstein, D. and G.
*Documents complémentaires au catalogue de l'œuvre de
Louis David*. Paris.

1974 Brookner, A.
Jacques-Louis David: A Personal Interpretation. Con-
ference of the British Academy, London.

1974 Schnapper, A.
'Les académies peintes et le « Christ en croix » de
David', in *La Revue du Louvre et des musées de France*,
N° 6.

1974-1975 *De David à Delacroix*. Exhibition cata-
logue. References to David by A. Schnapper. Paris,
Detroit, New York.

1975 Howard, S.
A Classical Frieze by Jacques-Louis David. The
Crocker Art Gallery, Sacramento.

1975 Sells, Chr.
'Some Recent Research on Jacques-Louis David',
in *The Burlington Magazine*, December.

1978 Crow, T.
'The "Oath of the Horatii" in 1785. Painting and
Prerevolutionary Radicalism in France', in *Art
History*, N° 4.

Index

The numbers in italics refer to the Plates on the pages indicated

Abildgaard, Nikolai-Abraham 36
Adam, Robert 35
Admetus 76
Adry, Father Jean-Félicissime 82
Agis 198
Agostino Veneziano 187
Ajax 196
Albani, Alessandro, Cardinal 33
Albinus, Lucius 12
Alcestis 76
Alexander 86
Alfieri, Vittorio 92
Alizard, Jean-Baptiste 81
Alquier, Charles-Jean-Marie, Baron 279, 286
Anaclet 106
Anacreon 88, 268
Andrea del Sarto (Andrea d'Agnolo di Francesco) 42, 47
Andromache 70
Angelico, Fra 194
Angiviller, Charles-Claude, Comte d' 12, 14, 15, 17, 21, 38, 40, 43, 44, 59, 60, 61, 62, 64, 65, 72, 74, 83, 90, 92, 97, 98
Angoulême, Louis de Bourbon, Duc d' 277
Aphrodite 89
Apollo 89, 164
Apollodorus 81, 82
Artois, Comte d' 59, 84, 86, 88; *see also* Charles X
Astyanax 70
Augustus 11

Bachaumont, Louis Petit de 70
Bacler-Dalbe, Louis-Albert-Ghislain, Baron de *205*
Bailly, Jean-Sylvain 102, 103, 113, 114, 116, 118, 131; *100*
Baltard the Elder, Louis-Pierre 141
Banks, Thomas 36
Barère, Bertrand Barère de Vieuzac 101, 114, 143, 150, 162, 279

Barnave, Pierre-Joseph-Marie 103, 113, 118, 120; *107*
Barnevelt, Jean Olden- 150
Barra, François-Joseph 141, 160, 162, 163, 170; *161*; *see also* David
Barry, James 36
Barthélémy, Jean-Jacques, Abbé 88
Bartolommeo, Fra (Baccio della Porta) 47
Batoni, Pompeo 33, 49
Baudelaire, Charles 160
Baudoin, Pierre-Antoine 18
Bayle, Pierre 146, 147; *143*
Beaufort, Jacques-Antoine 21, 66, 73, 90
Beauharnais, Eugène de 219, 232, 242, 250; *241, 257*
Beauharnais, Hortense de, wife of Louis Bonaparte 235; *236*
Beauharnais, Joséphine de: *see* Joséphine
Beaumont, Marc-Antoine, Comte 228
Beauvais de Préau, Charles-Nicolas 146-7; *143*
Beauvallet, Pierre-Nicolas 155
Belisarius 61, 62
Belloy, Jean-Baptiste, Cardinal 235; *237*
Benefial, Marco Giovanni Antonio 33
Bernadotte, Jean-Baptiste-Jules 219, 242, 282; *241*
Bernier, Etienne-Alexandre-Jean-Baptiste-Marie, Mgr 212, 216, 217
Bernis, François-Joachim, Cardinal 47
Berthélemy, Jean-Simon 22, 42, 65
Berthier, Louis-Alexandre, Prince of Neuchâtel, Prince of Wagram, Marshal 213, 219, 227, 246, 255; *241*
Berthomet *137*
Bervic, Charles-Clément (Balvay, Charles-Clément) 101
Bessières, Jean-Baptiste, Duke of Istria, Marshal 235; *237*
Bièvre, N., Marquis 74
Bilcoq, Marie-Marc-Antoine 98
Blanchard *138*
Blauw, J. *see* David
Blundell, Henry 35
Boilly, Louis-Léopold 268
Boissy d'Anglas, François-Antoine 178
Bonaparte, Caroline (Annunziata) Murat 235; *236*

Bonaparte, Charles-Lucien-Jules-Laurent, son of Lucien 288
Bonaparte, Charlotte, daughter of Joseph 288; *289*
Bonaparte, Elisa (Marianna) Bacciochi 210, 235; *236*
Bonaparte, Jérôme 213, 226
Bonaparte, Joseph, later Comte de Survilliers 206, 213, 219, 227, 235, 288
Bonaparte, Julie Clary, wife of Joseph 288; *236*
Bonaparte, Laetitia Ramolino, Madame Mère 221, 228; *225, 237*
Bonaparte, Louis 213, 219, 227, 228, 232, 235
Bonaparte, Lucien 203, 213, 228, 288
Bonaparte, Napoléon 7, 72, 144, 190, 199, 203, 205, 208, 210, 212, 213, 214, 216, 217, 218, 219, 220, 222, 223, 226, 227, 235, 246, 247, 248, 250, 251, 253, 255, 260, 262, 274, 277, 278, 280, 282, 283, 286, 288, 290; *207, 209, 220, 221, 233, 239, 242, 243, 263, 293*; *see also* David
Bonaparte, Napoléon, son of Louis 235
Bonaparte, Pauline (Paulette) Borghese 235, 260, 293; *236*
Bonaparte, Zénaïde, daughter of Joseph *see* David
Bonnemaison, Féréol de 260
Bonneuil, Mlle de 88
Bonvoisin, Jean 26, 148
Borel *99*
Borghese: *see* Bonaparte, Pauline
Bouchardon, Edme 139
Boucher, François 11, 12, 17, 18, 19, 21, 22, 36, 42, 45, 47, 50; *18*
Bouillé, François-Claude-Amour, Marquis 136
Bouquier, Gabriel 146
Braschi, Luigi, Cardinal 235; *240*
Brenet, Nicolas-Guy 17, 21, 66
Brennus 86
Brette, Armand 116
Brissac, de 228
Brissot, Jean-Pierre, later Brissot de Warville 133
Broc, Jean 186, 187
Bruni, Antonio Bartolommeo 141
Brutus 17, 50, 90, 91, 92, 93, 132, 133, 136, 154; *142*

Buffon, Georges-Louis 59
Buron, Jean-Baptiste 21
Buron, Mme, née Potain *see* David

Cabanis, José 210
Calas, Jean 136
Callet, Antoine-François 65
Cambacérès, Jean-Jacques-Régis de, Duke of Parma 213, 214, 220, 227, 246; *241*
Cambon, Joseph 279
Camilla 72, 74, 78
Camillus, Furius 12, 86
Camus, Armand-Gaston 103
Canova, Antonio 35, 47, 53, 294
Caprara, Giambattista, Cardinal 210, 212, 228, 232, 235; *229, 240; see also* David
Caravaggio, Michelangelo da (Michelangelo Merisi or Amerighi) 42
Carraci, Annibale 14, 19, 20, 35, 36, 186
Caso, Jacques de 48
Cassini, Jean-Dominique 65
Catinat, Nicolas, Marshal 66
Cato 50
Caulaincourt, Armand-Augustin-Louis, Marquis 213, 242; *241*
Cavedone, Giacomo 38
Caylus, Anne-Claude-Philippe, Comte 20, 36
Cellerier, Jacques 135; *133*
Cézanne, Paul 46
Chabot, François 156
Chalgrin, Emilie 88
Chalier, Marie-Joseph 147
Challe, Charles-Michel-Ange 81
Chaptal, Jean-Antoine 182
Chardin, Jean-Baptiste-Siméon 16
Charette, de 232
Chariclea 86
Charlemagne 205, 206, 210, 214, 219
Charles II, King of England 136
Charles IV, King of Naples 34
Charles IV, King of Spain 206
Charles X, King of France 190, 279; *see also* Artois, Comte d'
Chaudet, Antoine-Denis 88
Chaussard, J.B. Publicola *69*
Chénier, André 80, 130
Chénier, Marie-Joseph 131, 135, 136, 150
Chéreau *140*
Chloë 86
Clelia 86
Clement XIII, Pope 33
Clement XIV, Pope 33
Clérisseau, Jacques-Louis 37
Clermont d'Amboise, Jean-Baptiste-Louis, Comte 45
Clodion, Jean-Claude 36
Clootz, Jean-Baptiste (Anacharsis) 135
Clovis, King 214
Cobenzl, Johann Philip, Count 232
Cochin, Charles-Nicolas 11, 12
Colbert, Jean-Baptiste 14
Collatinus 90

Collot d'Herbois, Jean-Marie 118, 131, 136
Condorcet, Marie-Jean-Antoine de Caritat, Marquis 131, 150
Consalvi, Ercole, Cardinal 212
Constant (known as Wairy) 206
Copia, Louis 156
Copley, John Singleton 36
Corbière, Jacques-Joseph-Guillaume-François-Pierre, Comte 278
Corday, Charlotte 154, 155, 156, 158; *154*
Coriolanus 90, 93
Corneille, Pierre 72, 134
Cornelia 147; *142*
Cornelissen 295
Correggio Allegri, Antonio 38
Coupin, P.A. 80
Coustou, Nicolas 232, 246
Crito 81, 82
Cubières, Louis-Pierre, Marquis 88
Cunego, Domenico 36; *37*
Cuvillier 82

Damocles 89, 153
Dampierre, Auguste-Marie-Henri Picot, Marquis 153, 154; *153*
Daniele da Volterra (Daniele Ricciarelli) 47
Danton, Georges-Jacques 106, 148
Danzel, Jacques-Claude 82
Daphnis 86
Daru, Alexandrine Thérèse *see* David
Daru, Martial, Comte 208, 220, 222, 226, 246, 265
Daunou, Pierre-Claude-François 180
David, Eugène 277
David, Jacques-Louis *passim*
 An Ancient Philosopher 44; *44*
 Andromaque Mourning Hector 49, 53, 68, 71, 73, 82, 153, 279, 298; *37, 70, 71*
 Anger of Achilles at the Sacrifice of Iphigenia 297; *297*
 Apelles Painting Campaspe in Front of Alexander 271, 280; *283*
 Arrival of the Emperor at the Town Hall 208, 222, 247, 260; *248, 249*
 Barra, Joseph 35, 151; *163*
 Belisarius 45, 61, 64, 66, 80, 300; *62, 63*
 Bonaparte Crossing the Great St. Bernard 68, 206; *207, 209*
 Christ on the Cross 66
 Combat between Minerva and Mars 22; *23*
 Combats of Diomedes 40, 53
 Consecration of the Emperor Napoleon I and the Coronation of the Empress Joséphine 8, 208, 220, 222, 226, 228, 235, 247, 254, 265, 273, 278, 279, 288, 290; *220, 221, 223, 224, 225, 227, 228, 229, 230, 231, 233, 234, 236, 237, 238, 239, 240, 241, 293*
 Cupid and Psyche 271, 294, 298; *295*
 Death of Seneca 24, *25*
 Death of Socrates 72, 77, 80, 83, 84, 86, 101, 130, 174; *80, 81*
 Departure of Regulus 93

 Distribution of the Eagles 194, 198, 235, 247, 252, 265, 268, 270, 271, 273, 278, 279; *252, 253, 254, 255, 256, 257, 258, 259, 260, 261*
 English Government 147
 Farewell of Telemachus and Eucharis 295; *296*
 Head of an Old Man 64
 Head of a Young Woman 170
 Head of the Dead Marat 157
 Hector's Departure 40, 260, 298
 Homer Reciting his Verses to the Greeks 171, 172, 182; *173*
 Horatius Returning Victoriously to Rome after the Murder of his Sister Camilla 72
 Judge 144
 Legislator on Duty 144
 Leonidas at Thermopylae 35, 74, 88, 114, 190, 194, 195, 196, 208, 253, 255, 271, 277, 278, 279, 294, 297; *197, 271, 272, 273*
 Lictors Bringing Brutus the Bodies of his Sons 50, 53, 68, 72, 80, 86, 94, 100, 122, 133, 134, 186, 191, 193; *90, 91, 92, 93*
 Loves of Paris and Helen 68, 84, 86, 88, 182, 194, 269, 270, 294; *86, 87*
 Marat Assassinated 153, 226; *159*
 Mars Disarmed by Venus and the Graces 297, 298, 302; *299*
 Moses and the Brazen Serpent 40
 Napoleon in his Study 263
 Nude Study 39, 43
 Oath of the Horatii 17, 49, 68, 69, 71, 72, 73, 78, 86, 89, 90, 93, 101, 133, 134, 186, 300; *75, 76, 77*
 Oath of the Tennis Court 46, 74, 107, 114, 118, 122, 130, 134, 164, 194, 195, 198, 251, 253, 279, 282; *103, 105, 107, 108, 109, 110, 111, 113, 115*
 Obsequies of Patroclus 40, 44, 53, 64, 66, 298; *40, 41, 52, 53*
 Old Horatius Defending his Son 73
 People's Representative on Duty 145
 Phaedra and Hippolytus 298
 Portraits of:
 M. Blauw 174; *179*
 General Bonaparte 204
 Zénaïde and Charlotte Bonaparte 288; *289*
 Mme Buron 29; *28*
 Mme Daru 265; *264*
 Mme David 265
 J.-F. Desmaisons 67
 Count Estève 242
 Count François of Nantes 266; *267*
 General Etienne-Maurice Gérard 282; *284*
 Jean bon Saint-André 170; *171*
 M. de Joubert 128; *126*
 M. and Mme Lavoisier 50, 92; *85*
 Alexandre Lenoir 281
 Alphonse Leroy 69
 M. Meyer 180
 Antoine Mongez and his Wife Angélique 266, 274; *269*
 Mme d'Orvilliers 128; *121*

Mme de Pastoret 128, 151; *127*
M. Pécoul 80; *78*
Mme Pécoul 80; *79*
Cooper Penrose 208; *211*
Pope Pius VII 226; *244*
The Pope and Cardinal Caprara 226; *245*
Count Stanislas Potocki 52, 61, 64, 65, 70, 84, 173; *55*
Mme de Récamier 151, 174; *183*
Pierre Sériziat 124, 126, 172, 173; *124, 174*
Mme Sériziat 172, 173; *176, 177*
Emmanuel-Joseph Sieyès 283; *287*
Mme de Sorcy-Thélusson 128; *123*
Mlle Tallard 173; *178*
Mme de Trudaine 128, 174; *129*
Comte Henri-Amédée de Turenne 282; *285*
Mme de Verninac 174; *181*
Vicomtesse Vilain XIIII and her Daughter 288, 290; *291*
The Actor Wolf, known as Bernard 290; *292*
A Young Man *130*
Physician Erasistrates Discovering the Cause of Antiochus' Illness 26; *27*
Queen Marie-Antoinette on the Way to the Scaffold *146*
Sabine Women 8, 47, 74, 80, 88, 122, 170, 172, 174, 182, 186, 190, 192, 194, 198, 203, 206, 208, 246, 255, 270, 277, 278, 279, 280, 294, 297; *184, 185, 188, 189, 193, 195*
Sappho, Phaon and Cupid 268, 270, 282, 294; *270*
Self-Portrait *125, 168*
St. Jerome 44, 64; *44*
St. Roch Interceding with the Virgin for the Plague Victims 49, 50, 60, 64; *51*
Study after a Tomb in the Vatican *45*
Study for a Portrait of Louis XVI and the Dauphin 122; *120*
Study of a Bull *49*
Study of a Classical Pedestal *46*
Triumph of the French People *142, 143*
Vestal Garlanded with Flowers *172*
View of the Luxembourg Garden *169*
View of S. Agnese Fuori le Mura in Rome *49*
Woman Suckling her Child 64
Wounded Venus Complaining to Jupiter 260
David, Jules 277, 280
David, Marguerite Pécoul, Mme *see* David
Debret, Jean-Baptiste 74
Decazes, Elie, Duc 279
Degotti, Ignace-Eugène-Marie 222, 247
Delacroix, Eugène 174, 273, 302
Delafontaine, Pierre-Maximilien 44, 127, 167, 170, 174, 222
Delaroche, Paul 128
Delavergne 186
Delécluze, Etienne-Jean 42, 43, 46, 47, 48, 86, 112, 134, 153, 170, 174, 182, 183, 186, 187, 190, 194, 196, 205, 208, 226, 271-3, 278
Delsaux 106
Delvaux, Rémi-Henri-Joseph *216*

Denon, Vivant-Dominique, Baron 148, 208, 260
Descartes, René 65, 141
Deseine 277
Deshayes, Jean-Baptiste-Henry 19
Désilles, Antoine-Joseph-Marc 135, 137
Desmaisons, Jacques-François 21, 68; *see also* David
Desmarres, General 160, 162, 164
Desmoulins, Camille 135
Desprez, Louis-Jean 37
Devillers, Georges 226
Devosges, Anatole 151, 153
Diderot, Denis 12, 17, 18, 21, 59, 64, 80, 81, 82
Didot, Firmin 297
Dionysius 89
Domenichino (Domenico Zampieri) 13, 35, 36, 186
Douglas, Alexander, Duke of Hamilton 260
Dow, Gérard 16
Dowd, David Lloyd 292
Doyen, Gabriel-François 19, 24, 66
Drouais, Jean-Germain 66, 73, 74, 89, 98, 99
Dubois-Crancé, Edmond-Louis-Alexis 72, 107, 118; *107*
Duchemin 290
Ducis, Jean-François 84
Ducis, Louis 186
Ducos, Pierre-Roger, Comte 286
Ducreux, Joseph 98
Du Guesclin, Bertrand 65
Dumouriez, Charles-François 153
Dupasquier: *see* Pasquier
Du Pavillon, Isidore-Pineau 298
Duplay, Maurice 141
Duplessis, Joseph-Siffred 29
Duqueylar, Paulin 186
Durameau, Louis 21, 62, 66
Durand, Jean-Nicolas-Louis 141
Duroc, Géraud-Christophe de Michel, Duke of Friuli 213, 232, 235

Enghien, Louis-Antoine-Henri de Bourbon, Duc d' 203
Espercieux, Jean-Joseph 170
Estève, Comte 235; *see also* David
Esther 18
Eudamidas 81
Euripides 76
Euryptus 198

Fabre, François-Xavier, Baron 66, 68
Fabre, Jean 147
Fabre de l'Aude, Jean-Pierre 216
Félibien, André 16
Fénelon, François de Salignac de la Mothe- 65
Fesch, Joseph, Cardinal 212, 213, 216, 242
Flaxman, John 186, 190
Fleurieu, Charles-Pierre Claret, Comte 208, 223
Flouest *100*

Fontaine, Pierre-François-Léonard 213, 214, 251, 254; *251*
Fontanel, Abraham 66
Fontanes, Jean-Pierre-Louis, Baron 210
Fontanges, Mme de 228; *237*
Forbin, Louis-Nicolas-Philippe-Auguste, Comte 186, 279
Forty, Jean-Jacques 98
Fourcroy, Antoine-François de 143
Fragonard, Jean-Honoré 19, 60
Français, Antoine, Comte *see* David
François de Neufchâteau, Nicolas, Comte 216
Franklin, Benjamin 135, 136
Franque, Joseph 186, 187, 190
Franque, Pierre 186, 187, 190
Frémiet 294
Frémiet, Sophie: *see* Rude, Mme
Füseli, Johann Heinrich 36, 106

Gabriel, Jacques-Ange 20
Galle, André 297
Garat, Joseph-Dominique 120
Gardel 141
Garneray, Jean-François *69*
Gaubert, Henri 210
Gautherot, Claude 186
Gauthier *205*
Gautier, Théophile 302
Genlis, Stéphanie Félicité Du Crest de Saint-Aubin, Comtesse de 88, 127, 246
George III, King of England 148
Gérard, Etienne-Maurice *see* David
Gérard, François, Baron 17, 127, 173, 174, 178, 182, 222, 282
Gérard, Michel, known as Père Gérard 114, 118; *107, 115*
Géricault, Théodore 302
Gerle, Christophe-Antoine, Dom 116
Giaquinto, Corrado 35
GiLon, known as... Ginguené 88
Giotto di Bondone 194
Giraud, Jean-Baptiste 47
Girodet, Anne-Louis Girodet de Roucy-Trioson 66, 68, 164, 194
Gisors, Alexandre-Jean-Baptiste-Guy de 222
Gleizes, André 189
Gluck, Christophe 88
Goethe, Johann Wolfgang von 36
Gori, Antonio Francesco 34
Gossec, François-Joseph 136, 150, 153
Goujon, Jean 89
Grandin, Jacques-Louis-Michel 186
Granet, François-Marius 186
Granet, François-Omer 143
Grégoire, Henri, Abbé 116, 118; *117*
Grétry, André-Ernest-Modeste 293
Greuze, Jean-Baptiste 16, 18, 19, 69, 290
Gros, Antoine-Jean, Baron 86, 268, 278, 279, 280, 290, 297, 302
Guercino (Gian-Francesco Barbieri) 20, 35
Guérin, Pierre-Narcisse, Baron 268, 294

Guillotin, Joseph-Ignace 102
Guiraud 155
Guizot, François-Pierre-Guillaume 191

Hackert, Jakob Philipp 36
Hackert, Johann Gottlieb 36
Hallé, Noël 11, 21, 66
Hamilton, Gavin 34, 35, 36, 73, 90; *37*
Hamilton, William 34
Hancarville, Pierre-François-Hugues, Chevalier d' 34, 53
Hannibal 206
Hébert, Jacques-René 155
Hector 68, 70, 153, 186
Hegel, Georg Wilhelm Friedrich 35
Helen 89
Helman, Isidore-Stanislas *139*
Hennequin, Philippe-Auguste 66
Hérault de Séchelles, Marie-Jean 138, 140
Herbert, Robert 134
Hercules 142, 147, 198, 272
Herodotus 198, 272
Hersilia 8, 186, 191, 192, 193; *184*
Holbach, Paul Henri Dietrich, Baron 59
Homer 190
Horatius the Elder 74
Horatius the Younger 72, 80
Houdon, Jean-Antoine 36, 135
Howard, Seymour 53
Hubert (Auguste Cheval) 141, 143
Huibans 262
Huin, Mme 173

Ingres, Jean-Auguste-Dominique 128, 173, 174, 262, 294, 302
Isabey, Jean-Baptiste 167, 213; *219*
Ismene 86
Ismenes 86

Jaucourt, Arnail-François, Marquis 232
Jean bon Saint-André *see* David
Jenkins, Thomas 34
Jollain, Nicolas-René 62, 148
Jombert, Pierre-Charles 23, 24, 26
Joséphine de Beauharnais, Empress 214, 216, 218, 219, 220, 222, 223, 228, 232, 235, 246, 250; *220, 233, 237, 238, 256*
Joubert, Barthélemy-Catherine, General 286
Joubert, Philippe-Laurent de 66; *see also* David
Julie, Queen: *see* Bonaparte, Julie Clary
Julien, Pierre 36
Junot, Andoche, Duc d'Abrantès 232, 247
Justinian 61

Kauffmann, Angelika 36
Kellermann, François-Christophe-Edmond, Duc de Valmy, Marshal 219
Kemp, Martin 198
Kervelegan 118; *119*

La Bourdonnaye, François-Régis, Comte 278
Lacombe 128

Lacuée de Cessac, Jean-Girard, Comte 254
La Fayette, Gilbert Motier, Marquis 104, 131
Lafont de Saint-Yenne, Etienne 36
La Fontaine, Jean de 268
Lagrenée the Elder, Louis-Jean-François 11, 19, 21, 26, 49, 66, 82, 89, 282
Langlois, Jérôme-Martin 190; *301*
La Harpe, Jean-François de 88
La Live de Jully, Ange-Laurent de 16
Lally, Thomas Arthur, Baron de Tollendal, Comte de 61
Lamarie, Jacques 47
Lamoignon, Guillaume de 65
Lannes, Jean, Duc de Montebello, Marshal 255
Laporte 122
La Rochefoucauld, Mme de 232, 293; *234, 237*
Lavalé *218*
La Valette, Mme de *237*
La Ville, Comte 228
Lavoisier, Antoine-Laurent 84; *see also* David
Lazowski 153
Le Barbier, Jean-Jacques-François 98
Leblanc, Jean, Abbé 11
Le Brun, Charles 40, 62, 208
Lebrun, Charles-François, Duc de Plaisance 208, 210, 213, 220, 223, 227, 246; *228, 241*
Le Brun, Jean-Baptiste-Pierre 100
Lebrun-Pindare (Ponce-Denis Ecouchard) 72, 88
Le Chapelier, Gui 103
Lee, Virginia 112
Lefebvre, Pierre-François-Joseph, Duke of Danzig, Marshal 219
Lefèvre 106
Legrand, Jean-Guillaume 101
Lejéas, François-Antoine, Mgr *223*
Lejeune, Sylvain 279
Lekain (Henri-Louis Kaïn) 134
Lemoine, François 42
Le Monnier, Anicet-Charles-Gabriel 23, 24, 26
Lenoir, Alexandre 141, 146, 164, 219, 262, 268, 280; *see also* David
Le Noir, Jean-Charles 60
Lenoir-Laroche, Comtesse 274
Leonidas 197, 198, 272, 274
Lepelletier de Saint-Fargeau, Félix 150
Lepelletier de Saint-Fargeau, Louis-Michel 89, 147, 149, 150, 151, 153, 154, 156, 157, 158; *149, 152*
Lepelletier de Saint-Fargeau, Suzanne 150, 151, 208
Lépicié, Nicolas-Bernard 16, 66
Leroy, Alphonse: *see* David
Le Sueur, Eustache 59, 222
Levasseur, Antoine-Louis 279
Levitine, George 187
L'Hôpital, Michel de 65
Livy (Titus Livius) 90
Louis, King of the Netherlands 290
Louis XIV, King of France 11, 12, 16, 66, 102, 150, 208
Louis XV, King of France 139

Louis XVI, King of France 17, 21, 59, 120, 130, 135, 139, 150, 219, 232, 278, 286
Louis XVIII, King of France 191, 210, 266, 282
Louis-Philippe, King of France 232, 266
Lubomirska, Princess 88
Lucretia 90
Lullin, Adolphe Lullin de Châteauvieux 186

Mably, Gabriel Bonnot de 141
Mainbourg, de 171
Malbeste, Georges *250*
Mannlich, Johann Christian von 36
Mantegna, Andrea 190
Marat, Jean-Paul 147, 154, 155, 156, 158, 160, 162, 280; *154, 155, 157, 159*
Maratta, Carlo 19
Marchais, Mme de, later Comtesse d'Angiviller 59
Marcus Aurelius 11
Maria Theresa, Empress of Austria 288
Marie-Antoinette, Queen of France 148; *146*
Marie-Louise, Empress of France 250, 290
Marigny, Abel François Poisson, Marquis de 11, 14, 15
Marmontel, Jean-François 59, 61
Marsyas 89
Martin d'Auch (Joseph Martin-Dauch) *115*
Masquelier, Nicolas-François-Joseph 128
Masson, Frédéric 210
Maupetit, Michel-René 114
Maure, Nicolas-Sylvestre 156
Méhul, Etienne-Nicolas 141, 293
Ménageot, François-Guillaume 22, 65, 66, 82
Mengs, Anton Raffael 33, 35, 36, 37, 49; *36*
Merlin, Philippe-Antoine Merlin, Comte (Merlin de Douai) 279
Metsu, Gabriel 16
Metternich, Klemens Lothar Wenzel, Prince 232
Meunier, Claude-Marie, Baron 277
Meyer: *see* David
Michelangelo Buonarroti 19, 36, 47, 50, 53
Mignot, Abbé 131
Millin, Aubin-Louis 272
Mirabeau, Gabriel-Honoré Riquetti, Comte 106, 113, 114, 118, 131, 133, 135, 253; *107*
Moitte, Jean-Guillaume 72
Moitte, Mme 97; *99*
Moline, P.-L. 146
Molinos, Jacques 247
Moncey, Bon-Adrien Jeannot de, Marshal 235; *237*
Mondrian, Piet (Piet Cornelis Mondriaan) 46
Mongez, Antoine 232; *see also* David
Mongez, Marie-Joséphine-Angélique Levol, Mme 268; *see also* David
Monnet, Charles *139*
Monsiau, Nicolas-André 98
Montausier, Charles, Marquis 66
Montfaucon, Bernard, Dom 34, 53
Moreau, Charles 112, 183

Moreau the Elder, Louis-Gabriel 98
Moreau the Younger, Jean-Michel 134
Moriès 186
Mounier, Jean-Joseph 103
Mulard, François-Henry 186
Murat, Caroline: *see* Bonaparte, Caroline
Murat, Joachim 232, 235; *237*

Napoleon: *see* Bonaparte
Natoire, Charles-Joseph 38, 42
Navez, François-Joseph 279
Newdigate, Sir Roger 34
Ney, Michel, Duc d'Elchingen and Prince de la
 Moskowa, Marshal 278
Noailles, Catherine-Françoise-Charlotte de Cossé-
 Brissac, Marshal 66
Nodier, Charles 187
Nollekens, Joseph 36

Odevaere, Joseph-Dionisius 279, 293
Orléans, Louis-Philippe-Joseph, Duc d' 88, 134,
 150
Orvilliers, Louise Rilliet, Marquise 124; *see also*
 David
Ossian 190
Ozouf, Mona 130

Paganel, Pierre 279
Pahin de la Blancherie, Claude-Catherine Flammès-
 60
Paillot de Montabert, Jacques-Nicolas 186
Pajou, Augustin 101
Panini, Giovanni Paolo 33
Paris 150
Paroy, Jean-Philippe-Guy Le Gentil, Comte 88
Pascal, Blaise 66
Pasquier (*or* du Pasquier), Antoine 48, 148
Passeri, Nicola 34
Pastoret, Adelaïde-Louise Piscatory; Mme de: *see*
 David
Pastoret, Amédée de 128
Pastoret, Emmanuel de 128
Pau de Saint-Martin, Alexandre 98
Pécoul, Charles-Pierre 68; *see also* David
Pécoul, Mme: *see* David
Pécoul, Constance 141
Pécoul, Marguerite: *see* David, Mme
Penrose, Cooper: *see* David
Percier, Charles 213, 214, 251; *251*
Pérignon, Dominique-Catherine, Marquis de,
 Marshal 219
Péron, Alexandre 72, 74
Perugino (Pietro di Cristoforo Vanucci) 194
Peyre, Marie-Joseph 37
Peyron, Jean-François-Pierre 7, 19, 26, 47, 59,
 62, 76, 78, 82, 83; *35*
Phaon 86, 269
Phidias 190
Philip, King of Macedon 86
Pierre, Jean-Baptiste-Marie 12, 21, 60, 61, 65
Pietro, Michel di, Cardinal 228
Pietro da Cartona (Pietro Berretini) 19

Piranesi, Giovanni Battista 33, 34, 37, 46, 70
Pison du Galland, Alexis-François 103
Pitt, William 148
Pius VI, Pope 33, 212
Pius VII, Pope 7, 212, 213; *221, 223, 240, 245*;
 see also David
Plato 81, 82, 189
Pliny the Elder 280
Plutarch 90, 97, 114, 193
Pompadour, Jeanne Antoinette Poisson, Marquise
 11
Ponce, Nicolas *99*
Porsenna 86
Portalis, Jean-Etienne-Marie 212
Potocki, Stanislas, Count 53, 83; *see also* David
Poussin, Nicolas 19, 26, 36, 45, 46, 50, 63, 65,
 69, 77, 80, 81, 88, 192
Pradel, Comte 280
Pradt, Dominique-Georges, Abbé 212
Prieur de la Marne (Pierre-Louis Prieur) 279;
 115, 117, 137
Prud'hon, Pierre-Paul 294
Psyche 89
Pythagoras 189

Quatremère de Quincy, Antoine-Chrysostome
 44, 101, 102, 126
Quay (*or* Quaï), Maurice 187, 190

Rabaut-Saint-Etienne, Jean-Paul 116, 118, 120
Raimondi, Marc-Antoine 187
Ramel-Nogaret, Dominique Vincent 279, 286
Raphael 14, 19, 35, 36, 42, 46, 50, 83, 114, 170,
 187, 190, 194
Récamier, Juliette de 7; *see also* David
Regnault, Jean-Baptiste, Baron 7, 148, 182
Regnault de Saint-Jean d'Angélys, Auguste-
 Michel-Etienne, Comte 212
Regulus 89
Rehschuh 37
Reiffenstein, Johann Friedrich von 36
Rémusat, Auguste-Laurent, Comte 213
Reni, Guido 35, 38; *38*
Restout, Jean 17
Revett, Nicholas 190
Revoil, Pierre-Henri 186
Rewbell, Jean-Baptiste *115*
Reynolds, Sir Joshua 83
Ribera, José de 42
Richard, Fleury 186
Richelieu, Armand Emmanuel Du Plessis, Duc
 de 278
Richelieu, Armand Jean Du Plessis, Cardinal and
 Duc de 199
Rilliet 122
Rivière, de 88
Robespierre, Maximilien de 7, 106, 114, 120,
 141, 162, 167, 170, 253, 280
Robin 183
Roger-Ducos: *see* Ducos
Roland, Jean-Marie Roland de la Platière 148,
 186

Rollin, Charles 72, 97
Romme, Gilbert 104
Romulus 186, 191, 192, 193; *184*
Rosenblum, Robert 189
Rouget, Georges 222, 290, ·292
Rousseau, Jean-Jacques 135, 136, 141
Roxane 18
Rubens, Peter Paul 54, 222
Rubin, James 189
Rude, Sophie Frémiet, Mme 297

Sabina 74, 78
Saint-Non, Jean-Claude-Richard, Abbé 37
Sané, Jean-François 81, 82
Sappho 86, 268, 270; *270*
Sarette 141
Saxe-Teschen, Albert, Duke of 66
Scaevola, Mucius 17, 86
Schall, Jean-Frédéric 18
Schönborn, Count 295
Sedaine, Michel 21, 23, 24, 72
Séguier 36
Ségur, Louis-Philippe de 213, 214, 235; *237*
Seneca 50
Serangeli, Gioacchino 141
Sergel, Johan Tobias 36, 37
Sériziat, Pierre: *see* David
Sériziat, Mme: *see* David
Sérurier, Jean-Matthieu-Philibert, Marshal 235
Shelburne, Lord William 35
Sidney, Algernon 136, 150
Sieyès, Emmanuel-Joseph 113, 279, 286; *see also*
 David
Simonet, Jean-Jacques-François *217*
Snyders, Frans 54
Socrates 80, 82, 83
Solon 12
Sombret 162
Sommariva, Giovanni-Battista, Count 294
Sophocles 190
Sorcy: *see* Thélusson
Soult, Mme de 228; *237*
Stapleaux, Michel 298
Stendhal (Marie Henri Bayle) 192, 302
Stuart, James 190
Subleyras, Pierre 33
Sully, Maximilien de Béthune, Duc 65
Survilliers: *see* Bonaparte, Joseph
Suvée, Joseph-Benoît 22, 66
Suzanne, François-Marie 43, 47, 48

Taillasson, Jean-Joseph 22
Tallard, Catherine-Marie-Jeanne: *see* David
Talleyrand, Charles-Maurice de Talleyrand Péri-
 gord, Prince de Bénévent 101, 212, 213, 218,
 219, 227, 232, 242; *241*
Tallien, Jean-Lambert 136
Talma, François-Joseph 131, 134
Tardieu, Pierre-Alexandre 153
Tarquin the Proud (Lucius Tarquinius Superbus)
 90, 135
Tatius 186, 192, 193; *184*

Taunay, Nicolas-Antoine 182, 268
Telemachus 296
Tell, William 136; *142*
Teniers the Younger, David 16
Theagenes 86
Thélusson, Jean-Isaac, Count of Sorcy 122
Thélusson, Mme, née Rilliet: *see* David
Théroigne de Méricourt, Mlle (Lambertine) 136
Thibaudeau, Antoine, Comte 279
Thibaut (*or* Thibault), Anne-Alexandre-Marie *115*
Thiers, Adolphe 300
Thorwaldsen, Bertel *or* Alberto 260
Tiarini, Alessandro 38
Tiberius, son of Brutus 91
Tiepolo, Giambattista 35
Tischbein, Johann-Heinrich-Wilhelm 190
Titian 14, 42, 54
Titus, Emperor 11
Titus, son of Brutus 91, 133
Topino-Lebrun (François-Jean-Baptiste-Topino Lebrun) 120, 203
Tourteau, Marquis d'Orvilliers 124
Tourville, Anne-Hilarion de 66
Townley, Charles 35
Trajan, Emperor 11, 205
Treilhard, Jean-Baptiste 212
Trudaine de Montigny, Charles-Louis 80
Trudaine de Montigny, Mme: *see* David
Trudaine de Montigny, Jean-Charles-Philibert 72

Trudaine de la Sablière, Charles-Michel 80, 130
Turenne, Henri-Amédée-Mercure, Comte 283; *see also* David
Turgot, Anne-Robert 60, 80, 130

Vadier, Marc-Guillaume-Albert 279
Valentin (Valentin de Boulogne) 42, 43, 44
Van Dyck, Sir Anthony 54, 191
Van Loo, A. 84
Van Loo, Carle 11
Van Loo, César 37
Van Spaendonck, Gérard 182
Vaudreuil, Joseph-Hyacinthe-François de Paule, Comte 88
Vergniaud, Pierre-Victurnien 153
Vernet, Horace 163
Vernet, Joseph 222
Verninac, Henriette Delacroix, Mme de: *see* David
Viala, Agricol 141, 162, 170
Vien, Joseph-Marie 11, 16, 19, 20, 21, 22, 26, 29, 34, 35, 38, 40, 42, 43, 44, 48, 49, 50, 62, 66, 92, 99, 182, 186, 194, 232, 235, 268, 293; *21*
Vigée-Lebrun, Elisabeth-Louise 88
Vilain XIIII, Philippe-Louis, Comte 290
Vilain XIIII, Vicomtesse: *see* David
Villeneuve, Juliette de 288
Villette, Mme de 136
Villette, Charles-Michel, Marquis 131, 135
Vincent, François-André 7, 22, 62, 66, 101, 148, 182

Visconti, Ennio Quirino 268
Vivant: *see* Denon
Volaire, Pierre-Jacques 34
Voltaire (François-Marie Arouet) 62, 92, 130, 131, 132, 134, 135, 136, 150; *132, 133*

Wailly, Charles de 37, 72
Washington, George 92
Weddell, William 35
Weinlig, Christian Traugott 36, 37
West, Benjamin 36
Wicar, Jean-Baptiste 47, 66, 74, 91, 92, 128, 148, 268
Wille, Jean-Georges 98, 156
William I, King of the Netherlands 279, 288, 290, 293
Winckelmann, Johann Joachim 33, 34, 35, 36, 46, 49, 53, 54, 86, 196, 272
Wind, Edgar 72
Wolf, known as Bernard: *see* David
Wright of Derby 84

Xenophon 198
Xerxes 198

Yusupov, Nicholas, Prince 268, 277

Zeuxis 191

Photo Credits

The figures refer to the Plates. The photographs were kindly provided by the following:

Avignon, Musée Calvet 95 (photo Lauros-Giraudon, Paris)

Bayeux, Musée Baron Gérard 16

Bayonne, Musée Bonnat 33 (photo Lauros-Giraudon, Paris); 45, 46 (photos Etienne, Bayonne)

Berlin, Staatliche Museen Preussischer Kulturbesitz 20 (photo Walter Steinkopf, Berlin)

Brussels, Musées royaux des Beaux-Arts 93, 190

Brussels, A.C.L. 183

Buffalo, Albright-Knox Art Gallery 28

Cambridge (Mass.), Fogg Art Museum 18, 53, 130-132, 134, 136, 137, 181

Cherbourg, Musée Thomas Henry 15 (photo Savary, Tourlaville)

Chicago, The Art Institute 7 (photo Bulloz, Paris); 71, 99, 115, 162-164

Cleveland, Museum of Art 186

Copenhagen, Ny Carlsberg Glyptotek 180

Dijon, Musée des Beaux-Arts 26, 88

Dublin, National Gallery of Ireland 13, 14

Florence, Galleria degli Uffizi 69 (photo Gabinetto Fotografico, Florence)

Fontainebleau, Musée national du château 2 (photo Giraudon, Paris)

Leningrad, Hermitage Museum 173

Lille, Musée des Beaux-Arts 148 (photo Bulloz, Paris); 27

Malmaison, Musée national du château 119 (photo Giraudon, Paris); 120 (photo Lauros-Giraudon, Paris)

Marseilles, Musée des Beaux-Arts 22 (photo Studio Yann Thibault, Le Rove)

Montpellier, Musée Fabre 29 (photo Lauros-Giraudon, Paris); 70, 116, 140 (photos Claude O'Sughrue)

Munich, Bayerische Staatsgemäldesammlungen 67 (photo Blauel, Gauting)

New York, The Frick Collection 169
 – The Metropolitan Museum of Art 40, 179

Ottawa, National Gallery of Canada 68

Paris, Bibliothèque nationale 86, 87 (Photos Bulloz, Paris); 10, 48, 49, 74, 76-79, 90, 94, 118, 122-127, 154, 155

– Bibliothèque Thiers 149 (Musées nationaux, Paris)

– Bulloz 147, 156, 187

– Ecole des Beaux-Arts 6 (photo Bulloz, Paris); 31 (photo Lauros-Giraudon, Paris)

– Giraudon 73

– Musée Carnavalet 75, 91 (photos Bulloz, Paris); 84 (photo Lauros-Giraudon, Paris); 81

– Musée Jacquemart-André 171

– Musée du Louvre 1, 3, 11, 19, 21, 32, 35-37, 41, 42, 44, 50, 59, 60, 64-66, 72, 85, 96, 97, 100-102, 104, 106-108, 110-114, 117, 128, 129, 133, 135, 139, 150, 152, 153, 158-161, 174, 176, 177, 184 (clichés des Musées nationaux, Paris); 43, 141, 145 (photos AGRACI, Paris); 34, 80, 103, 109, 157 (photos Bulloz, Paris); 138, 142, 144, 191 (photos Giraudon, Paris); 172 (photo Georges Routhier, Paris)

– Musée du Petit Palais 4, 5 (photos Bulloz, Paris)

Philadelphia, coll. McIlhenny 151 (photo Chas. P. Mills & Co., Philadelphia)

Québec, cathédrale Notre-Dame 17 (photo Musée du Québec)

Sacramento, E.B. Crocker Art Gallery 24 (photo David Dangelo)

San Diego, Timken Art Gallery 121

Stockholm, Nationalmuseum 89

Toulon, Musée d'Art et d'Archéologie 182 (photo Bulloz, Paris)

Toulouse, Musée des Augustins 8 (photo Musées nationaux, Paris)

Tours, Musée des Beaux-Arts 38 (photo R. Arsicaud, Tours)

Versailles, Musée national du château 51, 52, 54-58, 61, 82, 83, 92, 165, 166, 185 (clichés des Musées nationaux, Paris); 167 (photo Giraudon, Paris)

Warsaw, Muzeum Narodowe w Warszawie 25

Washington, National Gallery of Art 168, 170

Author's archives 9, 12, 23, 30, 39, 47, 62, 63, 98, 143, 146, 175, 178, 188, 189

This book was printed in August 1982
by Imprimeries Réunies SA, Lausanne
Photolithographs: Imprimeries Réunies SA, Lausanne
Filmsetting: Photocomposition EP S.A., Lausanne.
Binding: Mayer & Soutter SA, Renens-Lausanne
Documentalist: Ingrid de Kalbermatten
Design and Production: Claude Chevalley
Produced in Switzerland

7

14 51495